# 天空交響曲
## AERIAL SYMPHONY

不同角度之下的肯亞及坦桑尼亞
Kenya and Tanzania from Different Perspectives

李秀恒
EDDY LI

# 天空交響曲 Aerial Symphony

不同角度之下的肯亞及坦桑尼亞
Kenya and Tanzania from Different Perspectives

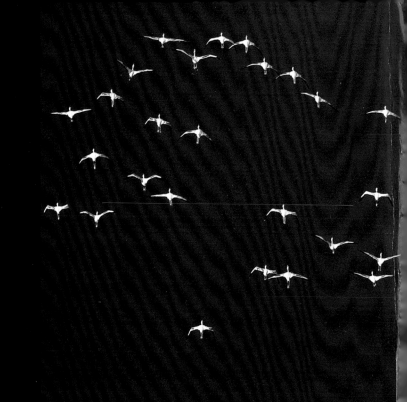

| | |
|---|---|
| 作者 Author | 李秀恒 Eddy Li |
| 翻譯 Translation | 李佳燁 Natalie Li |
| | 梁皓明 Kristie Leung |
| 責任編輯 Managing Editor | 吳家駿 Alvis Ng |
| 文字編輯 Text Writer | 李佳燁 Natalie Li |
| | 陳曉 Chan Hiu |
| 美術主任 Art Director | 駿二 Zimman Shunji |
| 美術編輯 Designer | 莫偉賢 Ryan Mok |
| | 李佳燁 Natalie Li |
| 發行人 Publisher | 熊曉鴿 Hugo Shong |
| 總編輯 Editor in Chief | 李永適 Yungshih Lee |
| 策　劃 Acquisitions Editor | 蔡耀明 Ivan Tsoi |

出版社 Publishing House　台灣 22175 新北市汐止區新台五路一段
97 號 14 樓之 10（遠雄 U-TOWN B 棟）
地址 Address　14F-10, No.97 Sec. 1, Xintai 5th Rd.,
Xizhi Dist., New Taipei City 22175,
Taiwan (R.O.C.)
電話 Tel　+886 (02) 26971600
傳真 Fax　+886 (02) 87971736

台灣總代理　大和書報圖書股份有限公司
港澳總代理　泛華發行代理有限公司

2020 年 7 月初版
定價 Price：NT$800 / HK$266
ISBN：978-957-8722-93-4（精裝）

國家圖書館出版品預行編目（CIP）資料

天空交響曲：不同角度之下的肯亞及坦桑尼
亞 Aerial symphony：Kenya and Tanzania from
different perspectives / 李秀恒著 .
-- 初版 . -- 臺北市：大石國際文化，2020.07
288 面；25x25 公分
中英對照
ISBN 978-957-8722-93-4( 精裝 )
1. 攝影集
958.2　　　　　　　　　　109008439

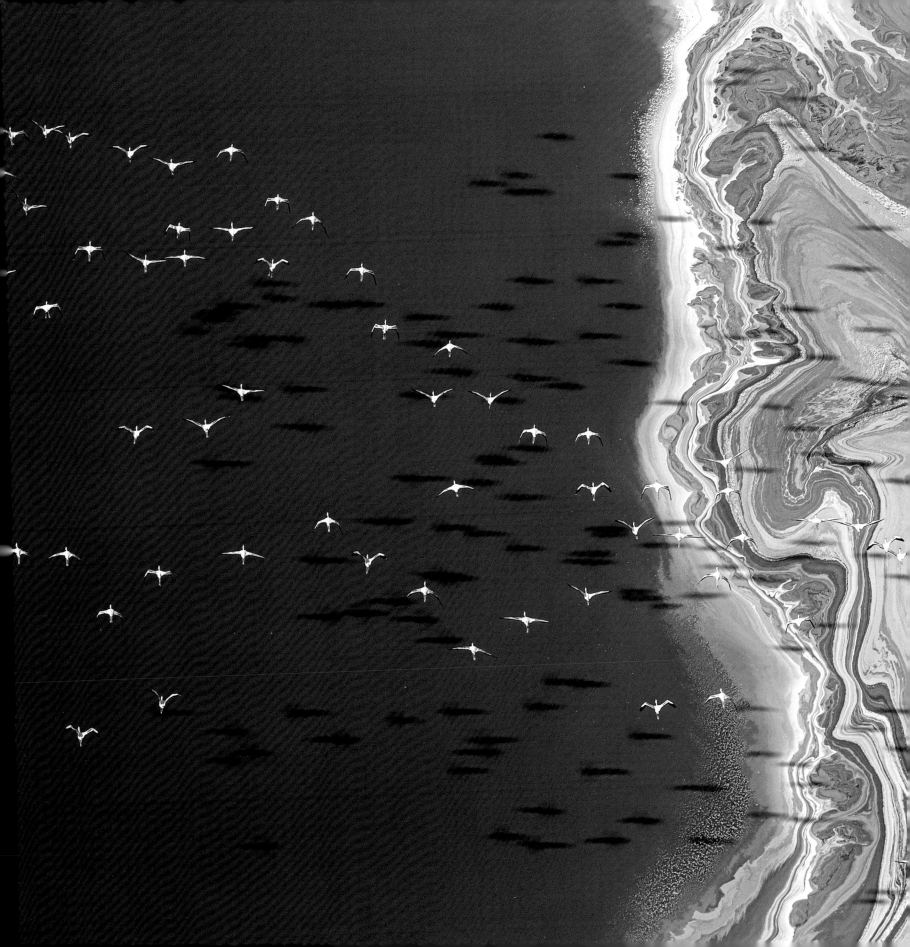

# 天空交響曲
# Aerial Symphony

## 目錄
## Index

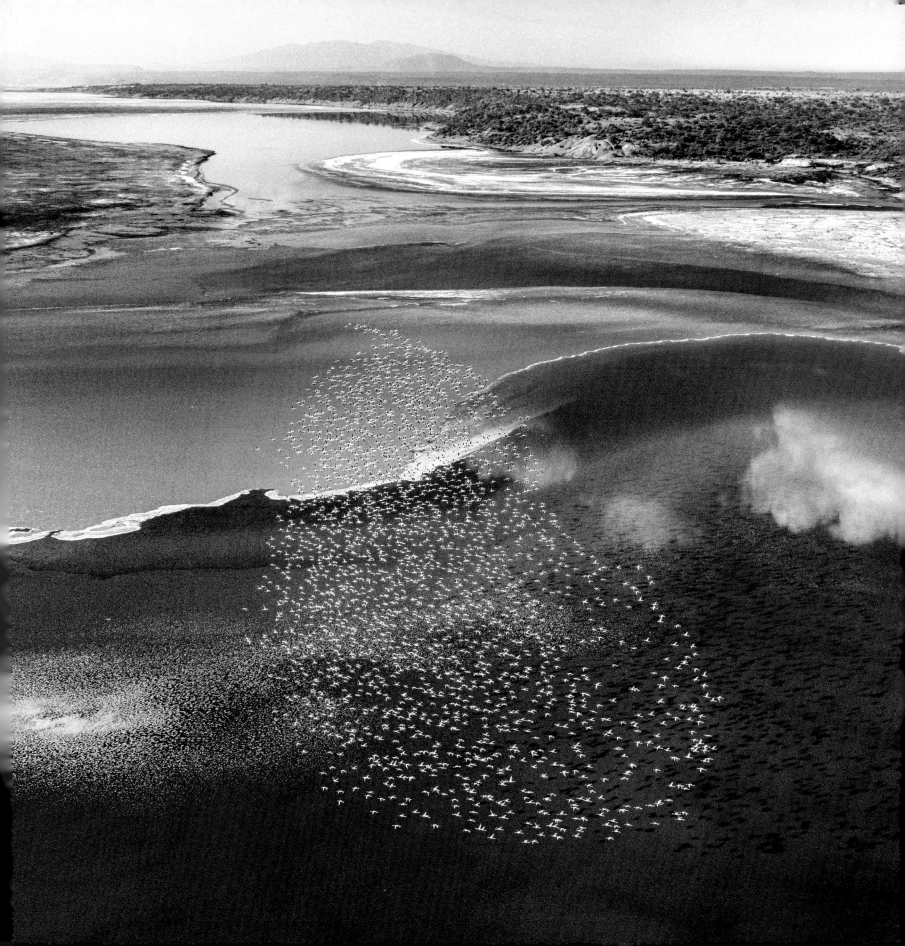

# 前言
# FOREWORD

或是從攝影這種藝術誕生開始，東非就是攝影師眼中的熱門攝影聖地，我自己就曾不下十次前往非洲拍攝。每一次去非洲，除了被地球贈予這片土地的恢宏所震懾外，也加深了對不同野生動物的生態、習慣及個性的了解，使每一次拍攝的作品漸臻佳境。

在此，未經馴服的野生動物展示著原始天性，獅子及花豹不再是動物園中的困獸，以先天的優勢稱霸草原；渺小的個體和龐大的群體皆可浸潤於大自然賦予的壯闊景色中，動物、湖泊及土壤組成玩味十足的圖案和色彩，彷彿一幅幅抽象畫；部落及城市在此與自然互相融合，人類與動物找到共存的平衡點……種種景象，共同交織成本書的主題——一首關於非洲的交響曲。

數年前在遊歷德國之時，我前往了貝多芬出生地，波恩的貝多芬之家，因此對這位偉大的作曲家有了更深的了解，亦藉此機會多了興趣接觸古典音樂，尤其是他的幾首「神級」交響曲作品。

也許或多或少受到了他音樂的影響，其後前往非洲進行拍攝的時候，腦海中不時響起他某一首傑作的旋律，彷彿鏡頭下所攝入的雀鳥、牛羊、獅豹，都成了天地間巨大五線譜上的生動音符，演奏著時而壯闊、時而淒美、或偶爾活潑的樂章。

貝多芬的音樂沿襲了古典樂派傳統的華麗工整之風，又加入了濃烈的個人情感及張力，而他的偉大之處，就是能夠平衡迥然不同的風格而創作出震撼的樂章和動人的旋律。曲調雖異，工妙則同。不少攝影愛好者亦是在努力找尋紀實與唯美兩者之間微妙的平衡點，利用構圖、色彩、對比，把肉眼可見的環境定格為一幅幅富有藝術性的畫面。

適逢貝多芬的誕辰 250 週年，希望本書可以把攝影與這位偉大作曲家的重要作品（其第三、第五、第六及第九交響曲）相結合，讓讀者能享受兩種藝術相融所帶來的新鮮觀感。

李秀恒

East Africa has been popular among photographers since, perhaps, the birth of photography. I, personally, have visited East Africa for more than a handful of times. I'd say that I am overwhelmingly amazed every single time by what nature has endowed with this piece of land, and my understanding for the lifestyle, habits and characteristics of assorted wild animals increases as well, which further enhances my experience in taking pictures of them.

The East Africa allows you to see how the untamed animals actually behave - lions and leopards are no longer trapped in a cage in the zoo and showing their capability here. Either as an insignificant individual or in a gigantic group, all creatures are integrated into the magnificence of nature given by our mother earth. Animals, lakes and lands are composing an abstract painting together, using interesting patterns and colors. Tribes and cities exist harmoniously with the nature, just as humans and animals have found their balance point to live together. All of these have echoed with the theme of this book - a symphony about Africa.

When traveling to Germany a couple of years ago, I paid a visit to the Beethoven House in the city of Bonn - where one of the greatest composers in history, Ludwig van Beethoven, was born. Having learned about his experience and the background stories behind his works, I grew more and more interested in classical music, especially his miraculously brilliant symphonies.

Later when I visited Africa and took pictures of the majestic land, the masterpieces of Beethoven just wouldn't stop chanting in my head, as if the earth had turned into a gigantic music sheet, on which the flying birds, the wandering flocks and herds, and the roaring lions and cheetahs had become representatives of notes, singing melodies that are either grandiose or melancholy or dynamic.

What's great about Beethoven is that he flavored the traditional arrangement of classical genre with his personal emotions and tensions, yet in the meantime being able to create stunning pieces and riveting melodies while balancing the highly contrasting music styles. This is delicately difficult in the same way for most photographers. Using composition, coloring and comparison, they have been constantly trying to find the "sweet spot" when balancing realism and aestheticism in photography.

This book is published in the year that celebrates Beethoven's 250th birthday. Flavoring photography with the masterpieces (the 3rd, 5th, 5th and 9th symphonies) of the great composer, I hope to present to all readers a new perspective brought by the combination of two different ways of artistic expression.

Eddy Li

7

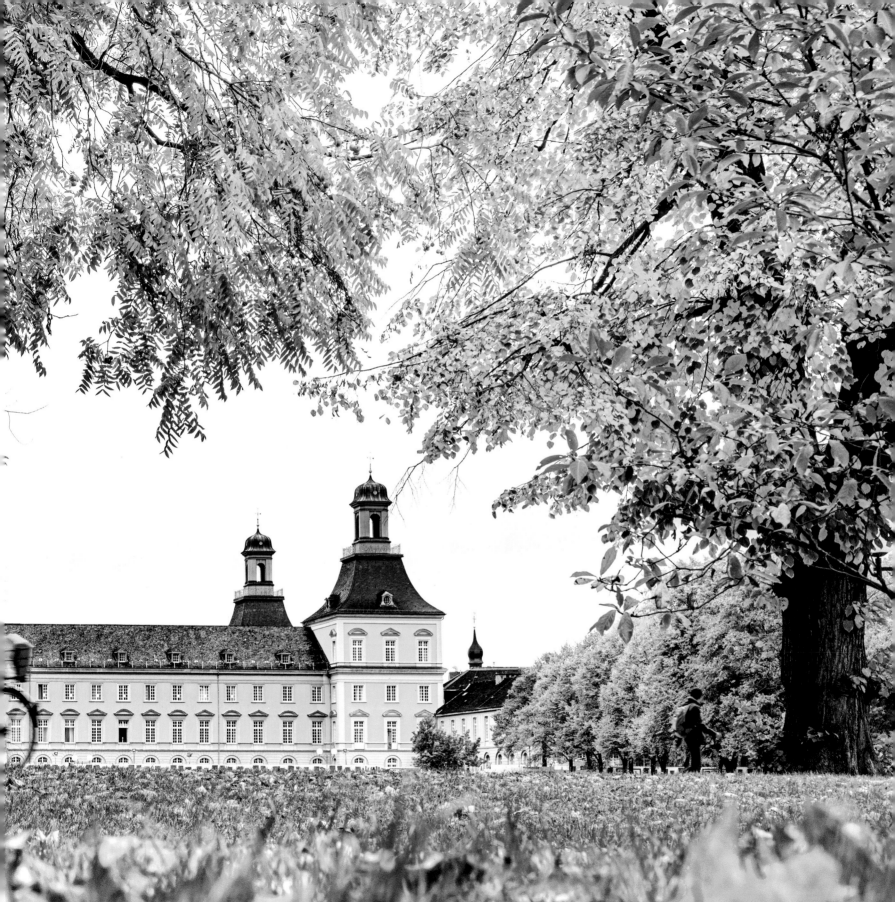

8-9

貝多芬故鄉的知名學府波恩大學

University of Bonn, a famous university
in Beethoven's hometown

10-11

貝多芬之家的正門入口

The main entrance of the Beethoven
House

# 貝多芬之鄉
# BEETHOVEN'S HOMETOWN

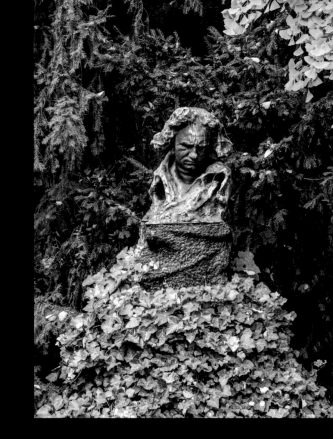

位於萊茵河畔的波恩，是前西德的首都，擁有 2,000 年的悠長歷史。城市北部波恩巷 20 號的民居驟眼望去或者平平無奇，但在 1770 年，這裡誕生了偉大的作曲家路德維希·范·貝多芬。1899 年他的故居被改成「貝多芬之家」博物館，共設 12 個展廳，是收藏有關貝多芬生平事物最大的博物館。

Sitting at the bank of the Rhine, Bonn, once the capital city of West Germany, is a city with 2,000 years of history. At Bonngasse 20 in northern Bonn, the residential building appears to be quite ordinary. Yet it is the birthplace of the extraordinary composer Ludwig van Beethoven, who was born here in 1770. This old residence of his had become the Beethoven House museum since 1899, which is the largest museum of collection telling stories about his life, with 12 exhibition halls in total.

12-13

花園中有一座貝多芬的半身銅像。（左）貝多芬出生於三樓的小閣樓內。（右）

A bronze bust of Beethoven has been erected in the garden. (Left) Beethoven was born in the attic on the third floor. (Right)

# 命運
# FATE

在非洲壯闊天地中自由翱翔的鳥群

The bird flocks flying freely in the air of the magnificent Africa

Sinfonia 5ta

da

Luigi Van Beethoven

# 命運
# FATE

貝多芬《第五交響曲》又稱《命運交響曲》，若稱它為古典樂中最廣為流傳的作品，一點也不為過。

在創作這首交響曲長達四至五年的期間（1804-1808），三十多歲的貝多芬正飽受日益嚴重的耳疾困擾。

開章以不斷重複推進的四個三短一長的音符所組成的動機，有些聽眾認為正如貝多芬的秘書安東·辛德勒所形容的「命運來敲門的聲音」，營造出扣人心弦的緊張感；而有些人則偏向相信貝多芬學生車爾尼提供的說法，認為這個動機片段的誕生，僅僅是啟發於貝多芬在維也納的公園內散步時聽到的鳥鳴之聲。

兩種說法相結合，似乎恰恰把雀鳥的啼鳴與對命運的吶喊聯繫起來。第一樂章先為我們勾勒出一片廣闊的天地，經過第二樂章的寧靜、第三樂章的不安和坎坷，第四章以不斷重複的 C 大調和弦譜寫出長篇激昂的樂段，象徵著最終戰勝命運的凱歌。

在這個章節中，龐大的鳥群在不斷變幻的環境中或棲息或翱翔，融入色彩繽紛、圖案各異的背景中。非洲的小紅鶴〔即小火烈鳥。全球有六種火烈鳥（Flamingo），東非有兩種，本書提及的主要是小紅鶴（Lesser Flamingo ）〕喜歡群居，當一隻小紅鶴冉冉起飛，其他的小紅鶴群都會一齊展翅，在天空中形成整齊的隊列，成為命運的共同體，享受自由的空氣，編織著共同的生命樂章。

It's safe to say that Beethoven's Symphony NO.5, which is also referred as the Fate Symphony, is one of the most popular pieces in the classical genre.

During the process of composing this masterpiece (1804-1808), Beethoven in his 30s was suffering from deteriorating hearing loss.

The opening four-note motif of "short-short-short-long" pattern repeats constantly to create a sense of tension. Its composition, as described by his secretary Anton Schindler, is what Beethoven heard as "fate knocking at the door". While some believing in this version of origin provided by Schindler, others prefer the simpler scenario told by Carl Czerny, Beethoven's pupil, that the creation of this motif was originally inspired by the bird songs when walking in a park in Vienna.

These two versions, combined, seem to have somehow created a bond between the crying of birds and the struggle of life. The first movement impresses us with its grandness, as if it's depicting the boundless sea and sky of the world. After the peacefulness and restlessness embodied in the second and the third movements, the symphony's cadence is a long passage of C major with increased tempo and volume to represent a song of victory against fate.

In this chapter, the huge flocks of birds are flying or resting in the ever-changing environment. Their beautiful figures are still able to stand out even on the background full of unusual colors and bizarre shapes. Lesser Flamingos are very social birds. When one of them spreads its wings, others in the group are ready to take off together. They line up in the sky as a whole to form a community of shared fate, enjoying the air of freedom.

17

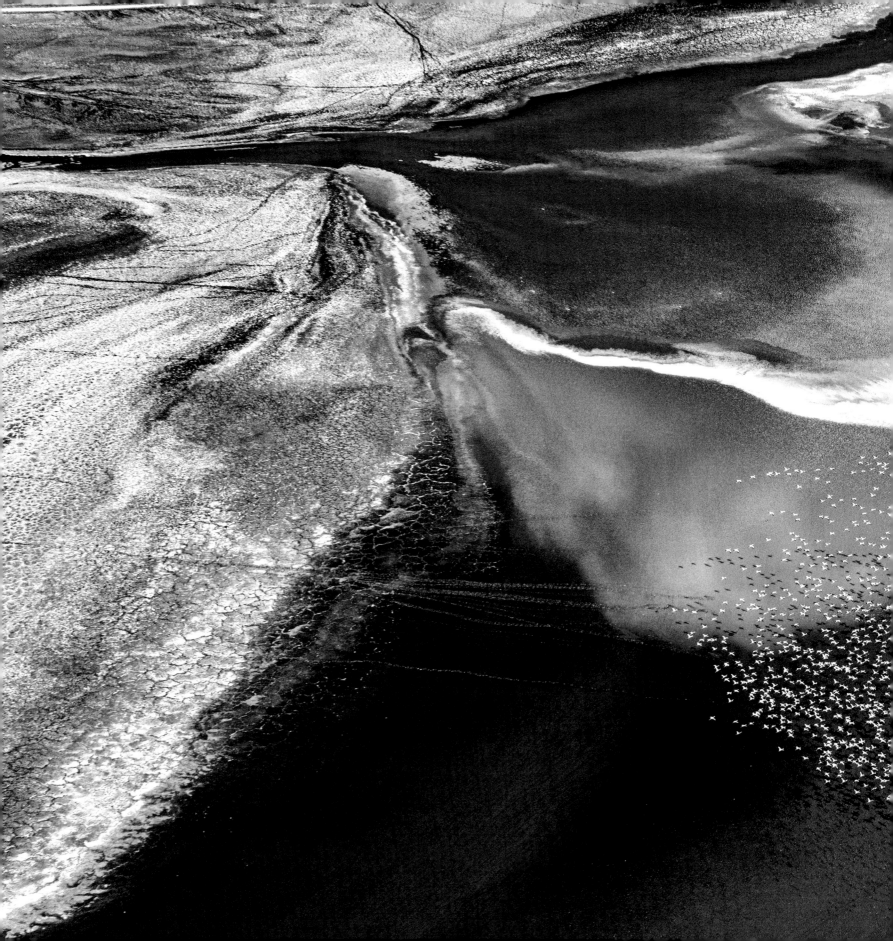

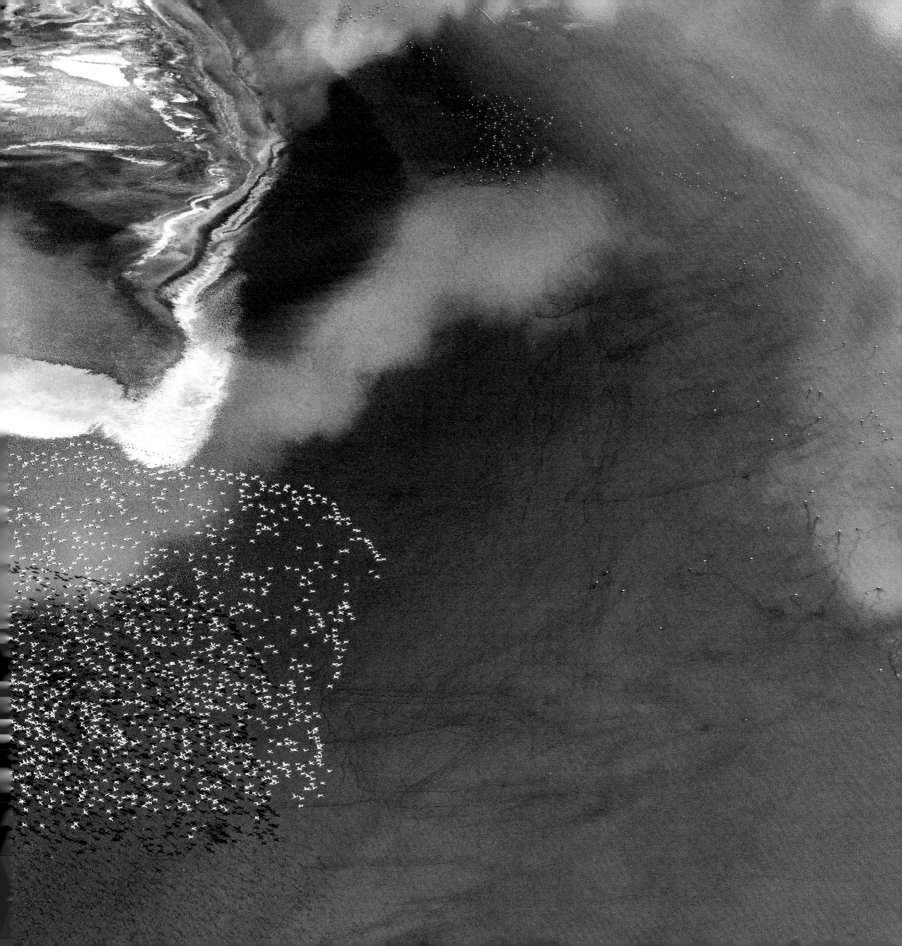

18-19

東非大裂谷區域的幾個鹼性湖，是成千上萬小紅鶴的主要覓食及繁衍聚集地。

Millions of lesser flamingos gather here at the several Soda lakes at the Great Rift Valley to forage or breed.

20-21

馬加迪湖位於肯亞的裂谷區，由斷層陷落形成。

Lake Magadi, formed by faulted volcanic rocks, is in the Kenyan Rift Valley.

22-23

湖水內高含量的碳酸化合物在湖面長期沉澱形成天然鹼。

The highly alkaline lake is constantly covered with deposited carbonate minerals .

24-25

在旱季，那特龍湖有一半以上的面積是乾涸的。粗細不一的支流彷如葉脈般自然生長。

During dry seasons, the area of Lake Natron shrinks dramatically as water evaporates. The branches look like the natural arrangements of veins.

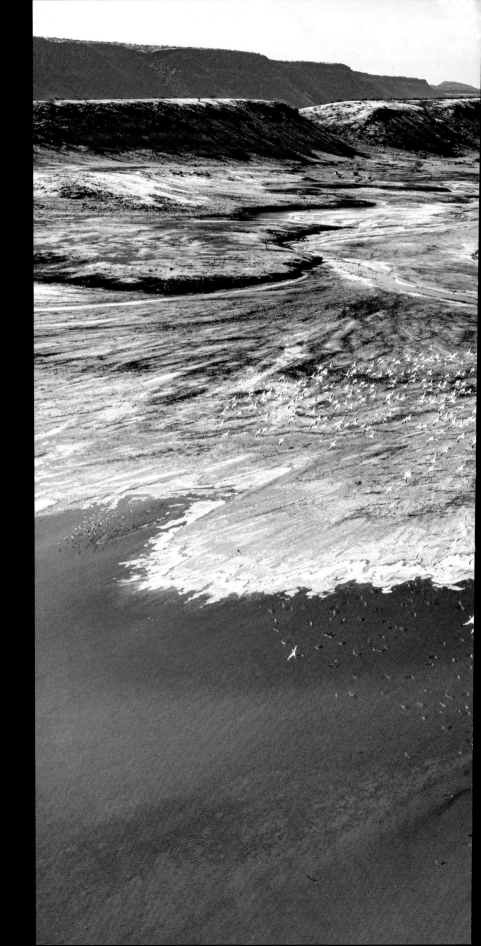

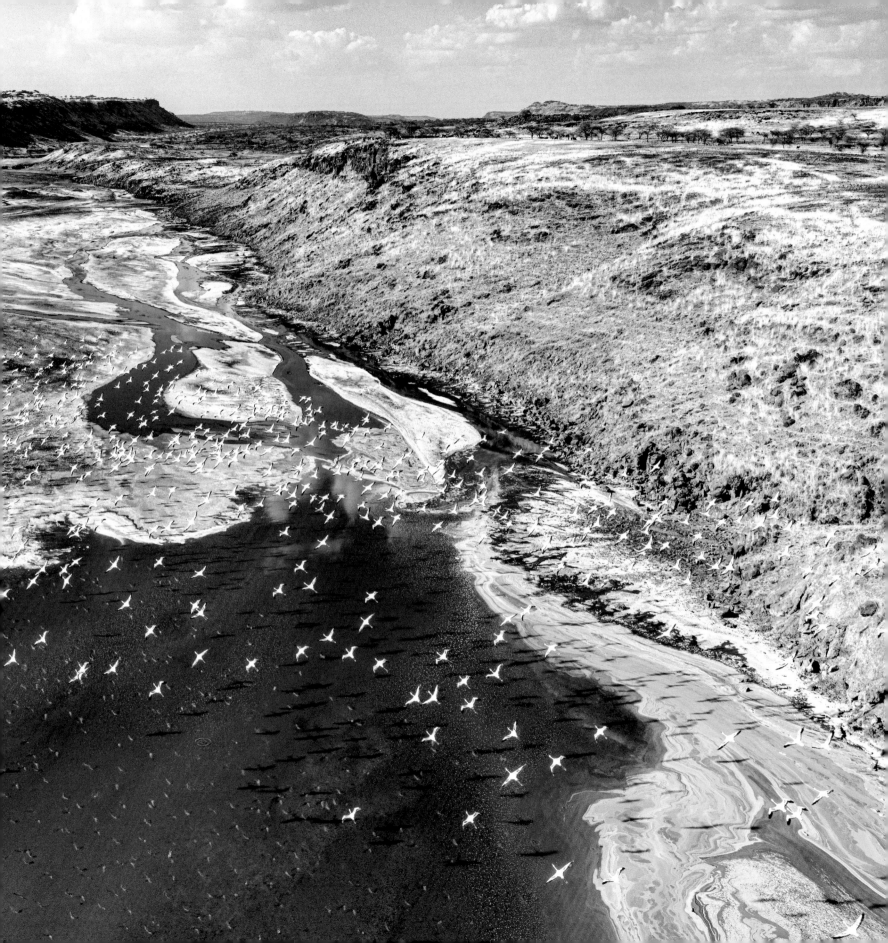

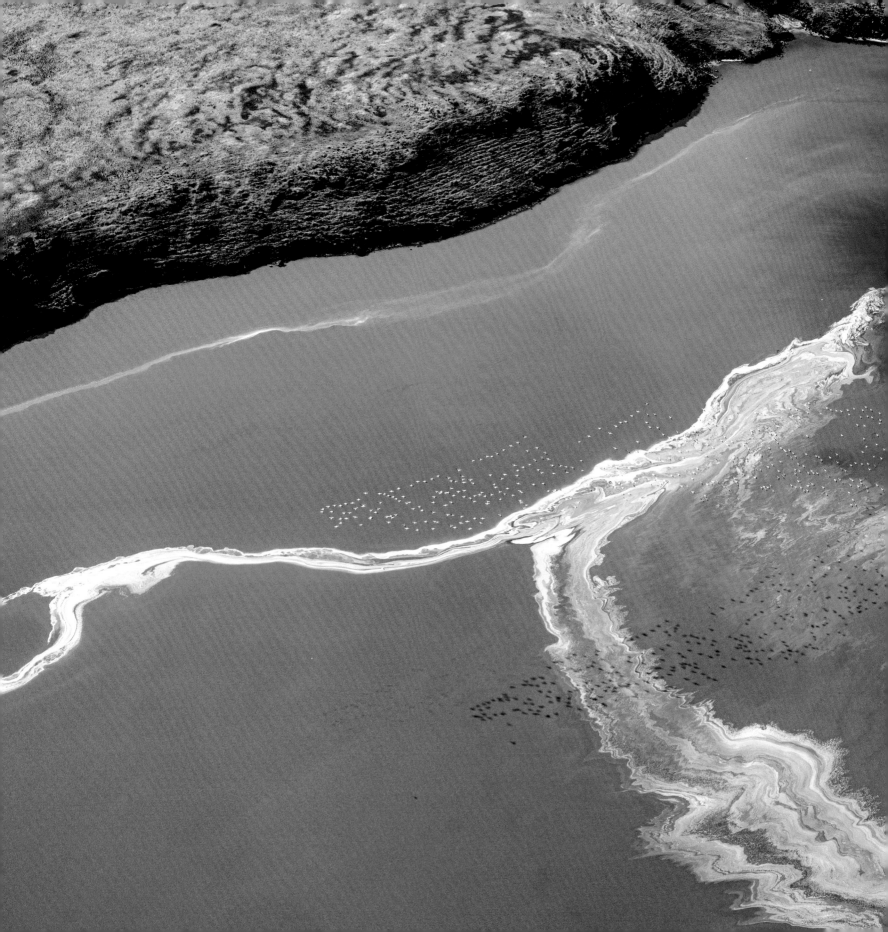

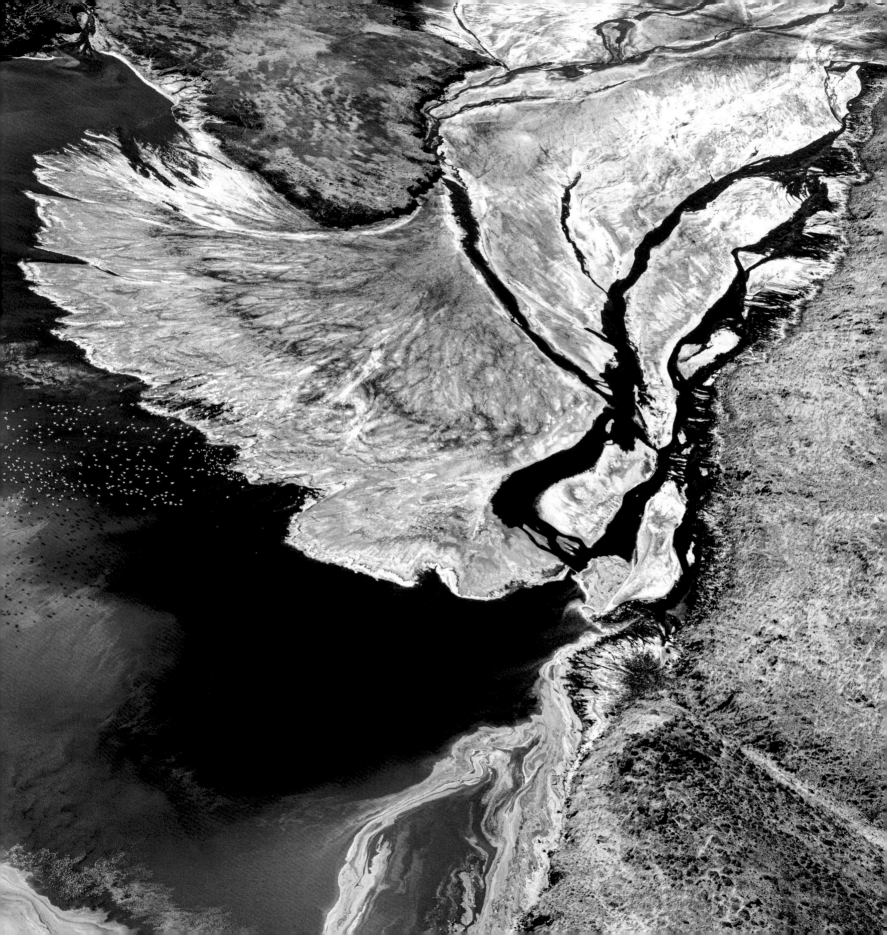

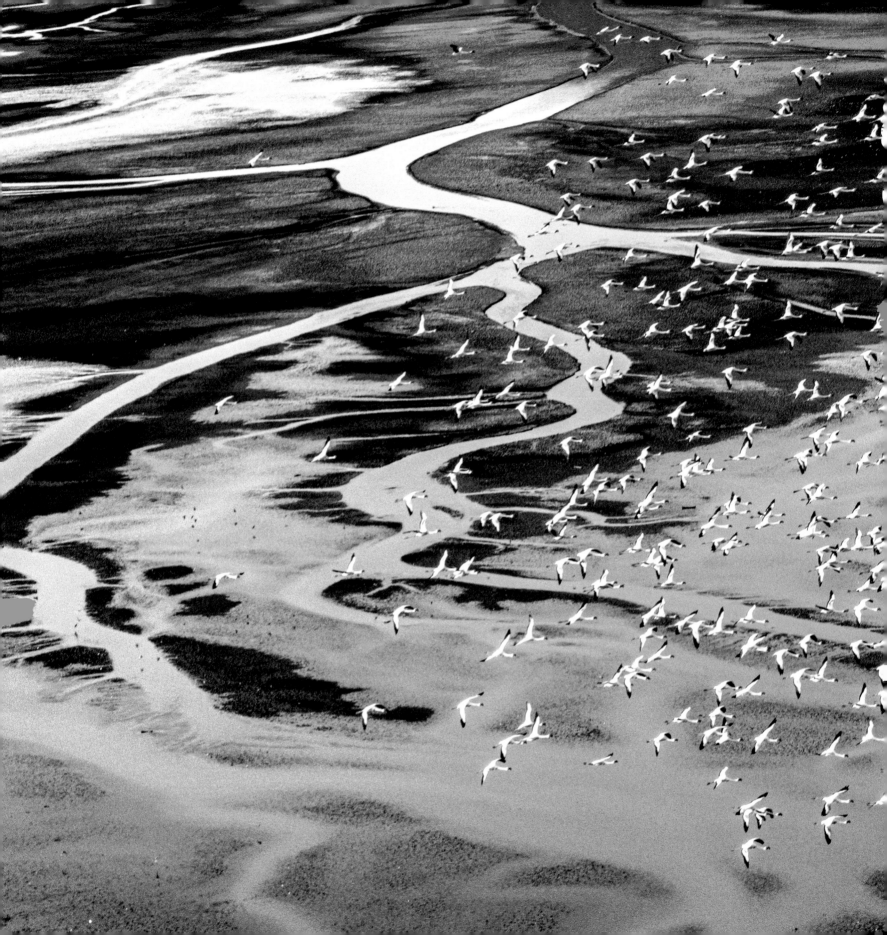

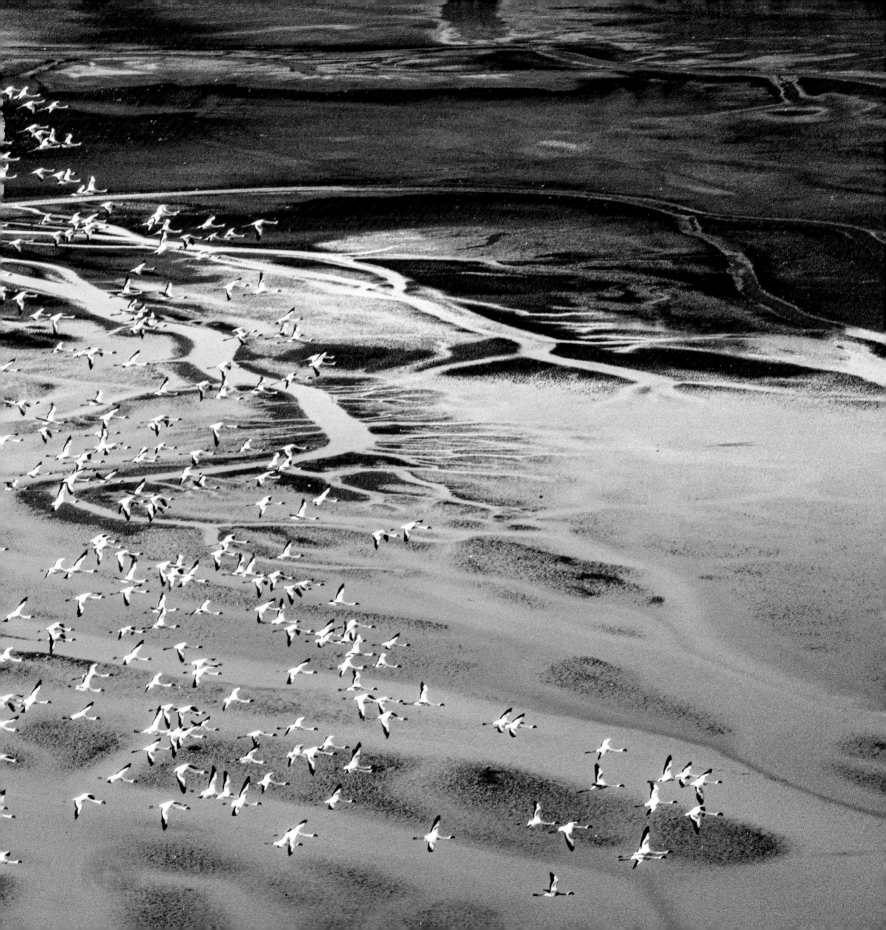

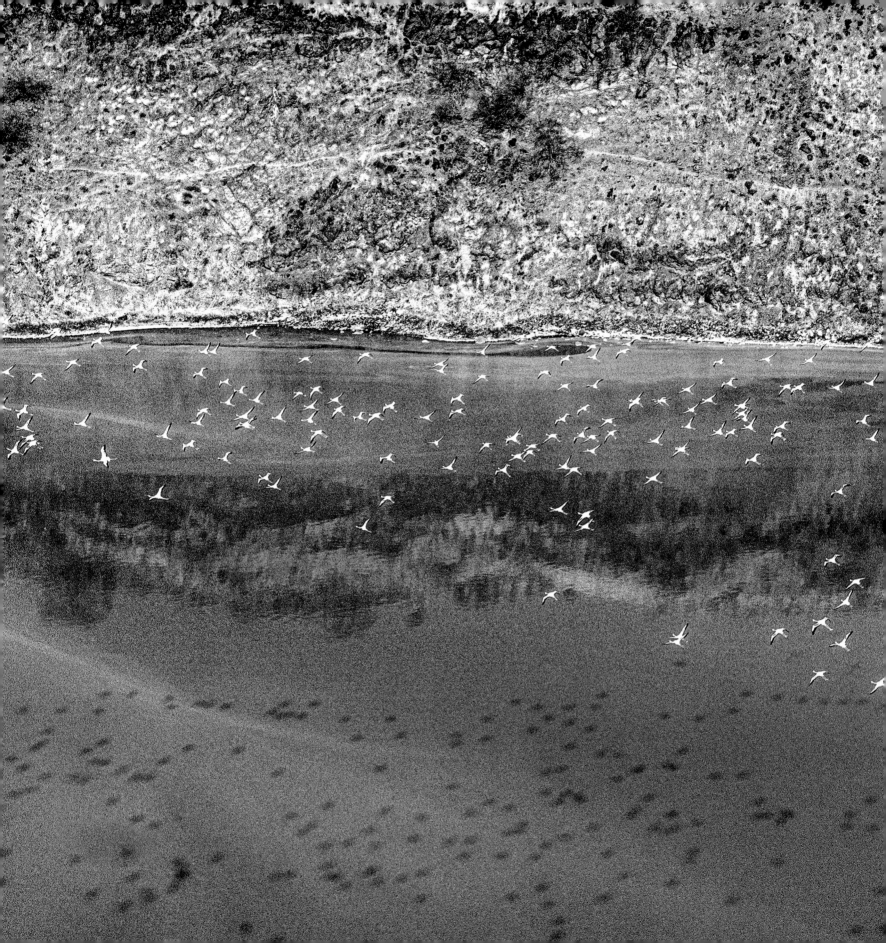

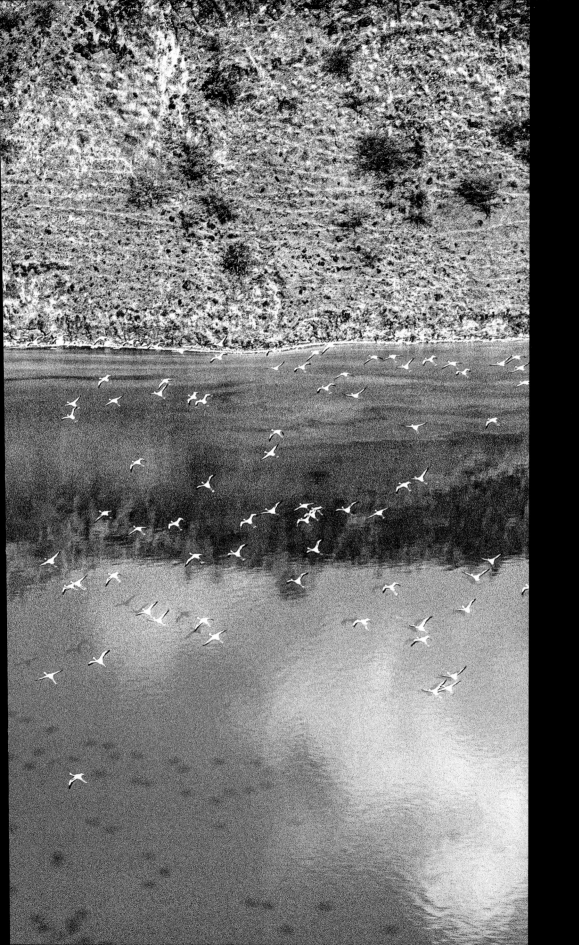

26-27

倒映著藍天白雲的湖面之上，飛過一群小紅鶴。但若把照片上下反轉，則彷彿看見它們從低空中掠過。湖水、岩壁及其倒影將相片劃分為相近的三份，小紅鶴群從中間翩然飛過。

A lesser flamingo flock is skimming over the lake, reflecting the cyan sky and white clouds. Turn the photo upside down, and it will seem as if they are flying in low altitude. The lake, rock cliff and its reflection have divided the photo into three approximately equal parts, with flamingos passing through the middle.

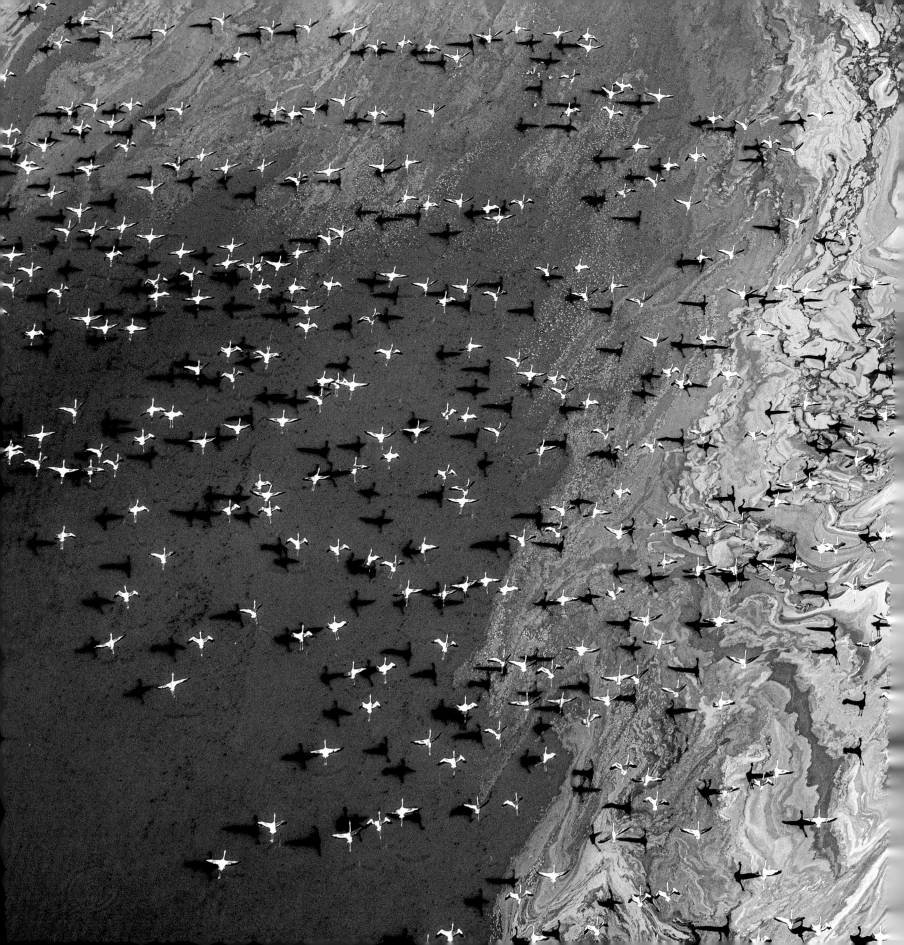

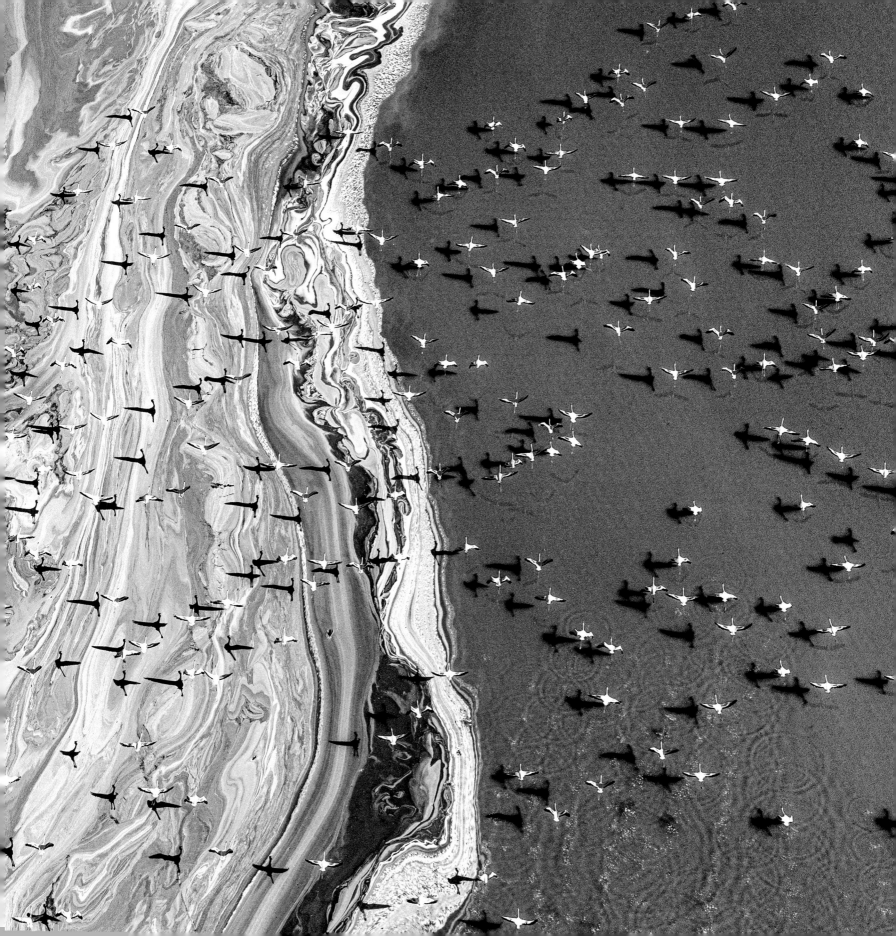

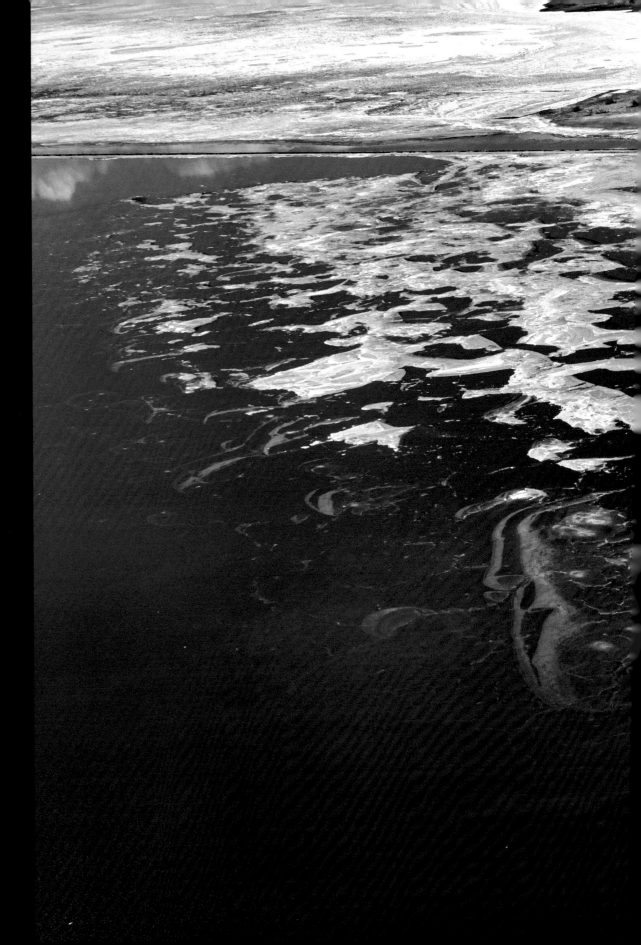

**28-29**

奶茶色及白色相間的紋路，
極像牛奶咖啡面上的拉花。

The tan and white patterns
greatly resemble latte art.

**30-31**

恩戈羅火山的碳酸鈉流入
了附近的納特龍湖，讓帶有
紅色素的藍藻有了高鹽度的
生長環境。

The sodium carbonate
from Ngorongoro Volcano
infiltrated into Lake Natron
has increased its salinity,
creating a favorable
environment for the blue-
green algae with red
pigments to multiply.

**32-33**

磚紅色的湖面給人一種致命
的危機感，事實上，高鹼性
的湖水能讓接觸湖水的動物
瞬間鈣化。

The brownish red color has
somehow set off a sense
of danger on the lake. In
fact, the alkaline water can
instantly turn animals into
stones.

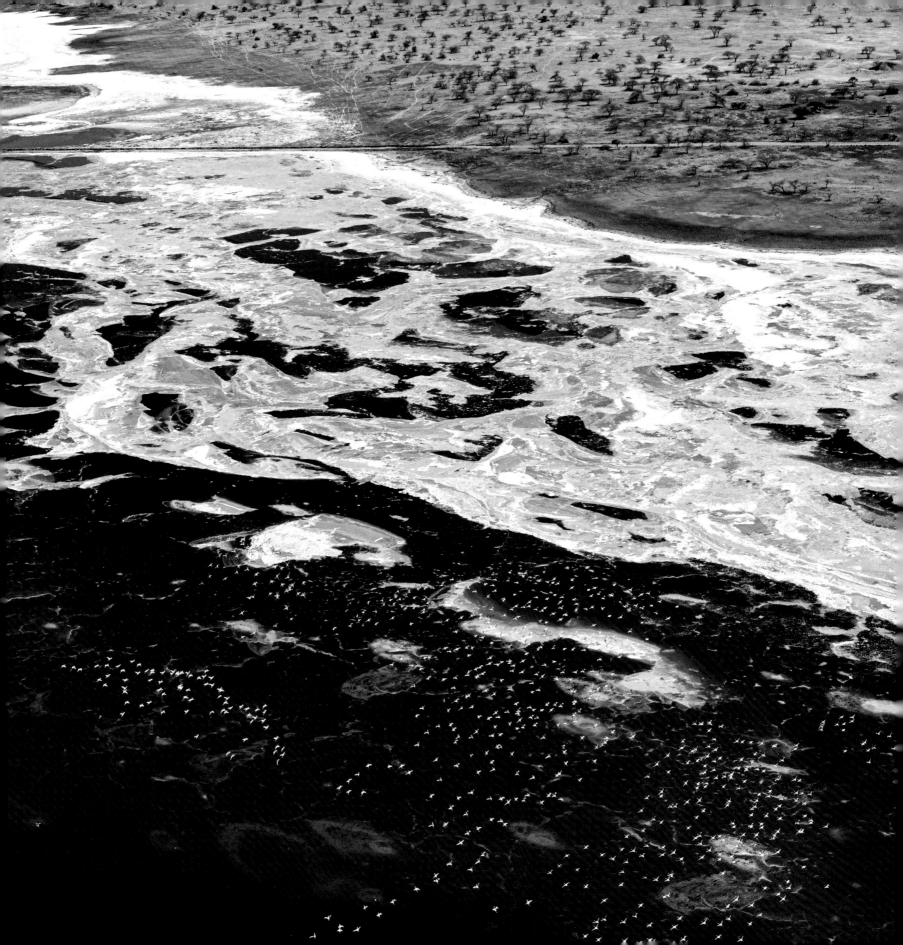

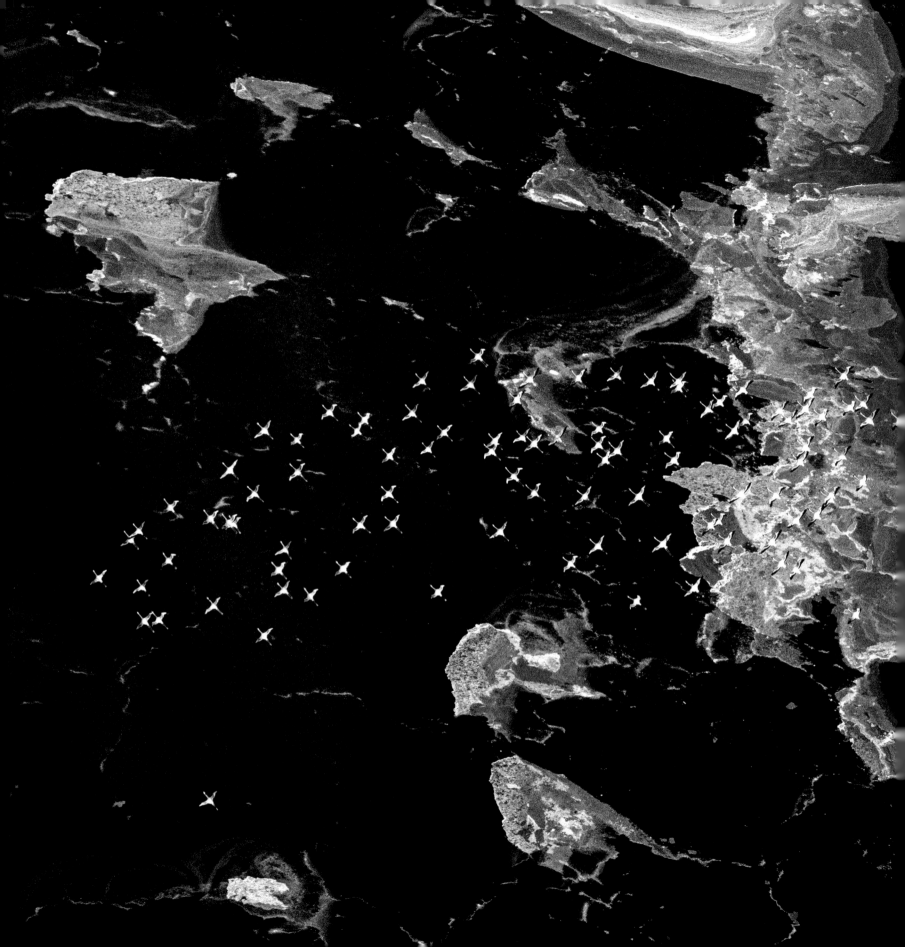

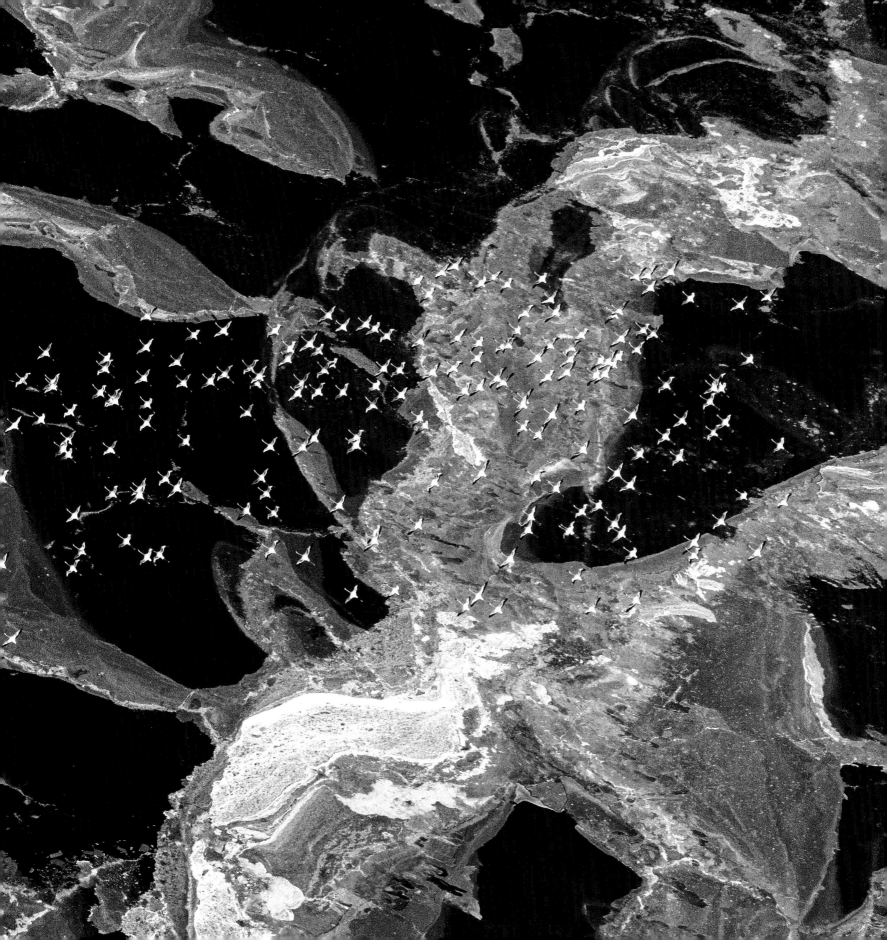

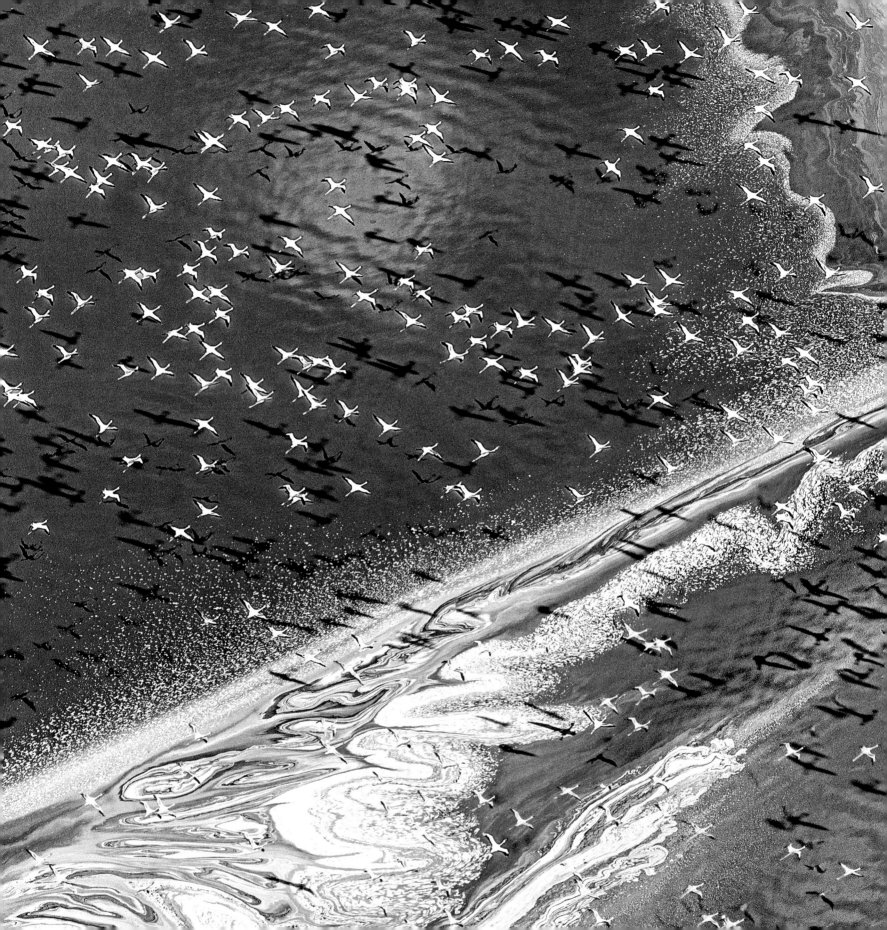

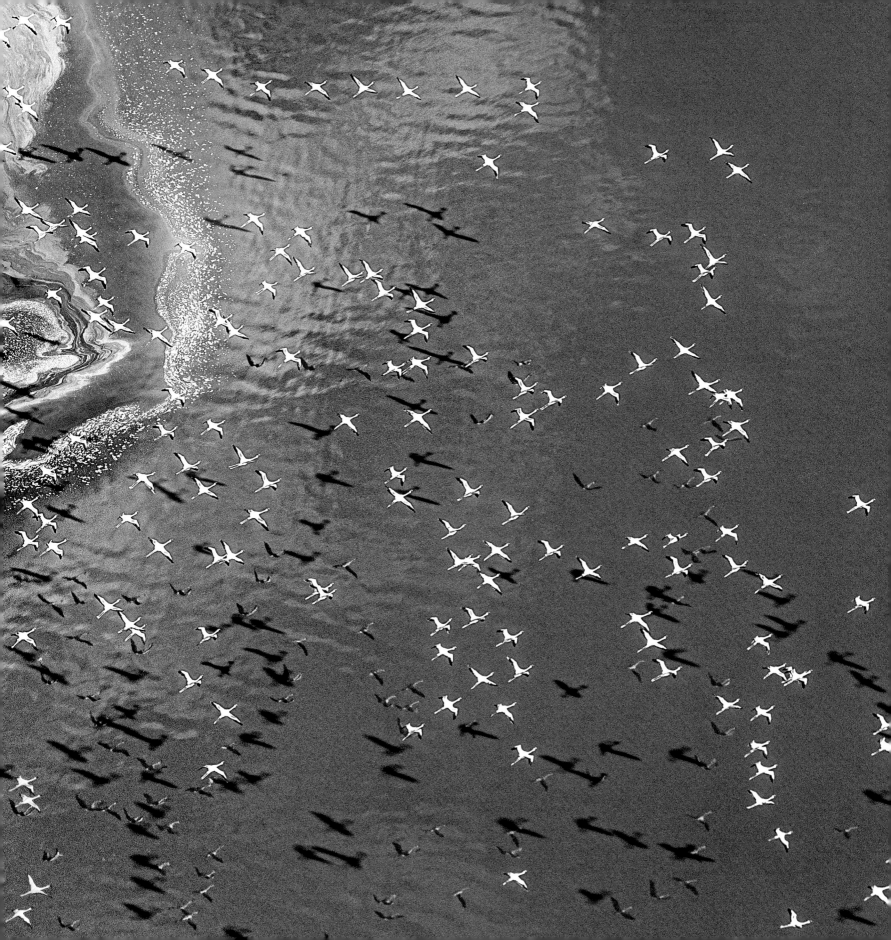

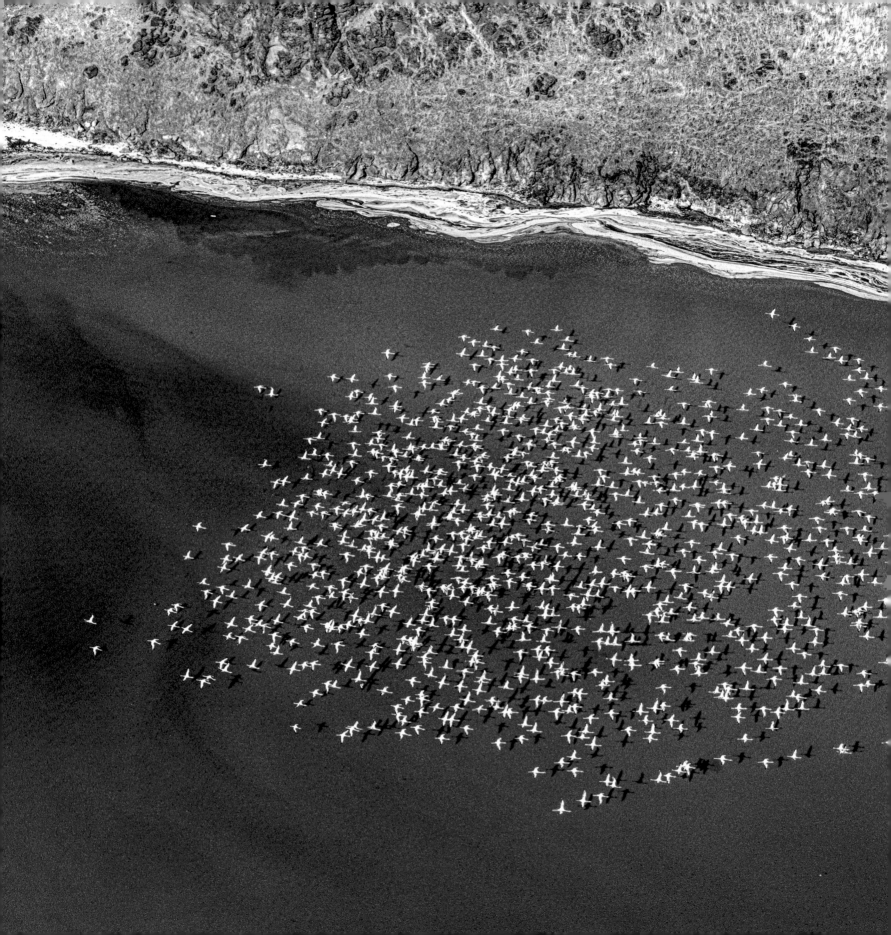

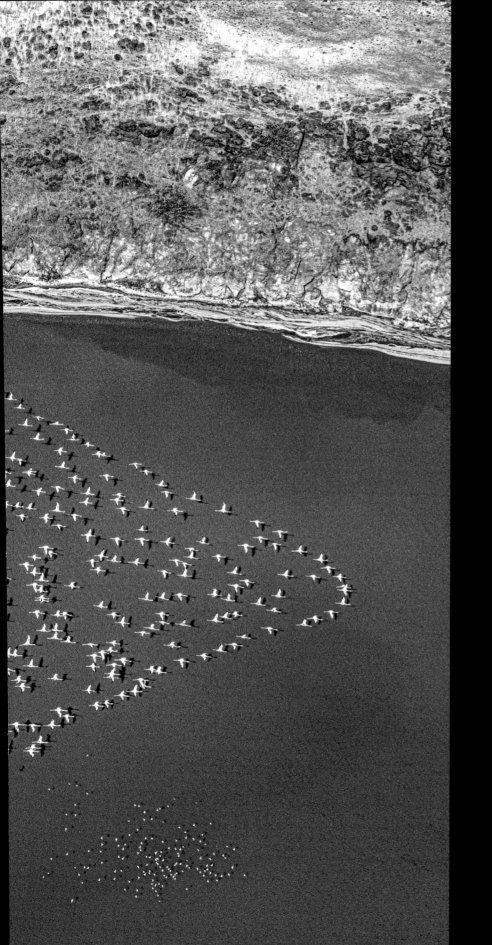

34-35

納特龍湖隨著水位的變化，呈現出豆沙綠色、磚紅色、白色、藍色等各種各樣的顏色。

Different colors appear in different stages of Lake Natron, including sage green, brownish red, whites and blues.

36-37

飛行中的小紅鶴群形成了類似向右的箭頭形狀。

The flying crowd of flamingos forms the shape of an arrow pointing towards the right.

38-39

湖水深淺的交替之處彷如形成了一簇簇浪花，追趕著小紅鶴群。

Different depths of the lake have created shapes like waves that are chasing the bird flocks.

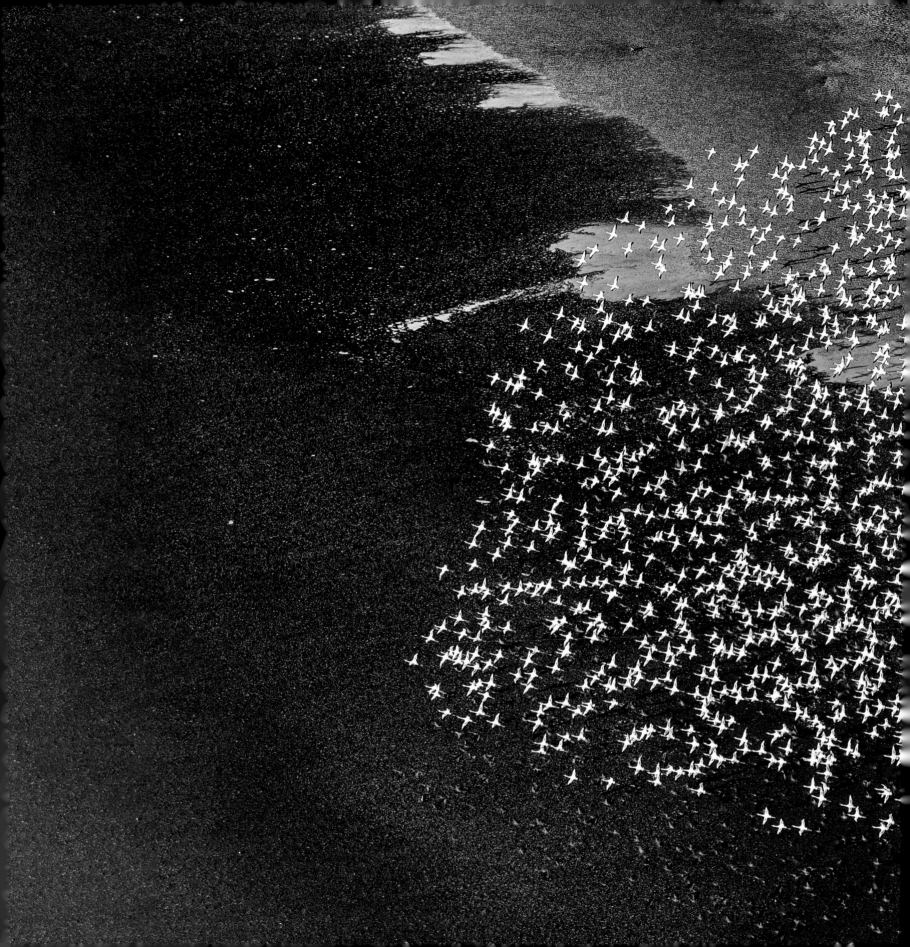

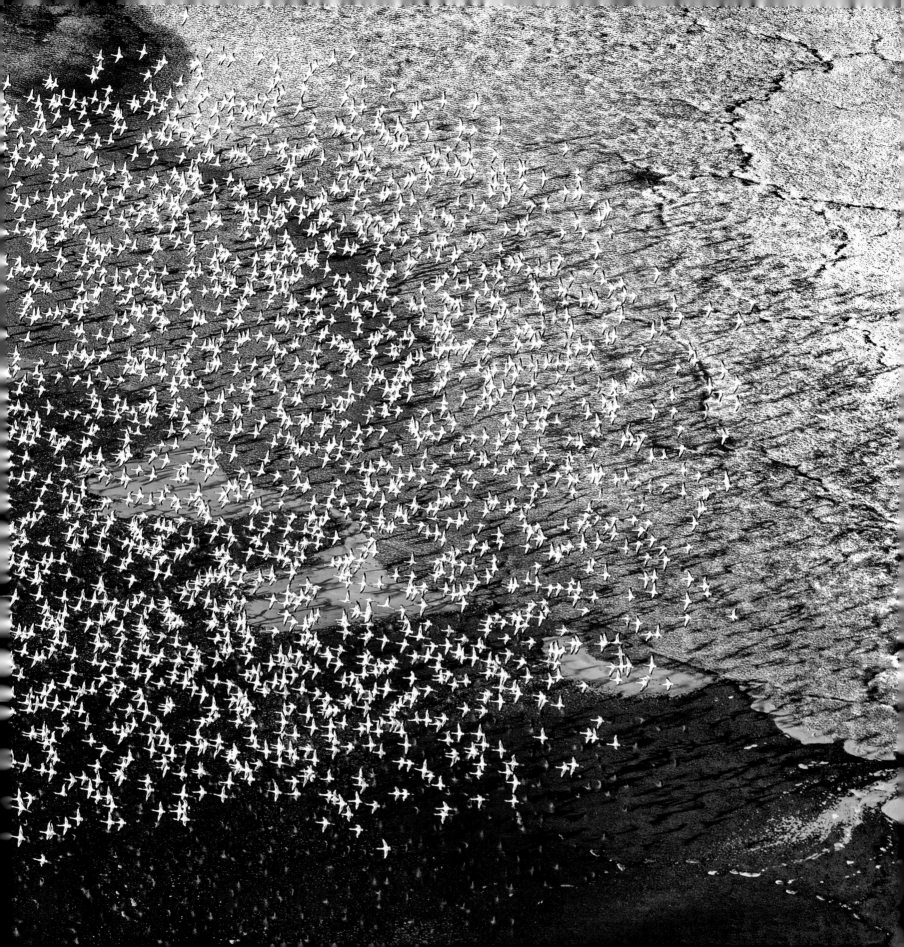

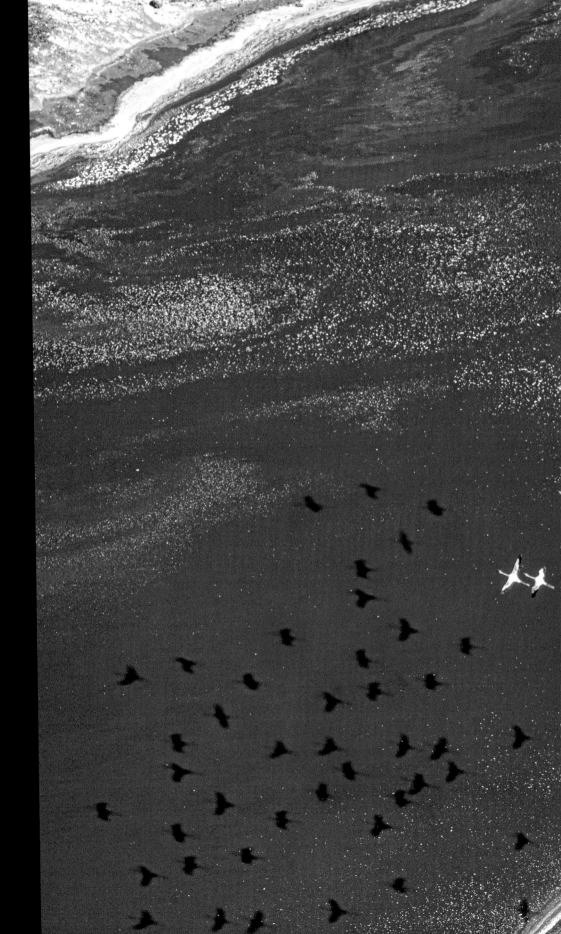

40-41

湖面的碳酸鈉層層分明的螺旋紋理分佈
仿如形成了岩石的橫切面。

the sodium carbonate floating on
the lake, with distinct layers of spiral
patterns, forms the construction of a
geological cross-section of rocks.

42-43

碳酸鈉晶體形成了猶如錨的形狀，小紅
鶴群彷彿也正模擬著這個形狀列隊。

The soda crystals form the shape
of an anchor, and the flamingos are
referencing this formation.

44-45

小紅鶴群在湖中的倒影及太陽照射下的
陰影彷彿使鶴群增加了兩倍數量。

The reflections in lake and the shadows
of flamingos have seemingly tripled the
total quantity.

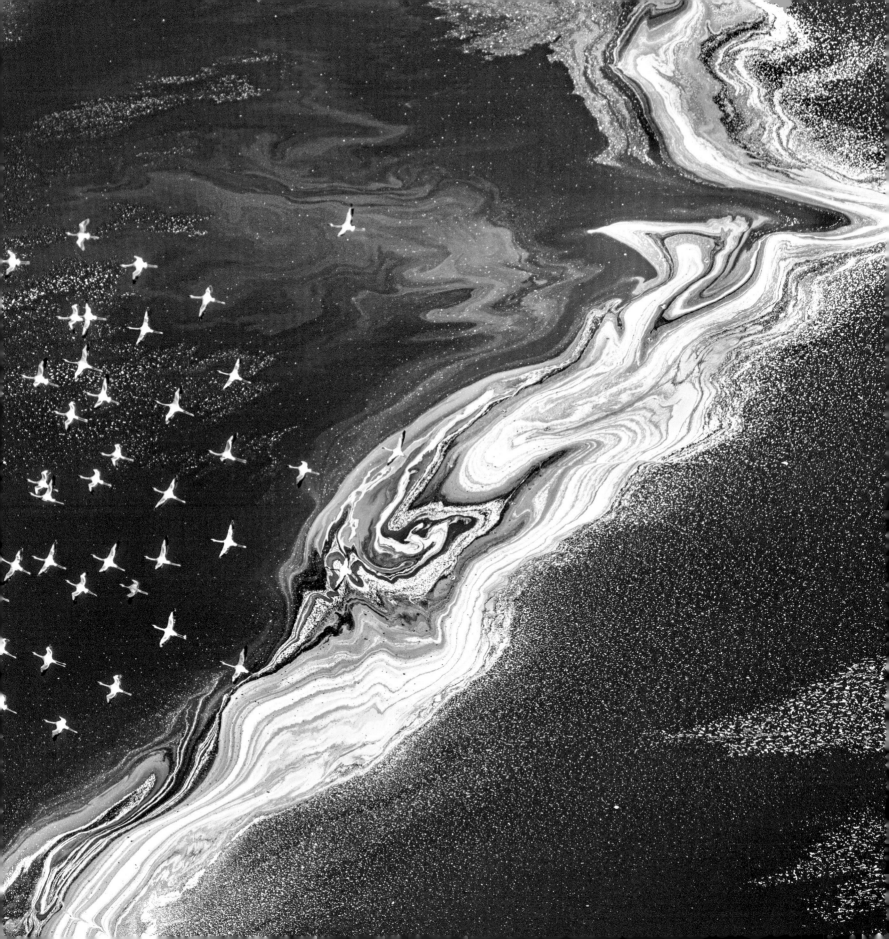

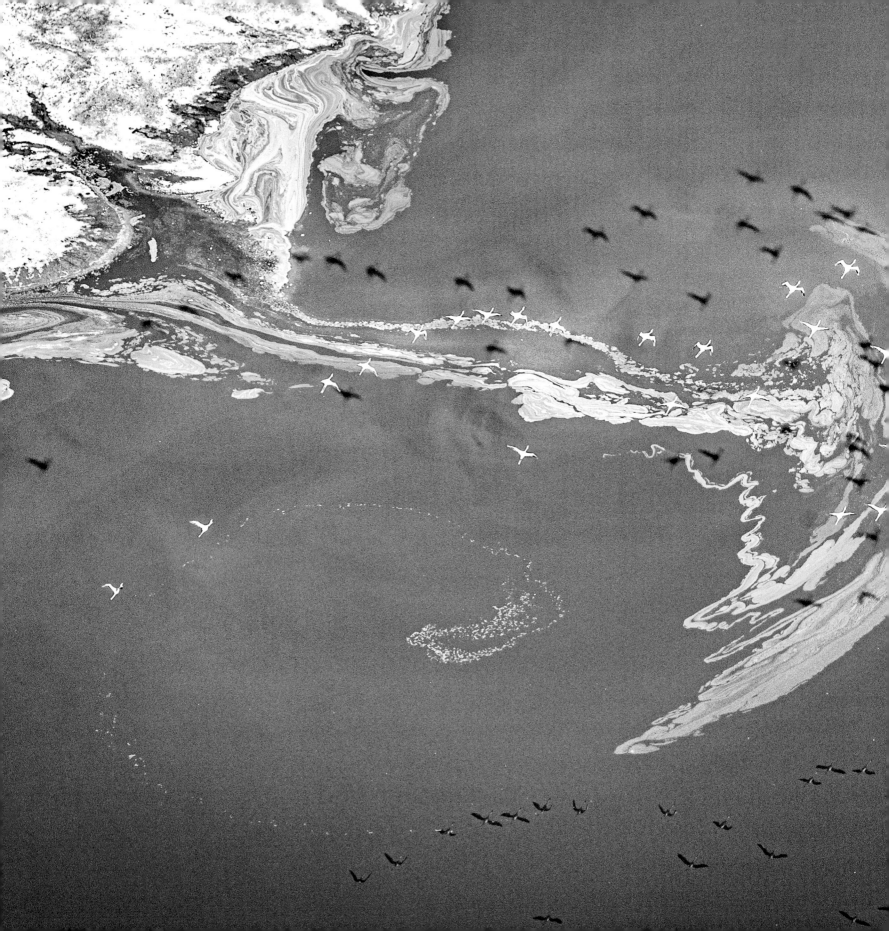

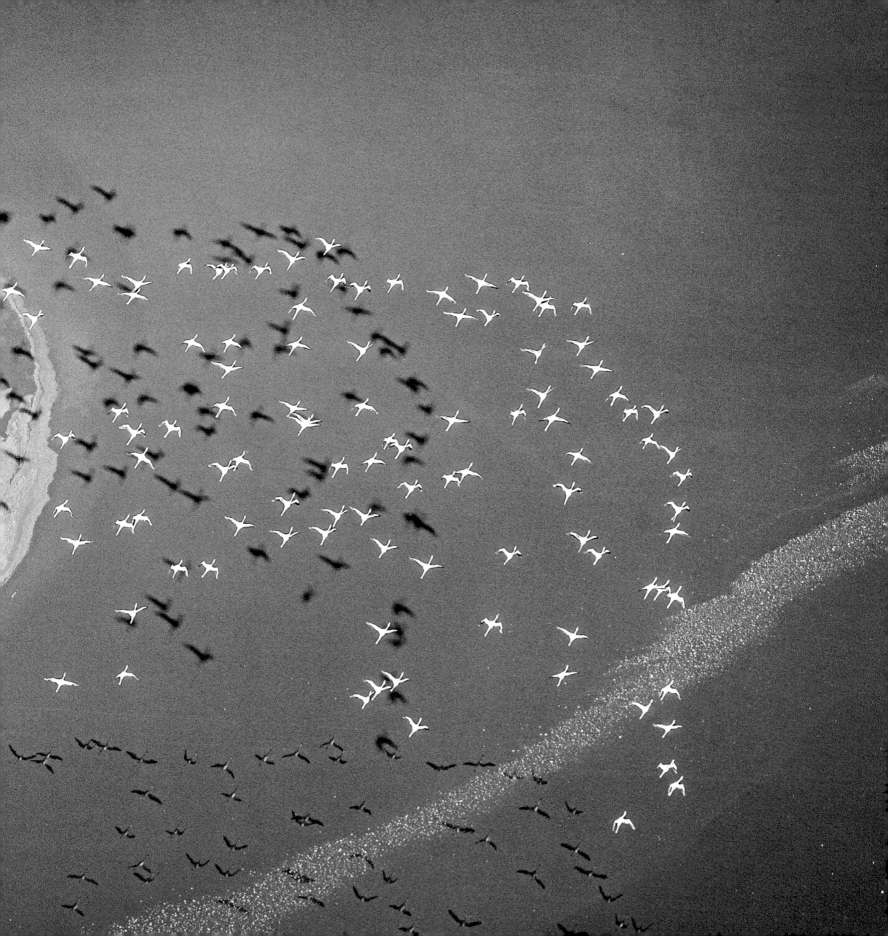

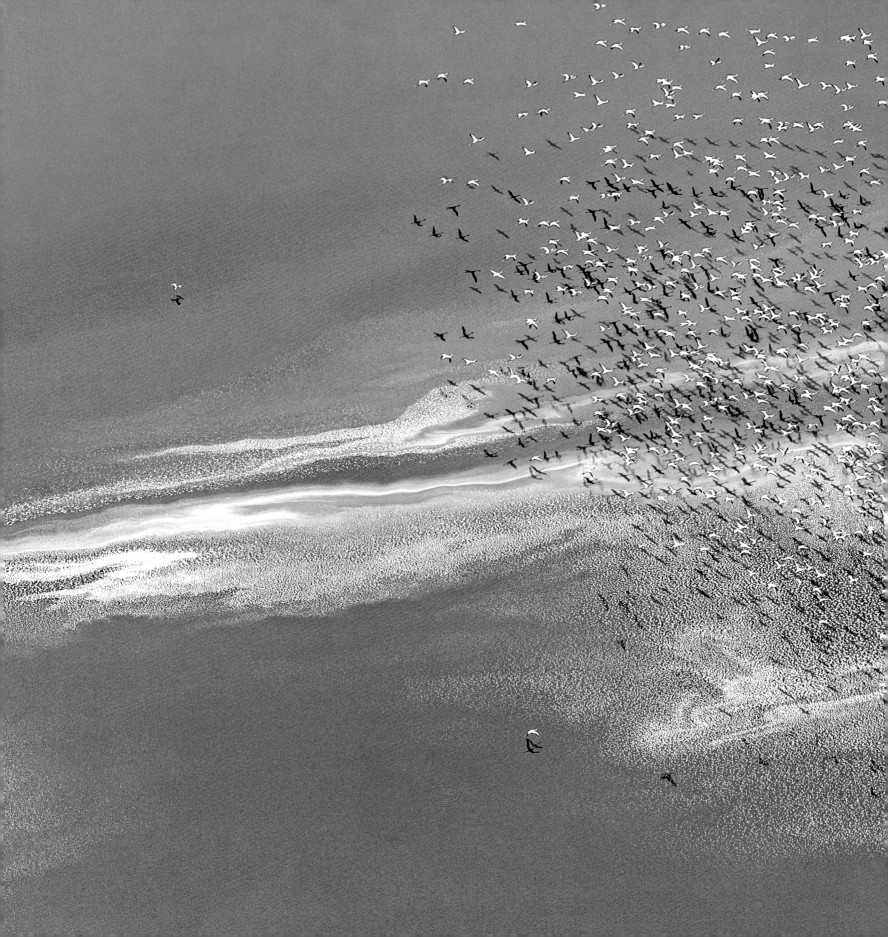

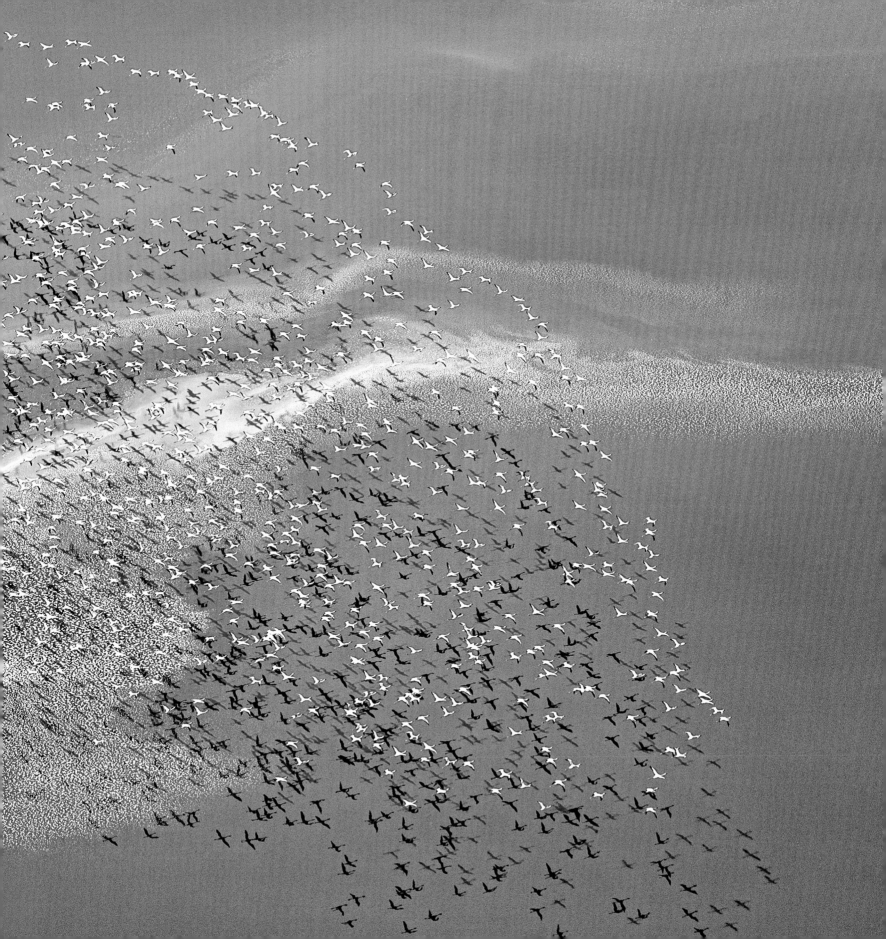

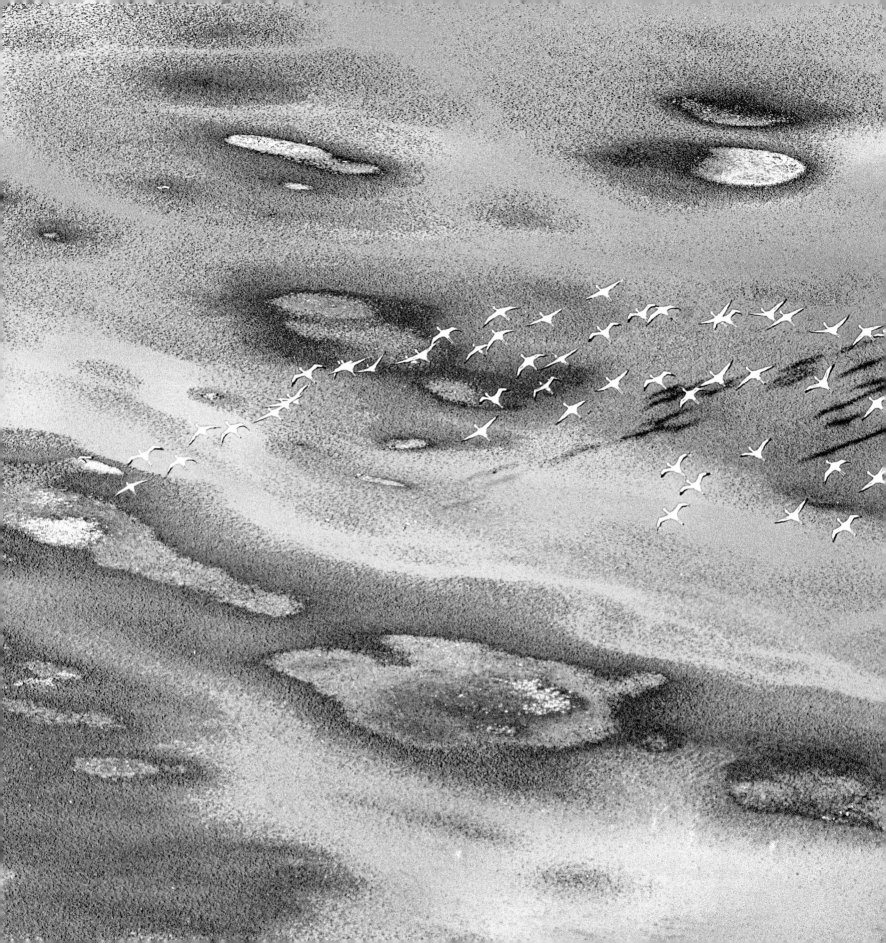

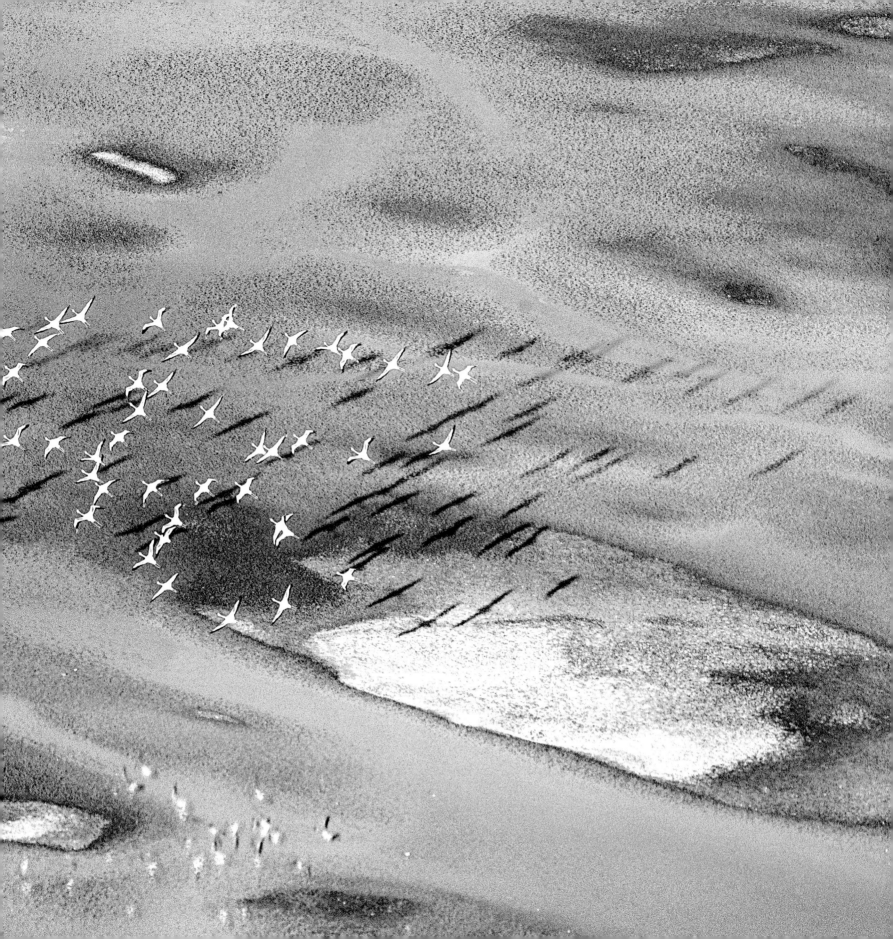

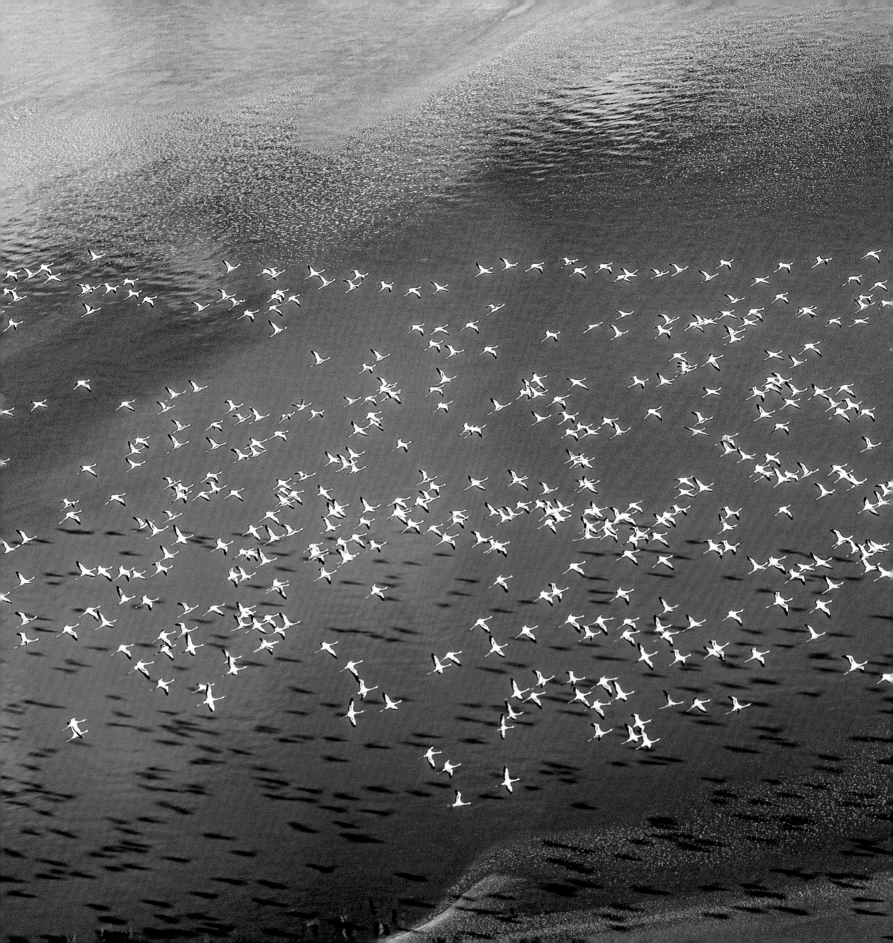

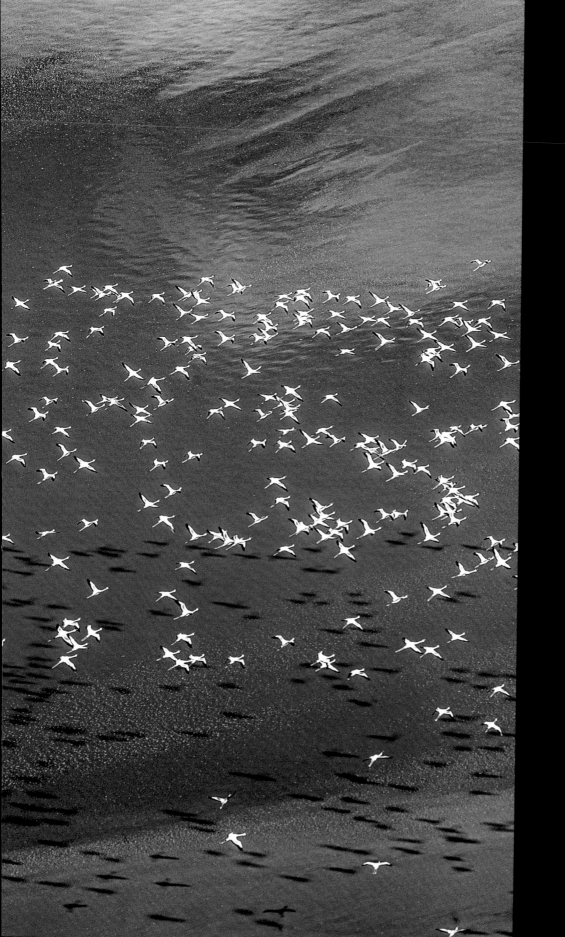

46-47

茶褐色的沉積物漂浮在藍色的湖面上，
小紅鶴群彷彿正掠過異星球表面。

The image of light brown sediment
floating on the cyan lake looks much
like the surface of another planet, over
which a flock of flamingos are flying.

48-49

從正上方來的陽光在湖面上灑落成金色
的波光，亦把小紅鶴優美身姿投射成斑
駁的黑點。

The sun from up above has dyed
the water ripples into golden color,
and projected the beautiful bodies of
flamingos as scattered black dots.

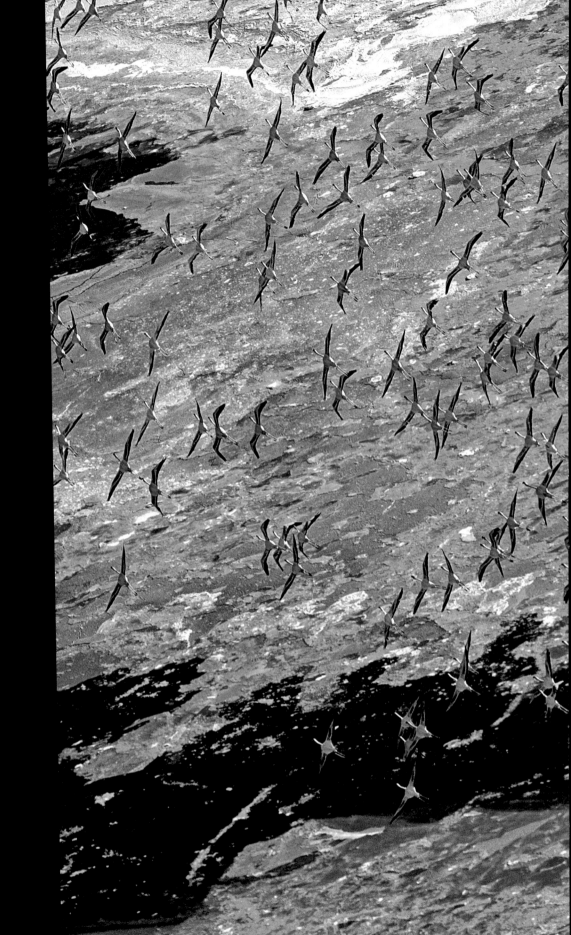

50-51

黃色的沉積鹽看起來像是一顆金色星球
的地表，而小紅鶴群猶如天外來客。

Lesser Flamingos are the visitors from
outer space, passing by this golden
planet covered by sodium ash deposits.

52-53

小紅鶴群彷彿正在使用碳酸鈉晶體於
湖面上進行沙畫藝術創作。

This group of flamingos are doing
sandpainting on the lake surface using
soda crystals.

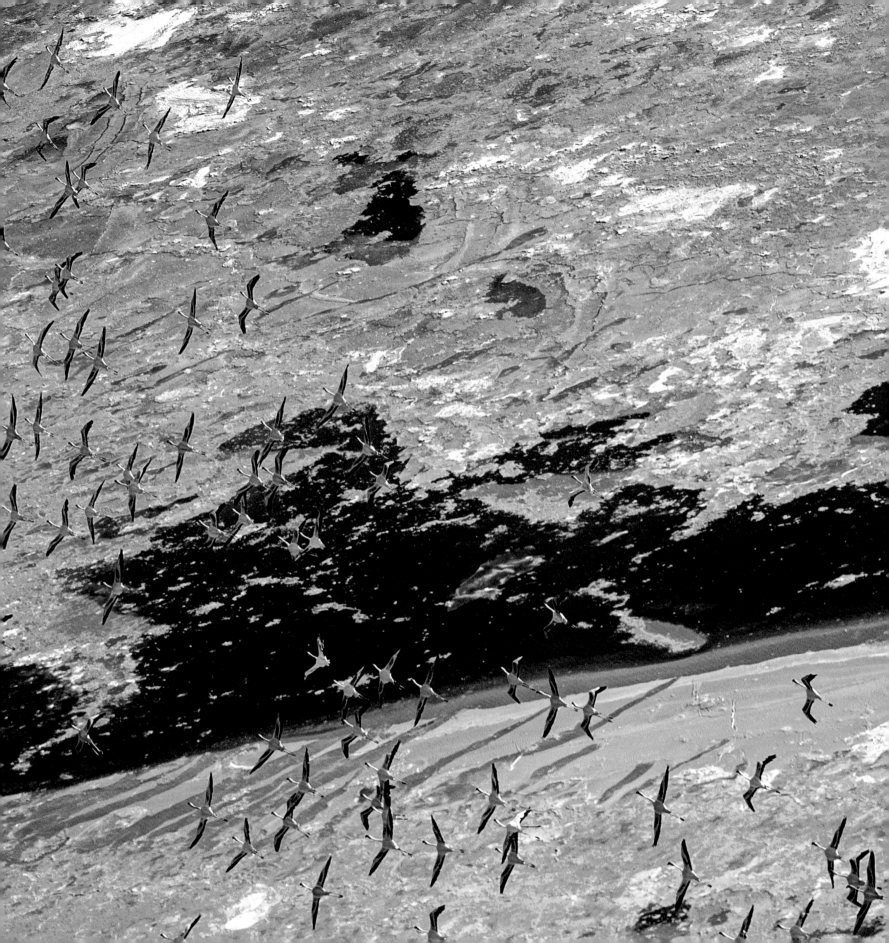

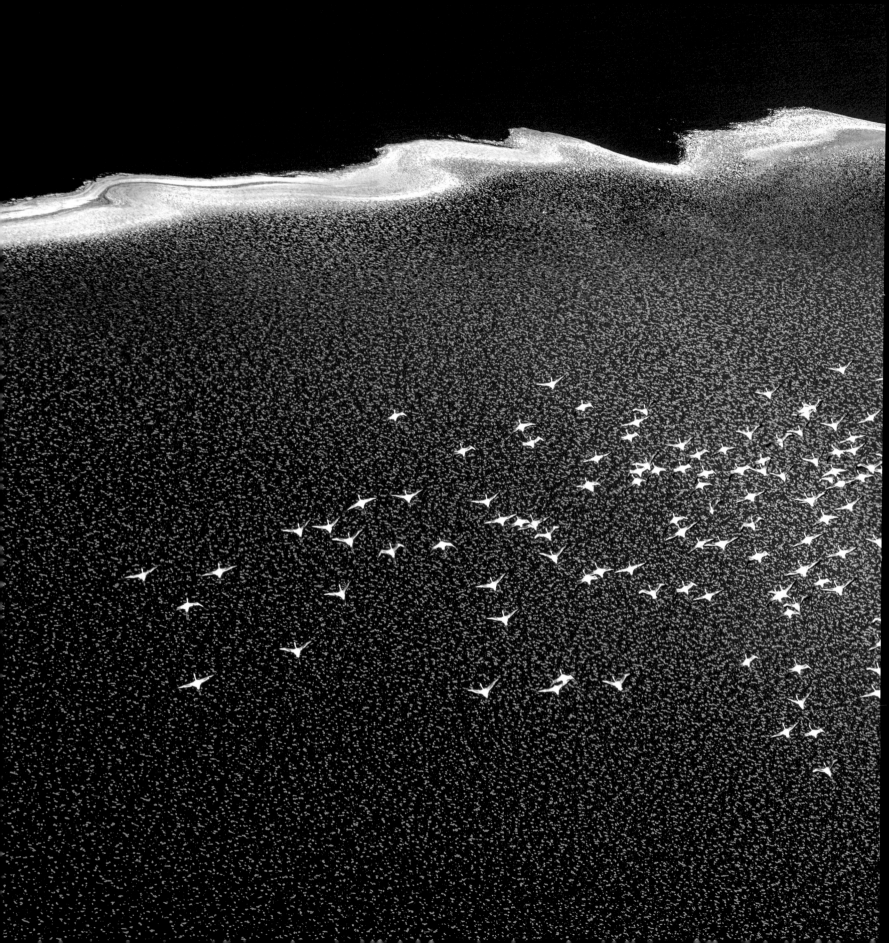

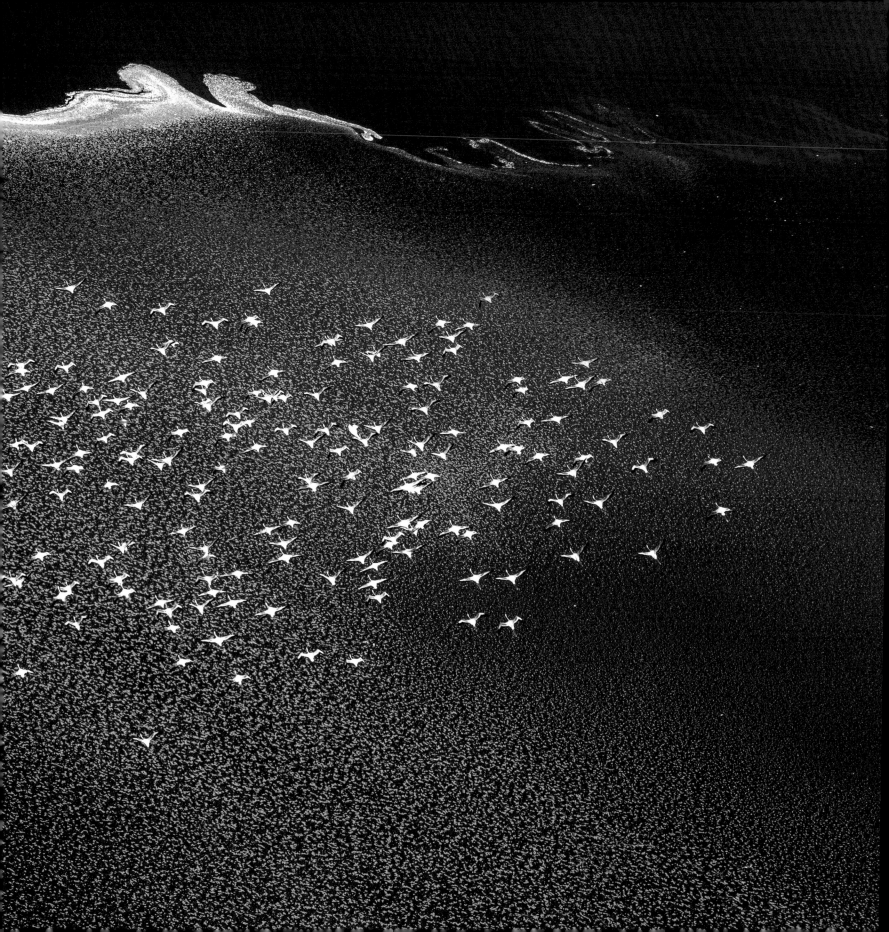

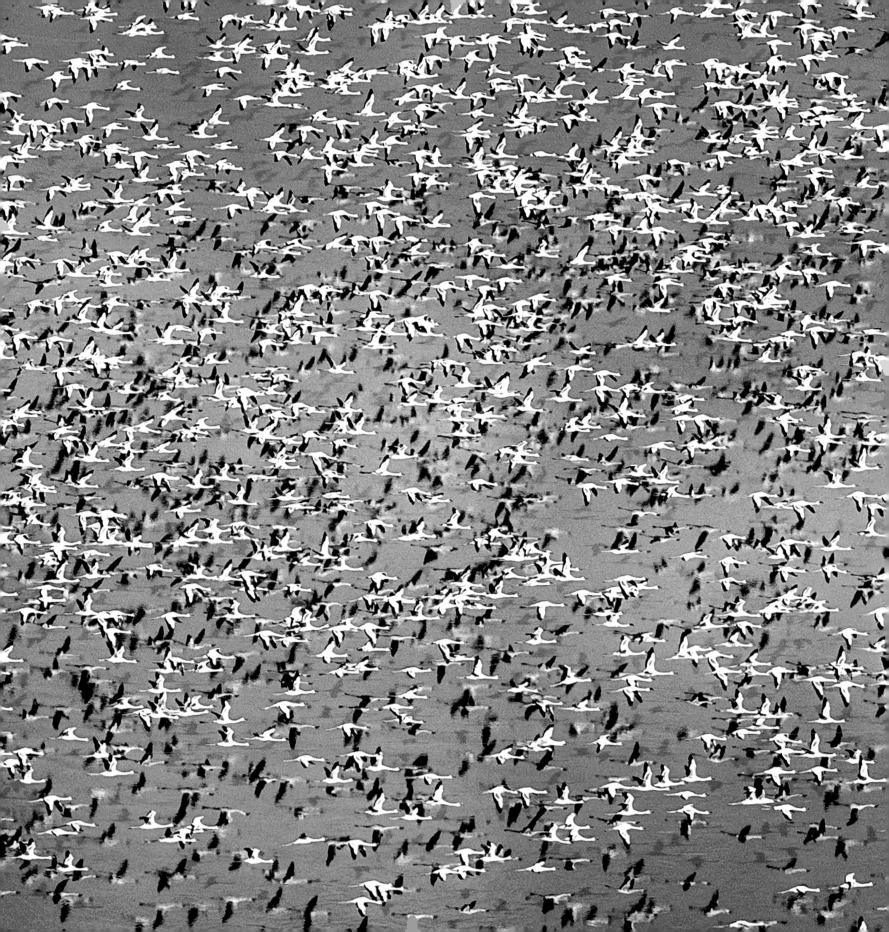

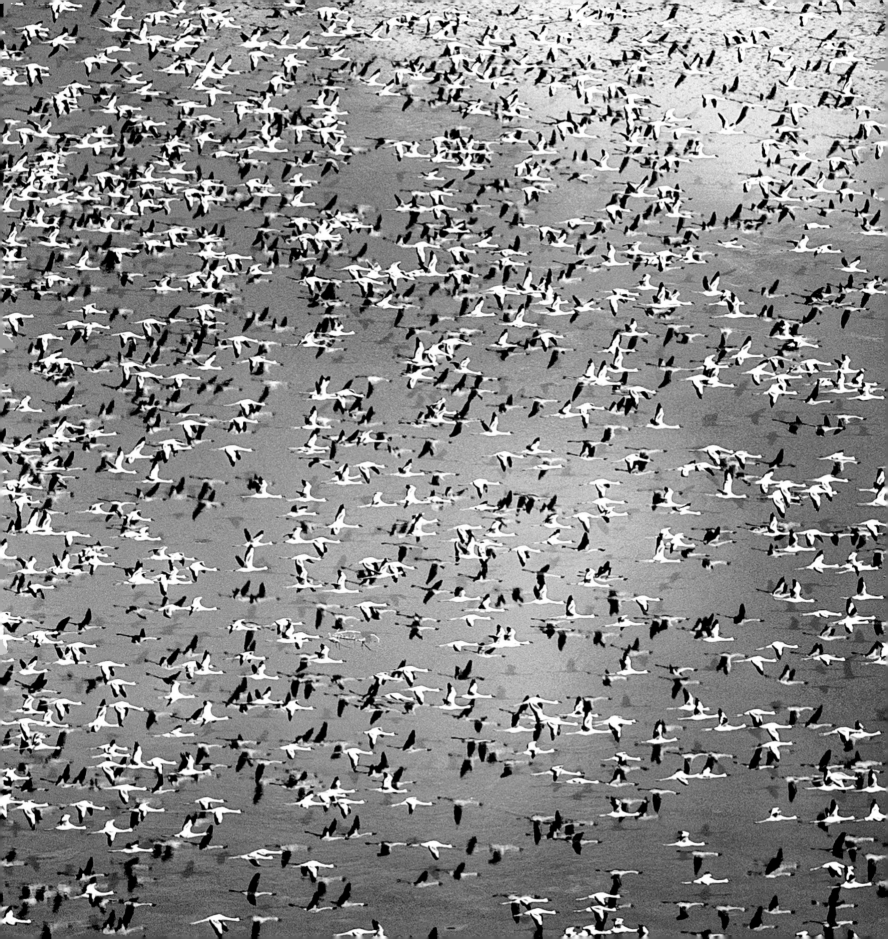

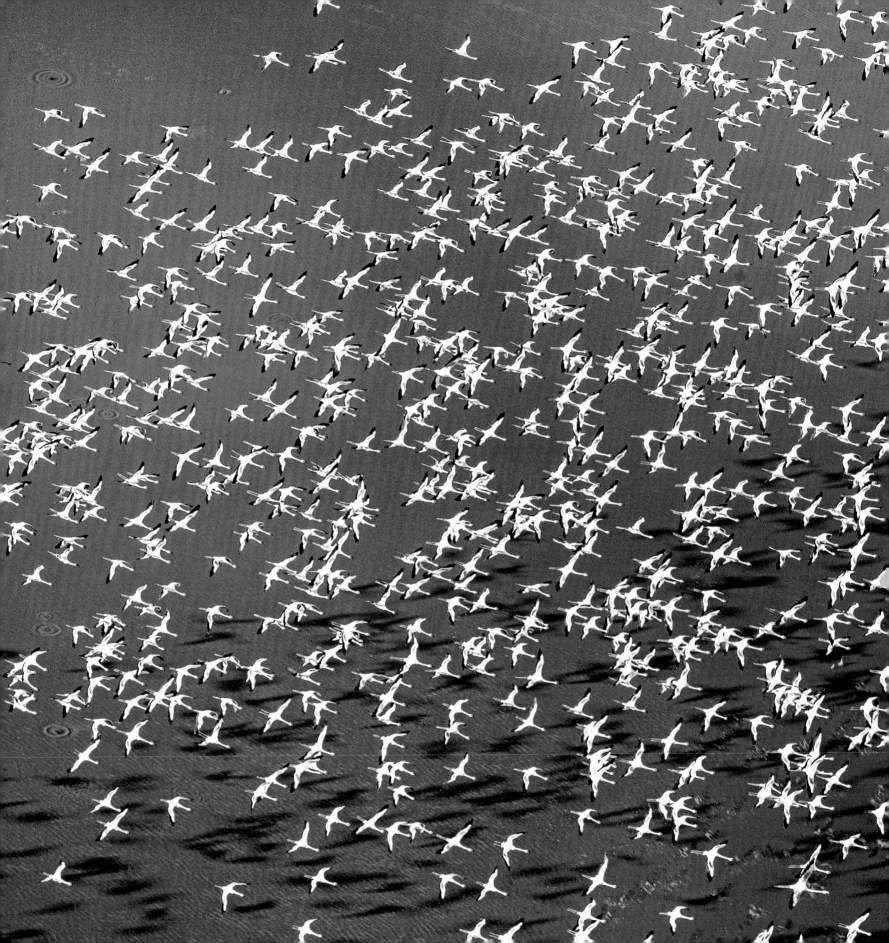

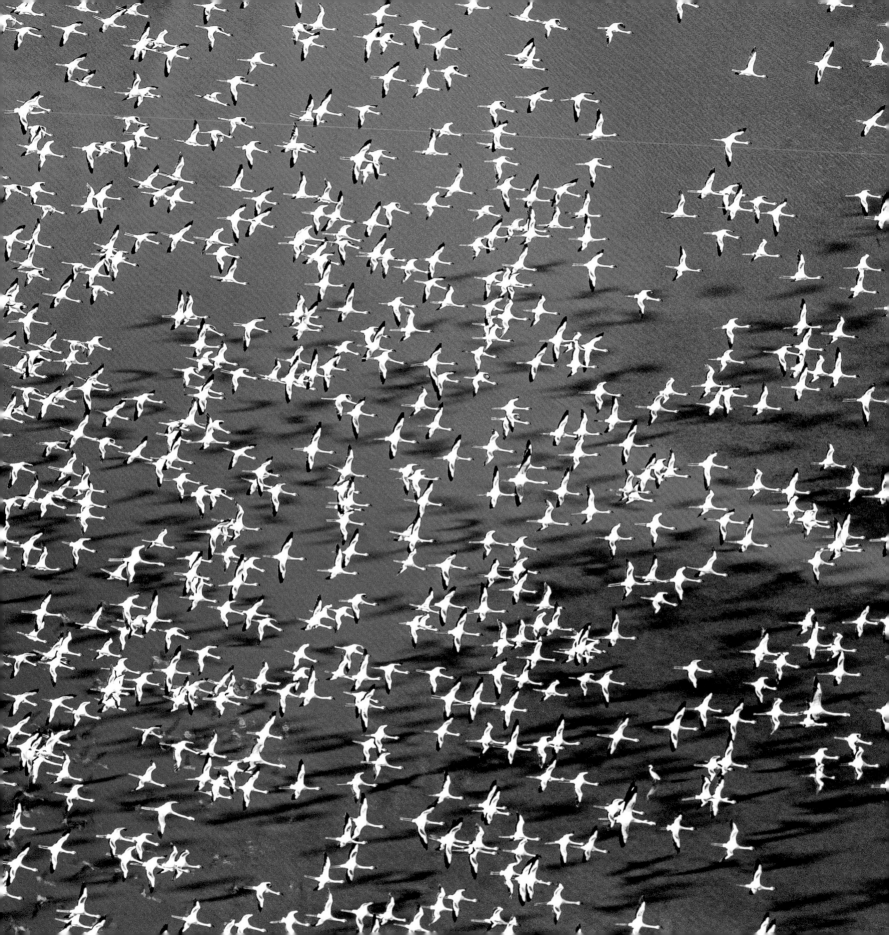

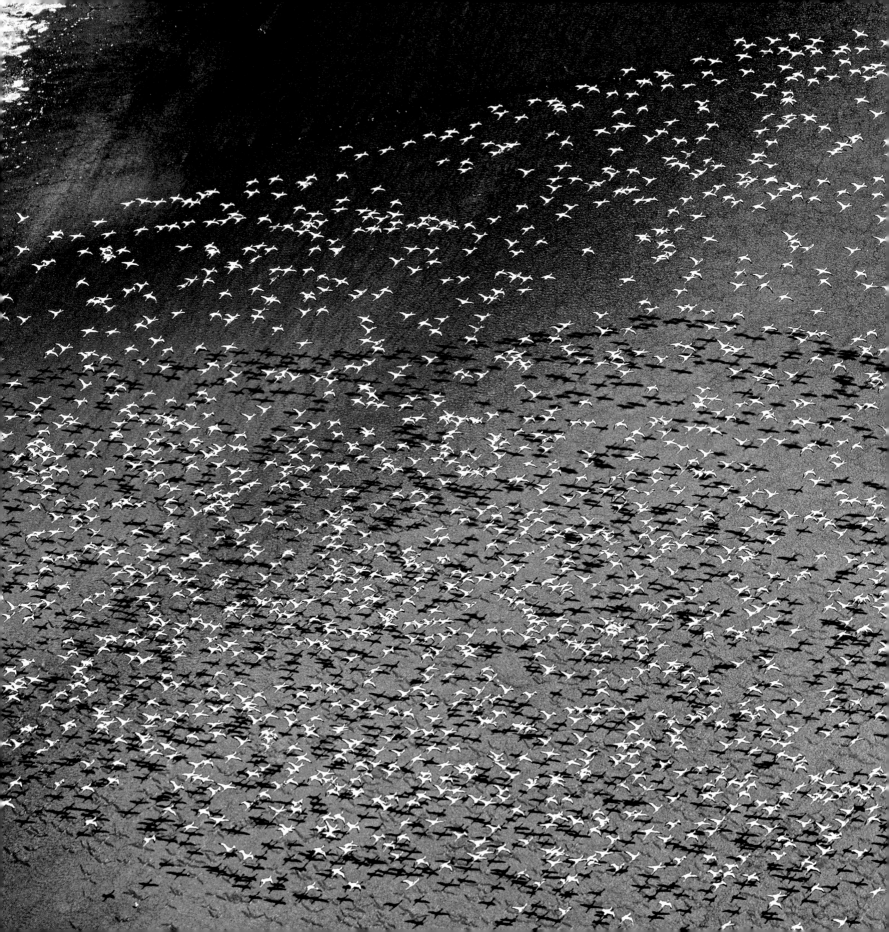

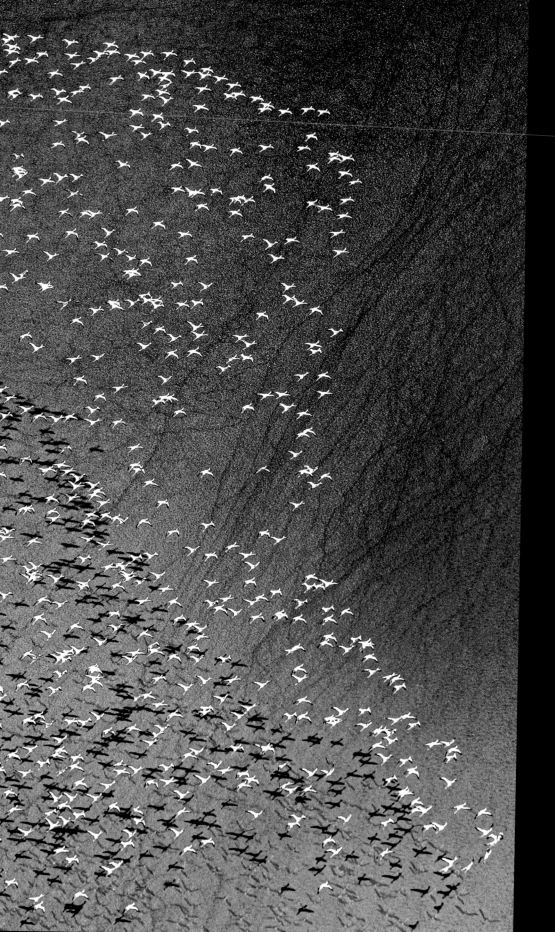

54-55

在東非大裂谷的周邊水域生活著約 250 萬隻小紅鶴。

The neighboring waterbodies of the Great Rift Valley are the habitats of 2.5 million lesser flamingos.

56-57

「萬鳥競翔」在此是十分常見的景色,在金色的陽光中尤為壯觀。

The scene of tens of thousands of birds flying together is commonly seen here. The view is extraordinarily spectacular under the golden sunlight.

58-59

偏紅的水中倒影及濃黑的影子,與雪白中點綴著粉紅色的軀體交織在一起。

The reflections tinted red and dark shadows are intertwined with the white and pink bodies.

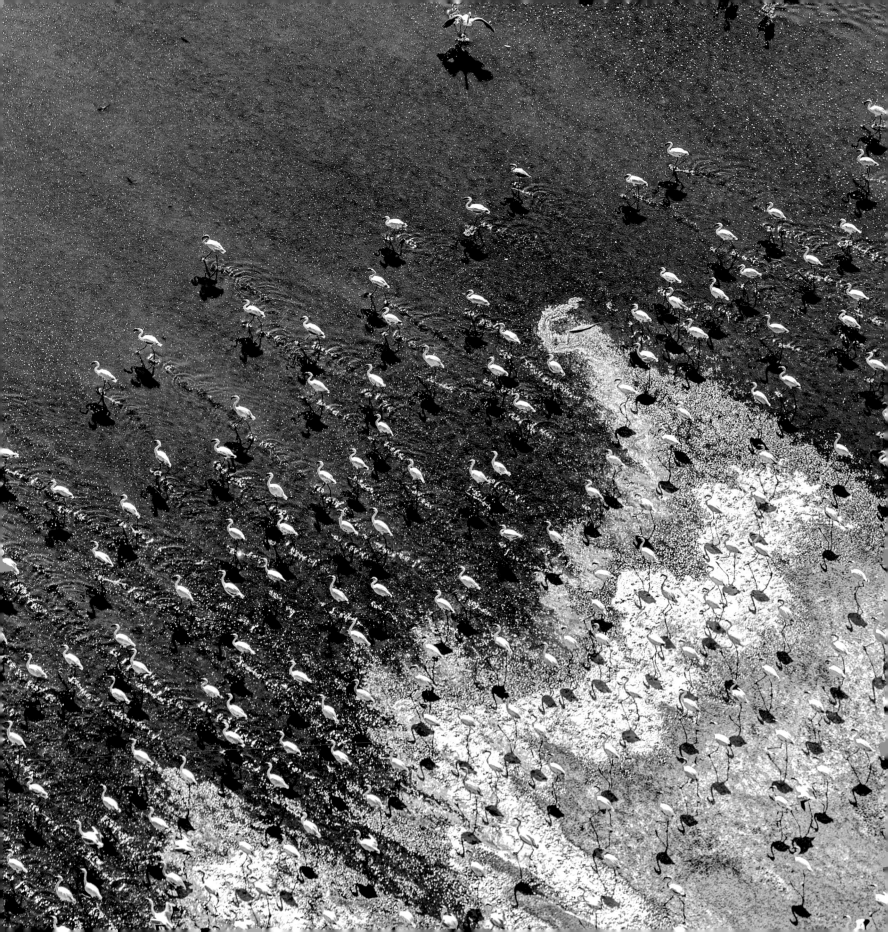

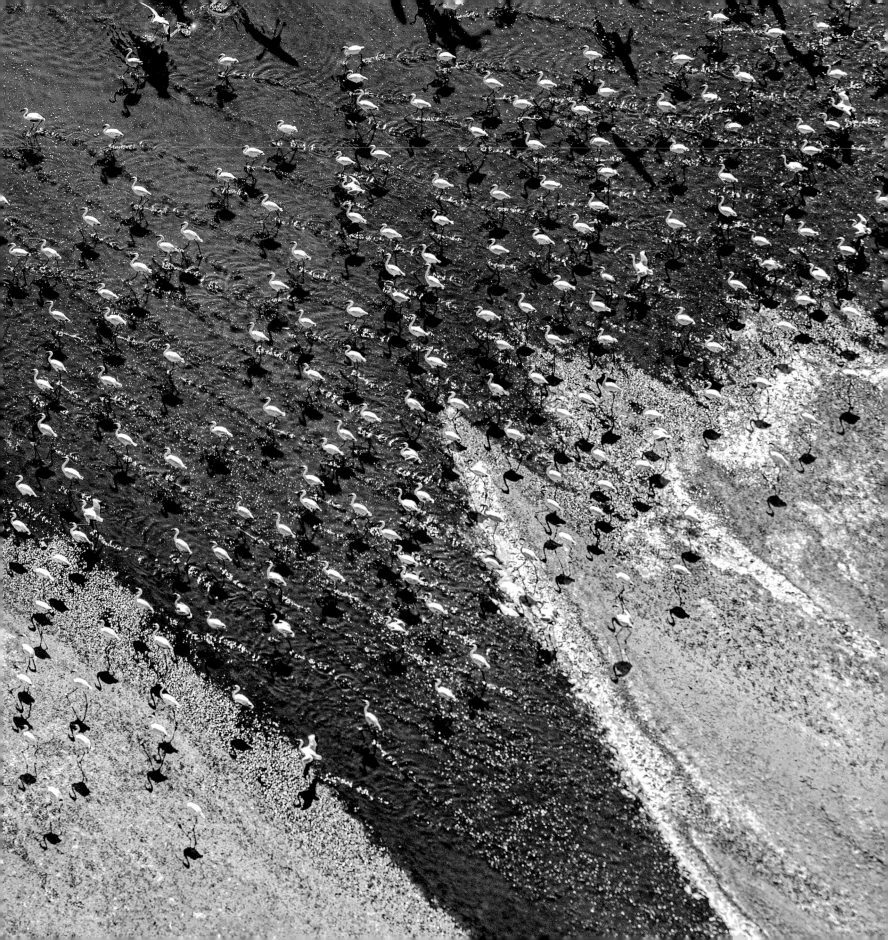

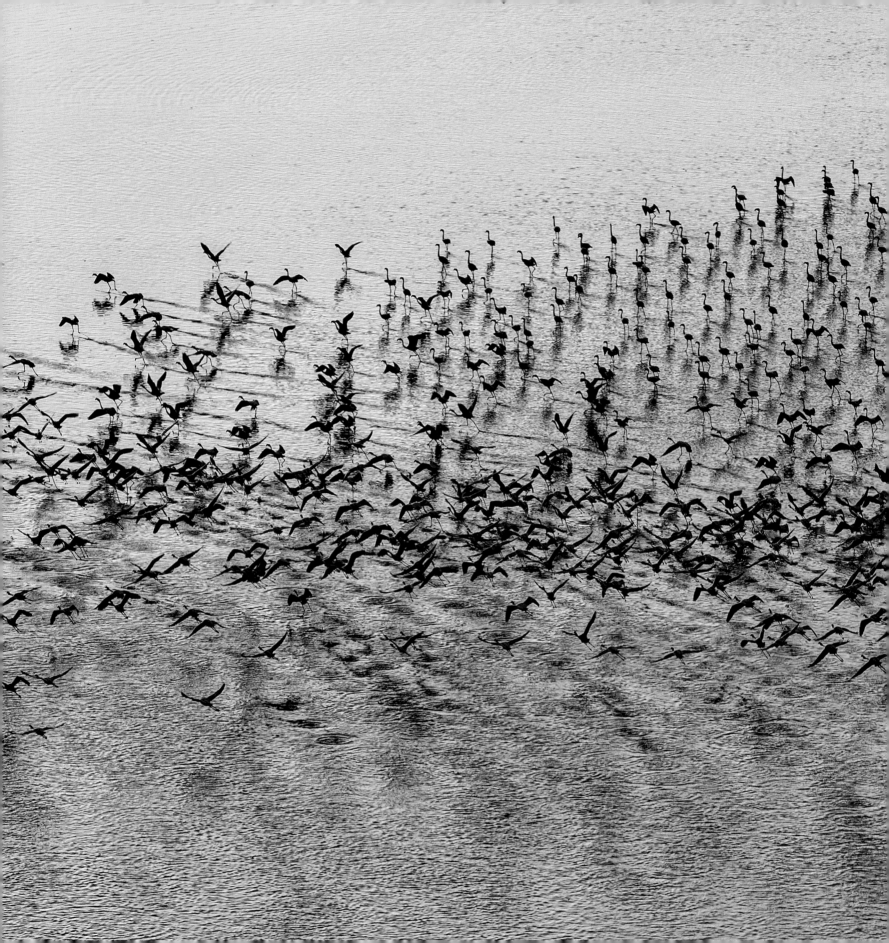

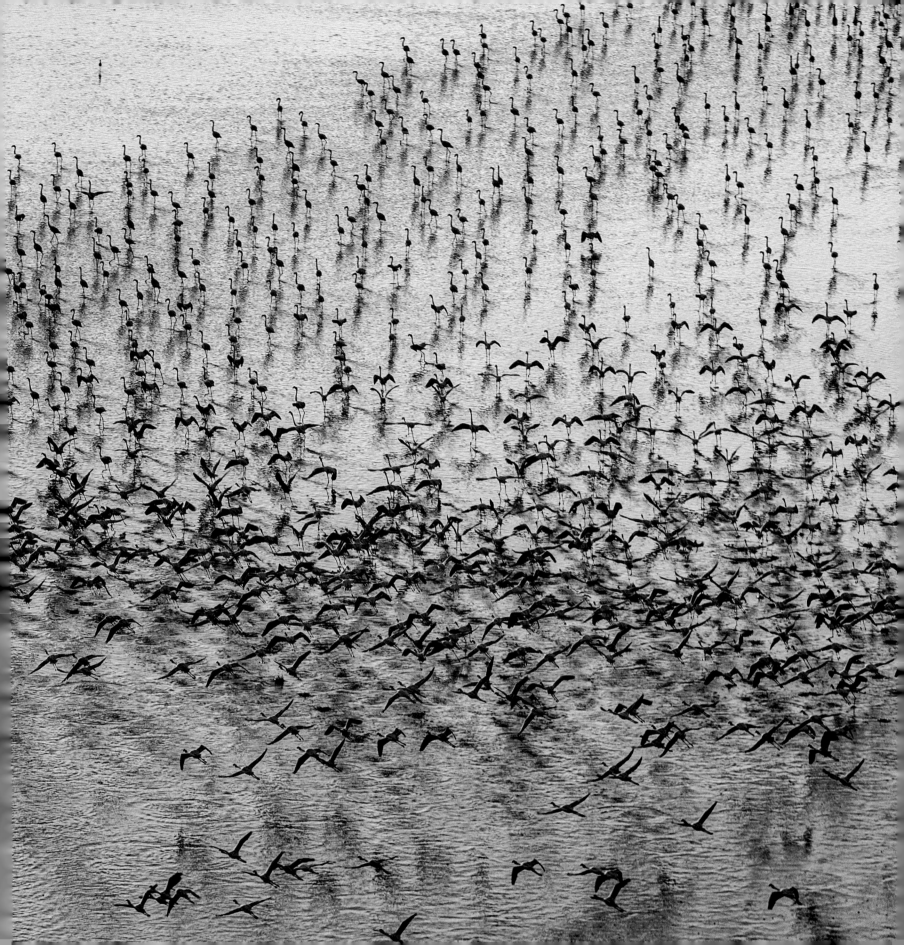

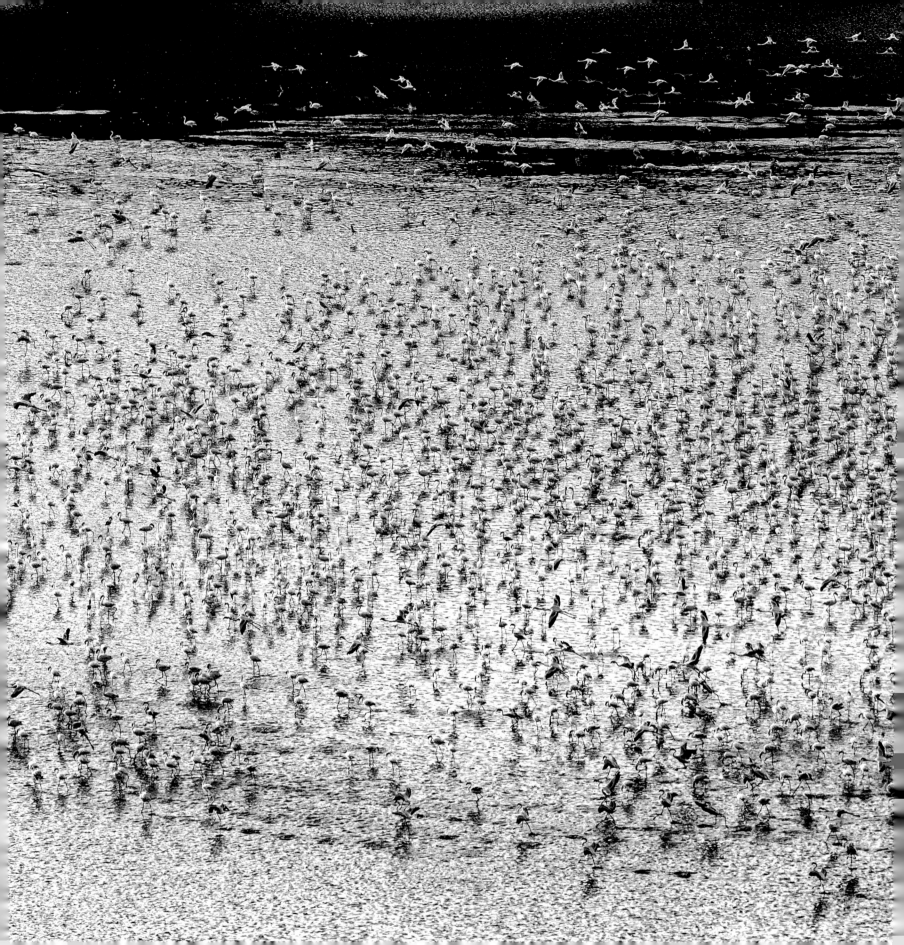

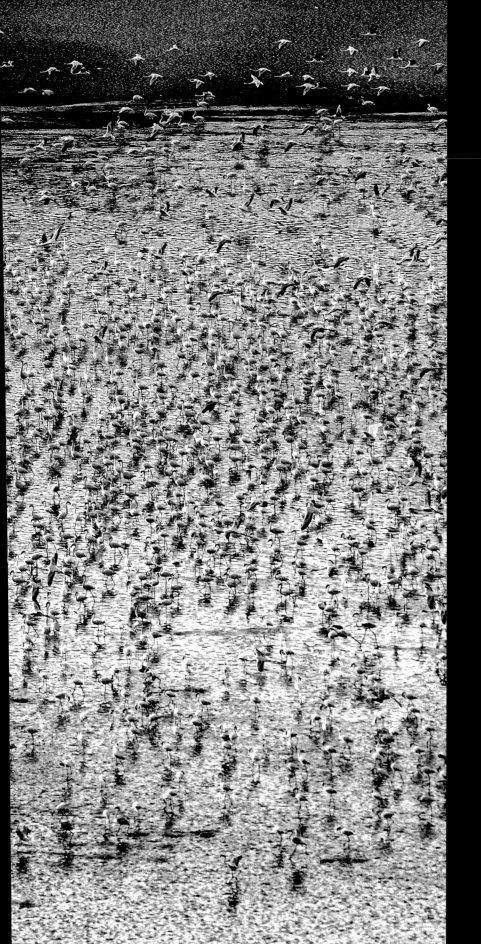

60-61

在繁殖季節，小紅鶴習慣高抬頭顱、亮出翅膀，在淺灘中齊步走。

During mating seasons, lesser flamingos tend to keep their heads up and wings extended while walking together in shallow waters.

62-63

陽光透過小紅鶴群的粉紅羽翼照射在湖水上，色彩的轉變豐富而自然。

On the lake shone by the sunlight through the pink wings of flamingos, the transition of colors is diverse and natural.

64-65

長期食用紅色海藻的小紅鶴，羽翼也漸變為粉紅色。

The food for lesser flamingos - the cyanobacteria with red pigments - has dyed their wings pink.

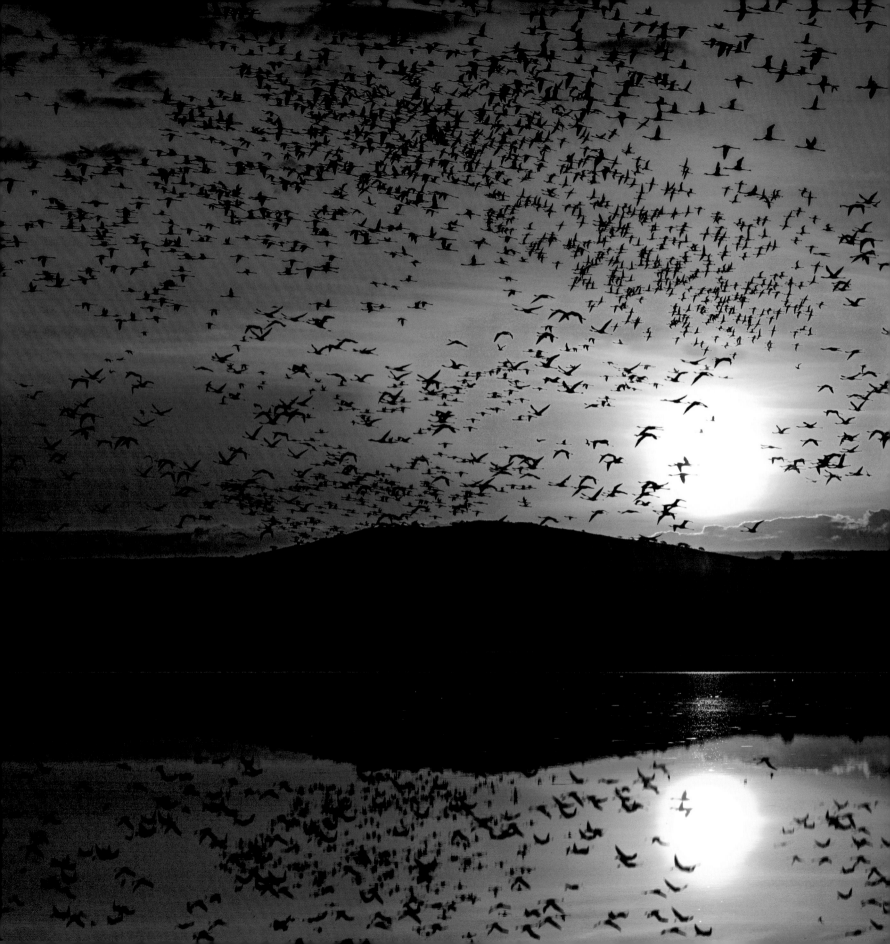

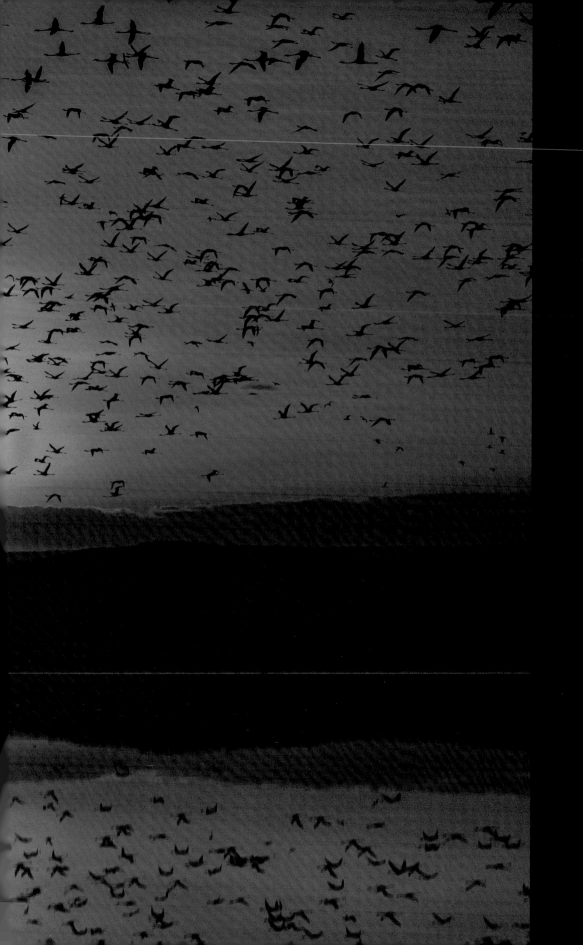

66-67

日落時分，龐大的小紅鶴群彷如烏雲壓頂般佈滿天際。

At dusk, hundreds of thousands of flamingos are covering the sky, like dark clouds.

# 英雄
# HEROIC

非洲「五大獸」及草原上的其他動物

The African Big Five and other animals on the savanna

Sinfonia grande

Louis van Beethoven

# 英雄
# HEROIC

貝多芬的降 E 大調第三交響曲，亦稱英雄交響曲，是貝多芬於 1803 至 1804 年間所創作的四樂章交響曲。最初，這首傑作是獻給他敬佩的法國革命英雄拿破崙·波拿巴。然而在得知拿破崙稱帝之後，貝多芬認為拿破崙的所作所為只是為了私利而非正義，隨即憤然將寫著「波拿巴」的字從樂譜上挖出來，留下了一個洞。最後，貝多芬將題目改為「英雄交響曲」。

第一樂章以濃烈的情感描繪了意氣風發的英雄，第二樂章《送葬進行曲》描述了英雄之死，第三樂章是走出死亡振奮重生的場景，而在最終章，貝多芬以其創作的芭蕾舞劇《普羅米修斯之創造》作為本樂章主題發展，又找回心靈的平靜。這與貝多芬的生平經歷息息相關。1801 年，貝多芬開始察覺自己的耳疾，繼而感到絕望並有輕生的念頭。但其後他受心目中的英雄人物普羅米修斯所啟發，決意以音樂為人們帶來勇氣。

英雄的形象，在非洲的大草原上或可具化為非洲五大獸，分別指非洲象、獅子、花豹、黑犀牛及非洲水牛這五種極難徒手捕捉的危險野生動物。雖然攻擊力極高，在草原上是絕對的王者，但他們依然面臨著數量不斷下降的危機，其中獅子和非洲象是易危動物，非洲水牛和花豹則被列為近危，而黑犀牛是極危物種。

其實除了五大獸，在牠們的爪牙之下為了生存、保育後代而掙扎求生的其他動物，也是草原上的英雄。無論是帶領著浩蕩的大遷徙角馬群渡河時勇於踏出第一步的「領頭羊」，抑或是保護幼崽不受捕食者侵害的其他動物，都各自在這片遼闊的草原之上扮演著自己或他人的英雄。

The Symphony No. 3 in E flat major, otherwise known as Heroic Symphony, is a symphony in four movements composed by Beethoven between 1803 to 1804. Initially, this masterpiece was dedicated to Napoleon Bonaparte, whom he admired as a hero in the French Revolution. But as he learned about Napoleon's crowning of himself, Beethoven reckoned what the emperor did was only for personal interest rather than public righteousness. He was so indignant that he actually scrubbed out "Bonaparte" from the dedication page, leaving a hole in it, and renamed the symphony as "Heroic".

The first movement depicts a high-spirited hero, using emotional passages; the second is a funeral march which represents the death of the hero; Beethoven then presented in front of us a scene of re-birth of the hero; and finally, he based the final movement on his ballet The Creatures of Prometheus to achieve inner peace. This arrangement has everything to do with his personal life. In 1801, Beethoven started to perceive his loss in hearing, and desperation caused by that even almost drove him to commit suicide. But inspired by Prometheus, whom he deemed as a heroic figure, he was resolute to bring courage to his audiences through music.

The African Big Five, namely the African elephants, lions, leopards, black rhinoceros and Cape buffaloes, are the heroic representation on the savanna, which are extremely dangerous and difficult to hunt with bare hands. Although being on top of the food chain, they are facing their own crisis of decreasing in quantities: African elephants and lions are vulnerable (VU) species, leopards and Cape buffaloes are near threatened (NT), and black rhinoceros are critically endangered (CR).

Apart from the Big Five, other animals who struggle to survive or protect their offsprings under the shadow of the predators are also heroes. Be it the first wildebeest to take the lead to cross the river in the great migration, or other animals who are willing to fight against significantly stronger enemies to protect their cubs, they all show great bravery in heroism.

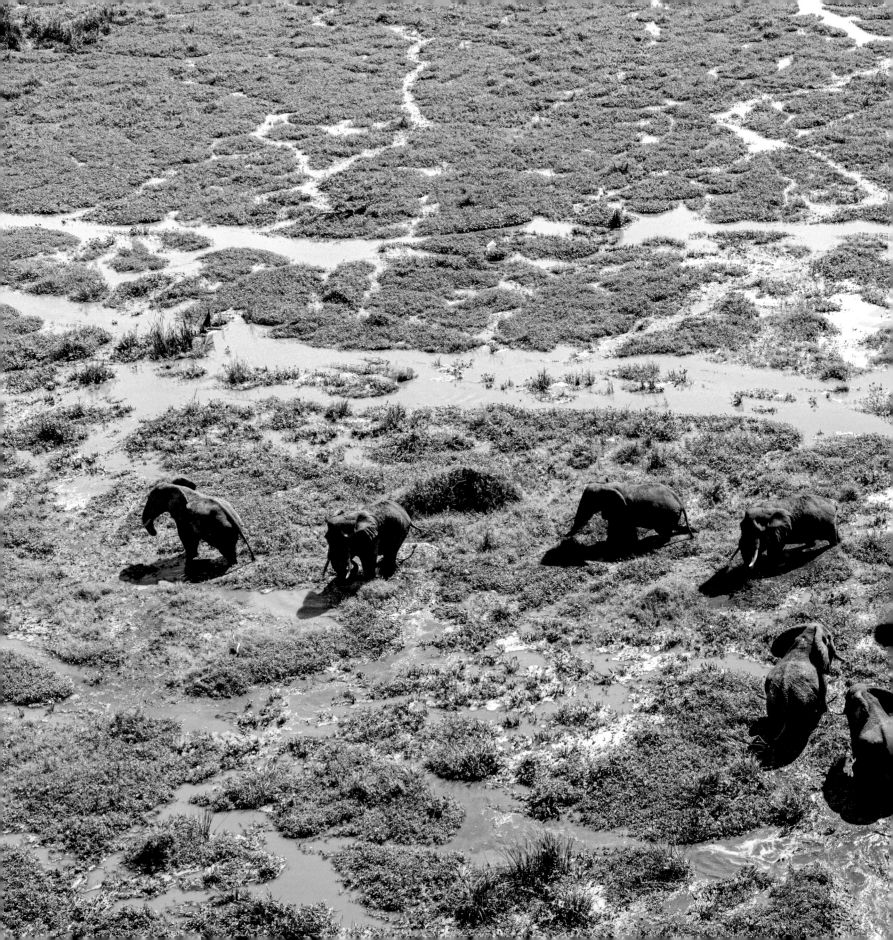

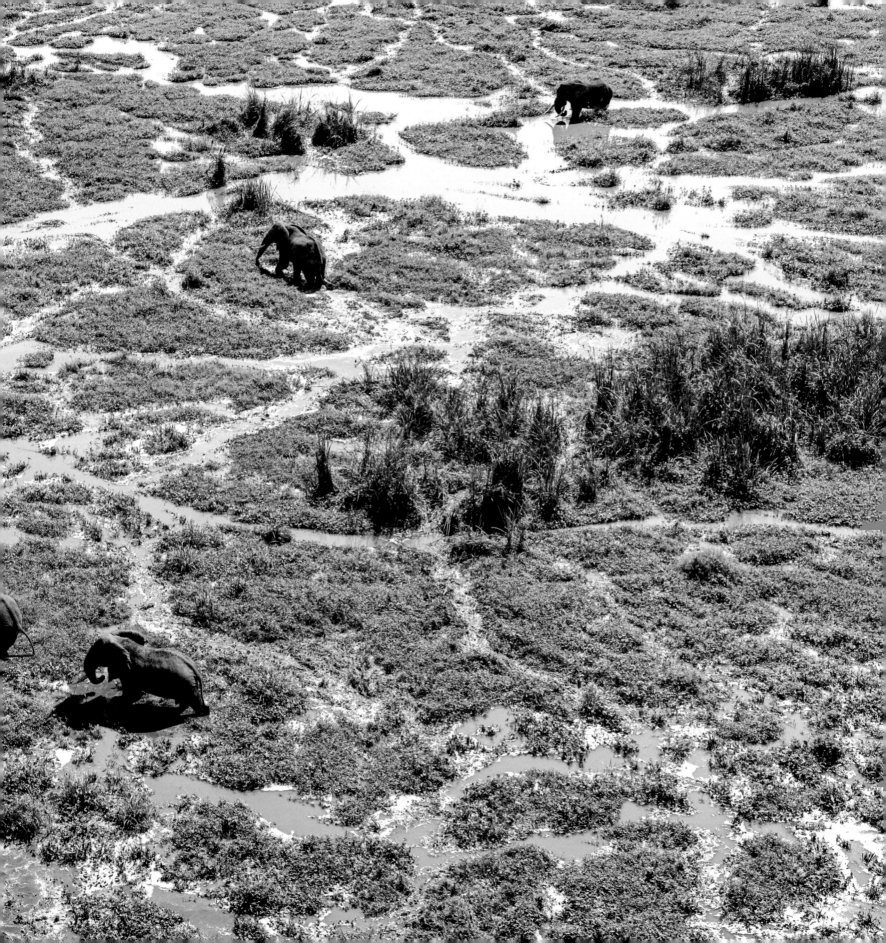

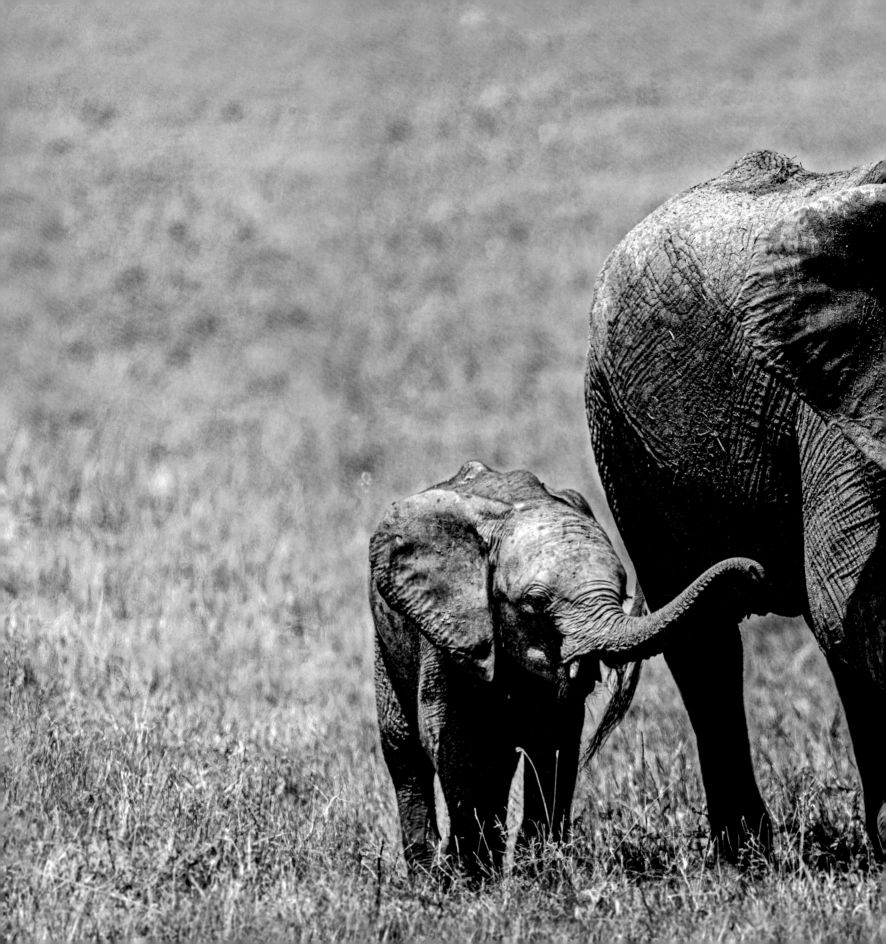

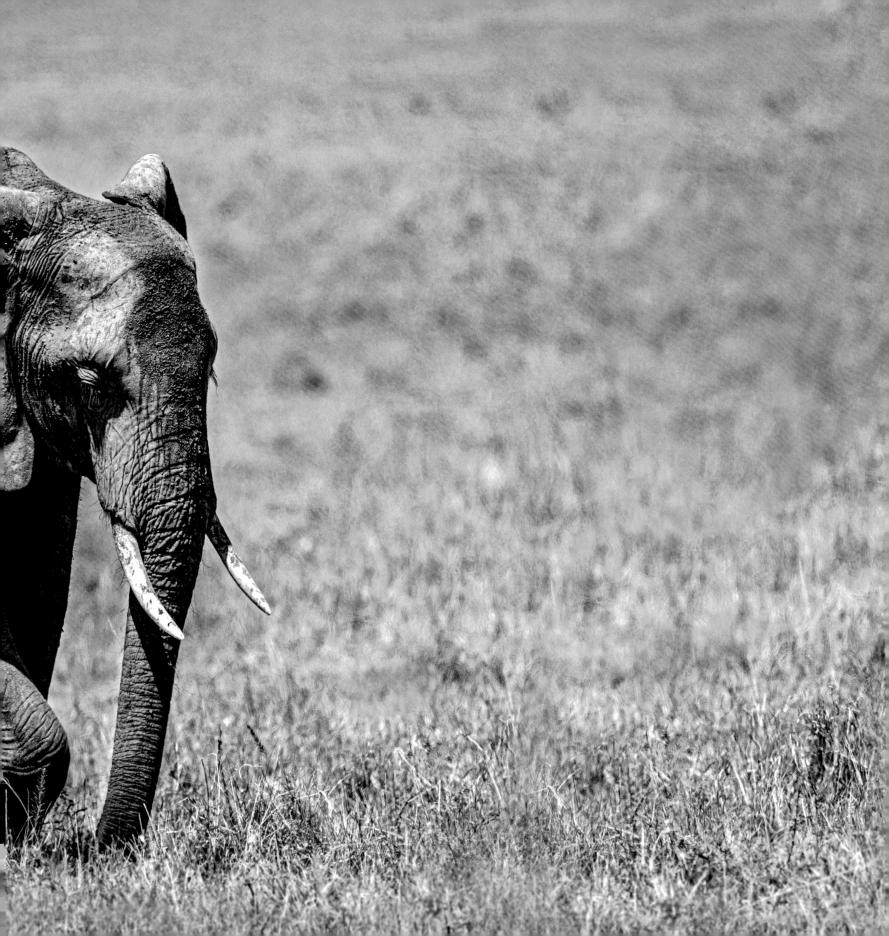

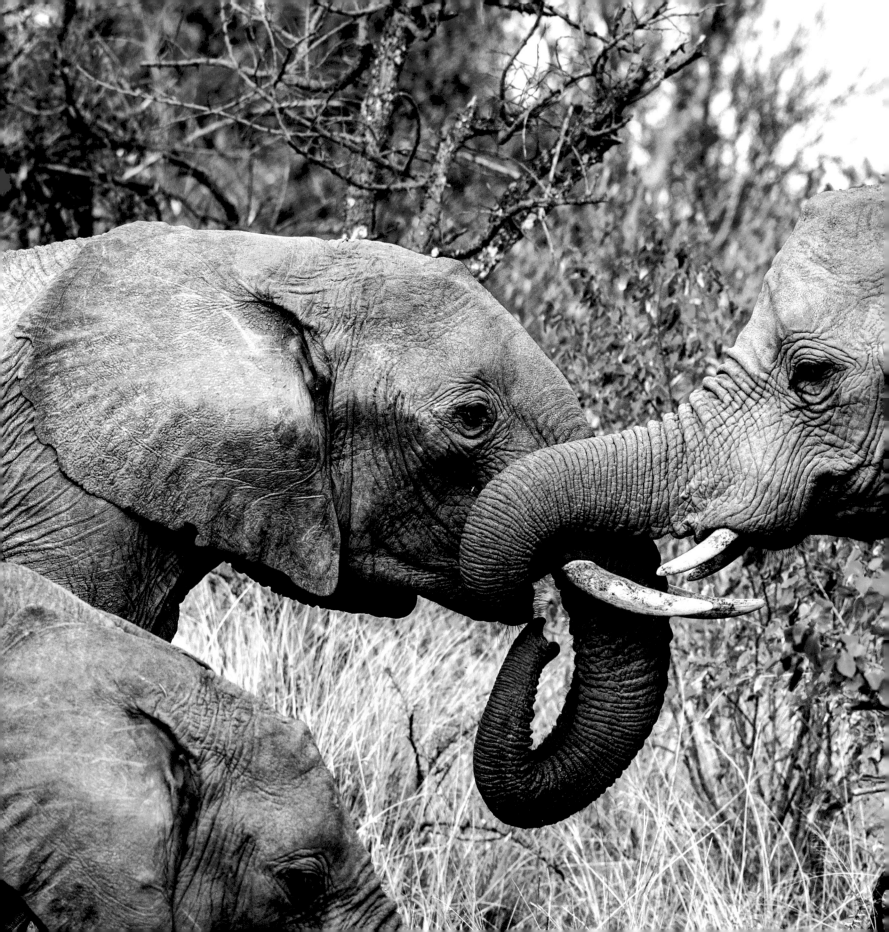

72-73

非洲象為群居動物，零星散佈的象隻在窪地中飲水。

African elephants are social animals. They scatter around in the marshes for drinking.

74-75

一隻大象正領著小象散步。野生非洲象甚為兇猛，被列為非洲最難徒手捕捉且高度危險的五大獸之一。

An elephant is taking a stroll with its child. Wild African elephants, one of the Big Five animals that are difficult to hunt bare-handed and highly dangerous, can be quite ferocious.

76-77

以象鼻交纏的動作，類似人類握手的行為，是年幼象隻之間常見的示好或遊戲方式。

The tangling of trunks to elephants is as hand shaking to human, which is commonly seen among younger elephants as showing of friendliness or a game.

78-79

體型龐大的非洲象在晨光中緩緩前行。

The gigantic African elephants are slowly walking in morning glory.

80-81

日落時分愜意的大象及羚羊。

An elephant and an antelope are spending the sunset hours at leisure.

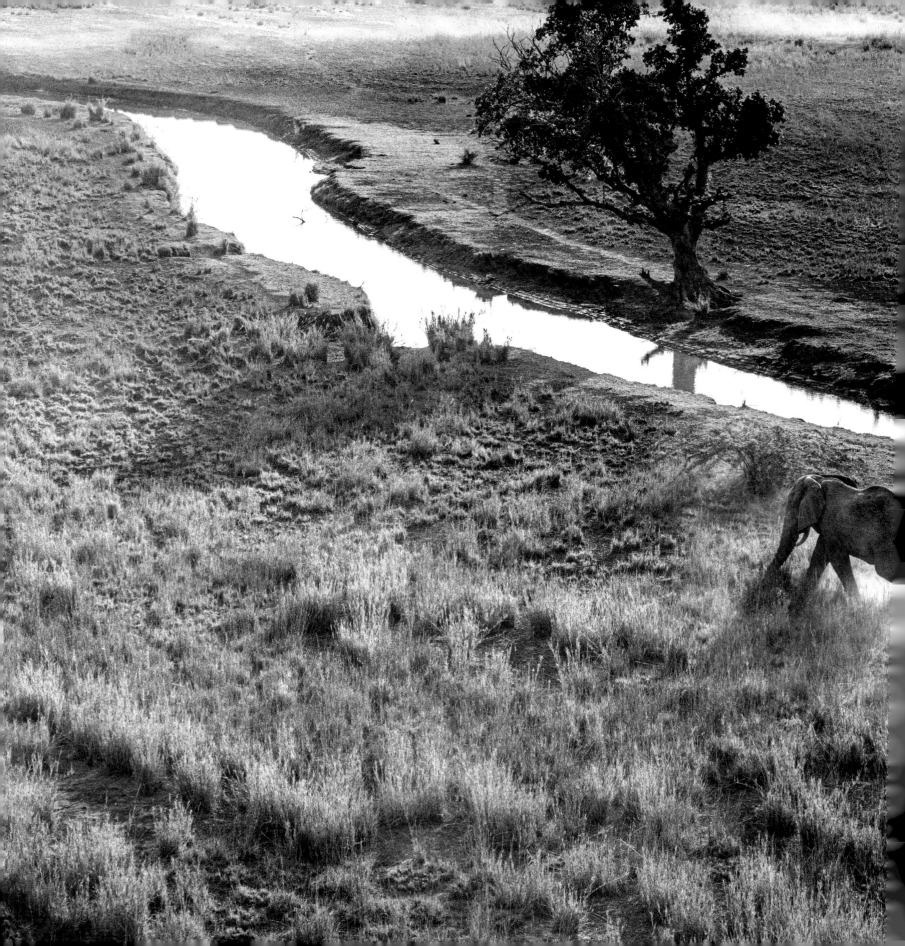

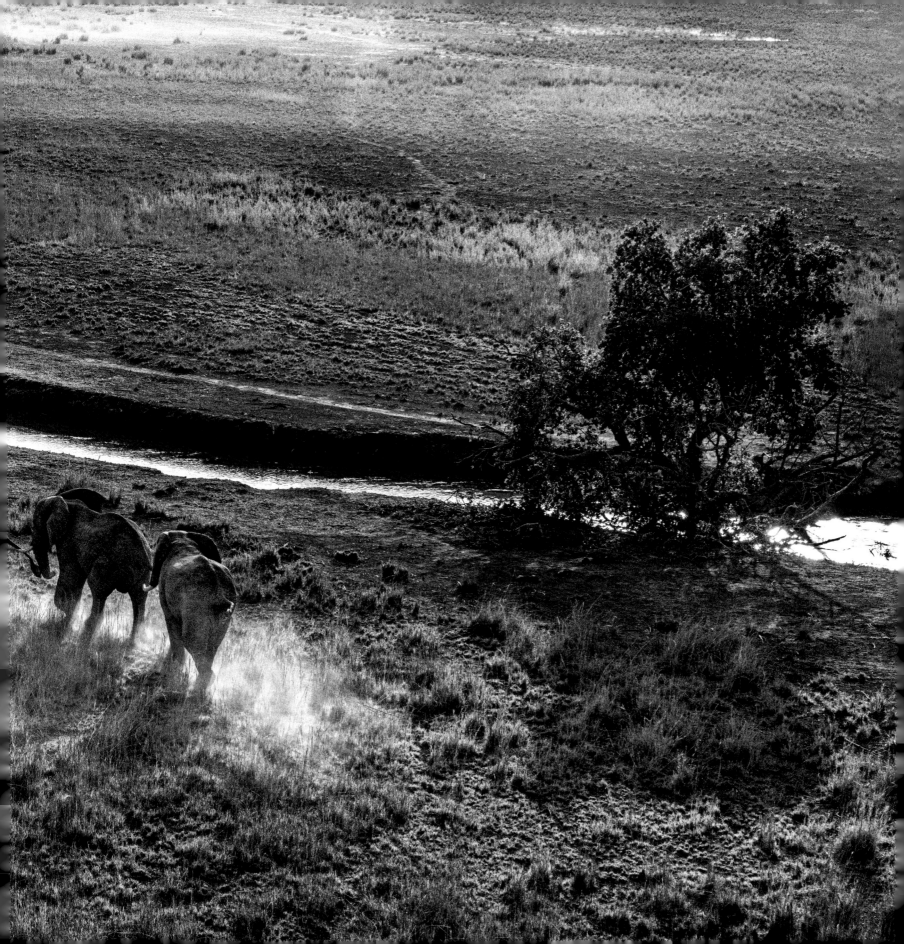

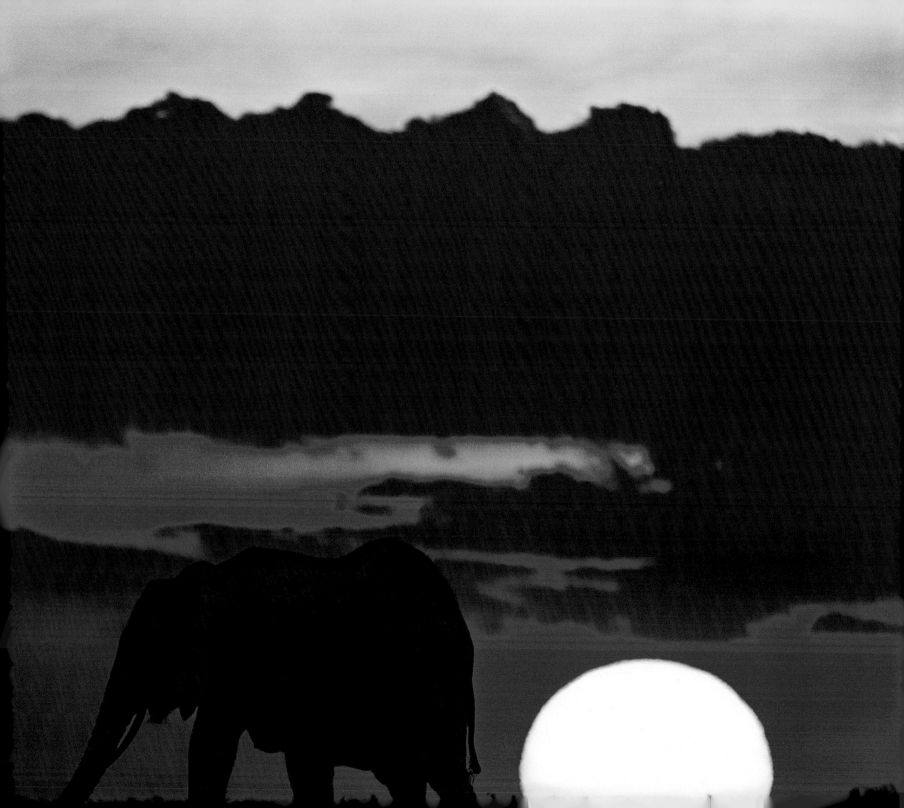

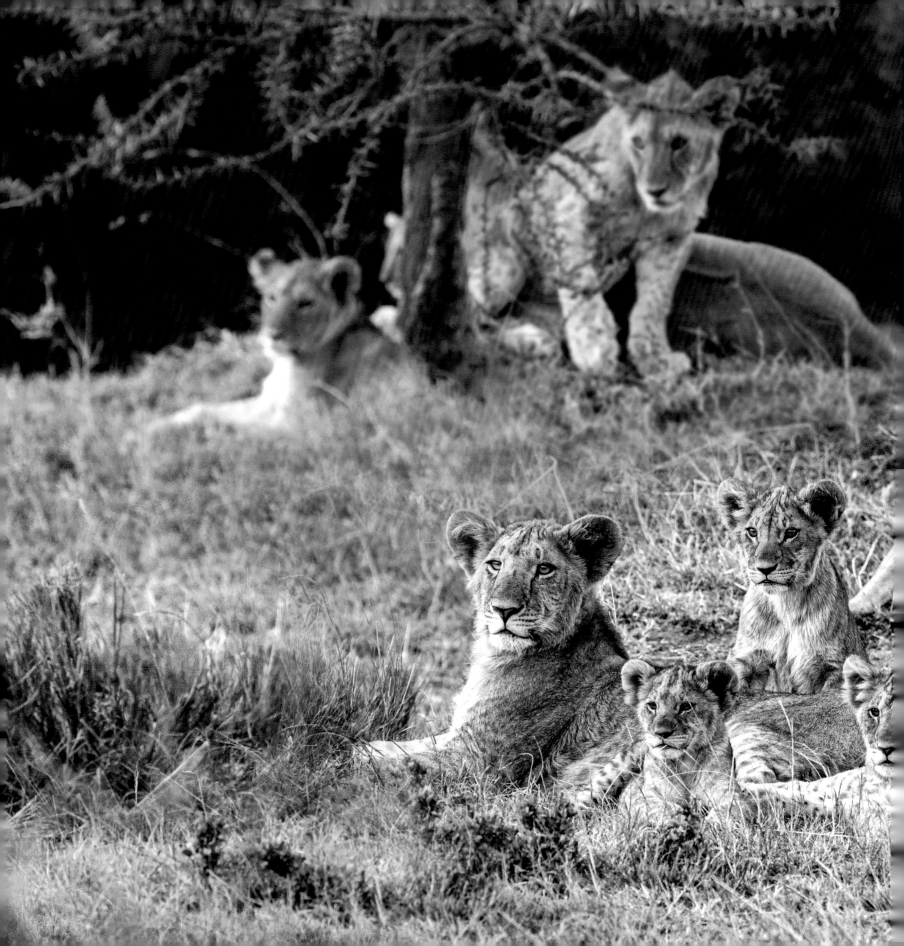

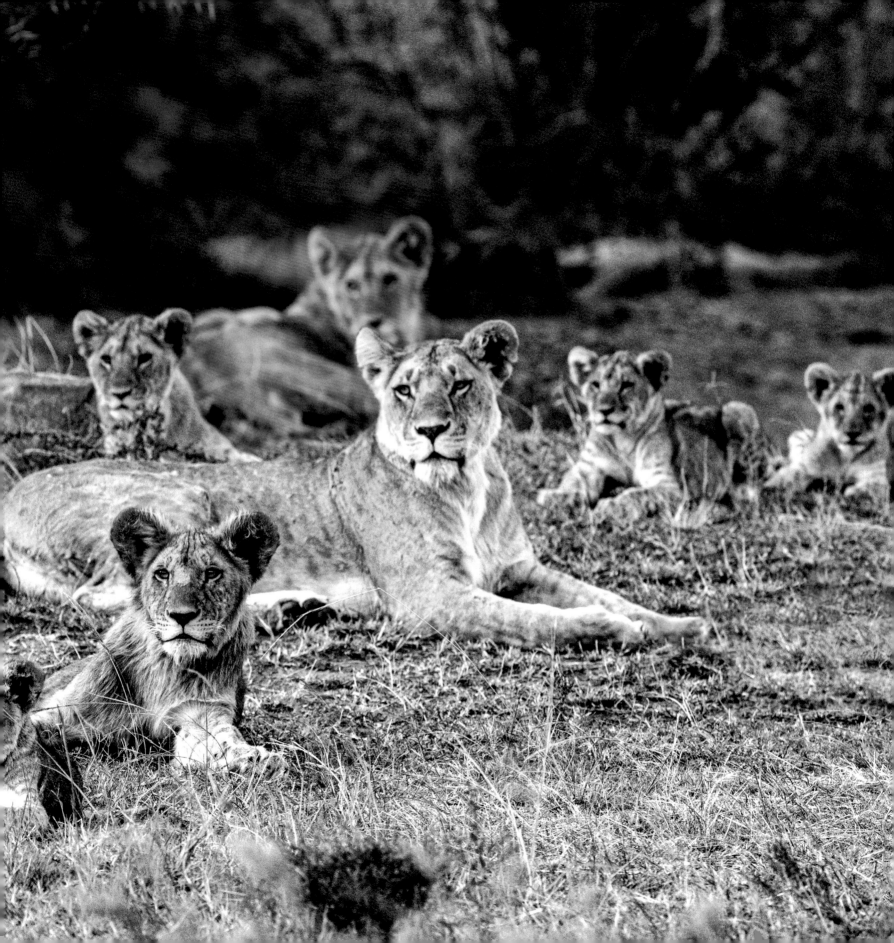

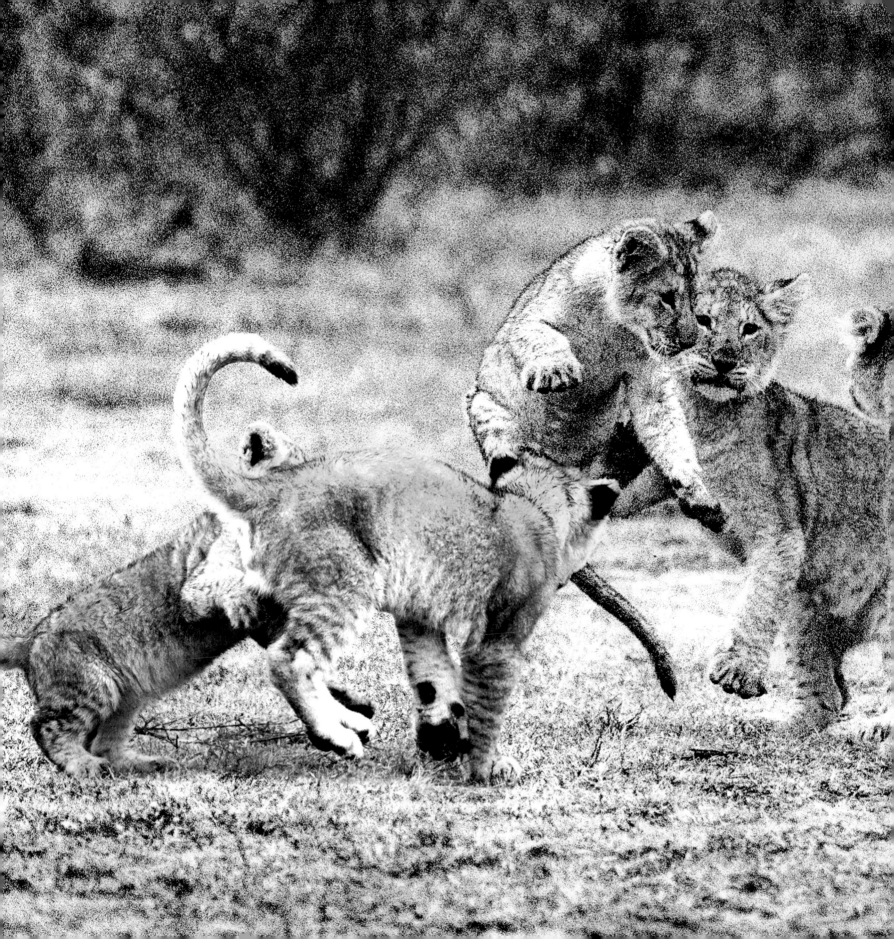

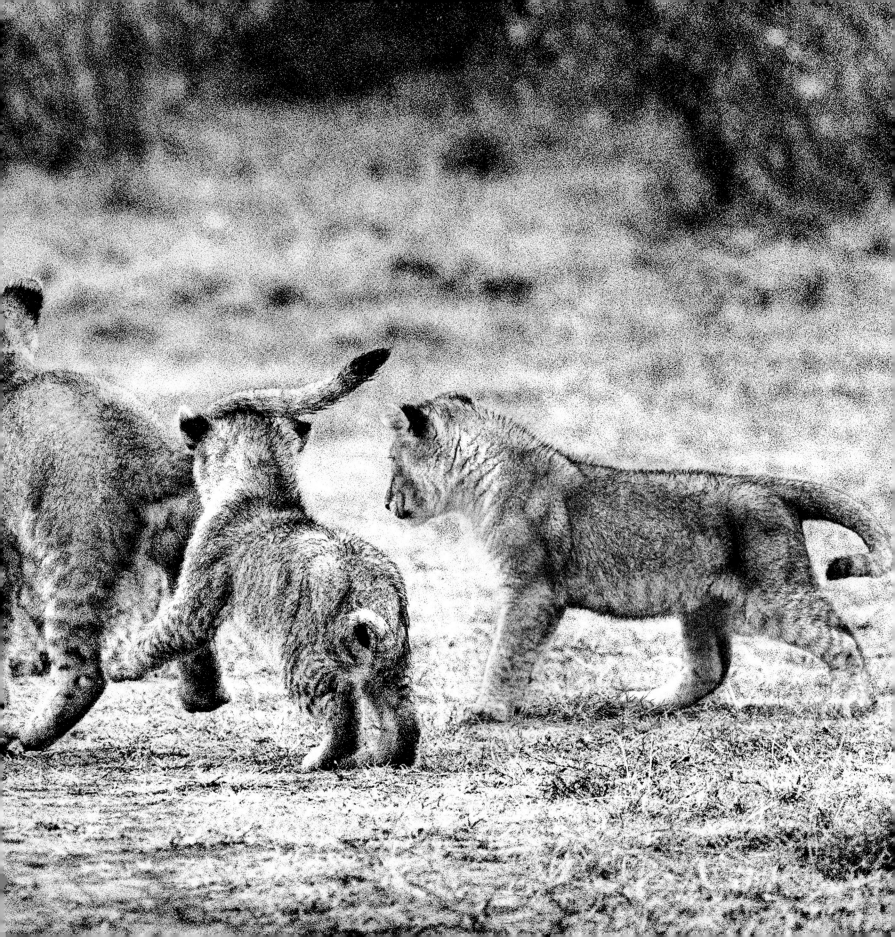

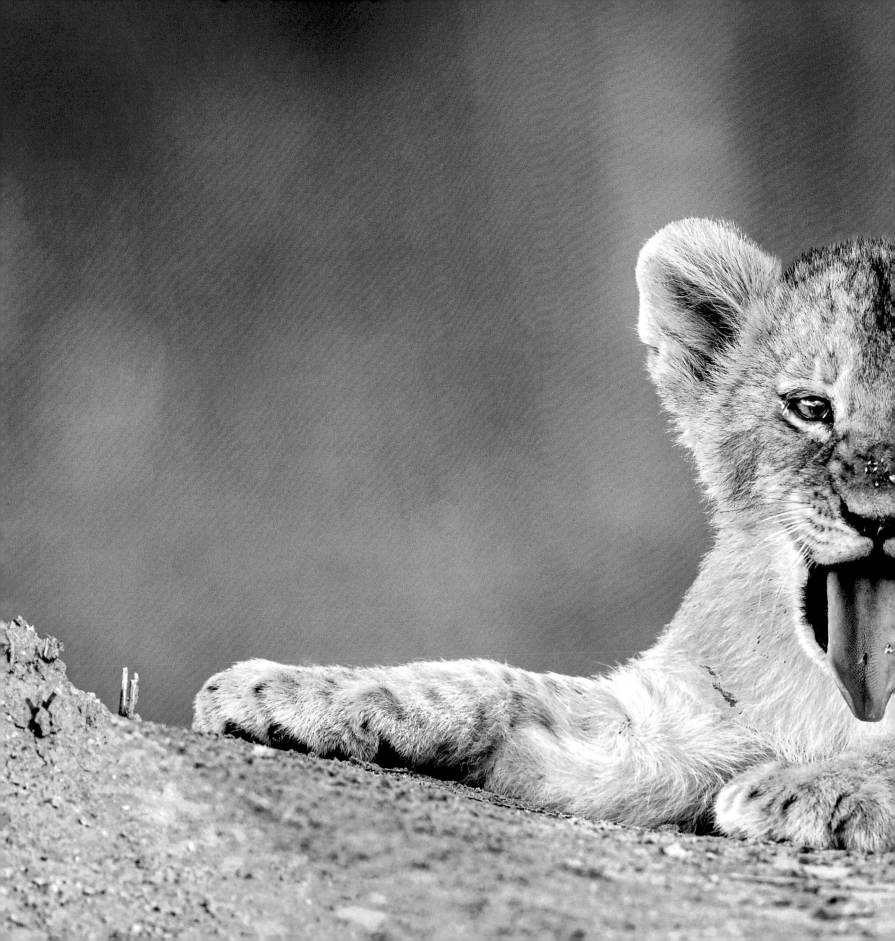

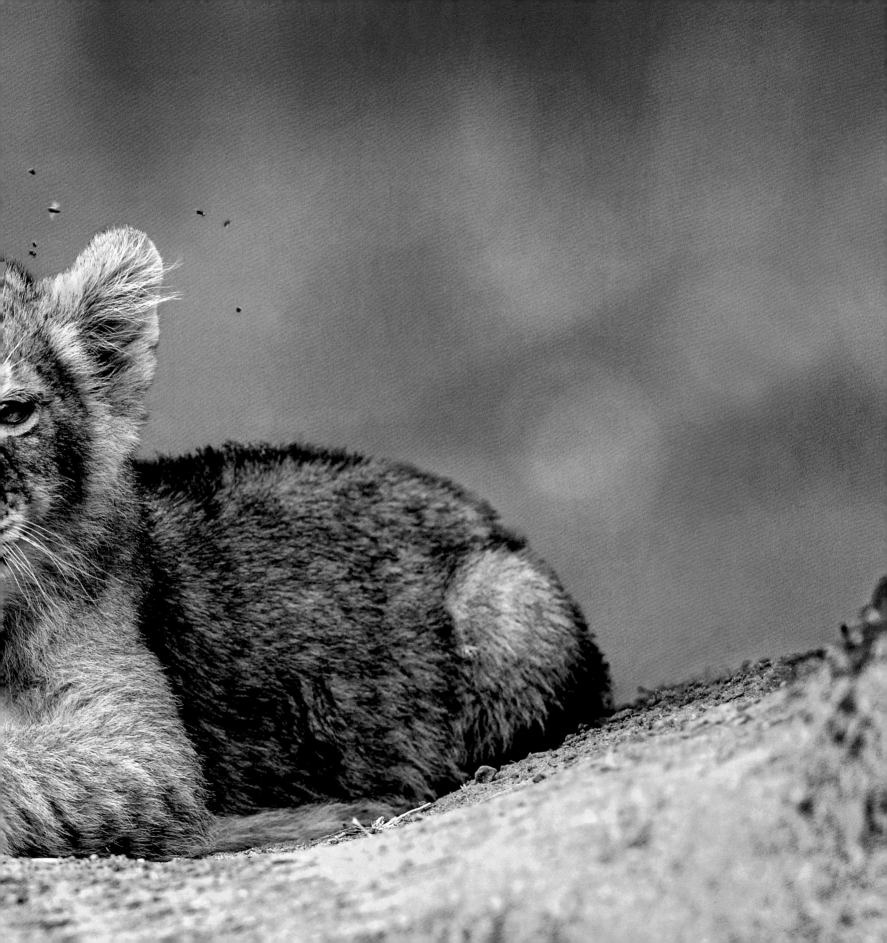

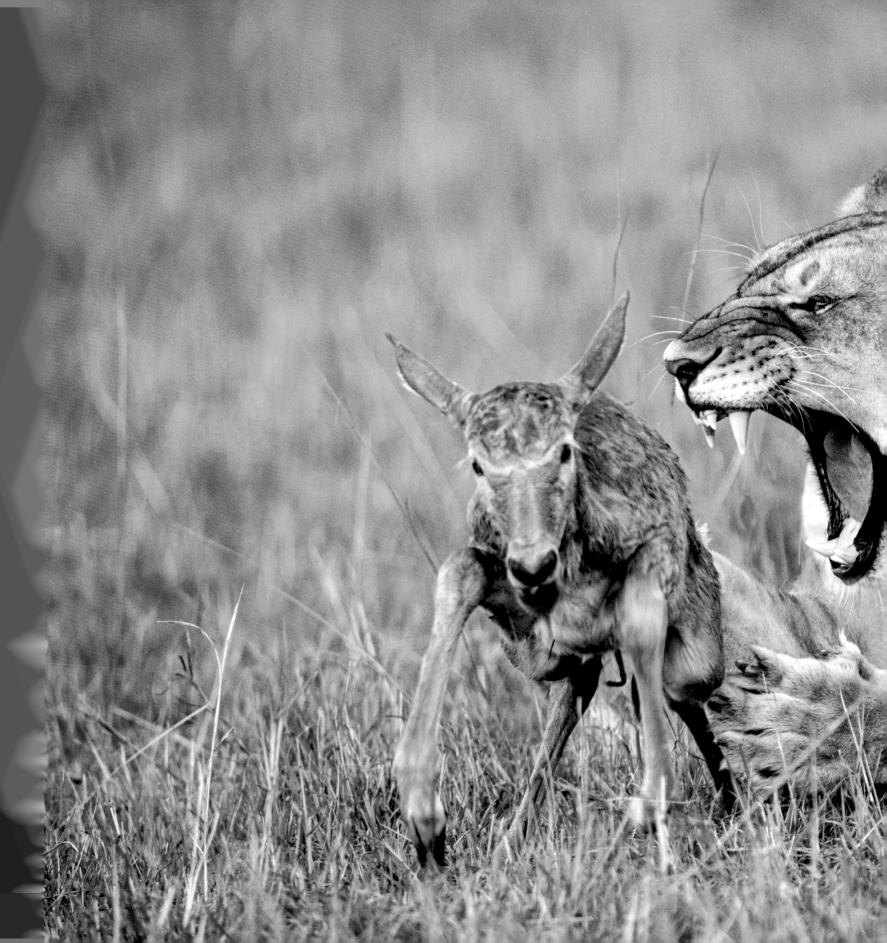

82-83

獅子為貓科動物中僅有的群居性動物，以母獅為首領，
公獅則通常在成年後離開獅群。

Lion is the only social species in the family of cats,
led by female lions. In most cases, a male lion would
leave its community when it comes of age.

84-85

玩樂在一起的幼獅看起來十分無害，難以想像長大之後
會成為草原上的萬獸之王。

It's hard to imagine these innocent creatures playing
together would grow up to be the kings of animals on
the savanna.

86-87

一隻可愛的幼獅正伸出舌頭，似乎在與飛過面前的蒼蠅
玩耍。

An adorable lion cub is sticking out its tongue, as if
it's playing with the flies in front of it.

88-89

獅子抓住小羚羊的腿部，露出了兇猛的表情。

A female lion is catching an antelope by its legs, with
a ferocious expression on her face.

90-91

一隻雄獅正在大快朵頤，飲血啖肉盡現威武霸氣。

A male lion is enjoying his bloody meal, showing his
prowess to bystanders.

92-93

獅子是貓科動物中擁有最顯著兩性差異的物種。一頭
雄獅的鬃毛越長、顏色越深，則越是勇武。

Lions are the only cat to be obviously sexually
dimorphic. The mane of a male lion correlates with his
power: the darker and longer, the mightier.

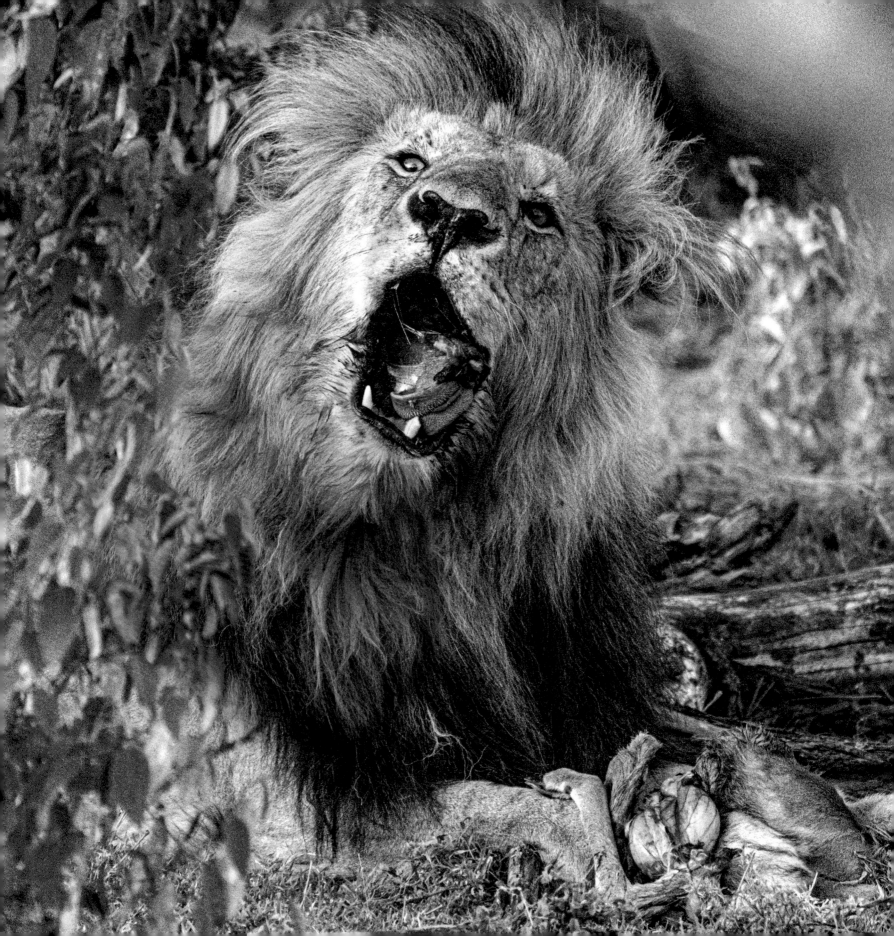

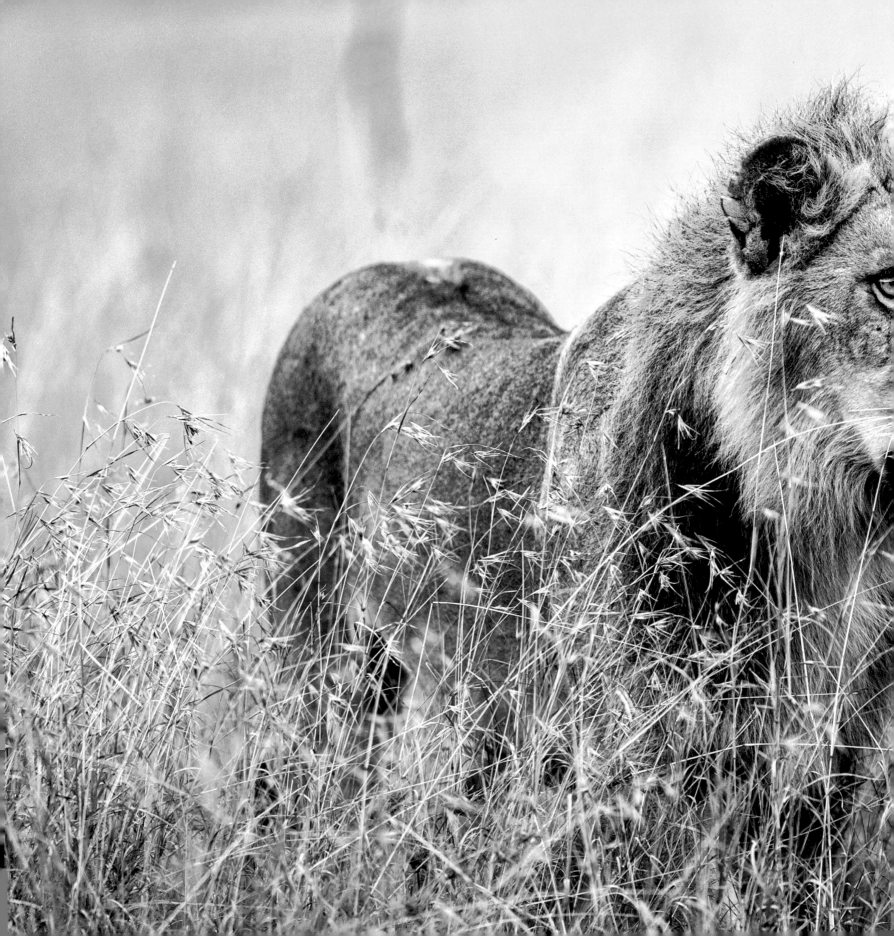

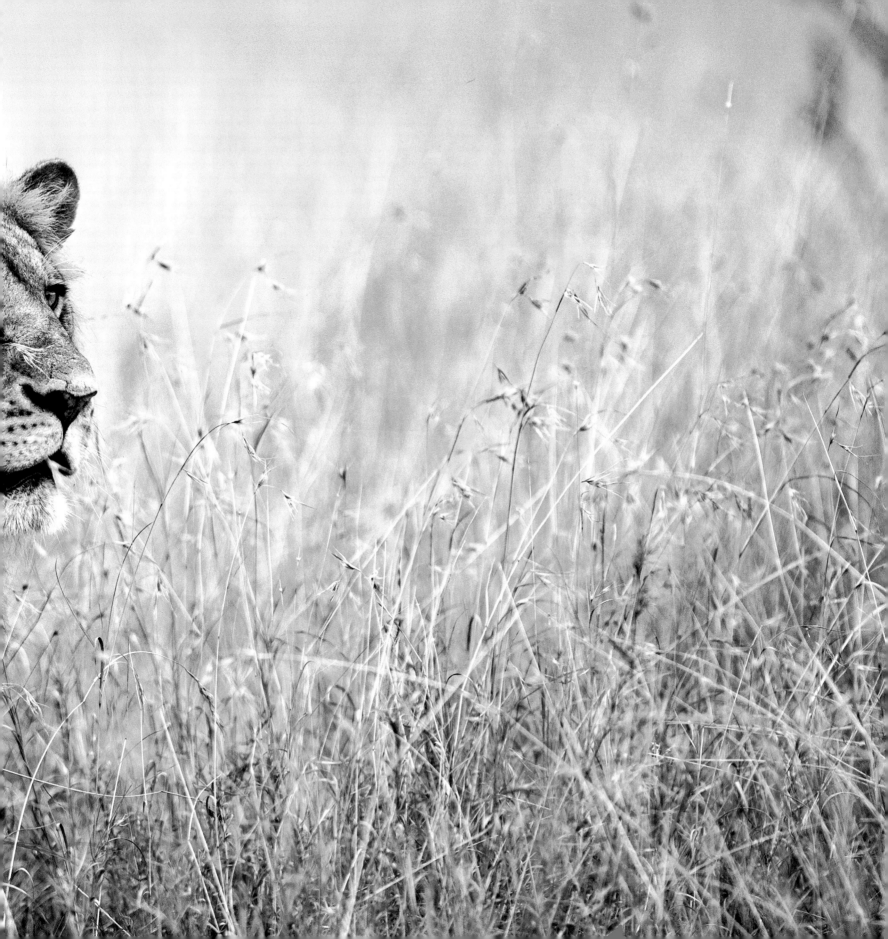

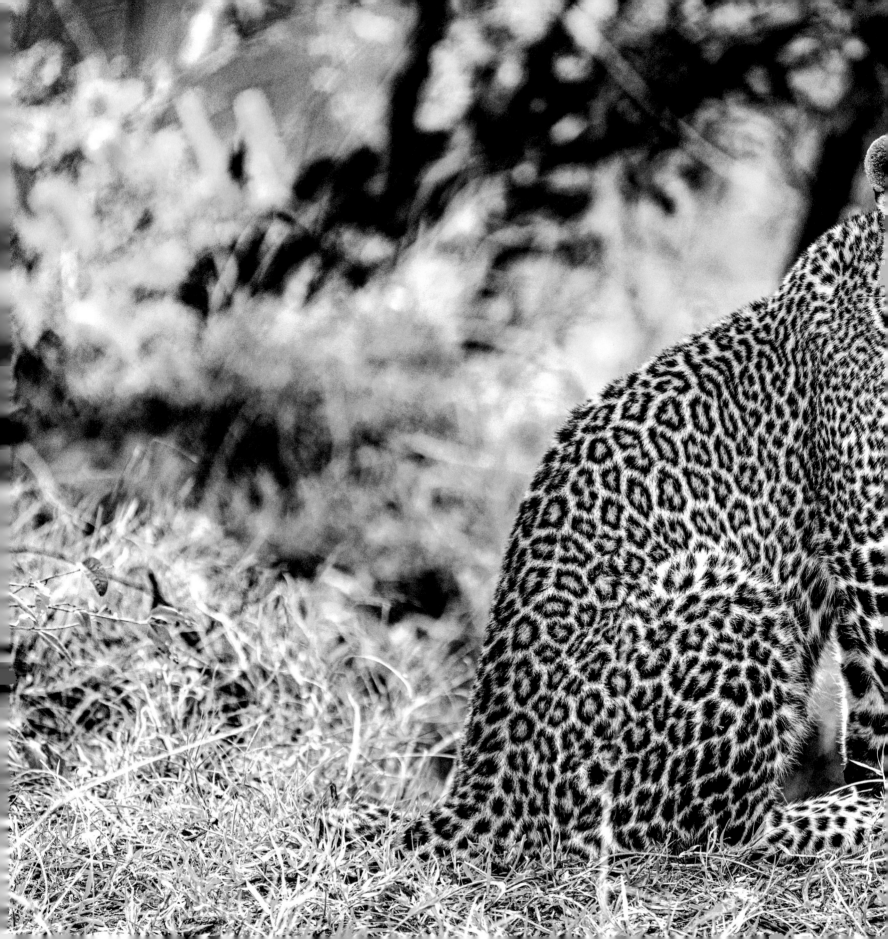

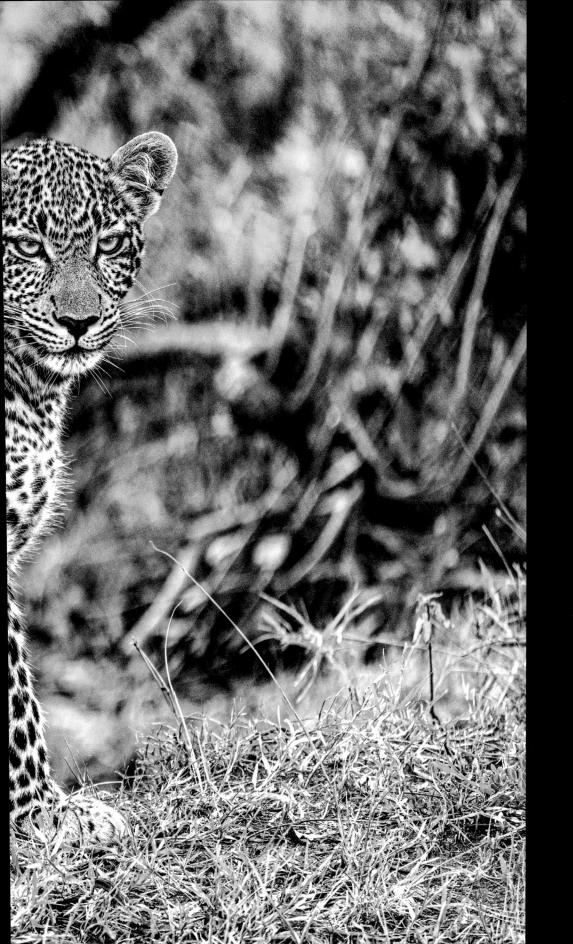

94-95

花豹全身遍佈不規則黑色空心斑紋，而
獵豹身上的則接近實心黑色圓點。

The black spots of a leopard are hollow
and irregular, while those of a cheetah
are rounded solid black dots.

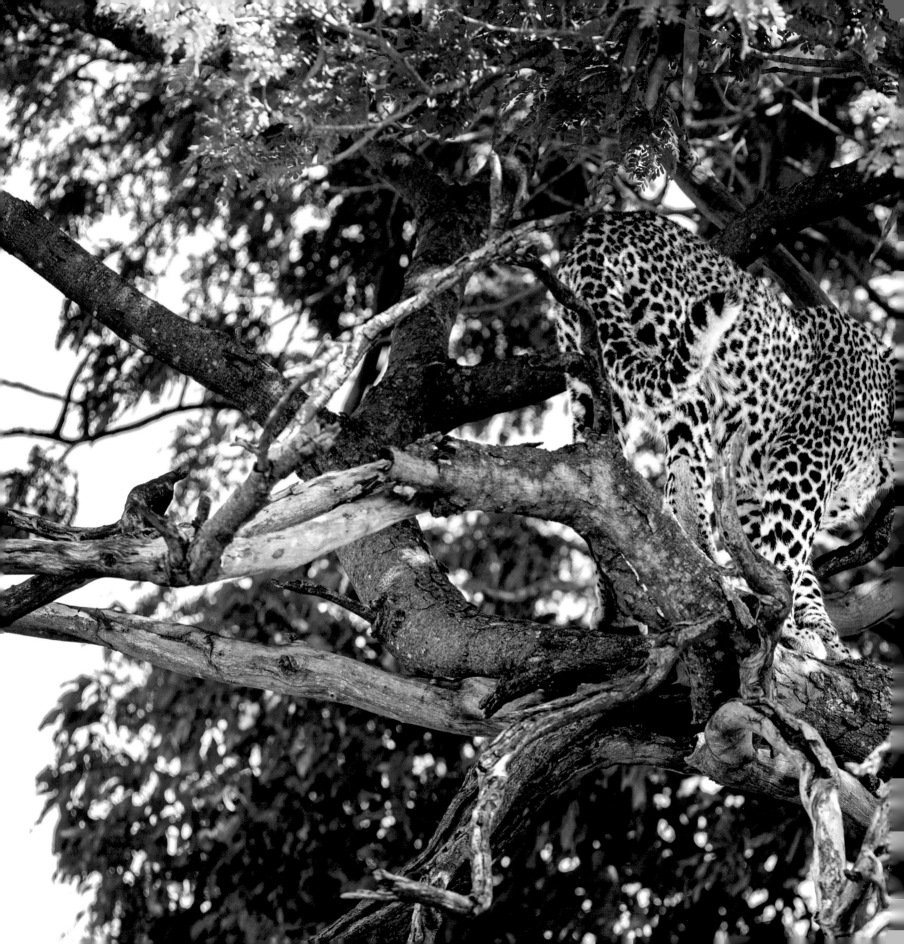

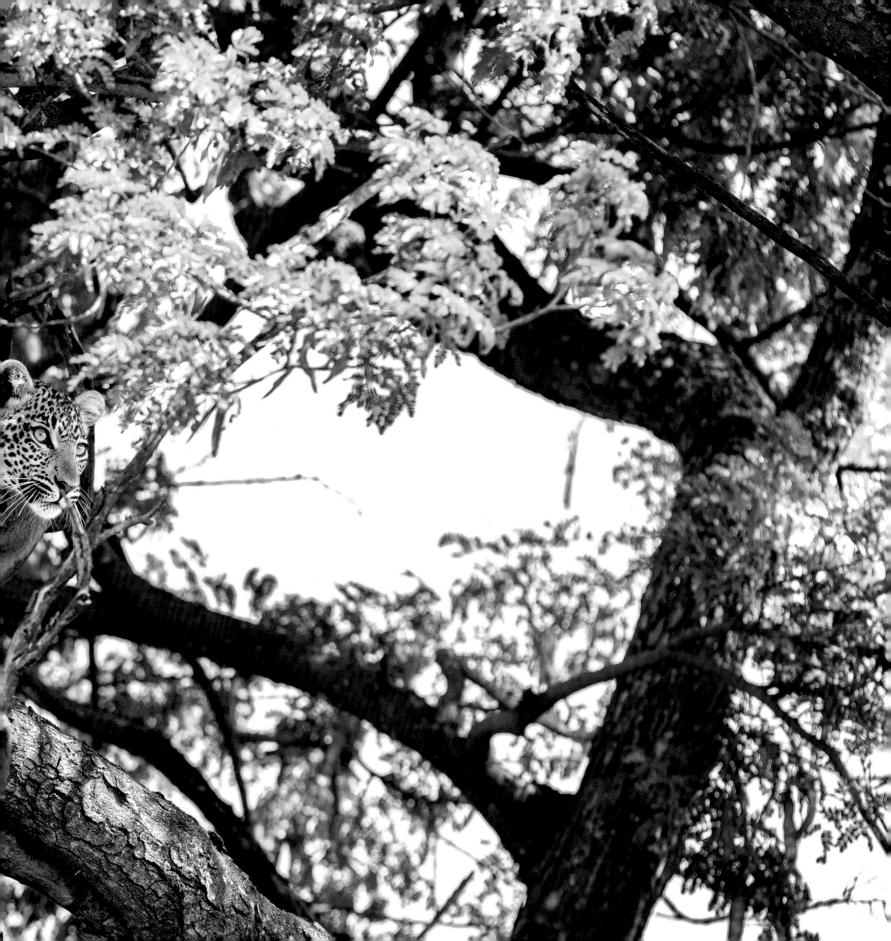

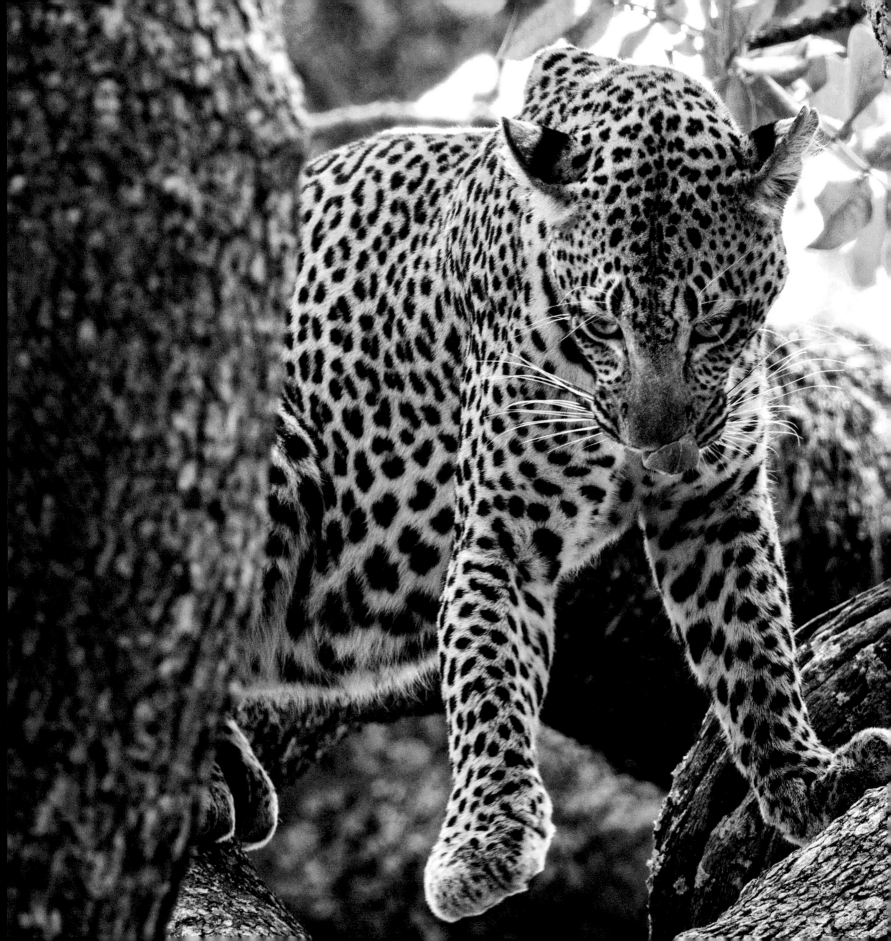

96-97

花豹迅猛危險，是非洲五大獸之一。黃色的虹膜在樹葉的映照下猶如珍貴的「祖母綠」寶石。

Leopard, also one of the Big Five, is speedy and dangerous. Their yellow irises, reflected by the leaves, look like precious emeralds.

98-99

花豹經常出沒於樹上，有時為防其他動物偷走獵物，亦會在樹上進食。

Leopards frequent on trees; they would even dine there to prevent others from stealing away their food.

100-101

獵豹是陸上速度最快的動物，面部有明顯的黑色「淚痕」式線條。當發現獵物時，花豹會迅速從埋伏的樹叢裡竄出，讓獵物措手不及。

Cheetah is the fastest land animal on earth. They have distinct black tear-like streaks on their faces. When spotting their targets, leopards swiftly ambush from the trees in which they are hidden and catch the preys off guard.

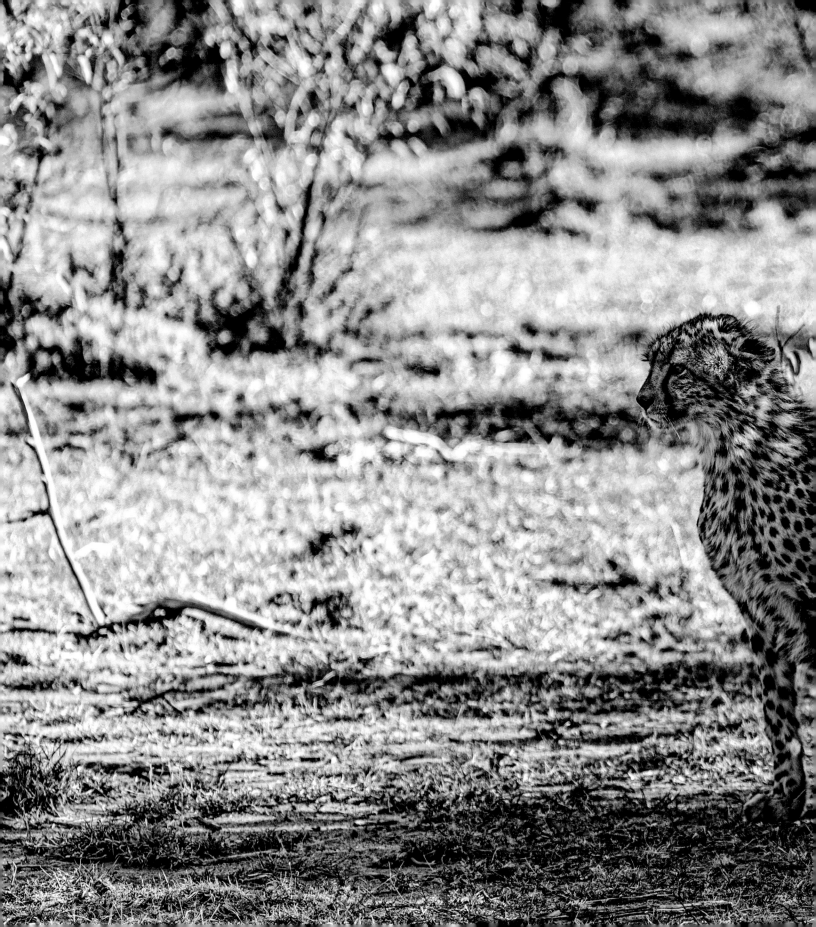

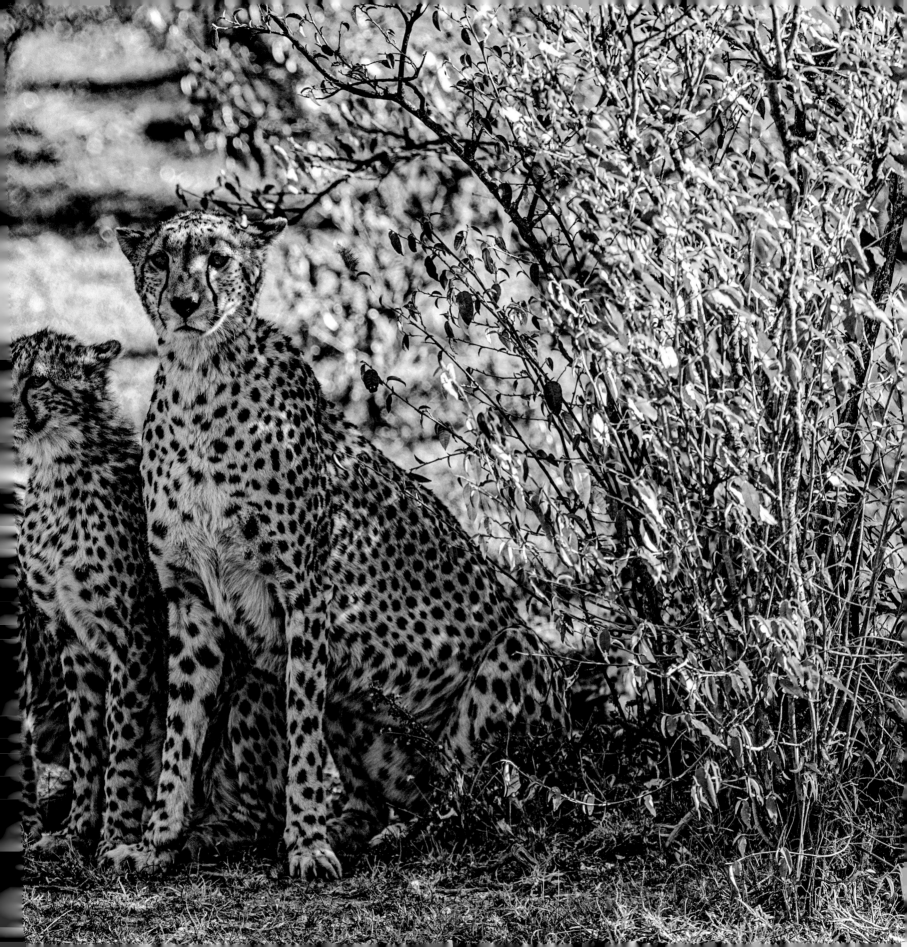

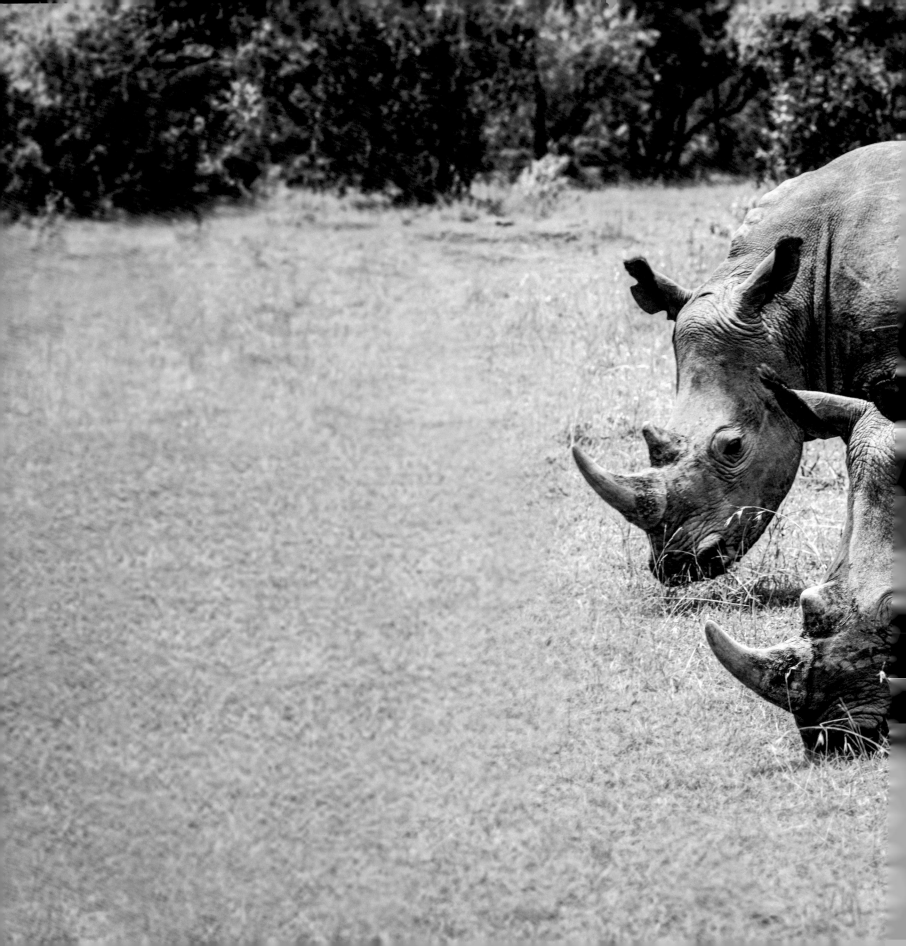

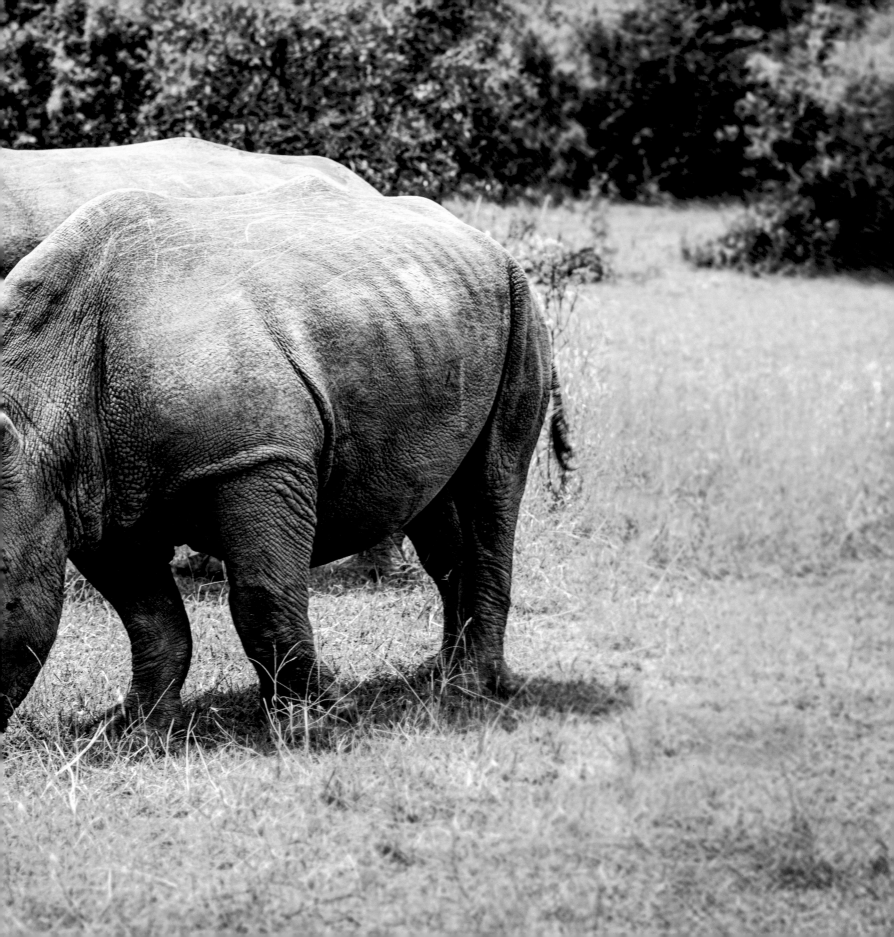

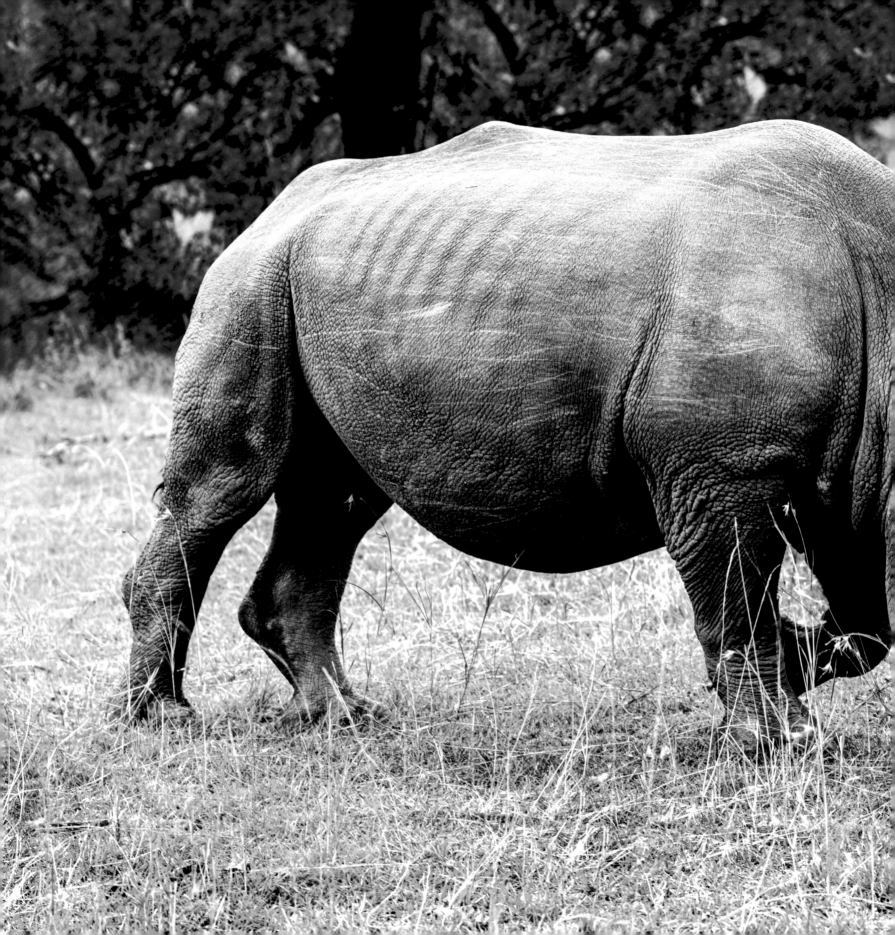

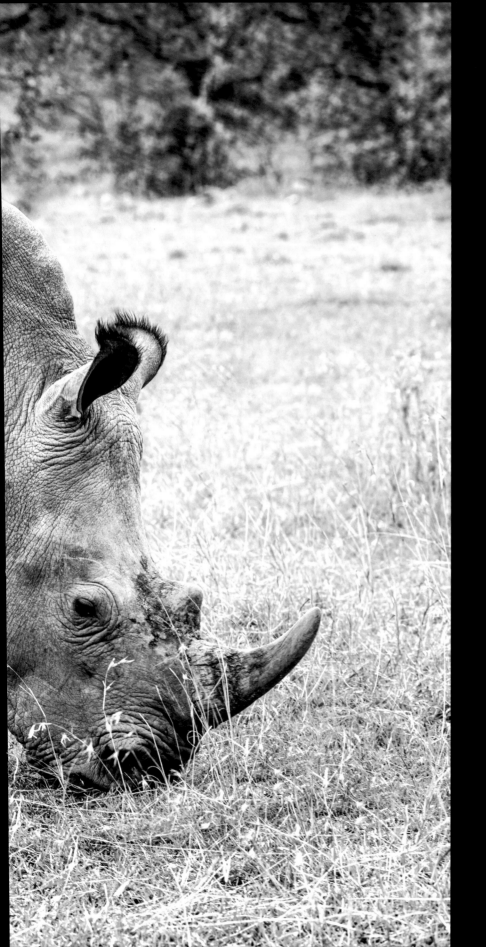

102-103

產於非洲的黑犀牛是非洲草原上的五大獸之一。成年的黑犀牛為獨居動物，只在交配期間會在一起生活。

Black rhinoceros, native to Africa, is one of the African Big Five. Adult black rhinos are generally solitary but can also be spotted in pair during estrous cycles.

104-105

黑犀牛實際上為灰色，名字的來源主要為了區別於白犀牛。兩者的主要分別在於體型，黑犀牛比白犀牛嬌小不少。

Black rhinoceros are actually in grey color. The name is only to differentiate them from the white rhinoceros, which are significantly larger than them.

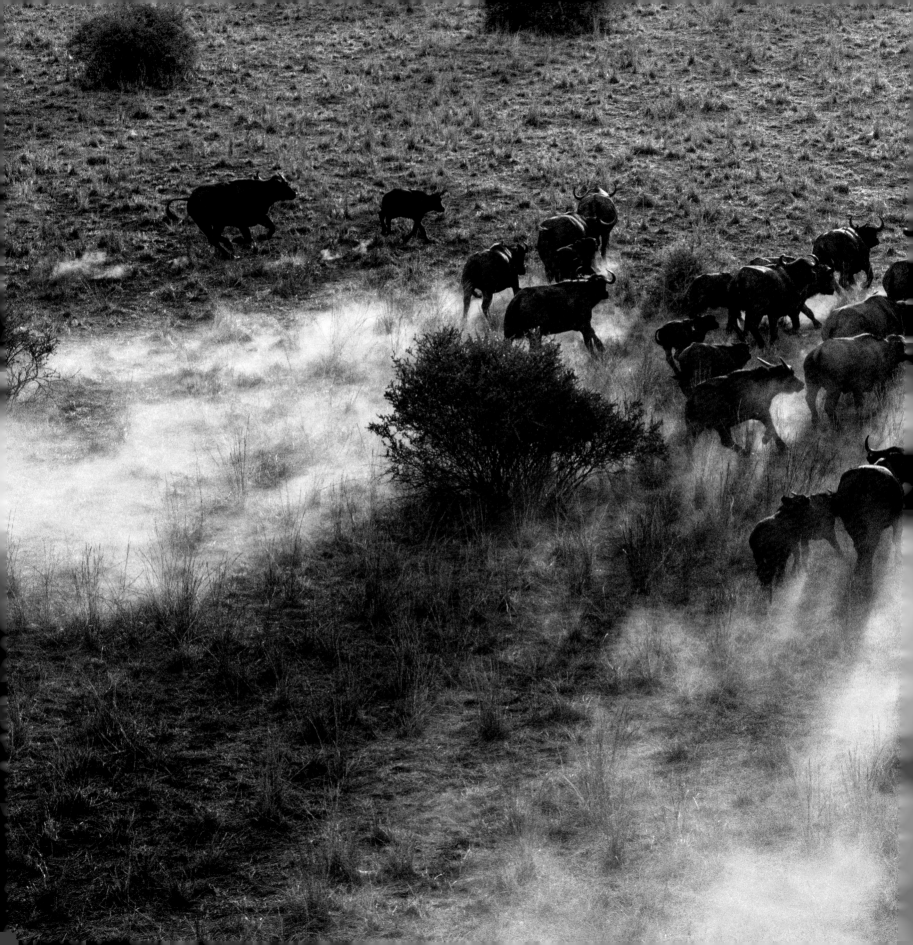

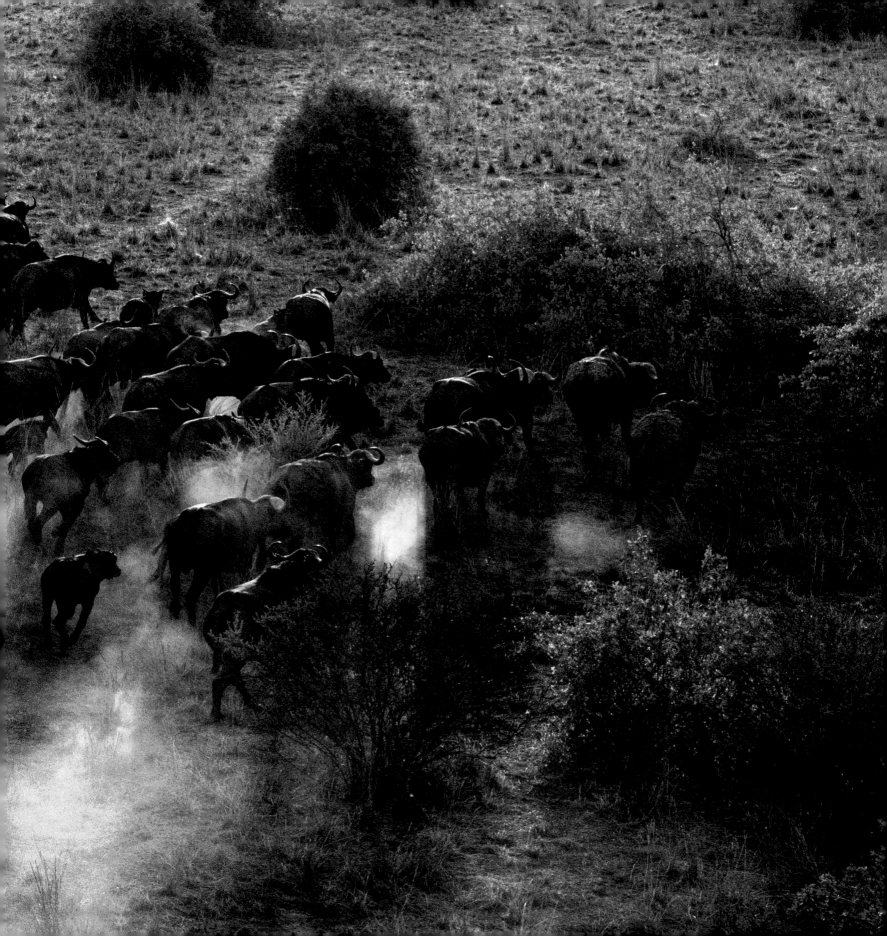

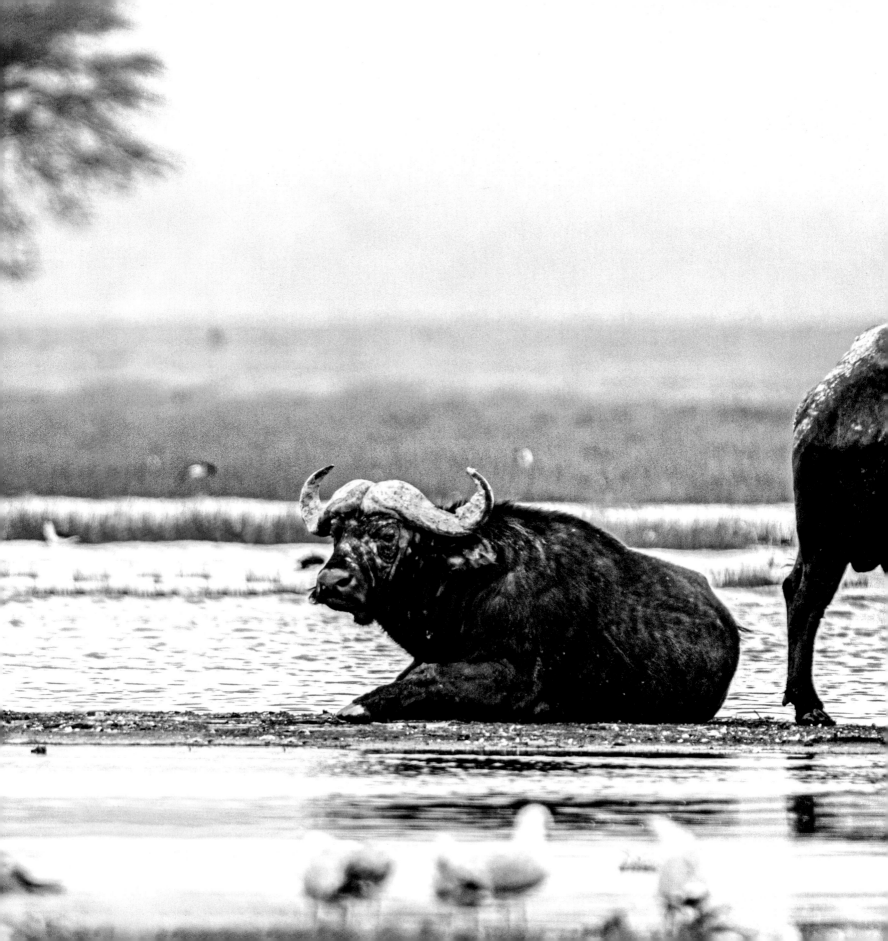

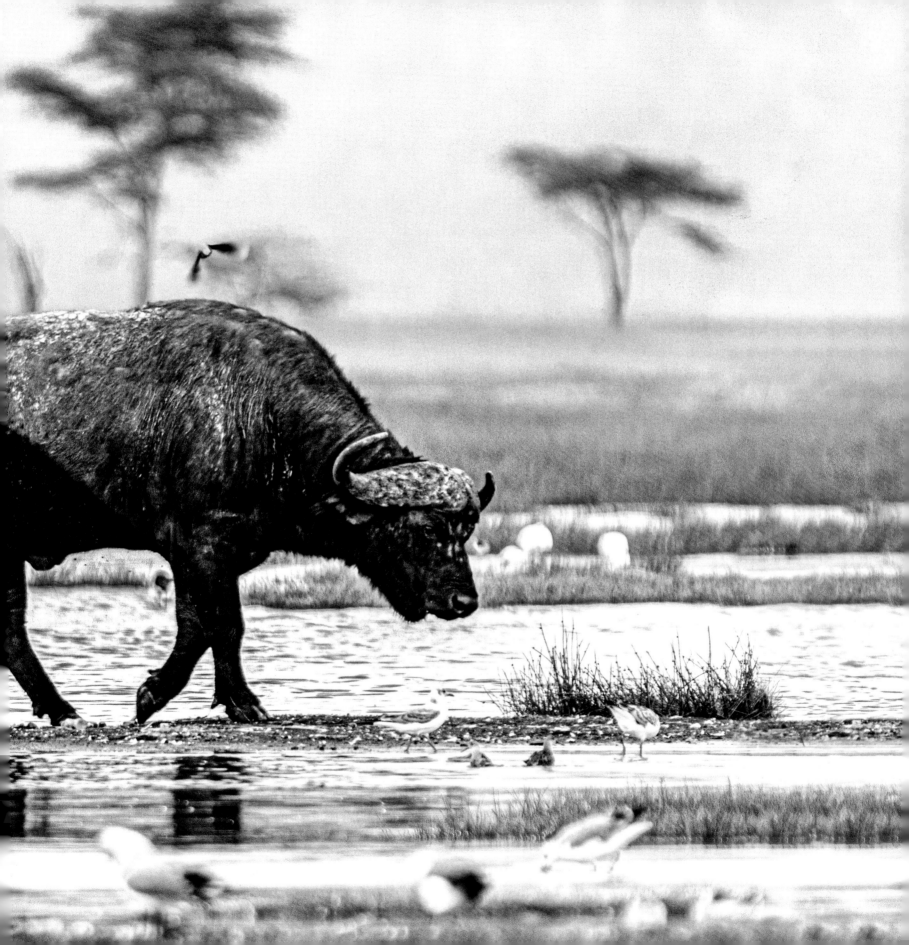

106-107

水牛群掀起的塵土被陽光照射成金色的霧氣。

The dust aroused by a herd of marching buffaloes has turned into golden color by the sunlight.

108-109

因酷愛飲水及以水調適體溫，總能在各種水源的附近找到水牛的蹤跡，圖中的兩隻正靜靜「顧影自憐」。

Buffaloes are easily found near water sources for they love drinking and bathing. This photo shows two of them pondering over their reflections.

110-111

閉目養神的水牛身上停著一隻小鳥，看起來完全不像非洲五大獸的一員。

A bird is resting on a napping buffalo, which does not look like a member of the Big Five at all.

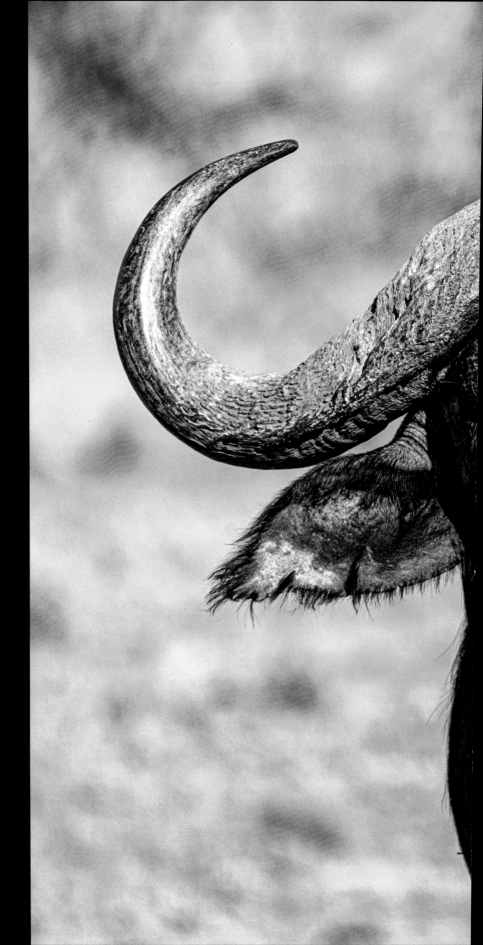

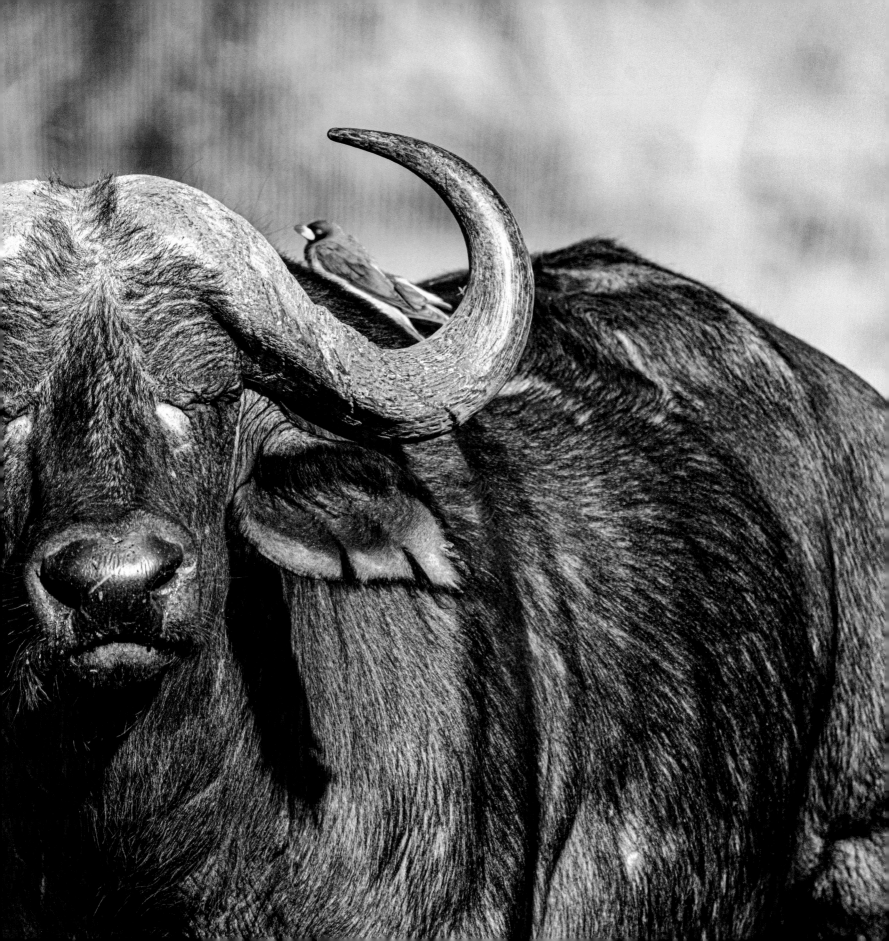

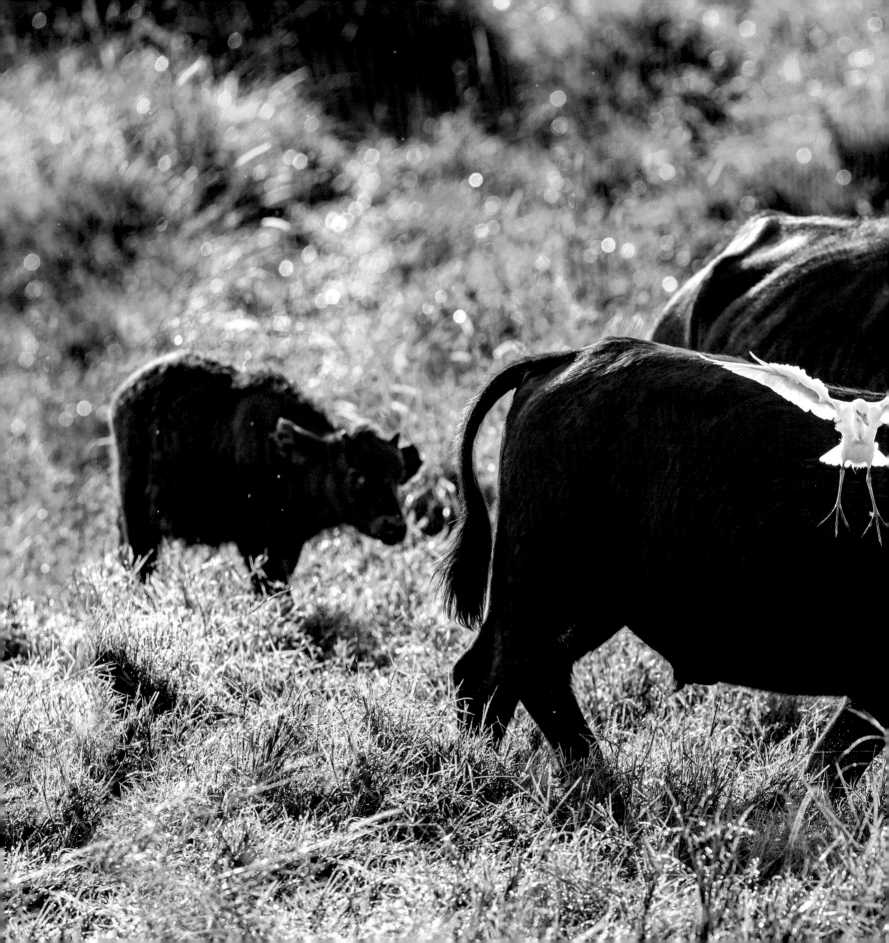

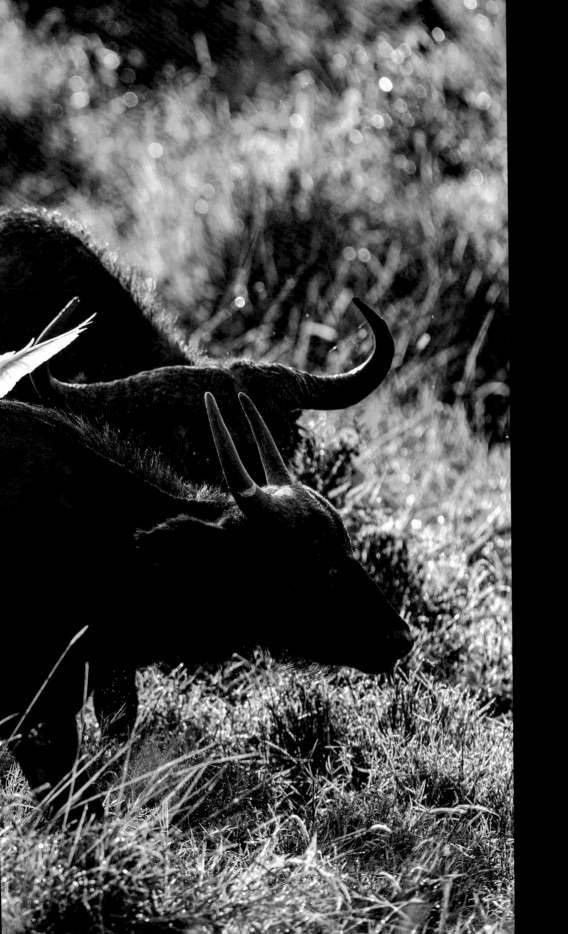

112-113

非洲水牛以群居為主，極少落單。一隻
小鳥正展翅從牠們身上掠過。

A bird is skimming over the buffaloes, a
social species that is rarely seen alone.

114-115

成年公牛互相對峙，可能是為了娛樂、
示威或貨真價實的搏鬥。若僅是玩耍，
牠們只會互相摩擦皮膚，不會造成實質
傷害。

Either it's for entertainment, prowess
manifestation or actual fight, adult
bulls are frequenters to sparring fields.
When sparring for fun, they only rub
the skins of each other without causing
substantive casualties.

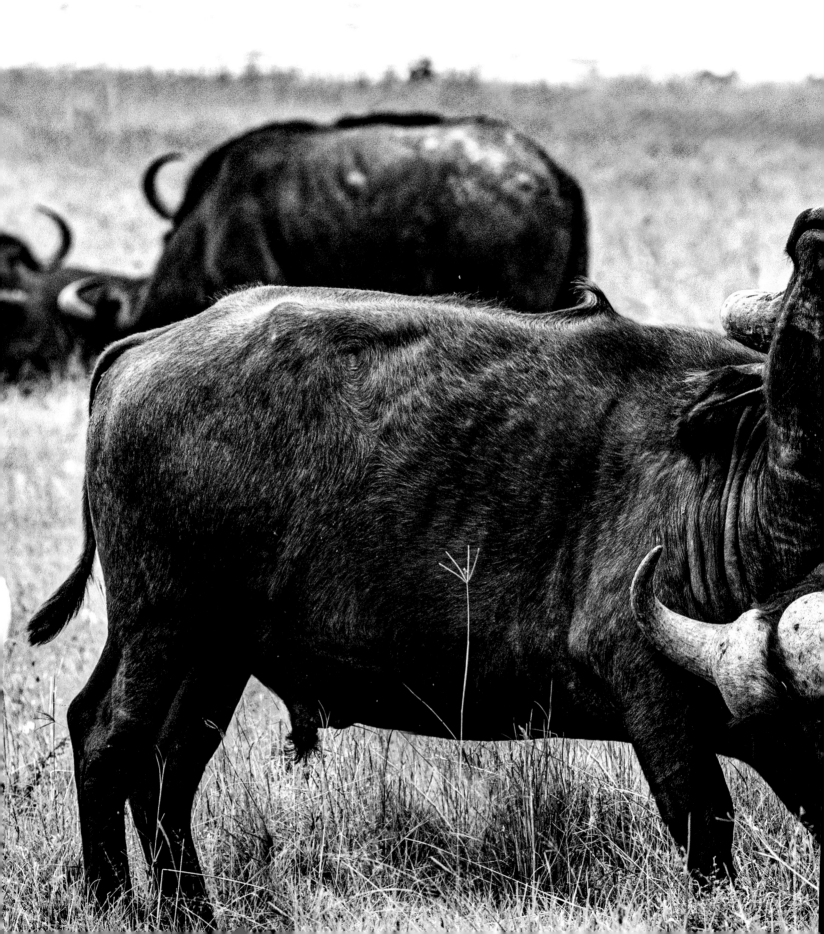

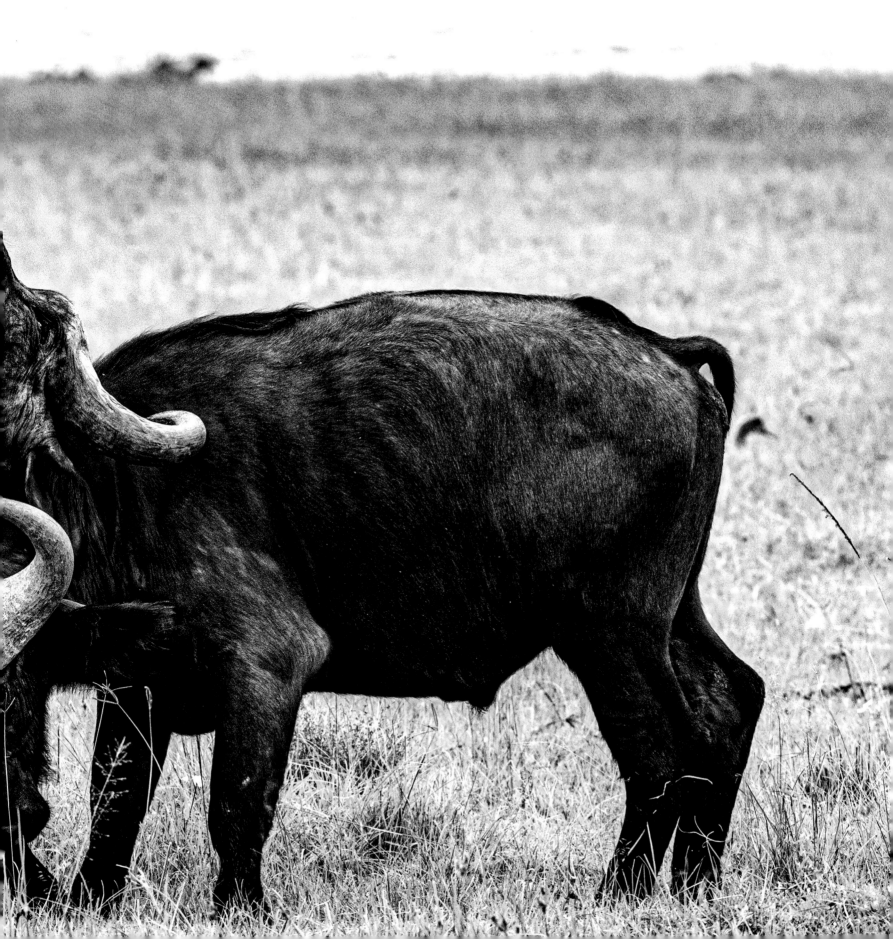

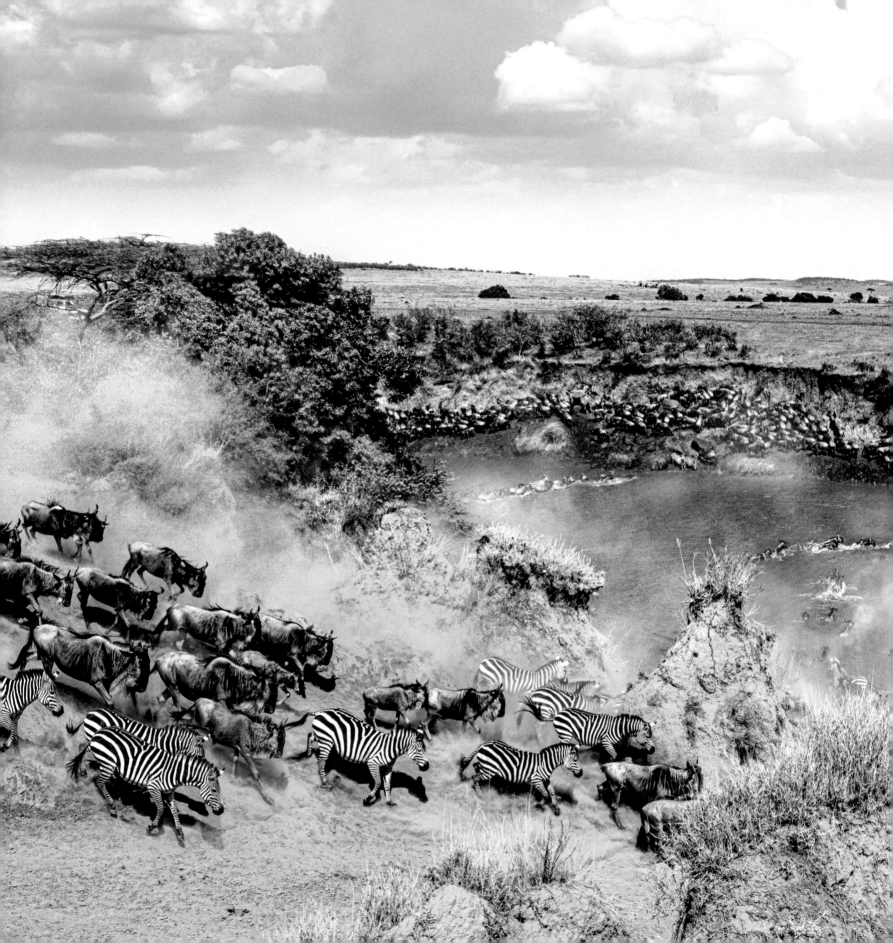

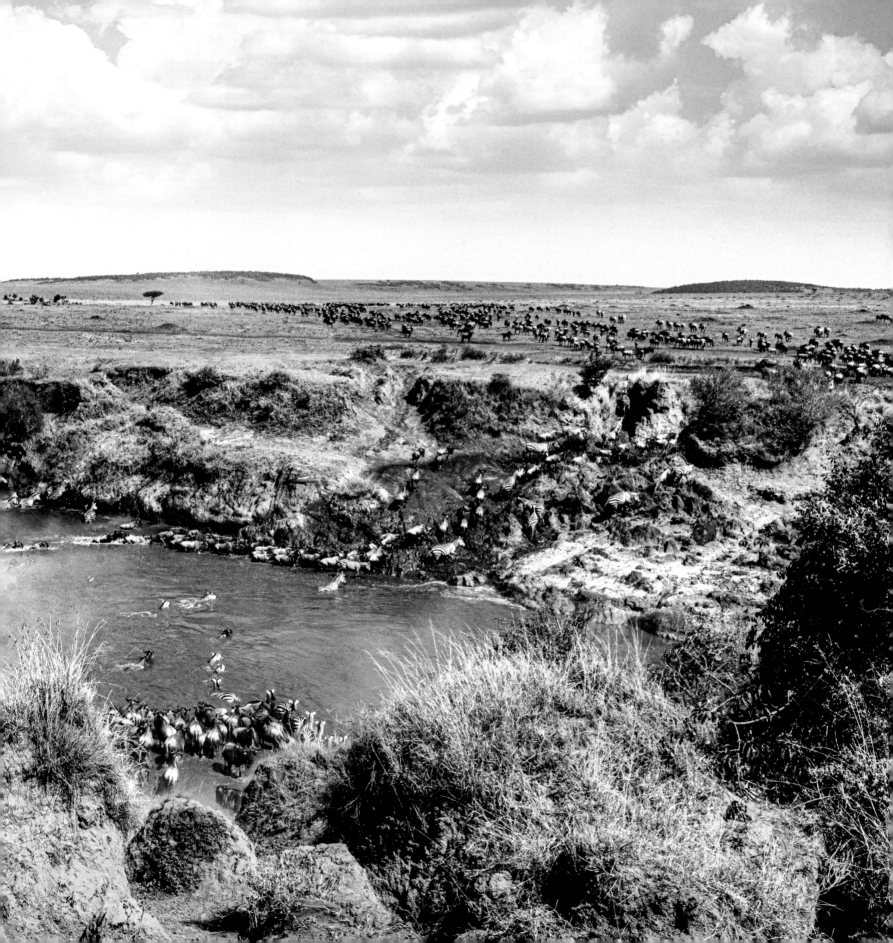

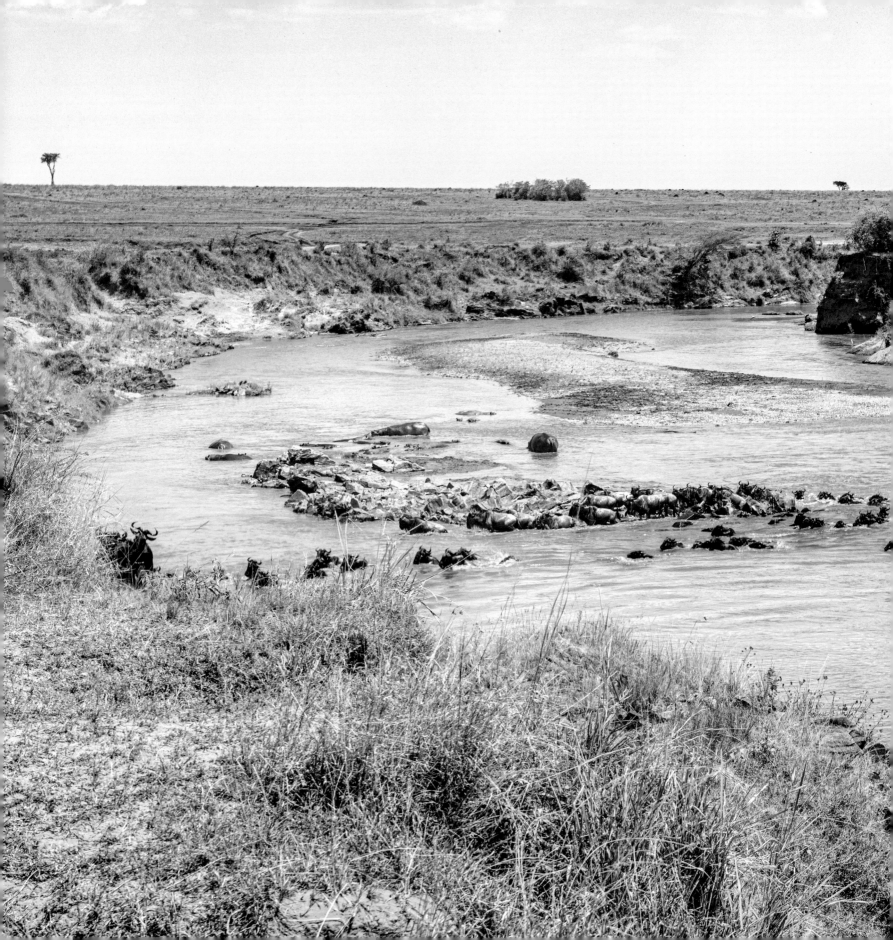

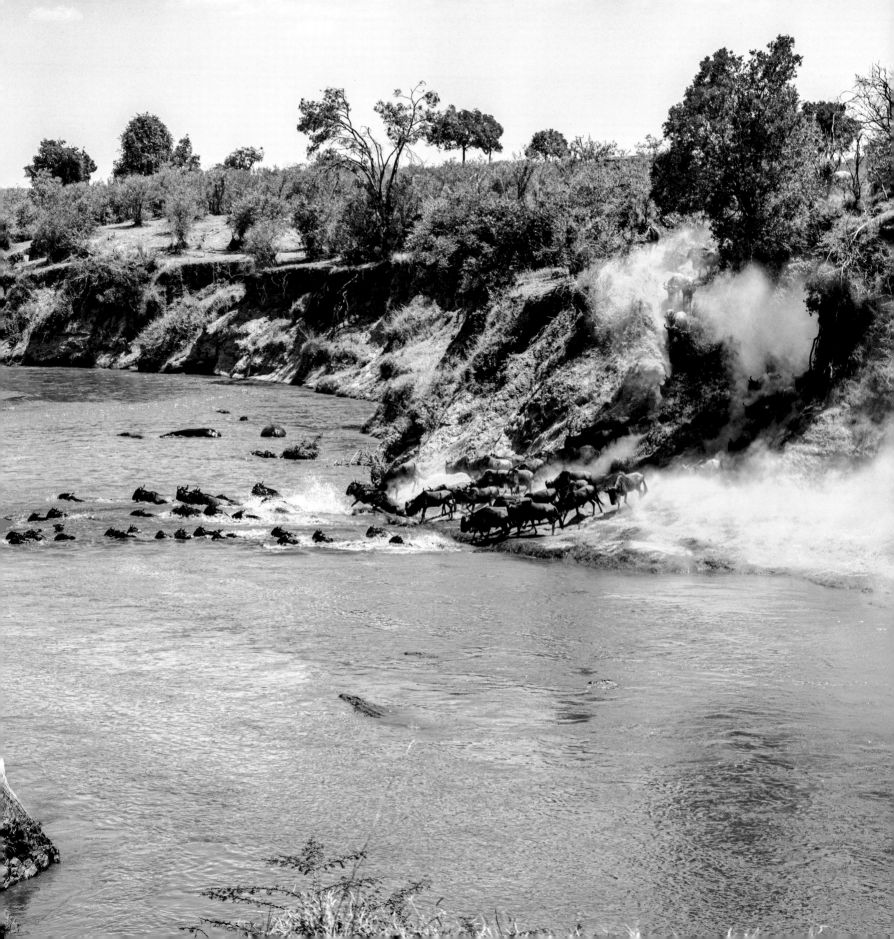

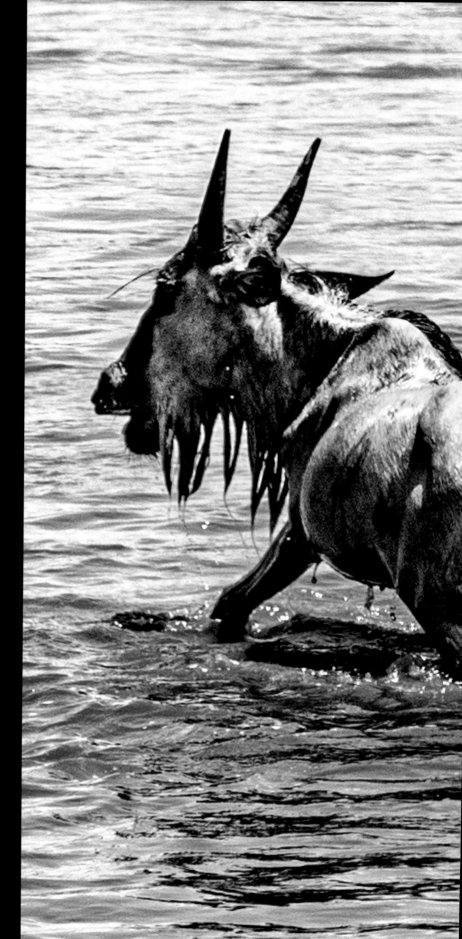

116-117

為了追逐最新鮮的水草，每年七至九月，數百萬頭角馬、斑馬和其他各種羚羊，都會共同上演一齣浩浩蕩蕩的大遷徙，渡過馬拉河，從塞倫蓋提到達馬賽馬拉。

In pursuit of a lush pasture, from July to September every year, millions of wildebeests, zebras and many other antelopes will put on a blockbuster of great migration, crossing the Mara River from Serengeti to Maasai Mara.

118-119

渡河的過程危機四伏，除了要警惕靜靜潛伏隨時出擊的鱷魚，若打擾到河馬的休息，看似溫順的牠們亦絕不會手下留情。

Surrounded by different perils, the migrating contingent has to be alert to the crocodiles, who are always waiting for their best chance to ambush, as well as the hippos who appear to be tame but show no mercy when bothered during their rest hours.

120-121

尼羅鱷是非洲最大的爬行動物，一次咬合就能夠產生每平方吋 5,000 磅的壓力，讓獵物「難逃虎口」。

Nile crocodiles are the largest reptiles in Africa. With a bite force as high as 5,000 pounds per square inch, they barely let go anything that slip through their mouths.

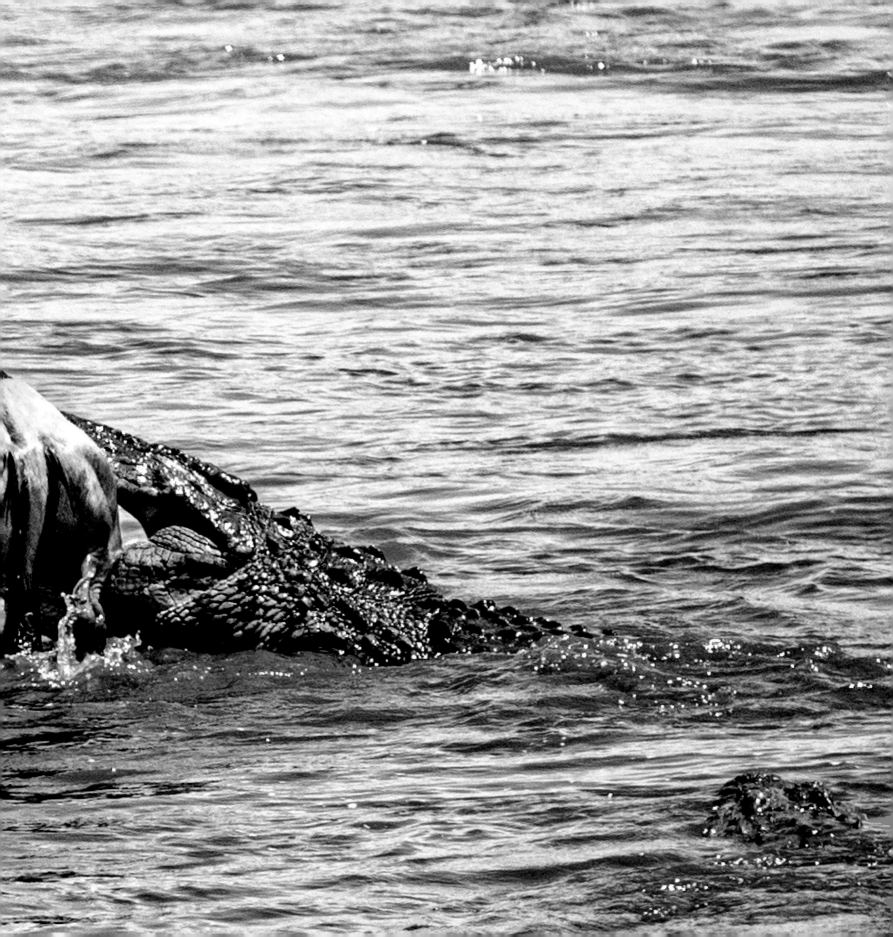

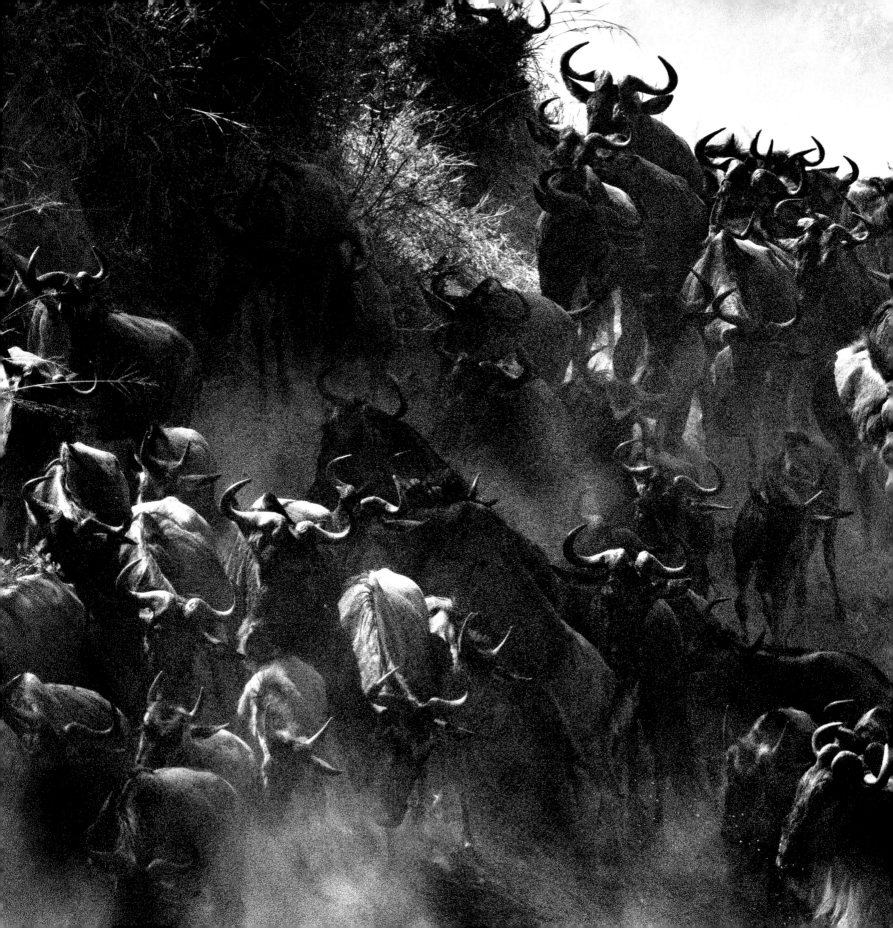

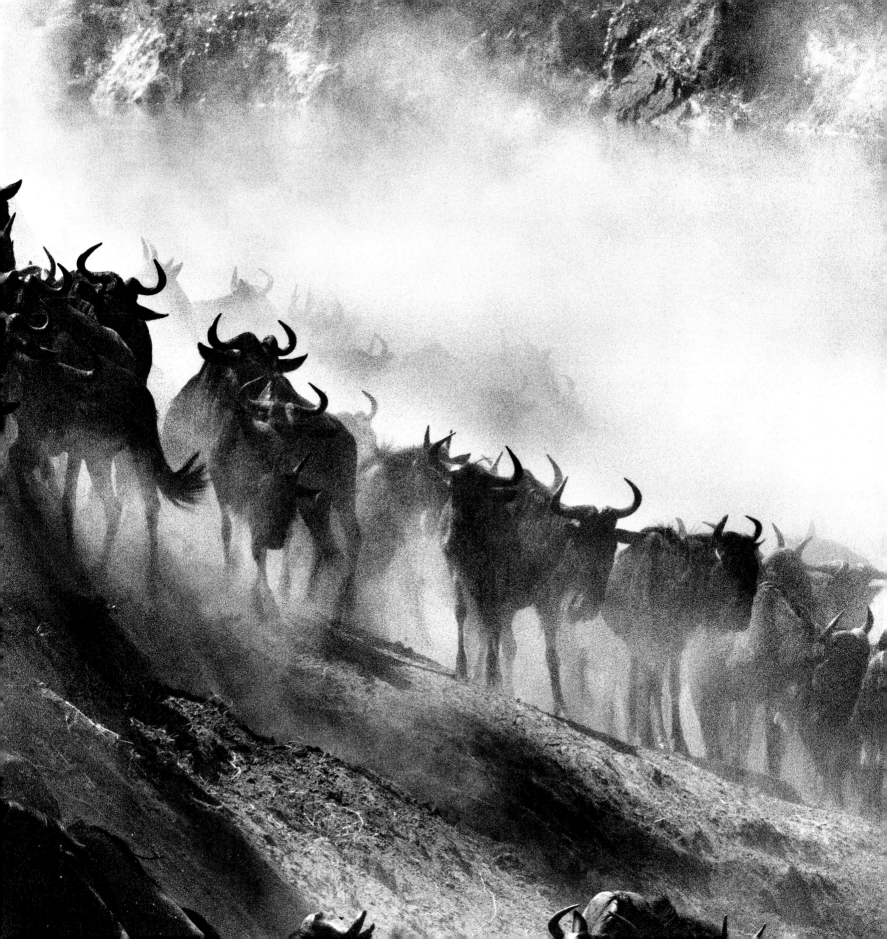

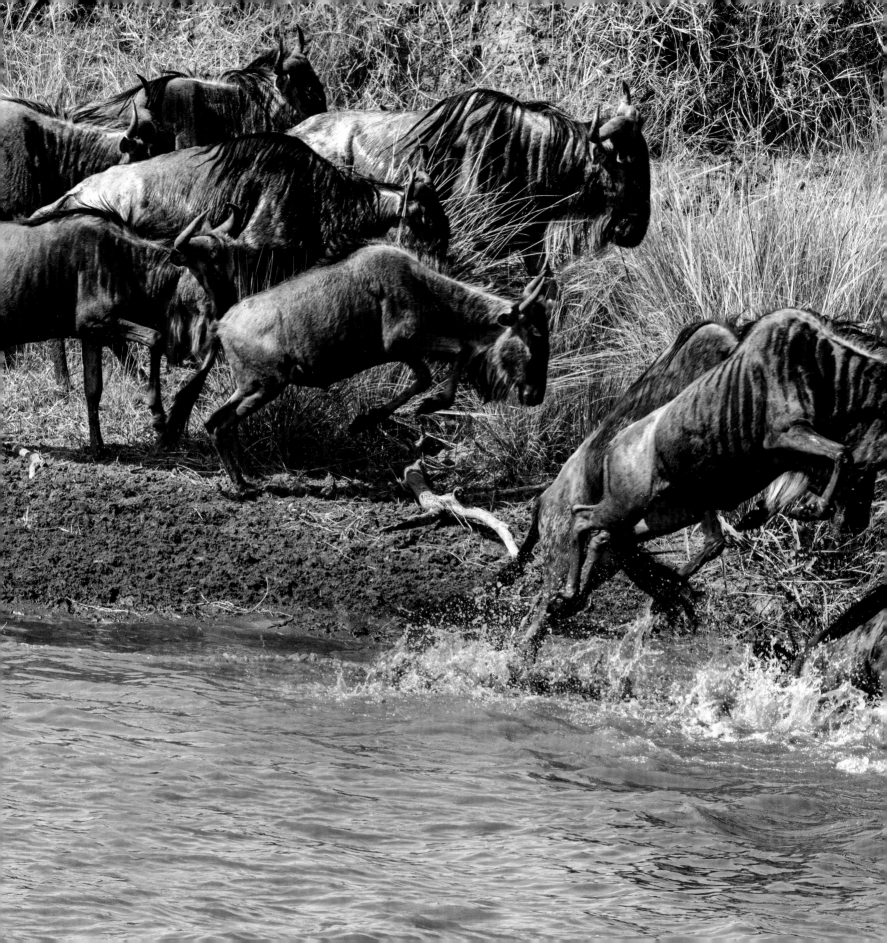

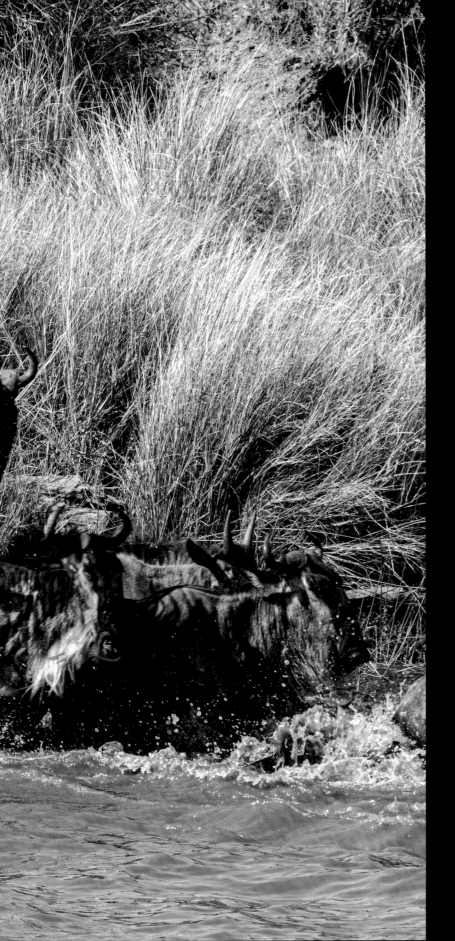

122-123

角馬作為大遷徙的主力軍，每年遷徙的種群約有 150 萬頭，氣勢磅礴。

As the protagonists of the great migration, a total of about 1.5 million wildebeests, as a whole, create a great momentum wherever they go.

124-125

在首領找到最合適的渡河點並縱身跳下後，角馬排列成直線一個接著一個鳧水渡河。

After the leader found the perfect spot and jumped into the river, the wildebeests cross the river one after another in a queue.

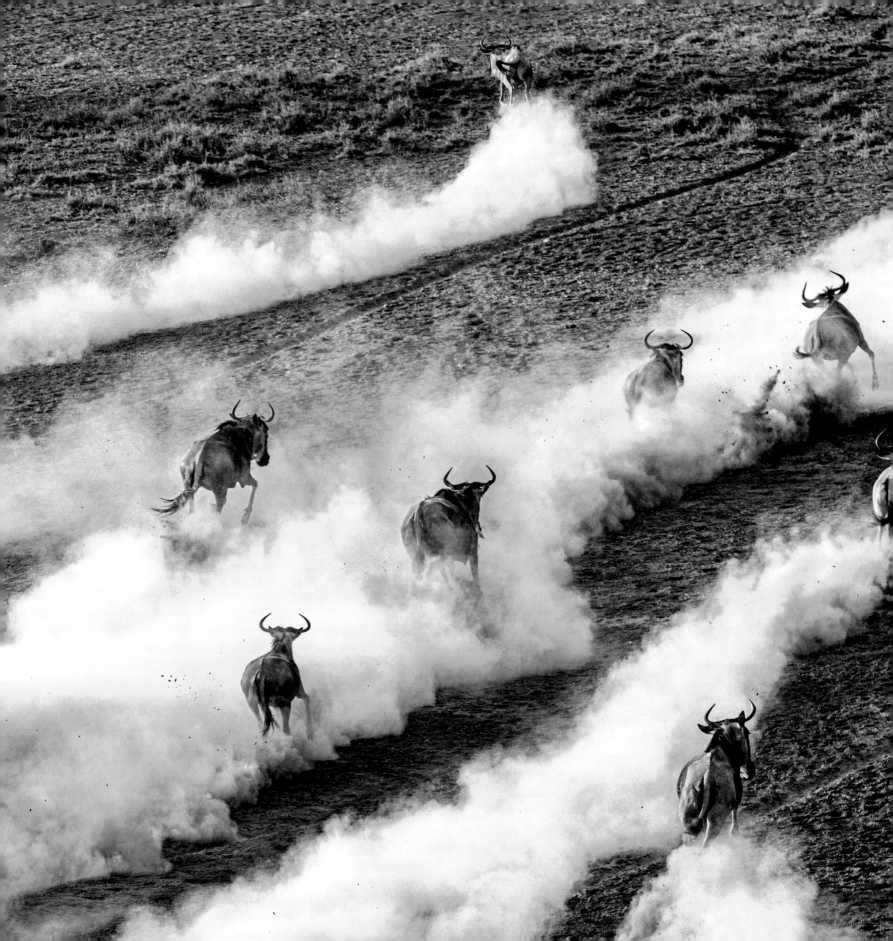

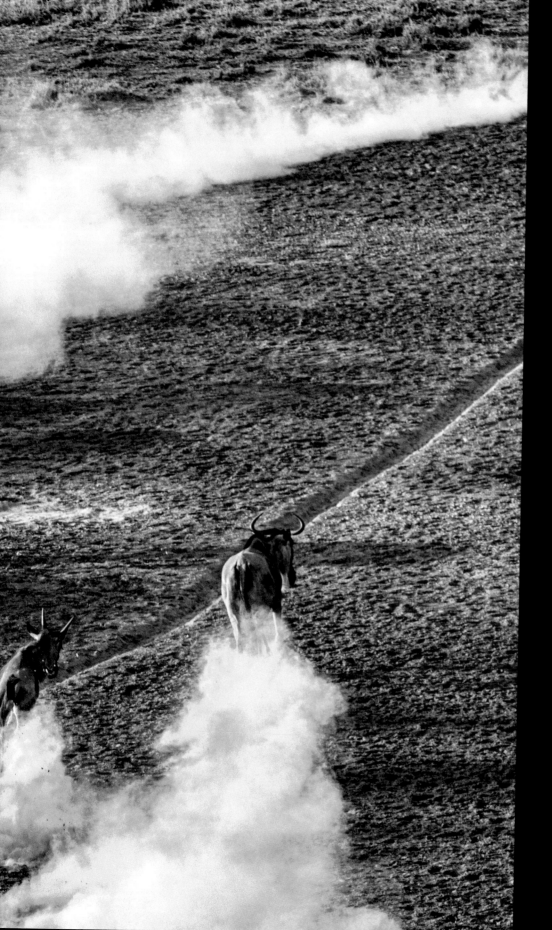

126-127

熱帶草原上的角馬以黑尾斑紋角馬為主，隨處可見。牠們的奔跑速度極快，可達每小時80公里，超過了大部分掠食動物。

Wildebeests on tropical savannas are mainly black-tailed ones with vertical stripes, which can be spotted almost everywhere. They can run at speeds of up to 80 kilometers per hour, exceeding that of most predators.

128-129

角馬與斑馬是大遷徙路上的好同伴，雖然斑馬只佔遷徙大軍總數的很少一部分，但獨特的花紋讓牠們十分矚目。

Wildebeests and zebras are good fellows along the journey of the great migration. Although taking up only a small amount in the movement, zebras stand out from the crowd by wearing unique patterns.

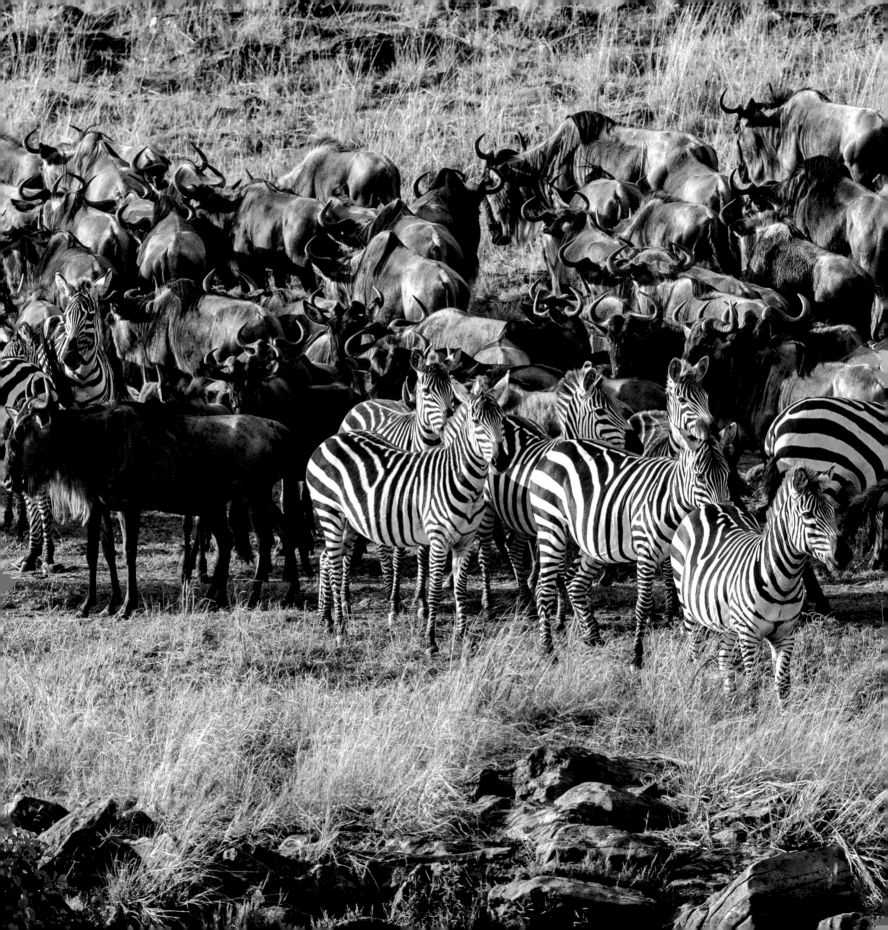

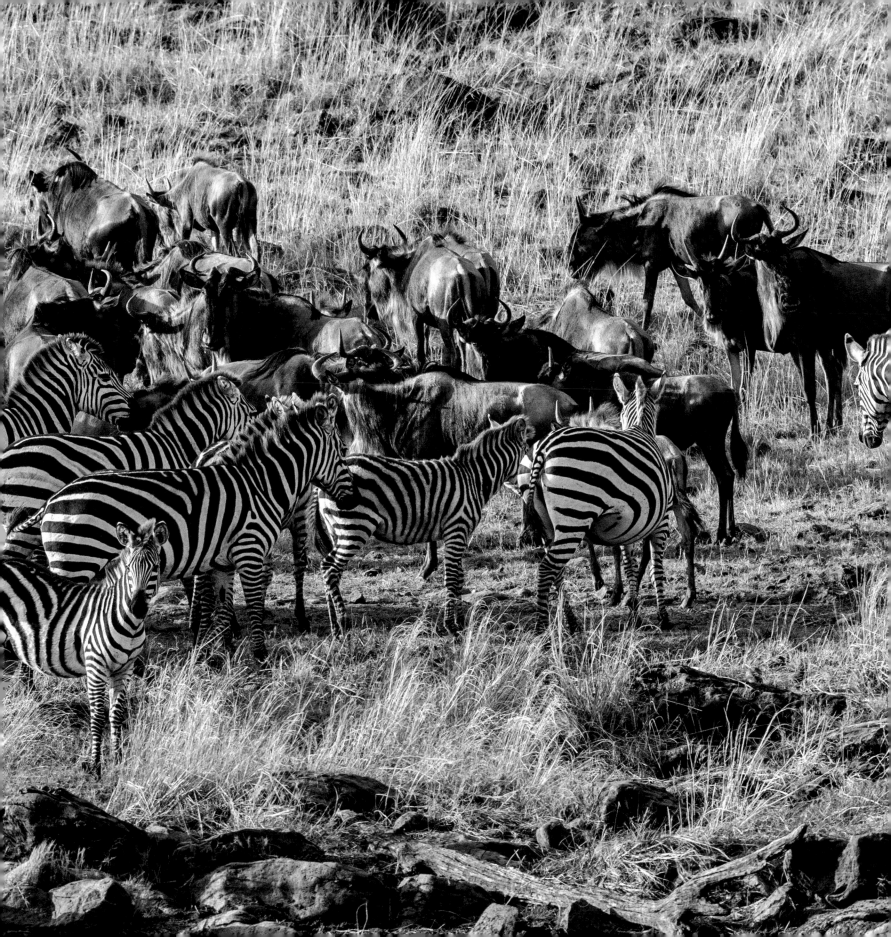

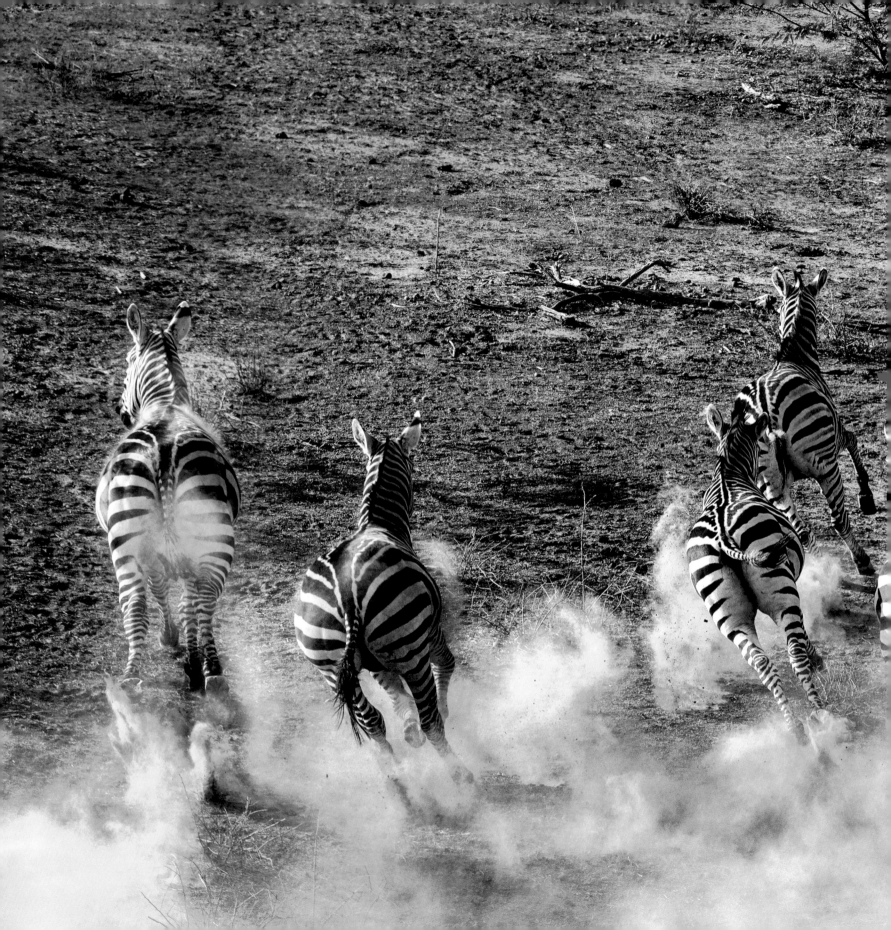

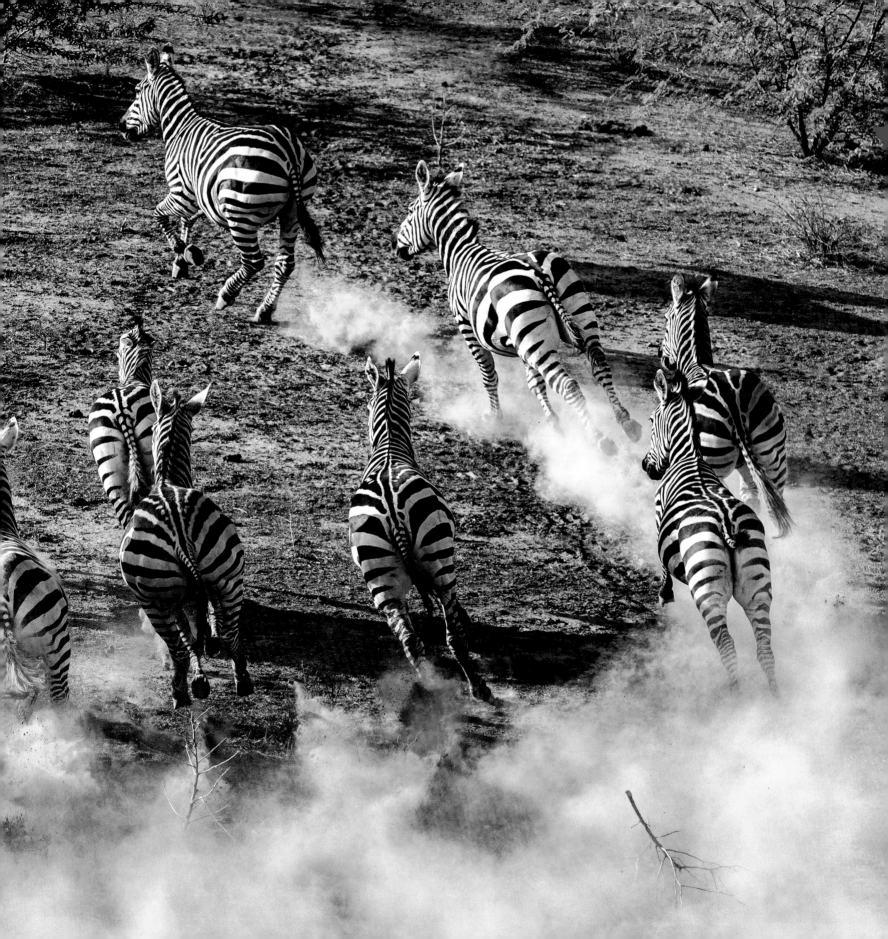

130-131

平原斑馬是東非大草原上分佈最廣泛的亞種，高度社群性的斑馬通常成群出現。在遭受攻擊時會圍成半圓形並把未成年幼崽置於圈內加以保護。

The plains zebras are the most common zebras on the savanna of East Africa. This highly social species usually appears in groups. Being under attack, adult zebras would form a semi-circle and place the underaged in it for protection.

132-133

斑馬群被牠們自己所帶起的煙塵所包圍。

This group of zebras is circled by the dust pulled up by themselves.

134-135

暖陽餘暉中互相推搡玩耍的斑馬。

Several zebras are playing and huddling together in the warm and orangey light during sunset.

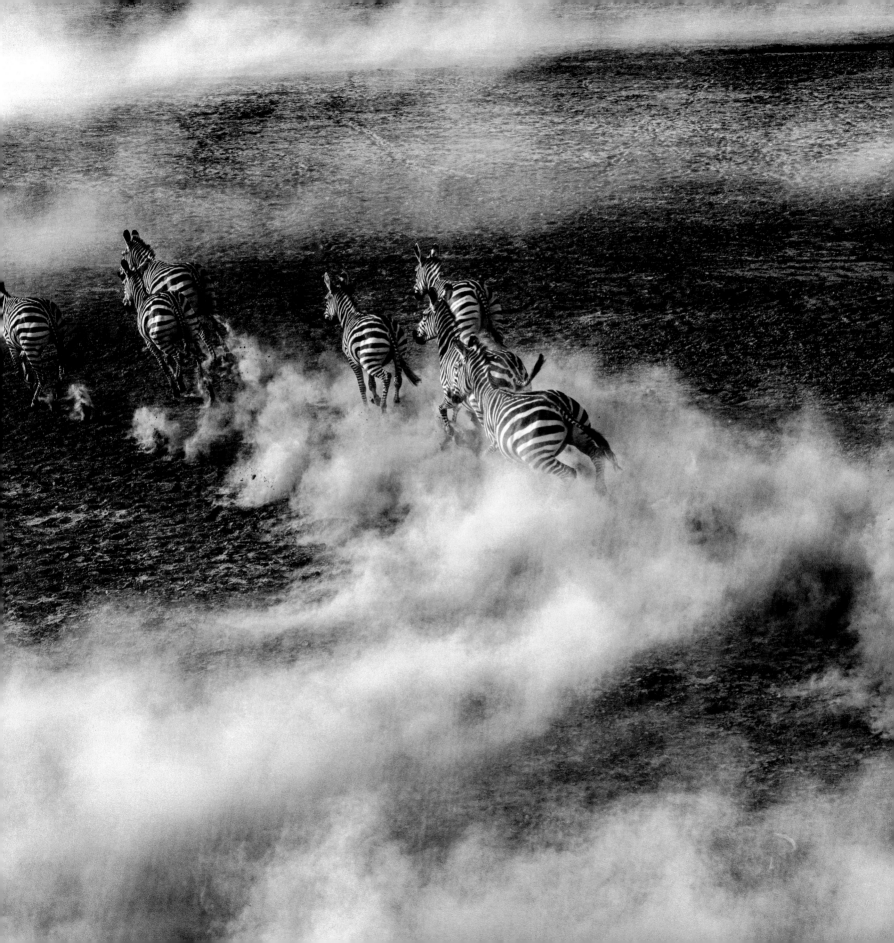

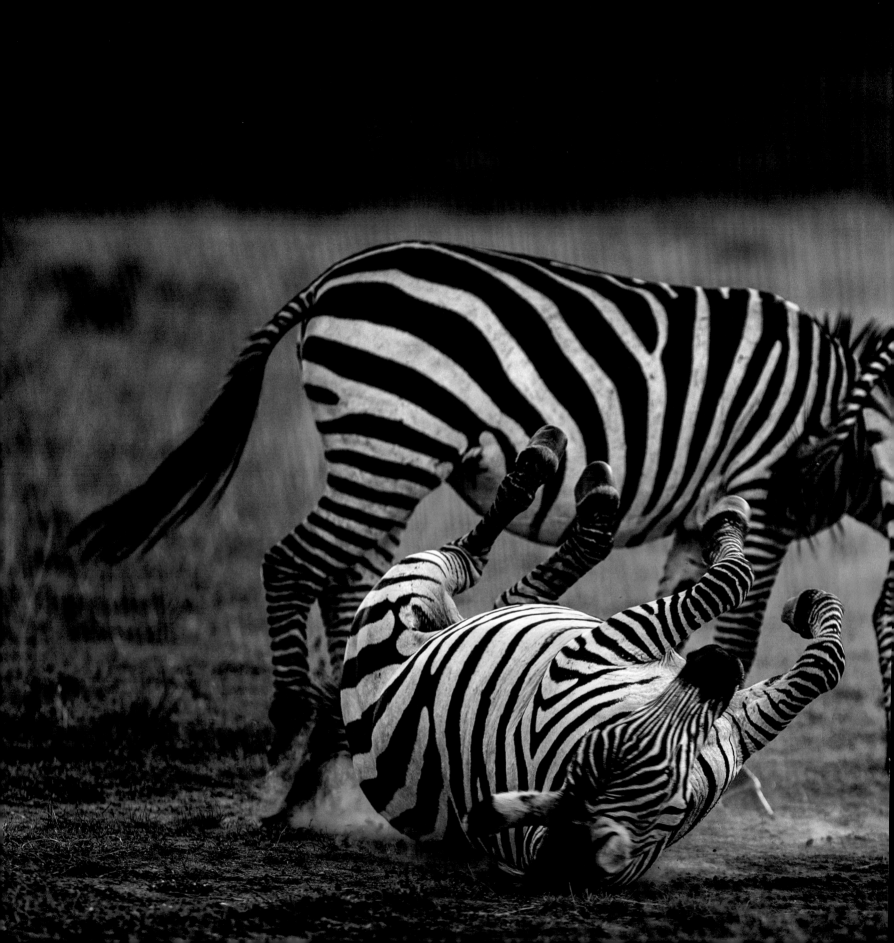

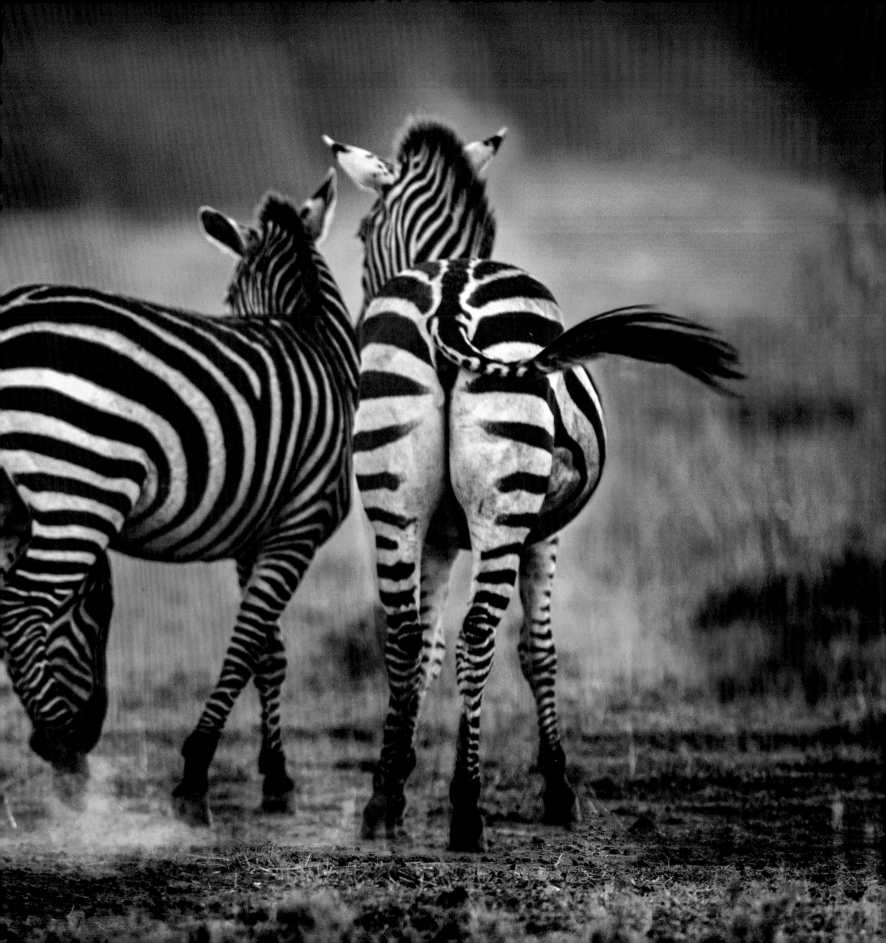

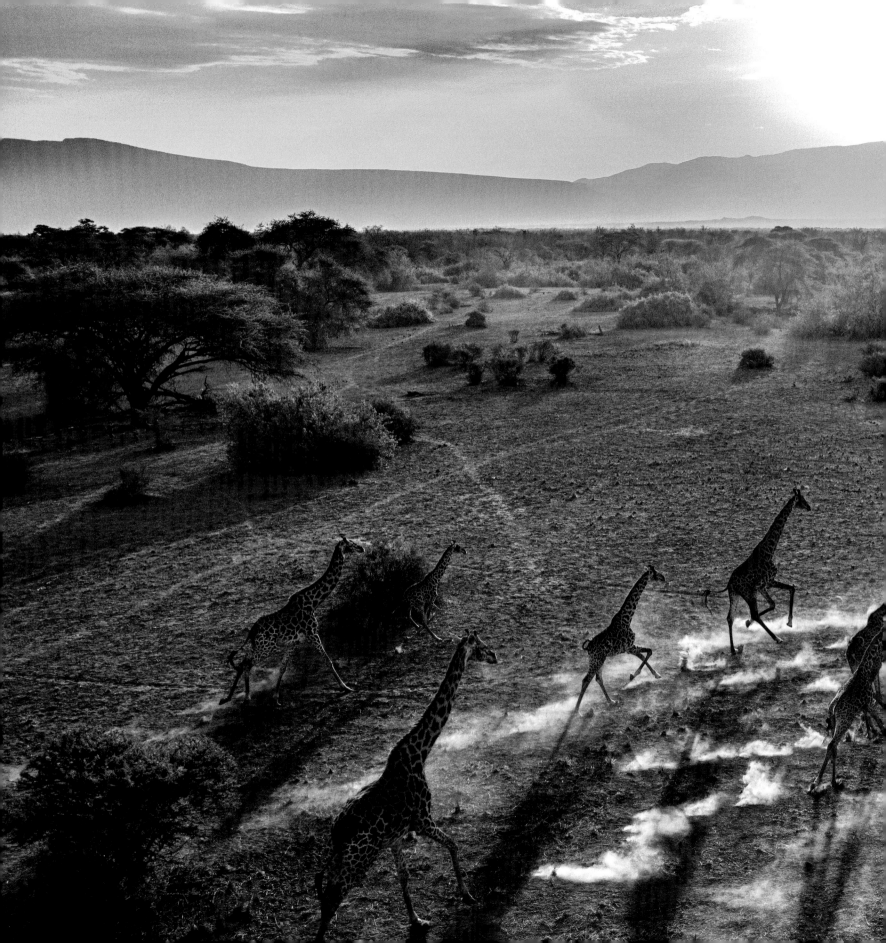

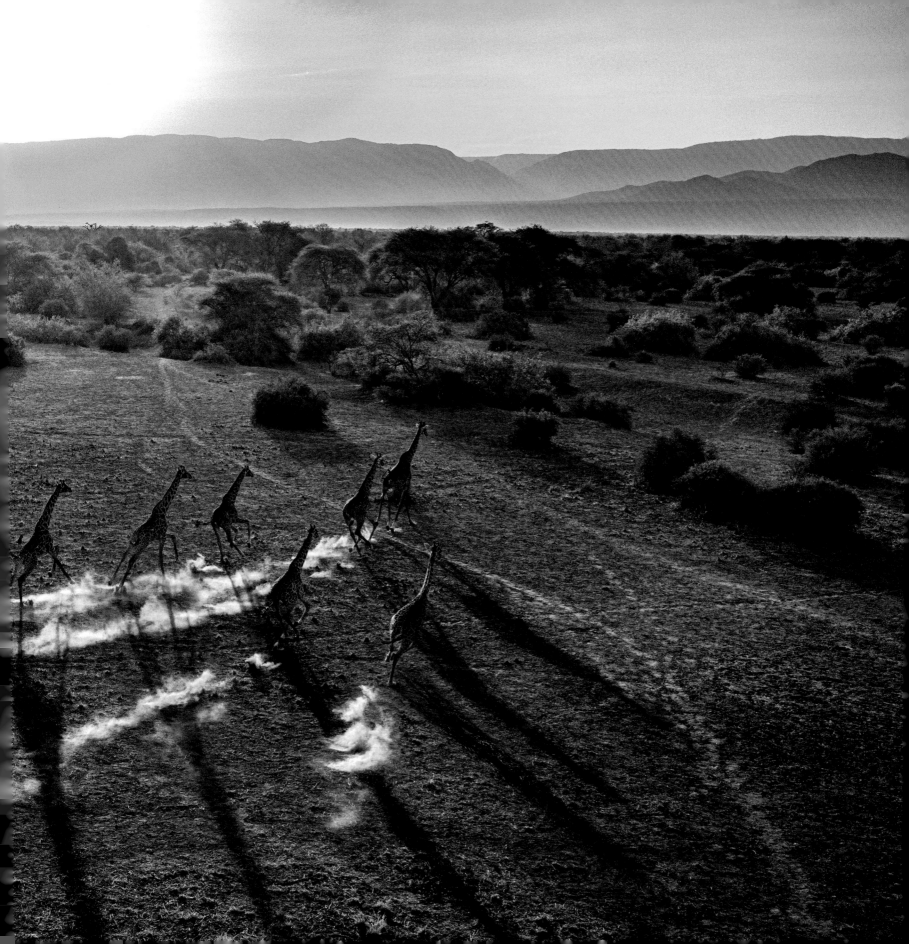

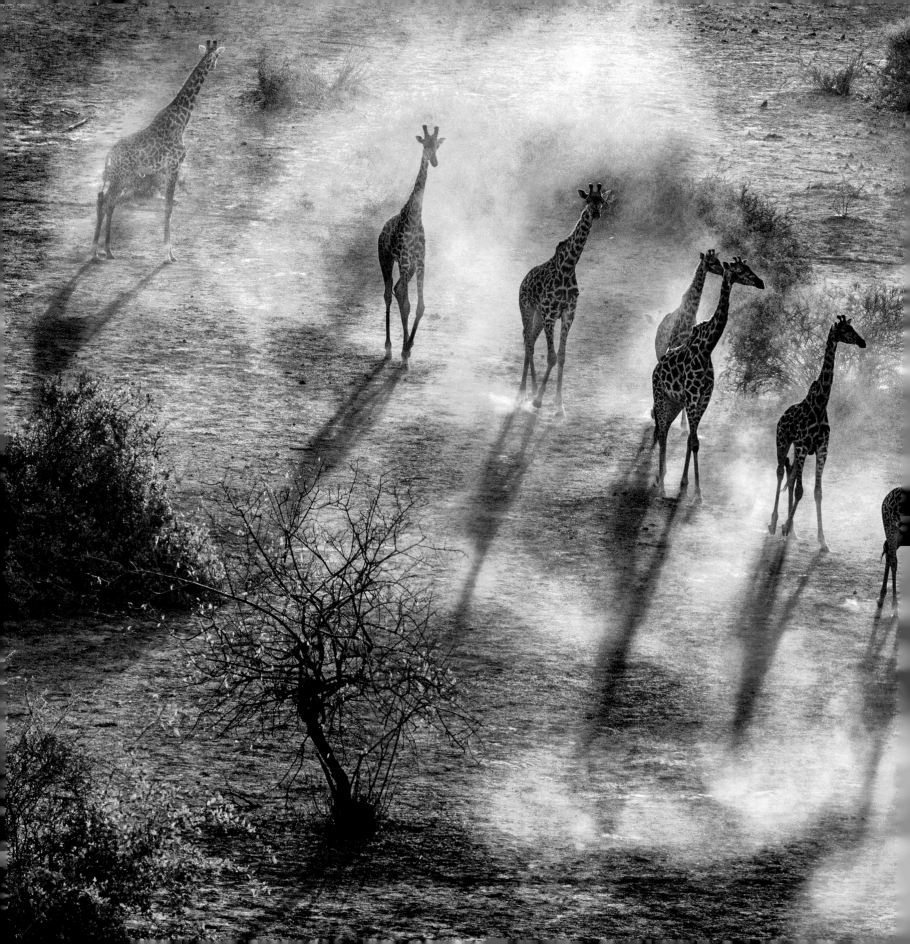

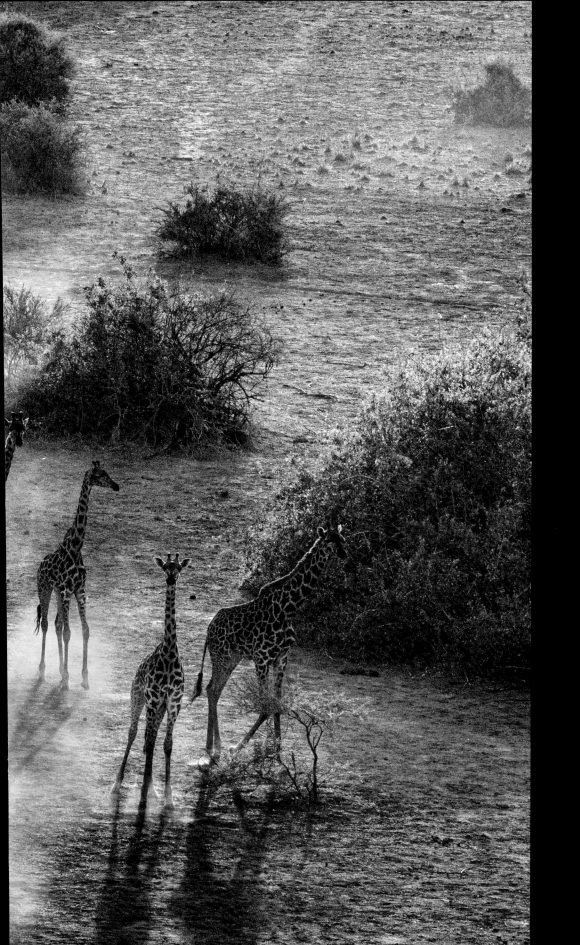

136-137

從飛揚的塵土可以看出，長頸鹿的腿力驚人，甚至可以一腳終結一頭獅子。

We can probably tell from the flying dirt that giraffes have such strong legs that a kick from them can kill even a lion.

138-139

十隻望向不同方向的馬賽長頸鹿在煙塵中彷彿是步入迷霧森林而迷路的旅人。

Ten Maasai giraffes facing different directions in the dust look like lost travelers in a misty forest.

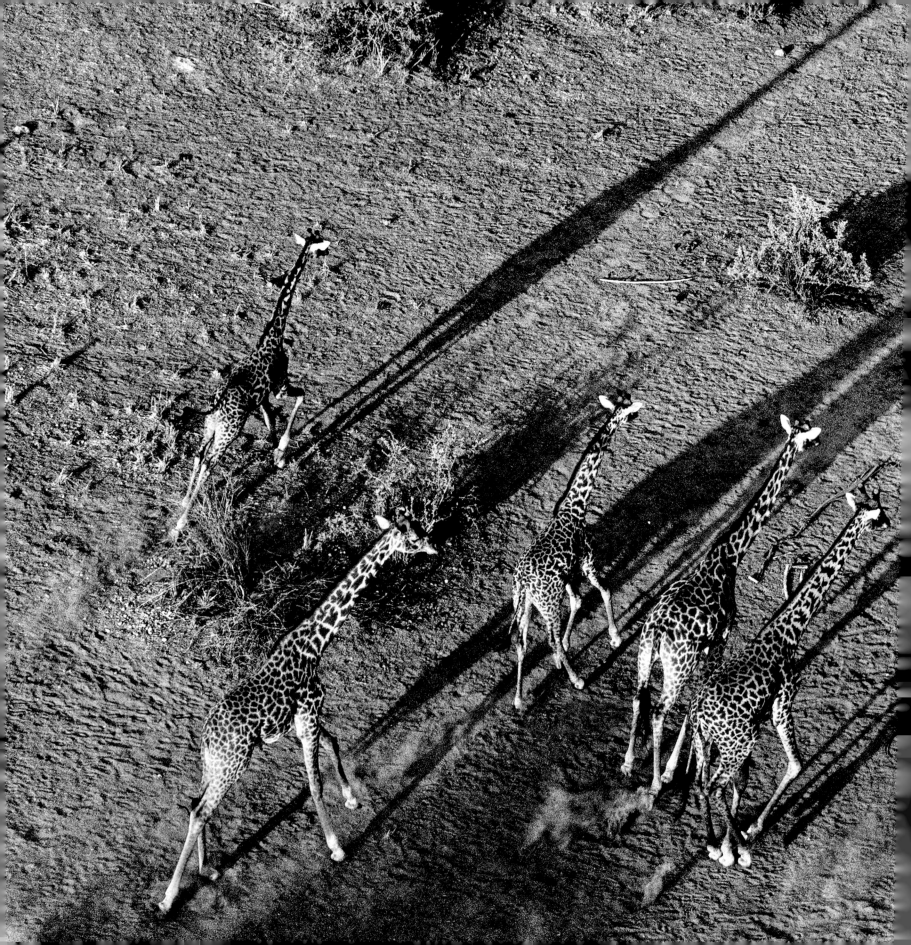

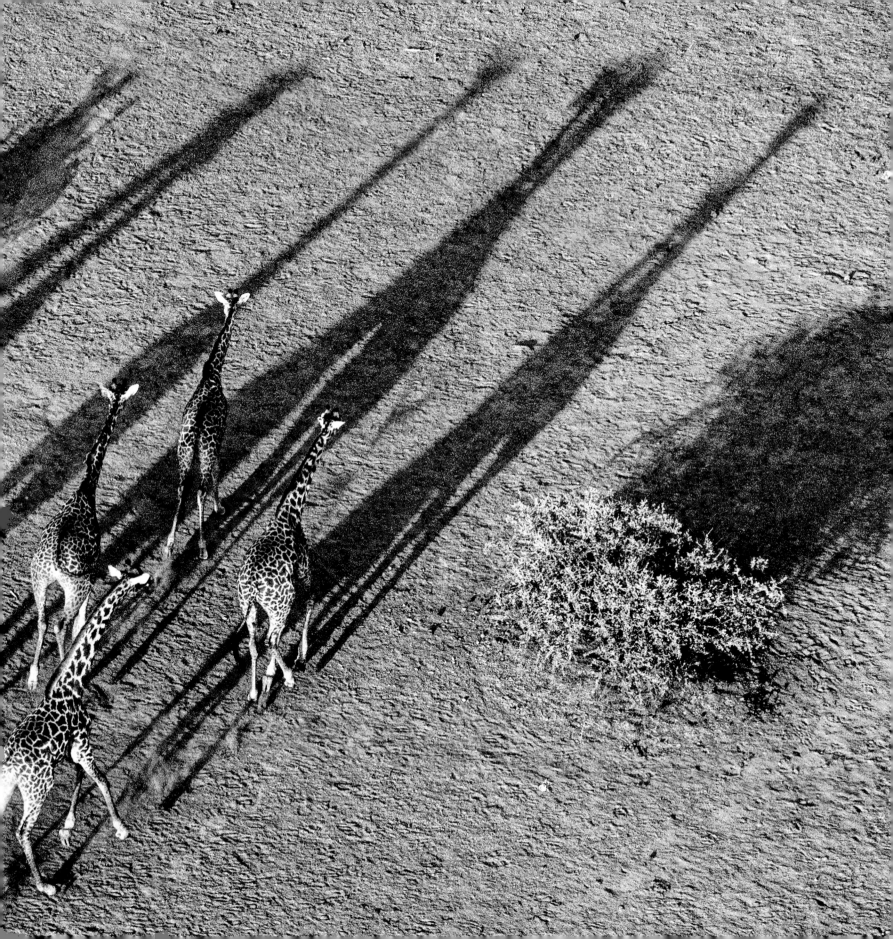

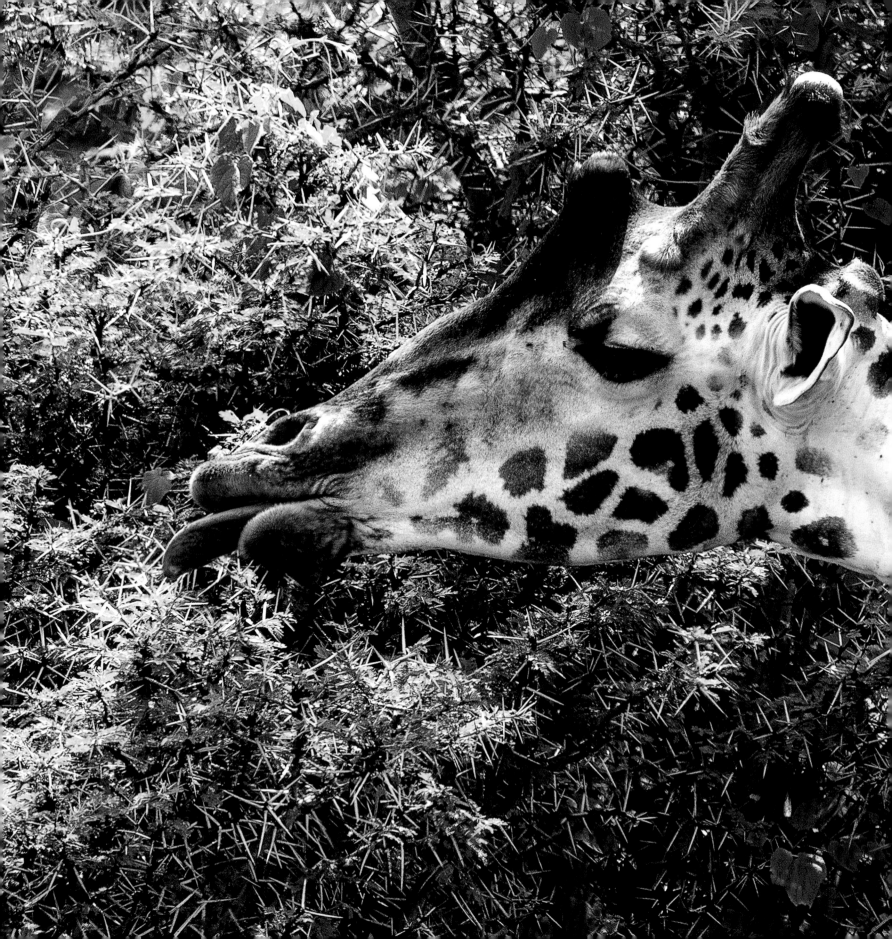

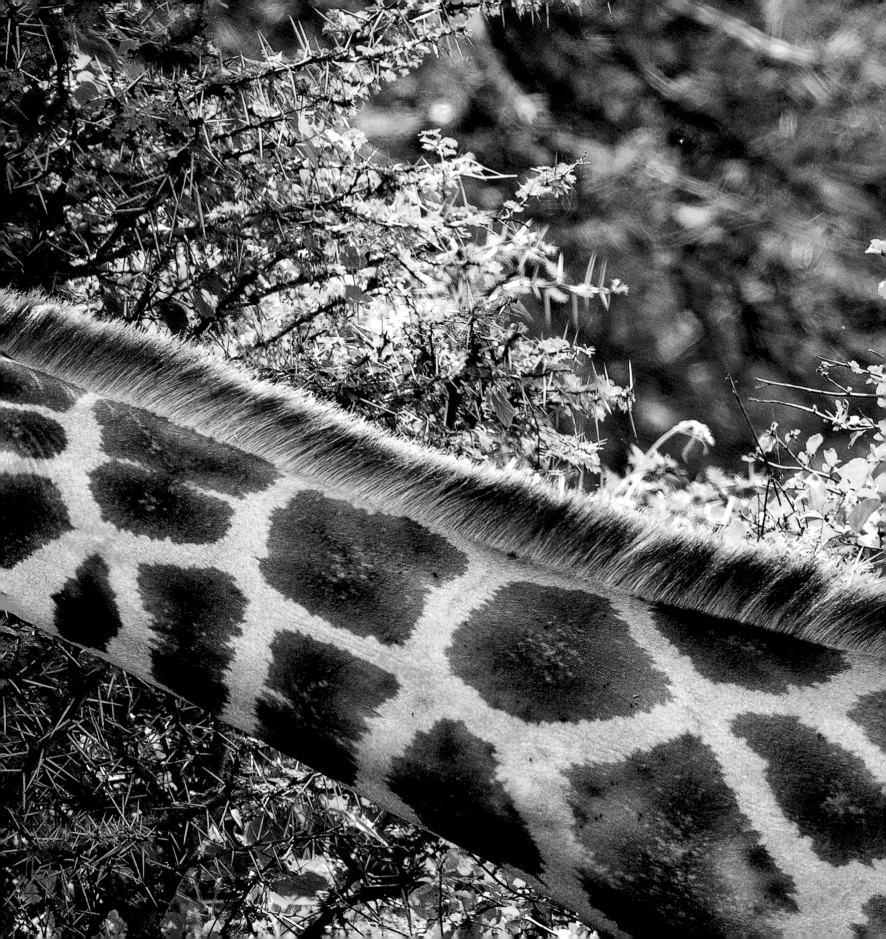

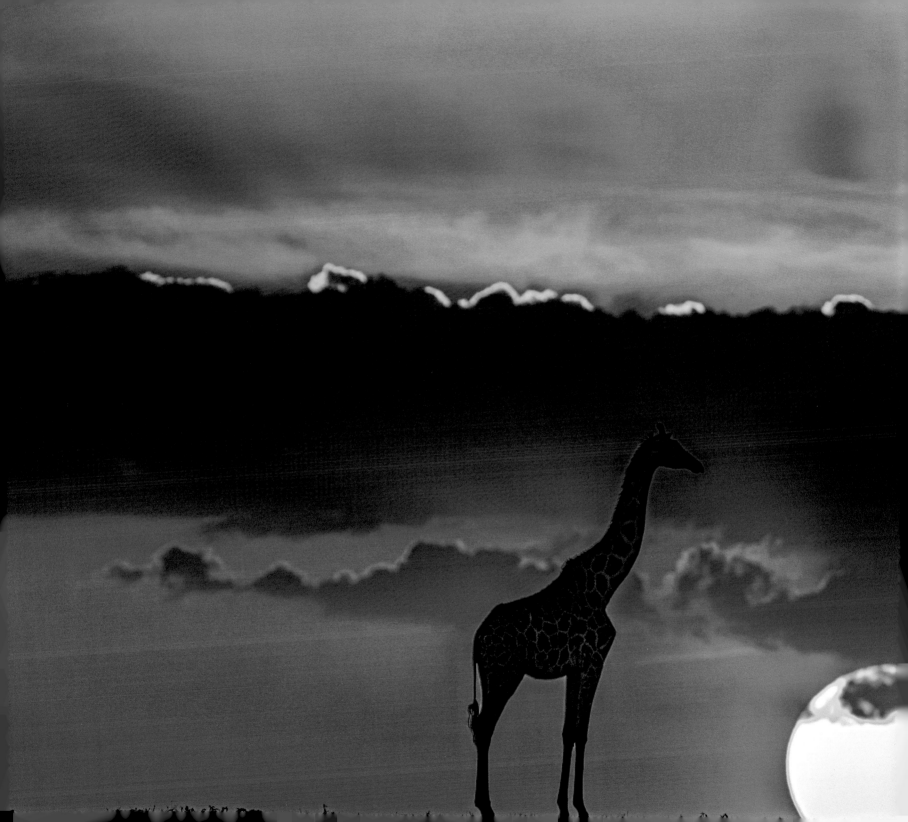

140-141

馬賽長頸鹿是體型最大的亞種，主要生活在坦桑尼亞及肯亞南部。皮毛的顏色較深，斑紋分佈不規律。

The Maasai giraffe is the largest subspecies of its kind which mainly inhabits in Tanzania and southern part of Kenya. They have darker skins and irregularly-shaped jagged spots.

142-143

長頸鹿最喜食金合歡樹的葉子，得天獨厚的長頸讓牠們在覓食的時候無往不利。

The leaves of sweet acacia are the favorite of giraffes. Their long necks enable them to indulge the meal without barriers.

144-145

靜立不動的一隻網紋長頸鹿彷彿正欣賞著草原上日落的美景。

A reticulated giraffe standing still and

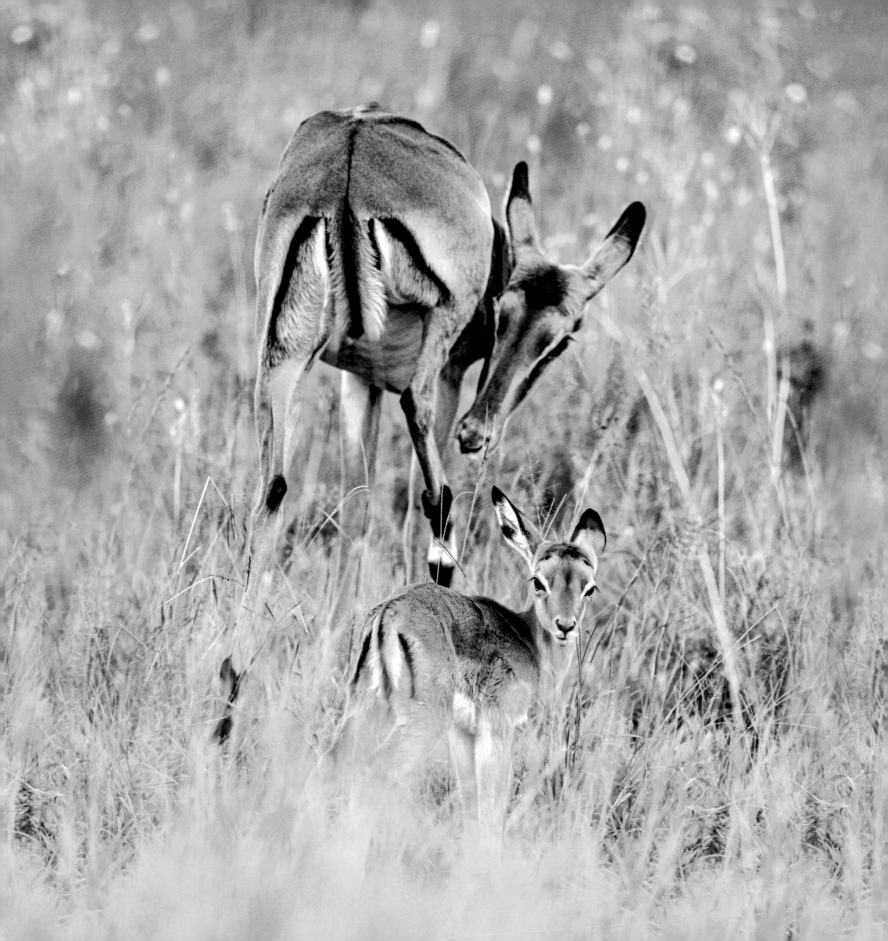

146-147

高角羚的亞種黑面高角羚面部有黑色斑紋，亦比普通高角羚體型更大。只有成年的雄性才會有高高豎起的角。

Impalas with black face are a subspecies, larger in size than normal ones. Only male impalas have slender horns.

148-149

作為草原上的弱勢群體，稍有風吹草動高角羚就會連跑帶跳地成群奔逃。牠們每次跳起可跨越 10 公尺，騰高 3 公尺，彷彿成群跳高選手在互相較勁。

As underprivileged groups on the savanna, even the tiniest sign of danger can force them to leap and run away. They can leap up to 10 meters in length and 3 meters in height, like a group of high jump athletes matching with each other.

150-151

夕陽扮演了兩隻羚羊角鬥場上的聚光燈。

The setting sun is acting as a spotlight focusing on two sparring gazelles.

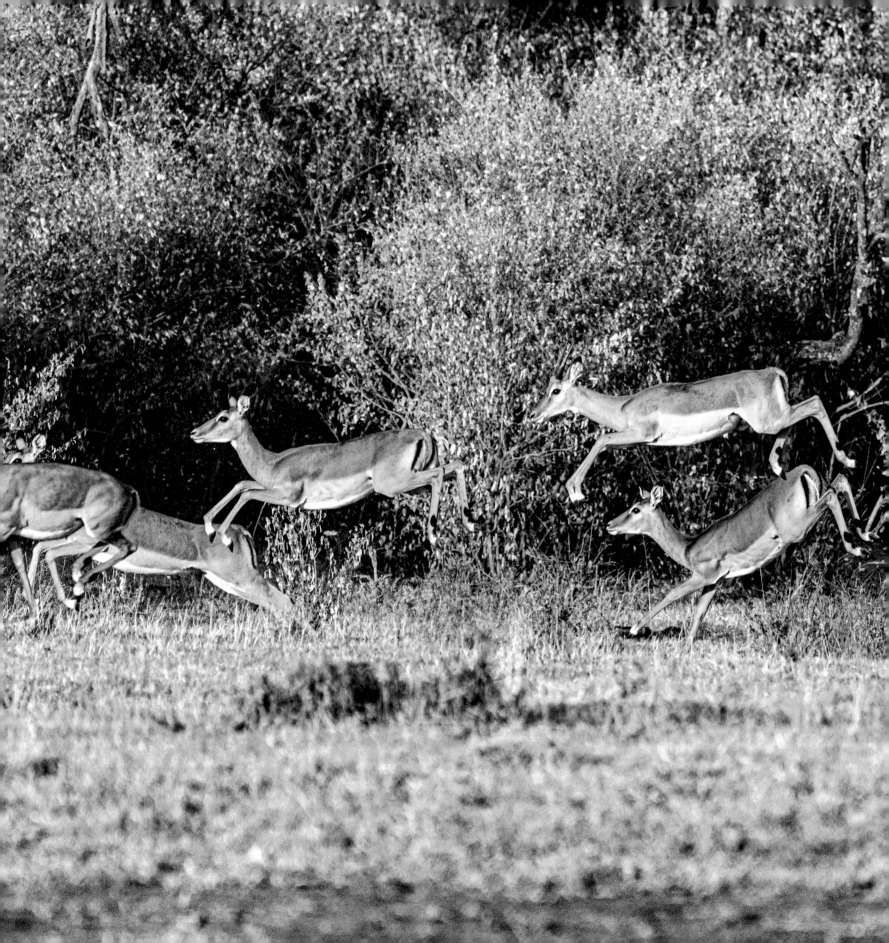

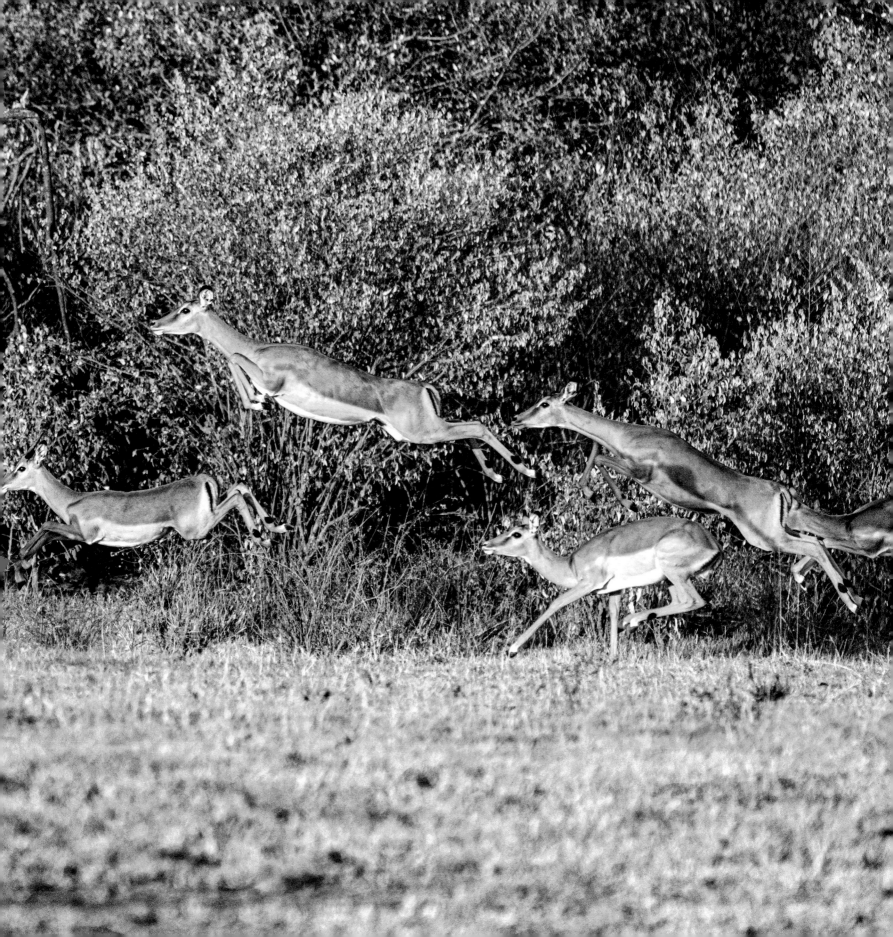

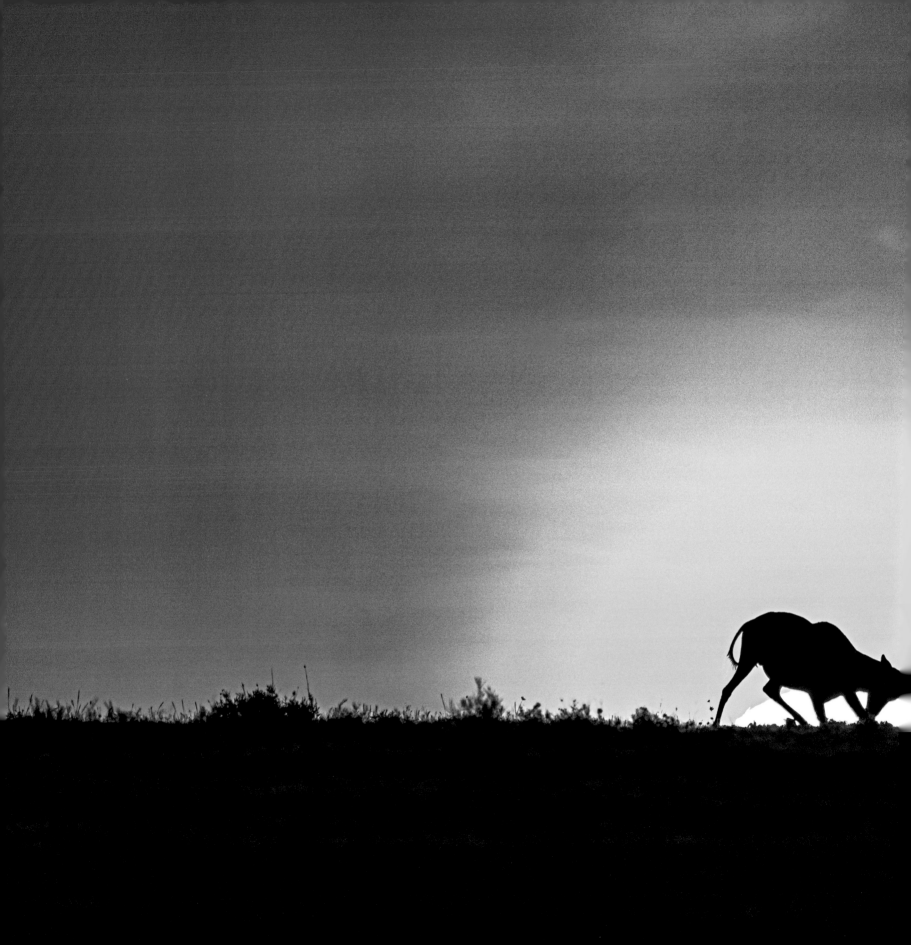

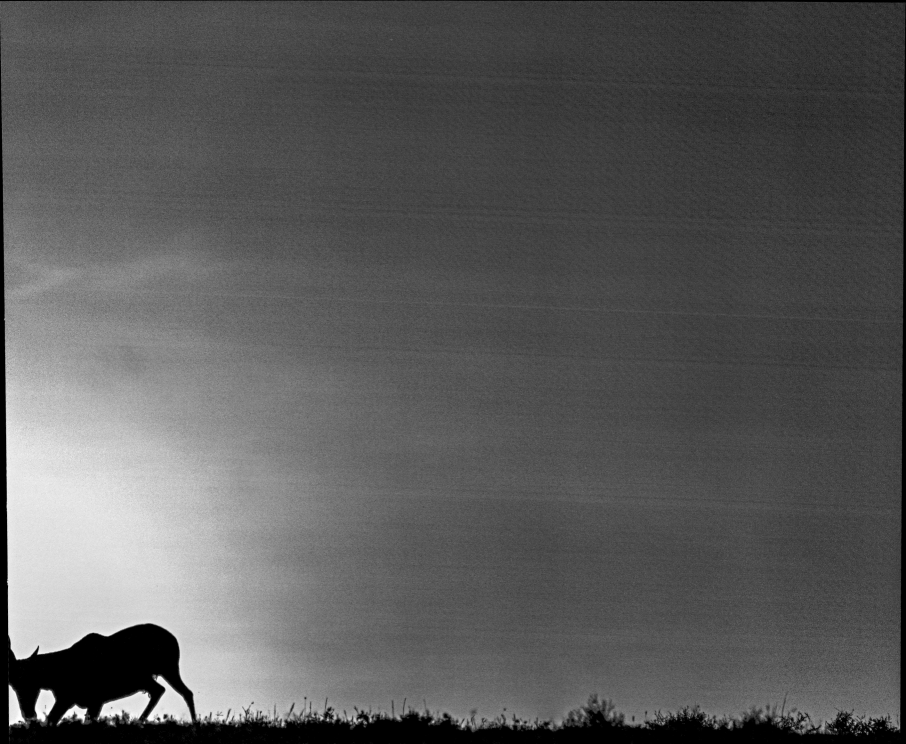

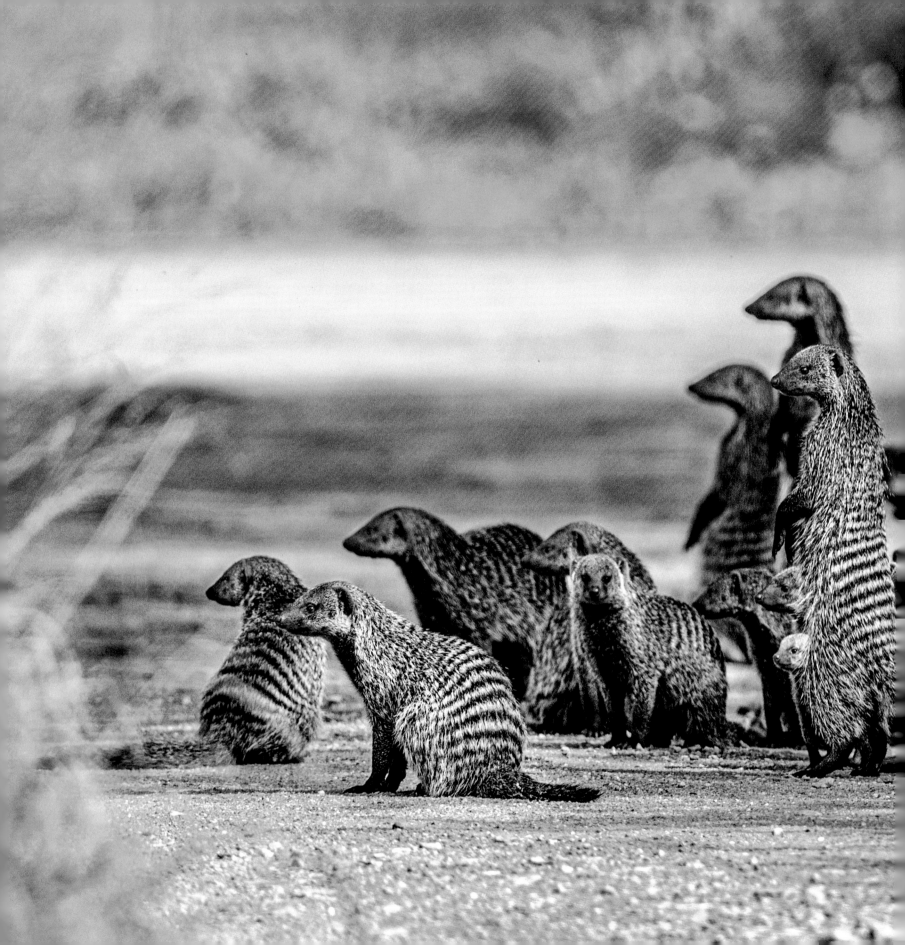

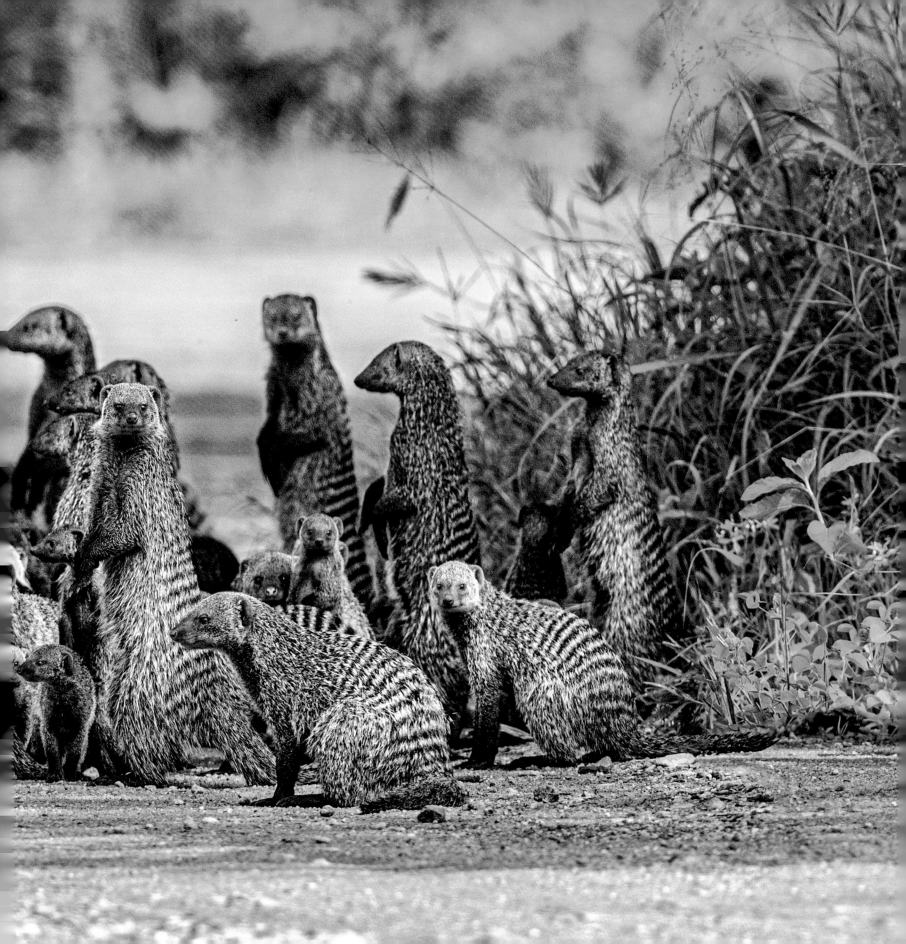

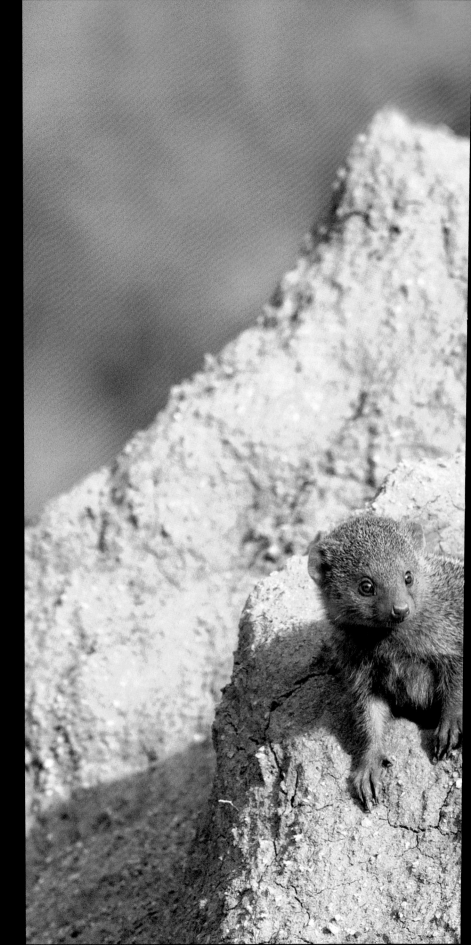

152-153

橫斑獴常在日間集體活動，看起來雖然可愛無辜，牠們實際上靈活且機警，有極高的生存能力。

The banded mongooses are often found in groups during daytime. With lovely and innocent looks, they are actually extremely flexible and vigilant – these characteristics have highly increased their viability.

154-155

侏獴的前爪又尖又利，非常擅長挖洞，作為牠們躲避危險、夜間休息的家園。

The long and sharp foreclaws of dwarf mongooses are the ideal tools for digging holes – which protect them from danger and accommodate them during the night.

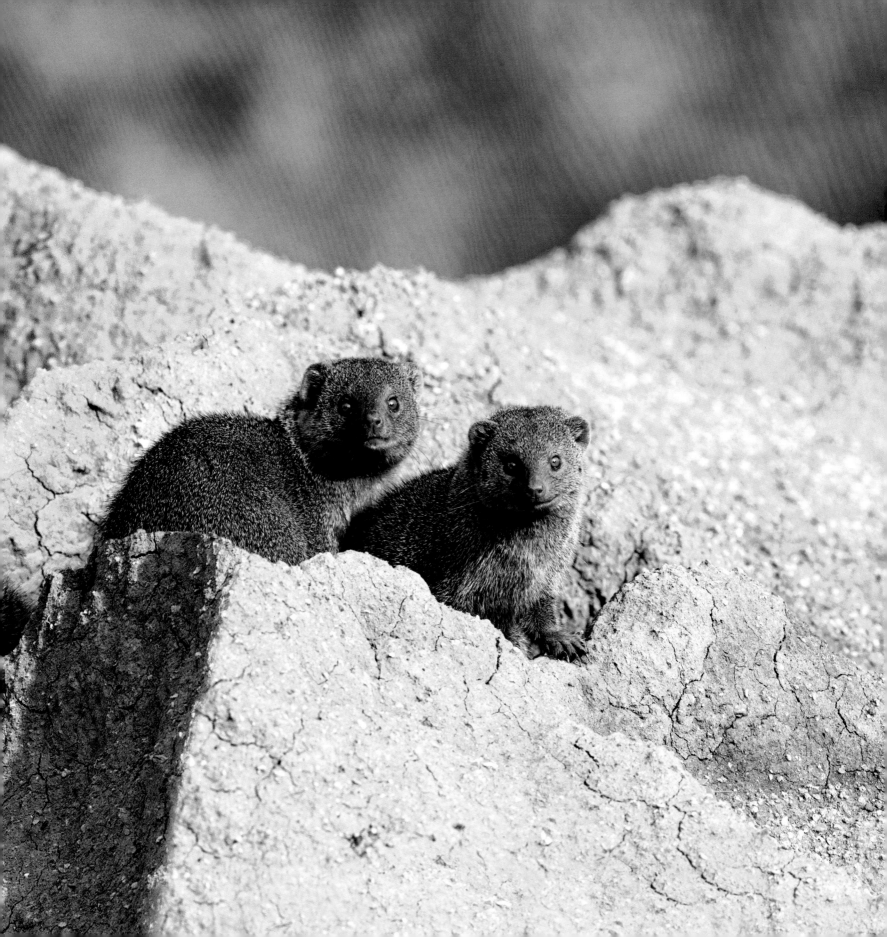

156-157

黑背胡狼整體外形似狗，而面部卻如同狐狸，通常奉行終生單配偶制，與家族及後代一齊生活、覓食。體型嬌小的胡狼較少主動捕獵，常竊取獅子的食物。然而正因體型對獅子來說毫無威脅，卻往往能夠成功搶食。

The black-backed jackal looks like a dog in shape but a fox in face. This monogamous species often lives with their partners and offspring and forage for food together. The relatively small jackals scarcely hunt by themselves; instead, they steal from lions for a living. Luckily, their small size, which does not pose any threat to lions, is exactly the reason why they can achieve a high rate of success.

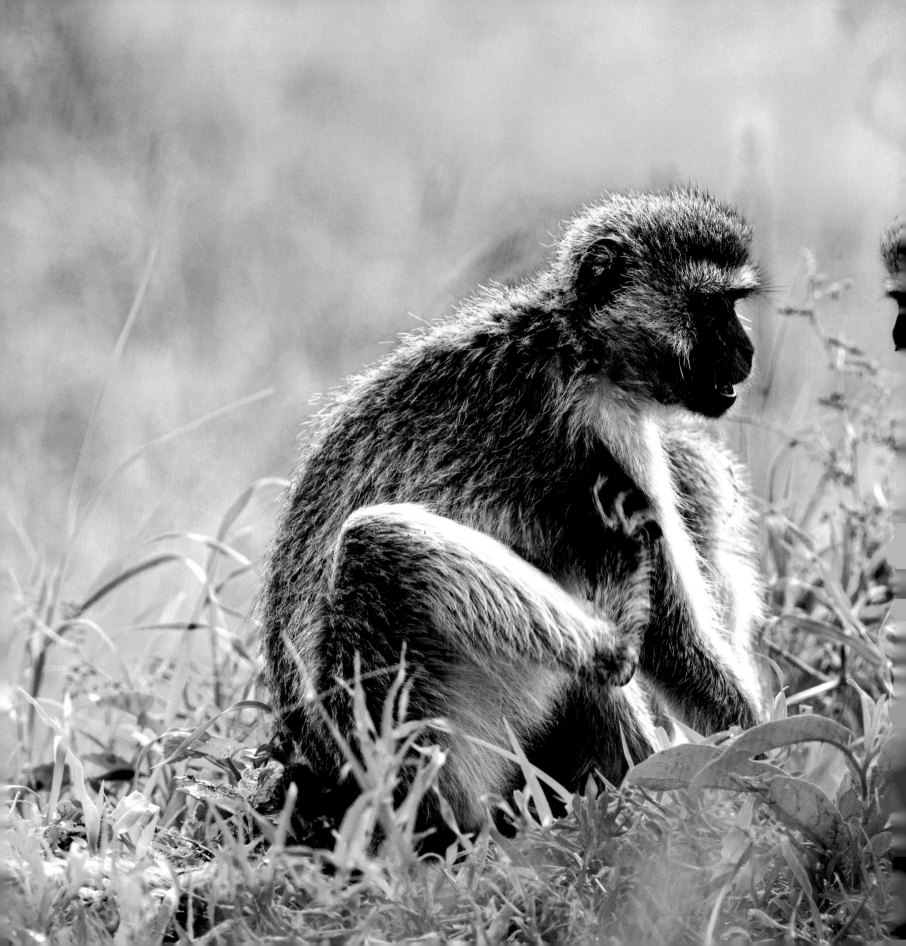

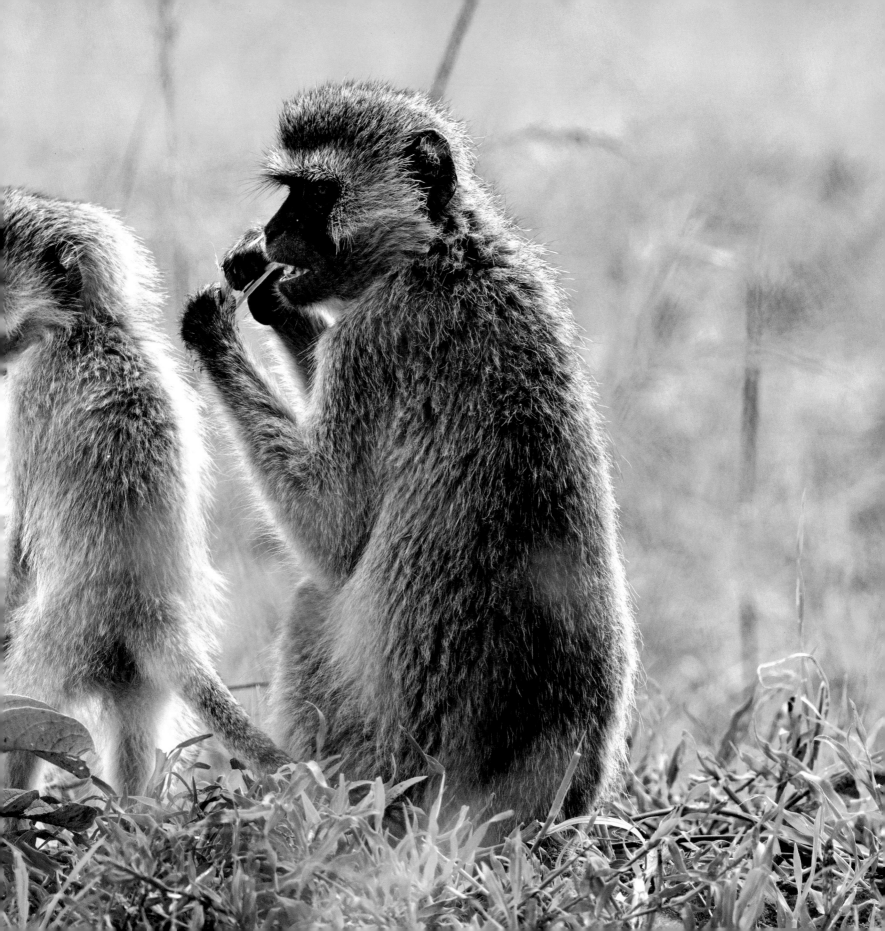

158-159

黑面長尾猴在非洲十分常見，頑皮的牠們
總是在草原各處成群結伴地玩耍。

Vervet monkey is a naughty species
native to Africa, which can always
be seen playing in groups almost
everywhere on the savanna.

160-161

群居的斑鬣狗是草原上絕對不容小覷的
掠食者，他們甚至敢從獅豹手下偷走獵物。

Spotted hyenas are highly social and
dangerous predators who even dare to
steal preys from lions and leopards.

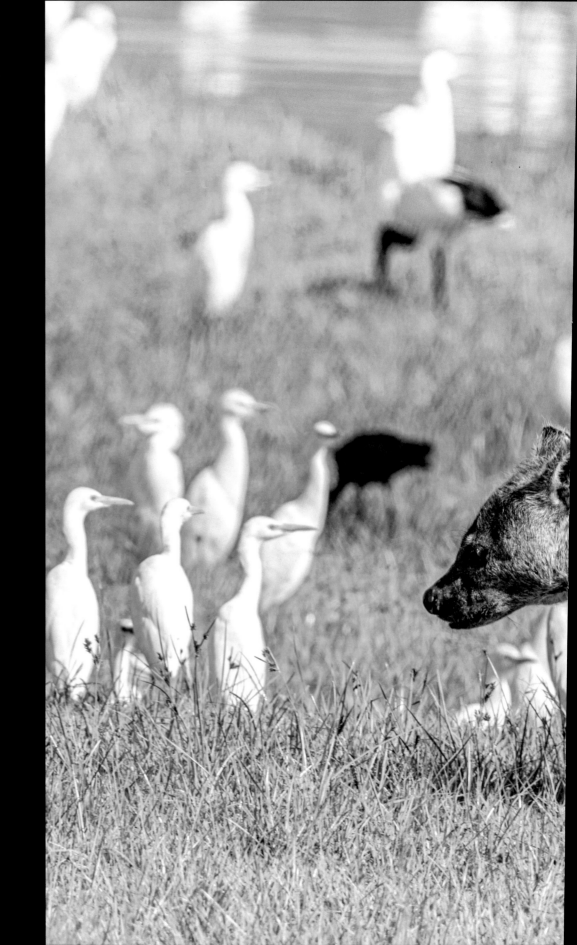

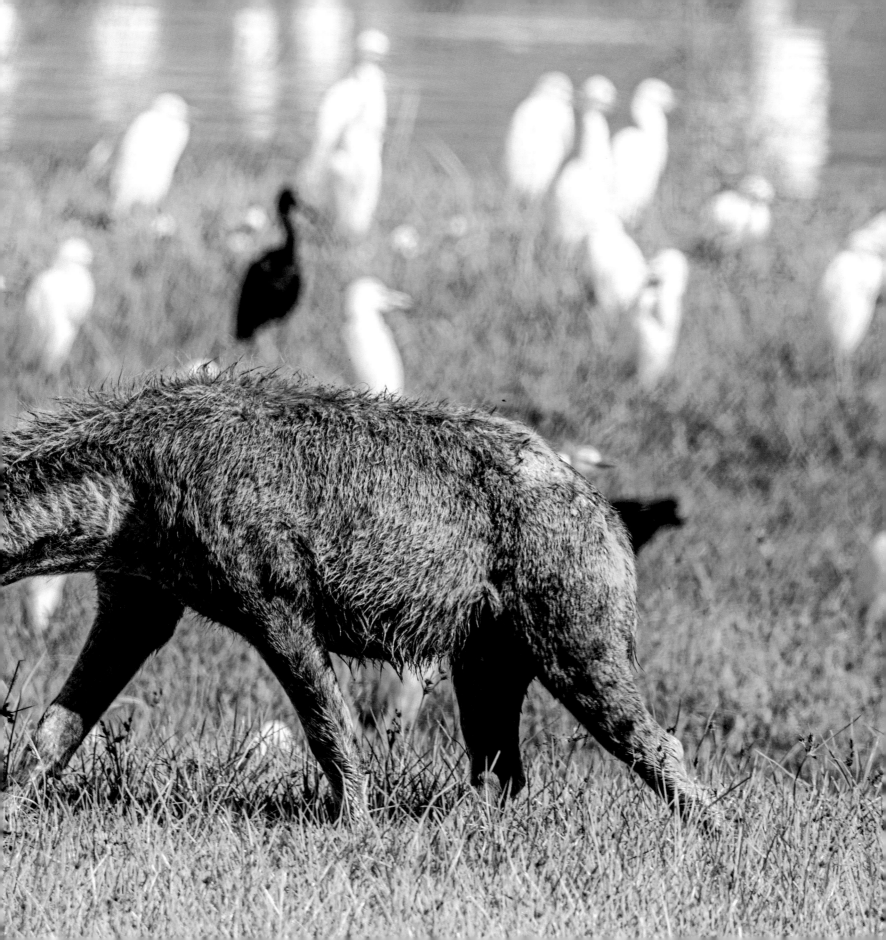

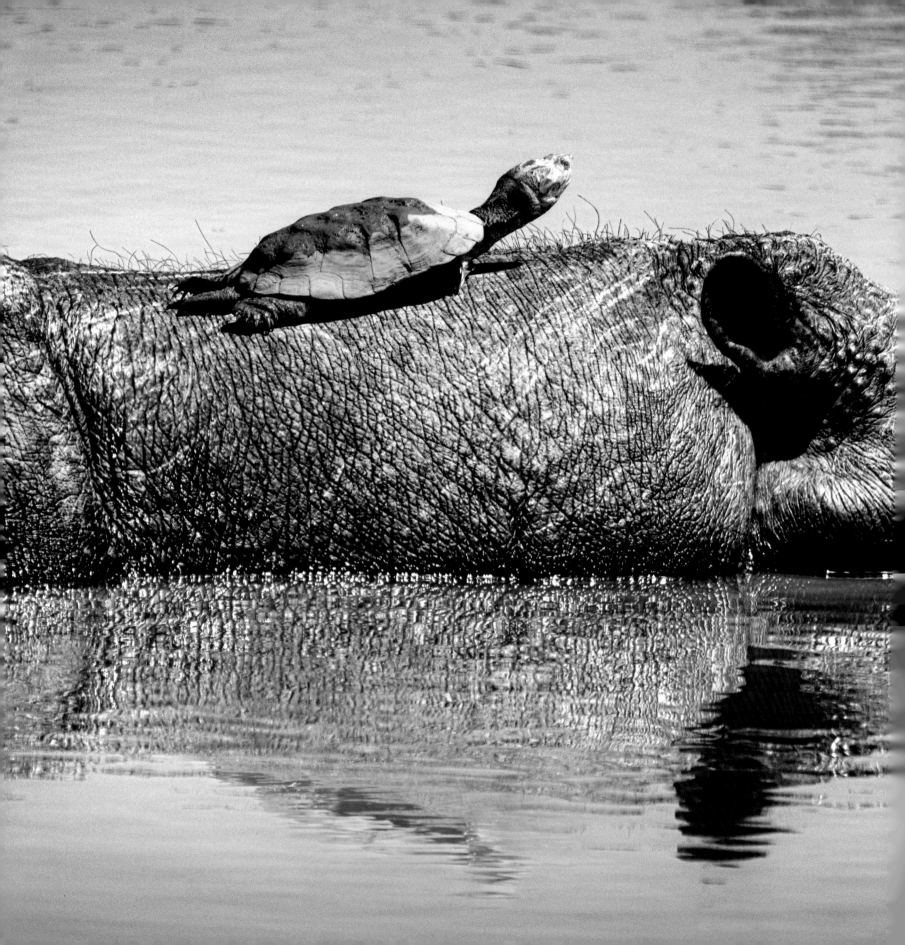

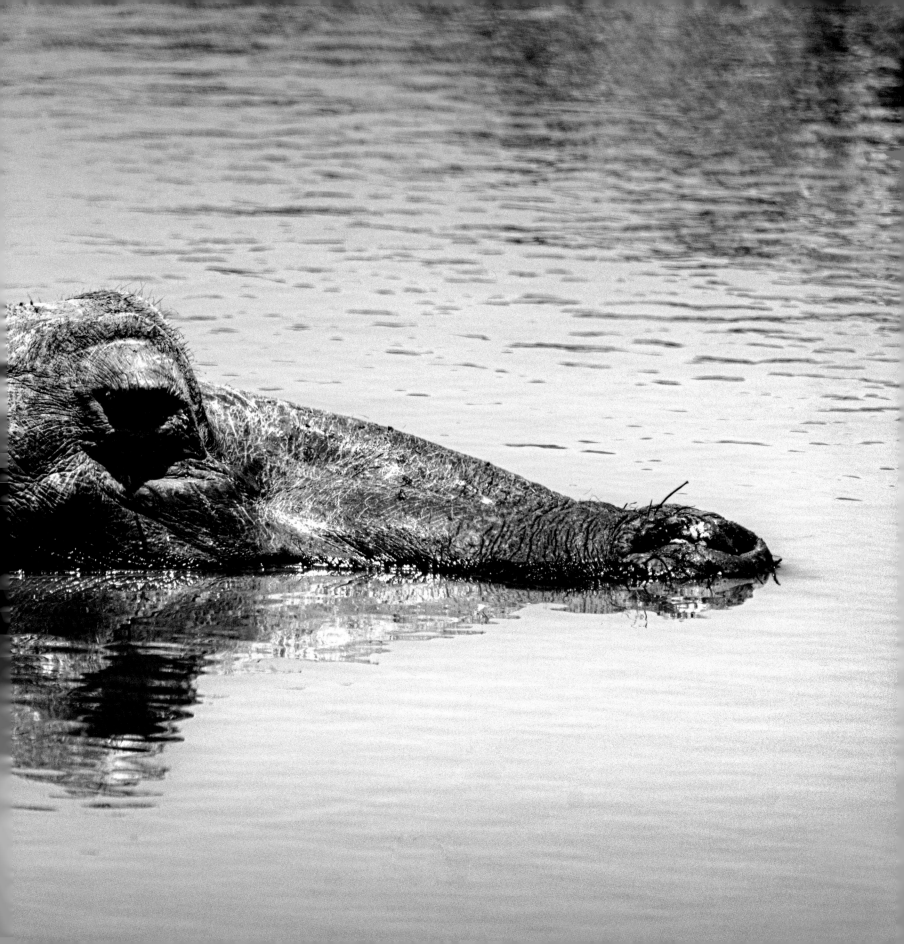

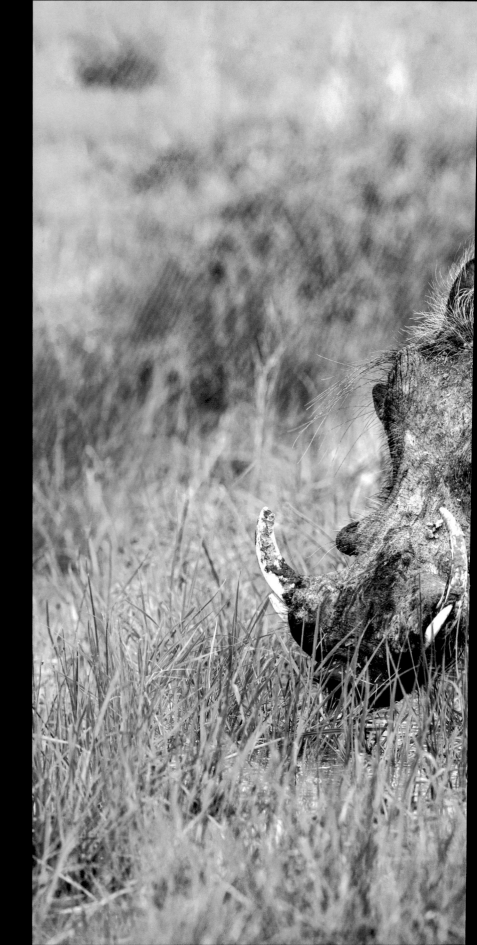

162-163

河馬在水中浸浴，小烏龜爬到河馬背上享受「日光浴」。

While bathing in the river, this hippo has also offered its back to a turtle to sunbathe.

164-165

荒漠疣豬面部有兩對彎彎的大獠牙，看起來兇惡猙獰。牠們喜歡浸浴於泥水中消暑，並消滅身上的寄生蟲。

Desert warthogs are equipped with two pairs of large curving canine teeth, looking ferocious and savage. Bathing in muddy water is their way of thermoregulatory and antiparasitic treatment.

166-167

姆萬扎平頭飛龍蜥身穿一件紅藍相交的緊身衣，酷似超級英雄蜘蛛俠的造型。

Mwanza flat-headed rock agama, wearing a tight costume in red and blue, is probably cosplaying superhero Spiderman.

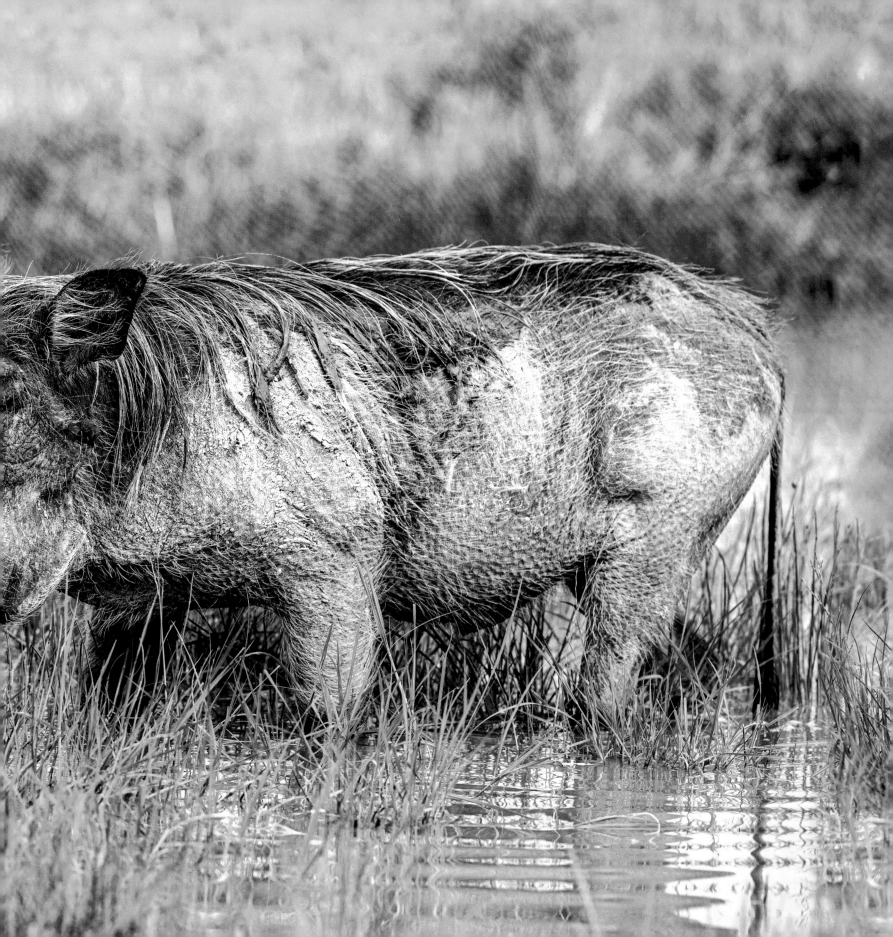

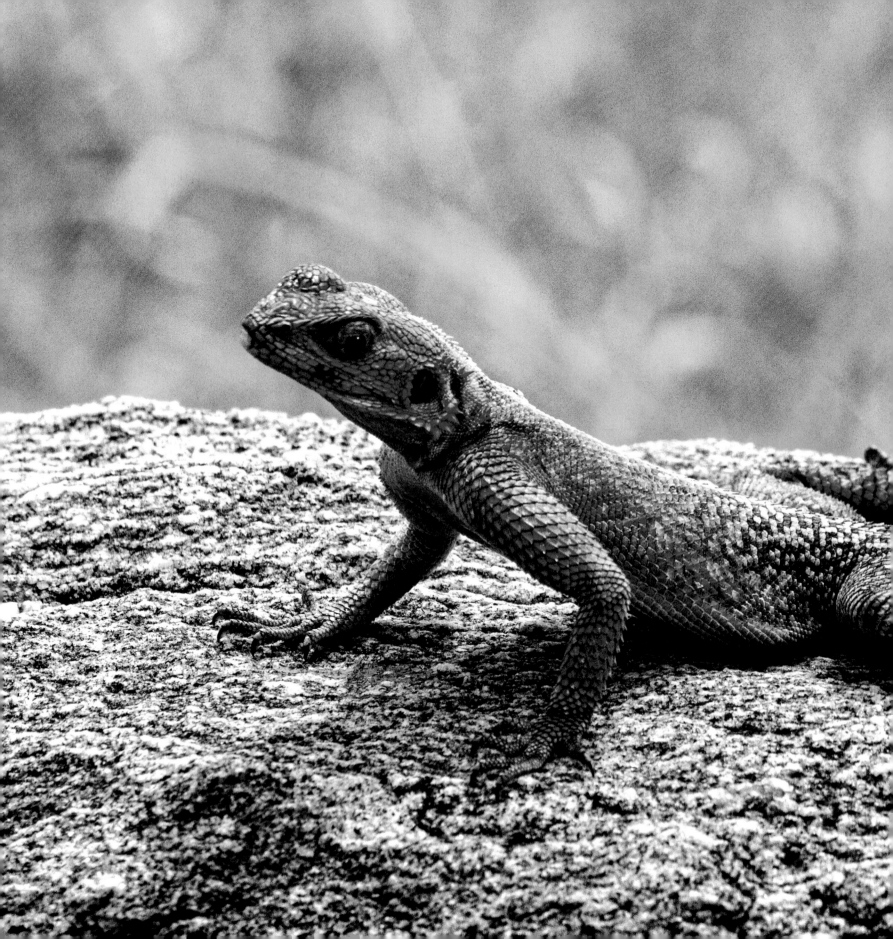

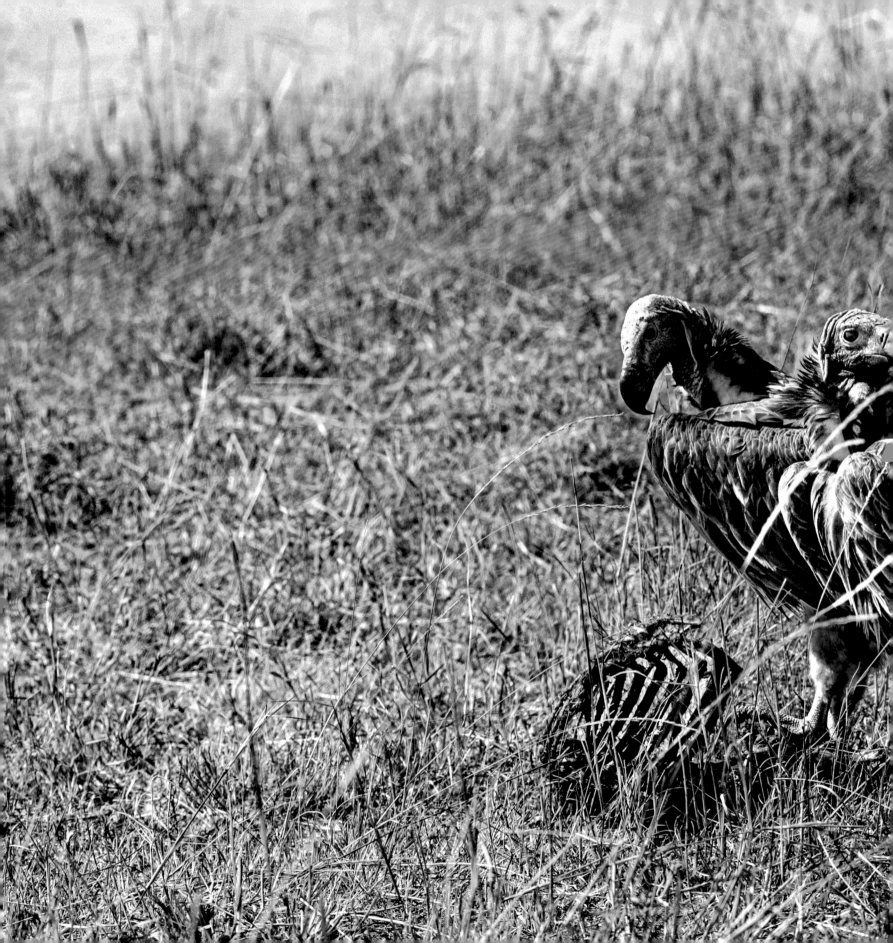

168-169

在非洲草原上，有猛獸獵食的地方，上空就能看到視覺極其敏銳並聚集盤旋的禿鷹，準備享用他們用剩的大餐。

Where there are predation activities, there are vultures, who have acute eyesight flying over the bodies, waiting for their chance to have a meal.

170-171

肉垂禿鷹屬於舊大陸禿鷲種類，在全球的城市化進程中，由於不少家畜體內含藥物，禿鷹整體數量驟降，肉垂禿鷹被列為瀕危物種。

The lappet-faced vulture is an Old World vulture species. Global urbanization has caused a drastic drop in population of all vultures for there are more and more drugged livestock. The lappet-faced vulture is listed as endangered (EN).

172-173

黃頸裸喉鷓鴣有著無毛髮覆蓋的黃色喉部及紅色眼周，彷彿穿了一身連頭套的羽衣。

The yellow-necked spurfowl has a yellow throat and red eyes exposed in the air, as if it is wearing a feather robe attached with a mask.

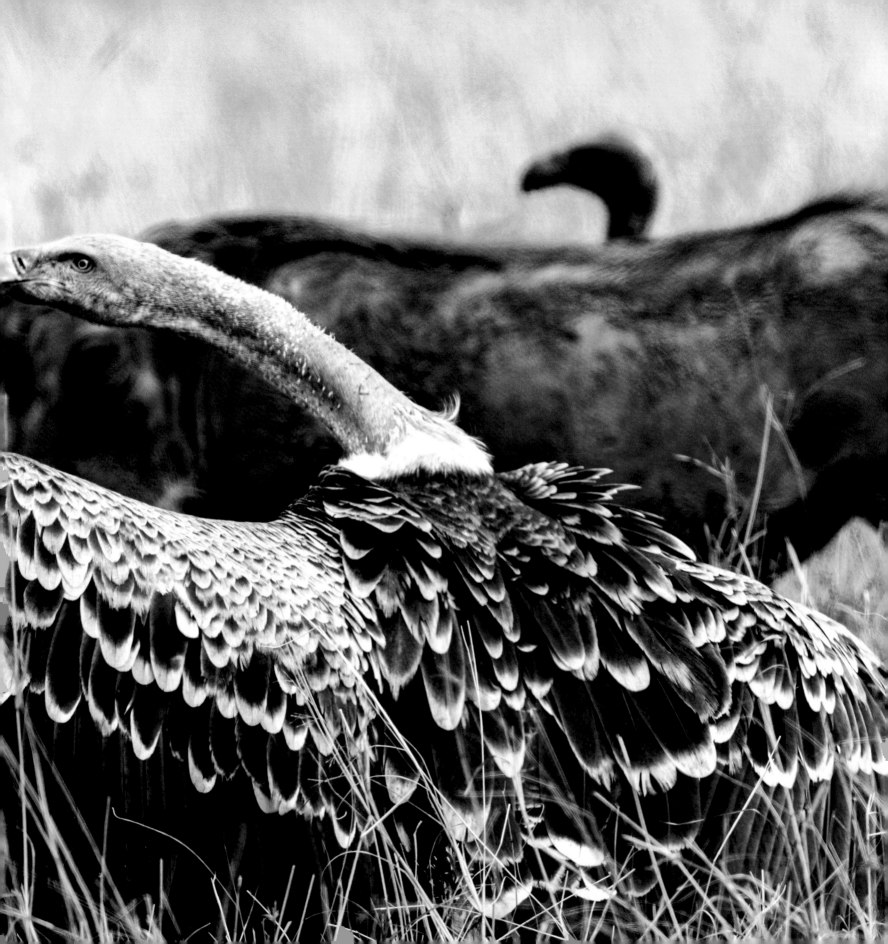

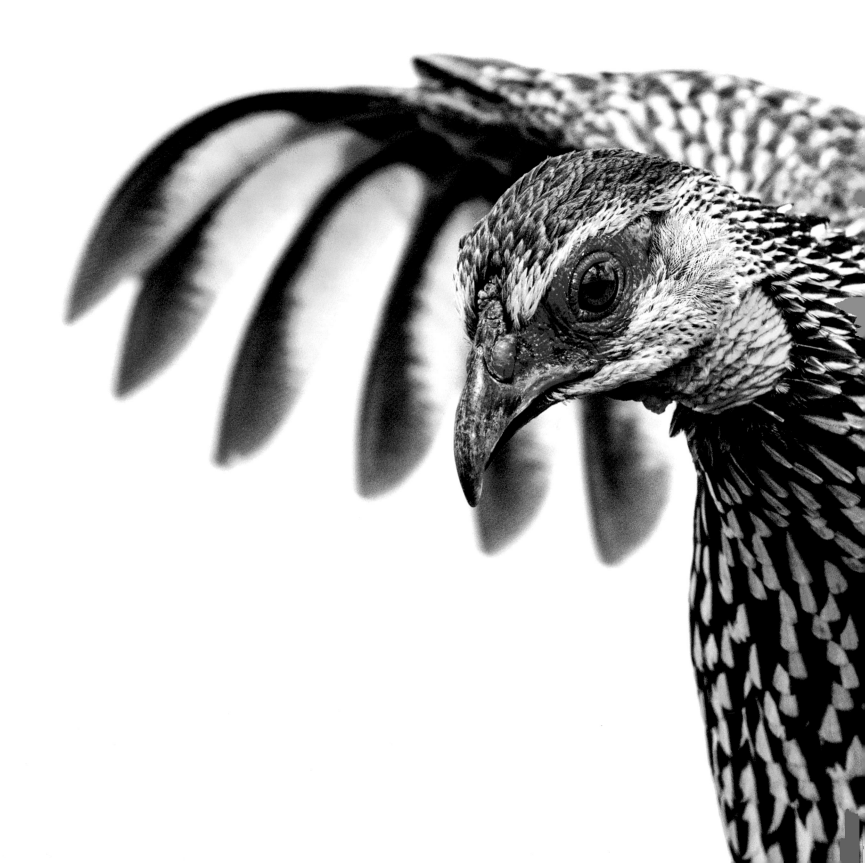

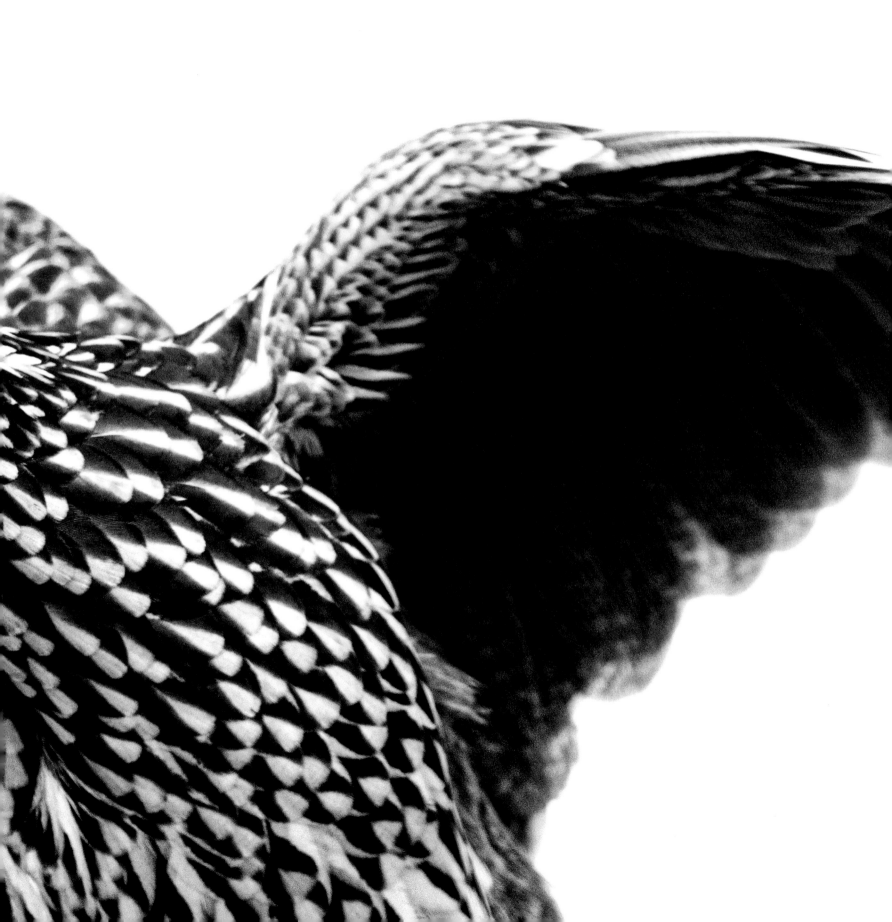

# 田園
# PASTORAL

當地居民的日常生活
The lifestyle of local people

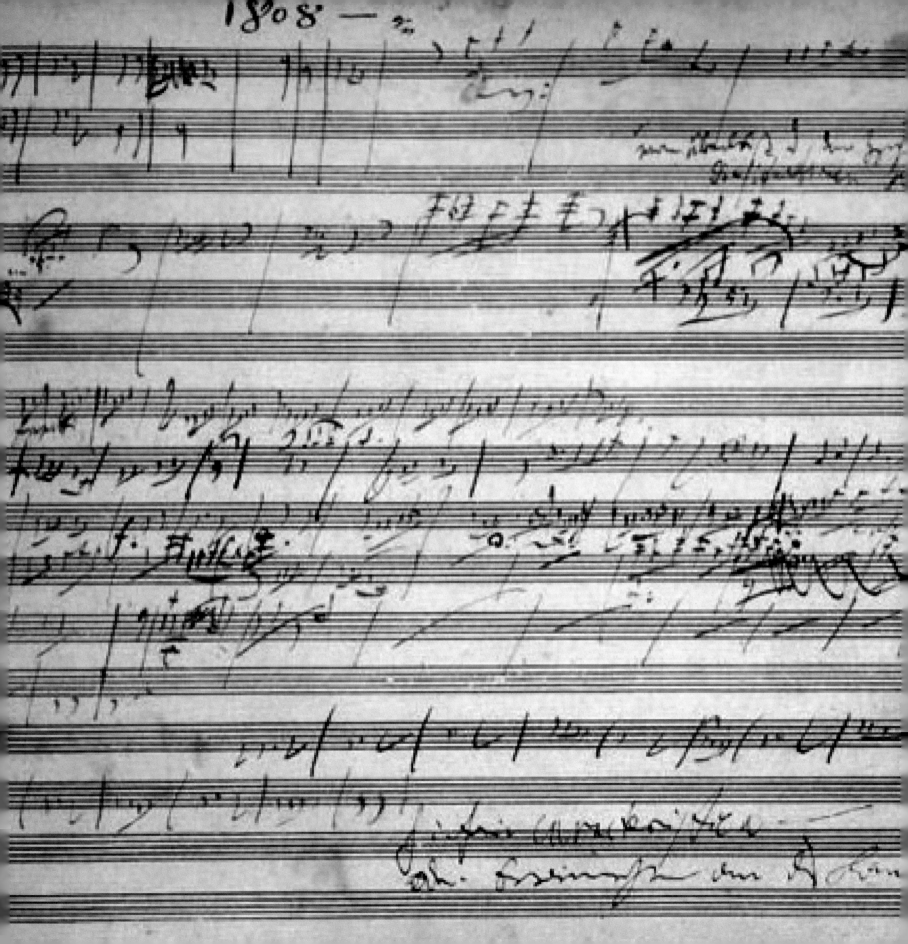

# 田園
# PASTORAL

F 大調第六交響曲，又稱田園交響曲，是貝多芬為大自然所譜寫的讚歌。

這首交響曲與第五交響曲同期作於 1807 至 1808 年間，並同場首演。難以想像的是，「命運」的激昂澎湃與「田園」的恬靜悠然，竟然可在同期出自一人之手。處於創作高峰期的他，雖然罹患失聰，卻仍然能譜寫出曲風迥異卻又同樣精彩絕倫的兩首傳世之作，不得不讓人敬服。有人猜測，正是由於貝多芬當時承受巨大的壓力，經常到郊外散心紓壓，大自然為他帶來內心的平靜，而他則以動人的樂章回饋大自然。

田園是貝多芬眾多交響曲中最「平易近人」的作品，是他對自然的聲音描繪，但卻不僅僅停留在初級層面的對自然界各種聲音的模擬，而是為聽眾營造出一種氛圍，讓聽者眼前浮現出晴朗的碧空、靜謐的湖面、搖曳的枝椏、活潑的雀鳥——種種景象聚成一陣飄逸的清風拂面而來，讓心靈亦得到滌蕩。

從居住已久的都市來到東非大草原，正如田園交響曲給人的感覺一般，讓人返璞歸真、樂而忘憂。每一天，生活在此的人們可以直面未經改造過的大自然的鬼斧神工，可以與其他物種共享這片富饒的水土，而不需追趕現代化城市緊湊高效的生活節奏。

此章聚焦肯亞人的生活環境，不但有田園農莊、放牧場景，也可以一睹肯亞城市發展的狀況。

The Symphony No. 6 in F major, also known as the Pastoral Symphony, is a paean dedicated to nature from Beethoven.

Both composed between 1807 and 1808 and shared a debut concert with the fifth symphony, it's quite hard to imagine the passionate "Fate" and the peaceful "Pastoral" came from the same person within such a short time. The fact he was so productive during that period that he actually managed to compose two masterpieces which are marvelous in different ways is absolutely admirable. Some theories are that it was because of the great pressure he felt from his hearing loss that Beethoven spared much time in the suburb, where he found inner peace in nature and, in turn, reciprocated with a mellifluous piece.

Pastoral is easy on the ear compared to all his other symphonies. It is an audio description of nature but by no means simply a few mimicking sounds. It creates a scene in front of us, in which we can see the clear

and vast sky, the lake of Serenity, the gently swaying branches, the adorable and lively birds, and etc. Imagining these beautiful sceneries is a cleanse to our minds that brings pure mental freshness.

Leaving behind the modern cities and stepping onto the savanna of East Africa is similar to listening to Pastoral – they enable us to return to our original simplicity and reduce anxiety. Every single day, people living here are able to get along with the unspoiled natural magnificence and share this richly endowed land with other creatures. They don't have to follow the lifestyle of modern society that can be nerve-racking sometimes.

This chapter focuses on the living environment of Kenyan, in which one will be able to take a look at the village life as well as the development of surrounding cities.

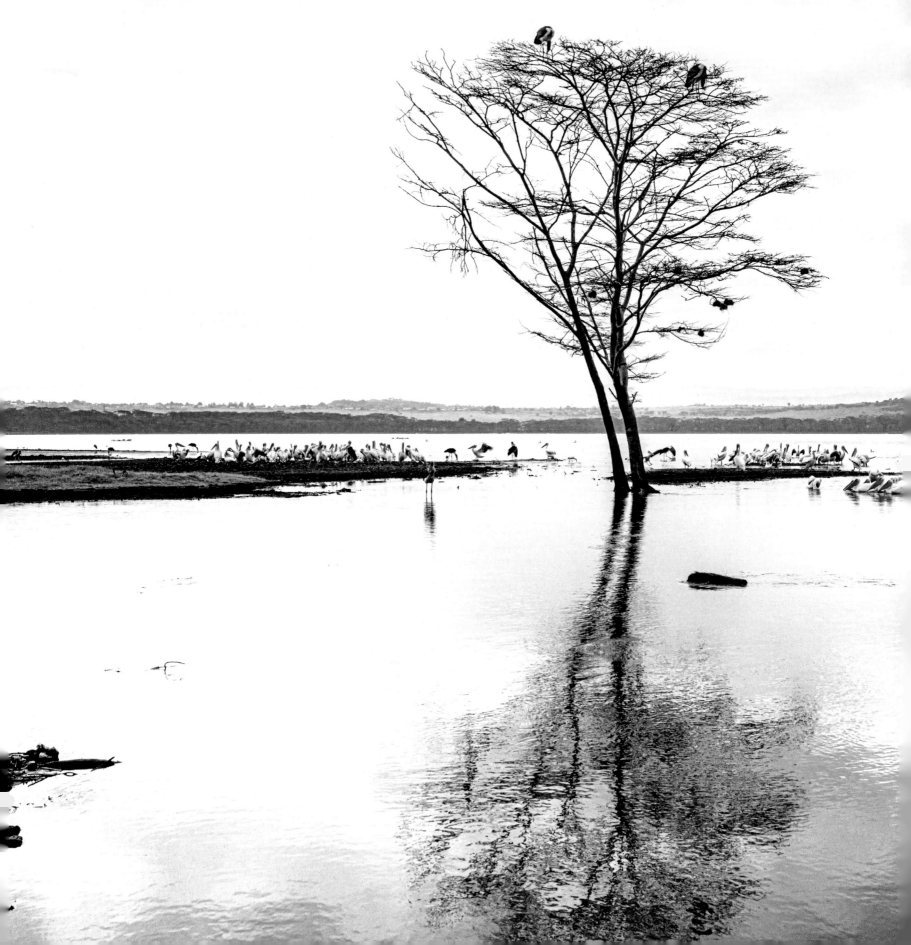

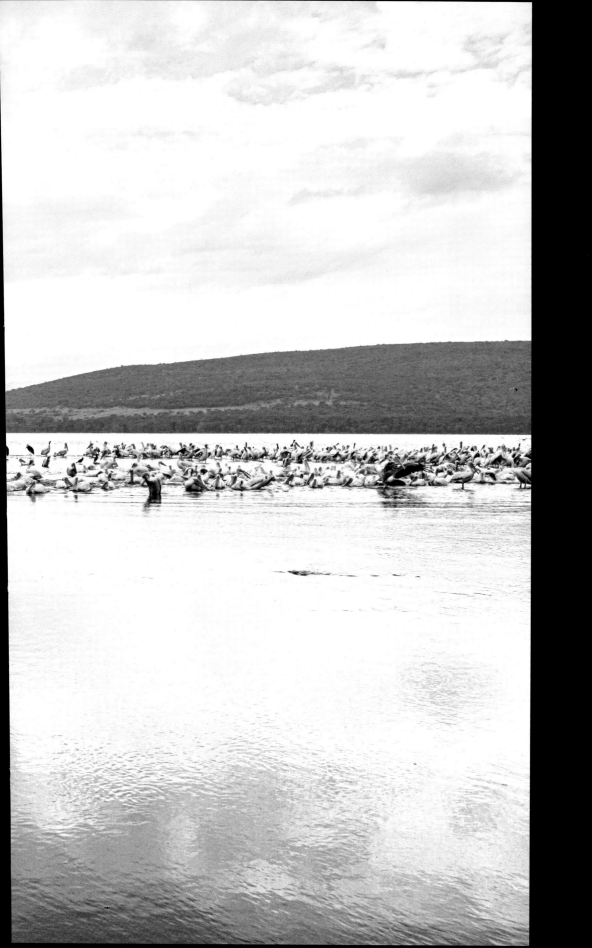

178-179

在田園交響曲中，貝多芬將第二樂章命名
為「溪邊景緻」，描繪了一幅微風徐徐、
流水潺潺、鳥鳴呦呦的美好畫面。在蕩著
絲絲波光的納庫魯湖面上棲息著白鵜鶘
群，這個場景彷彿重現了這一樂章。

Beethoven named the second
movement of the Pastoral Symphony
"Scene by the brook", depicting a
pleasant scenery consisting of warm
breeze, flowing water and singing birds.
The view of a large group of great
white pelicans resting on the flickering
surface of Lake Nakuru echoes with the
second movement.

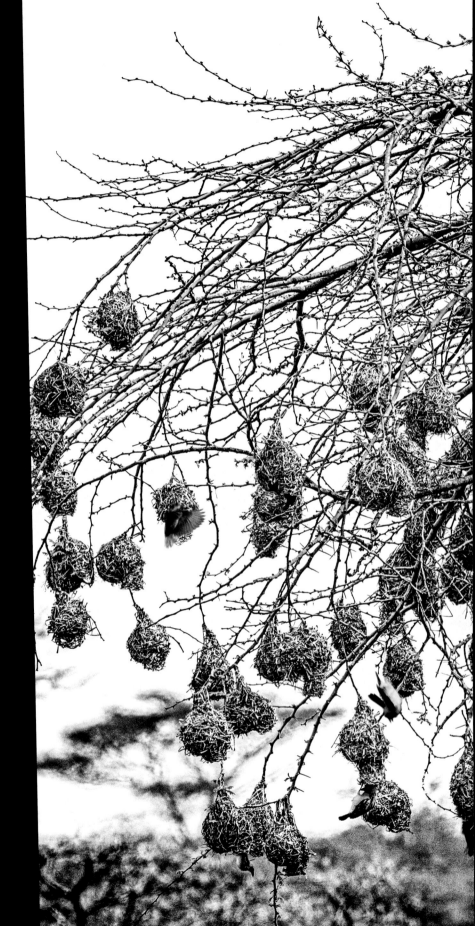

織布鳥是天生的「建築師」，喜歡群居的牠們常常在同一棵樹上築造幾十個雀巢，互為鄰里。

Weavers are born architects. Being highly social, they tend to build tens of nests on the same tree, acting as neighbors to one another.

跟斑織布鳥不像許多其他群居營巢的織布鳥，會獨立一對在樹上築巢。雄鳥會負責大部份工作，但有時亦可以見到雌鳥協助築巢。

Unlike many other weavers that breed in colony, spectacled weaver nests in solitary pairs. Although male bird will do most of the job, female may also contribute to nest-building.

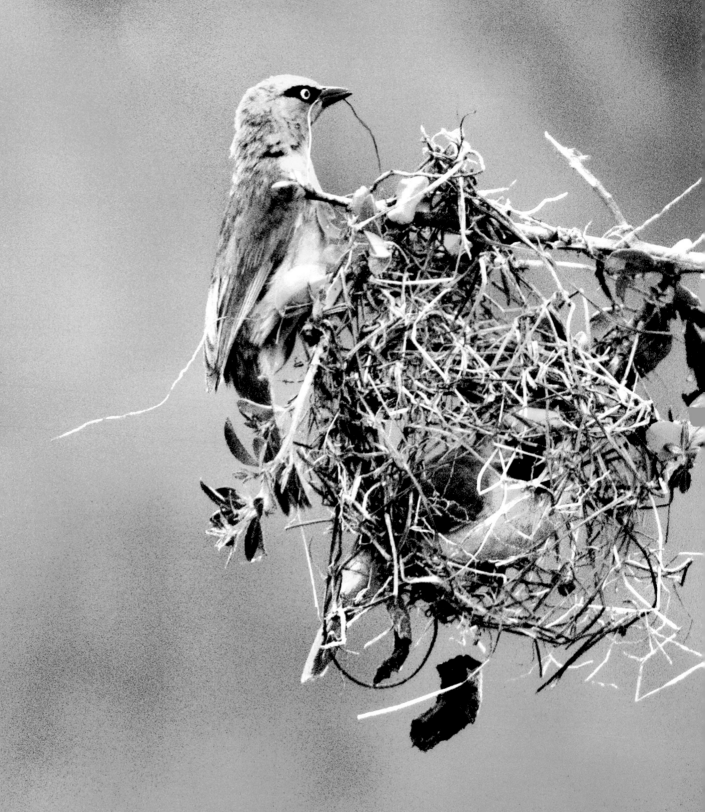

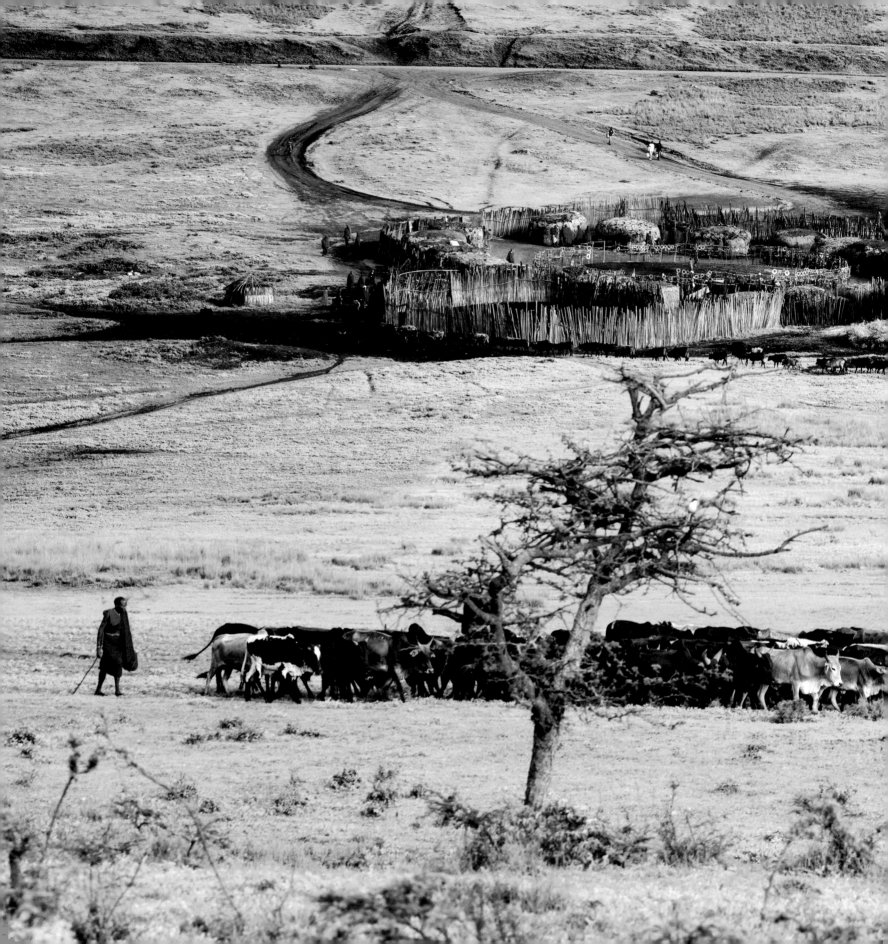

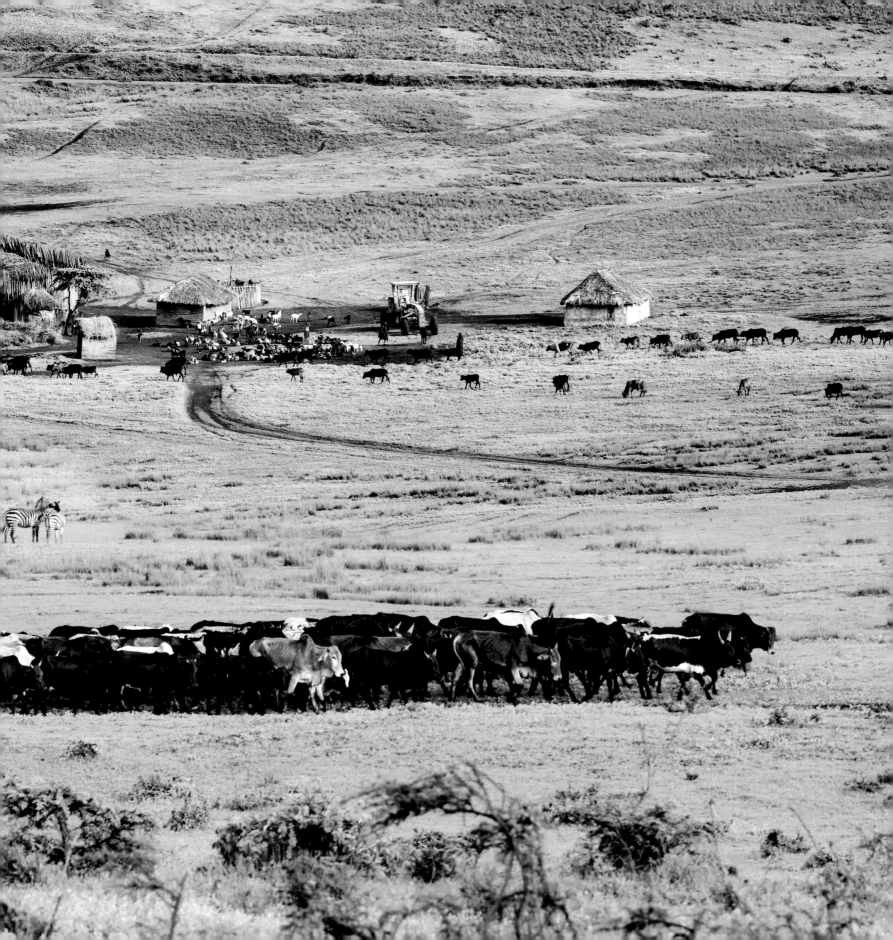

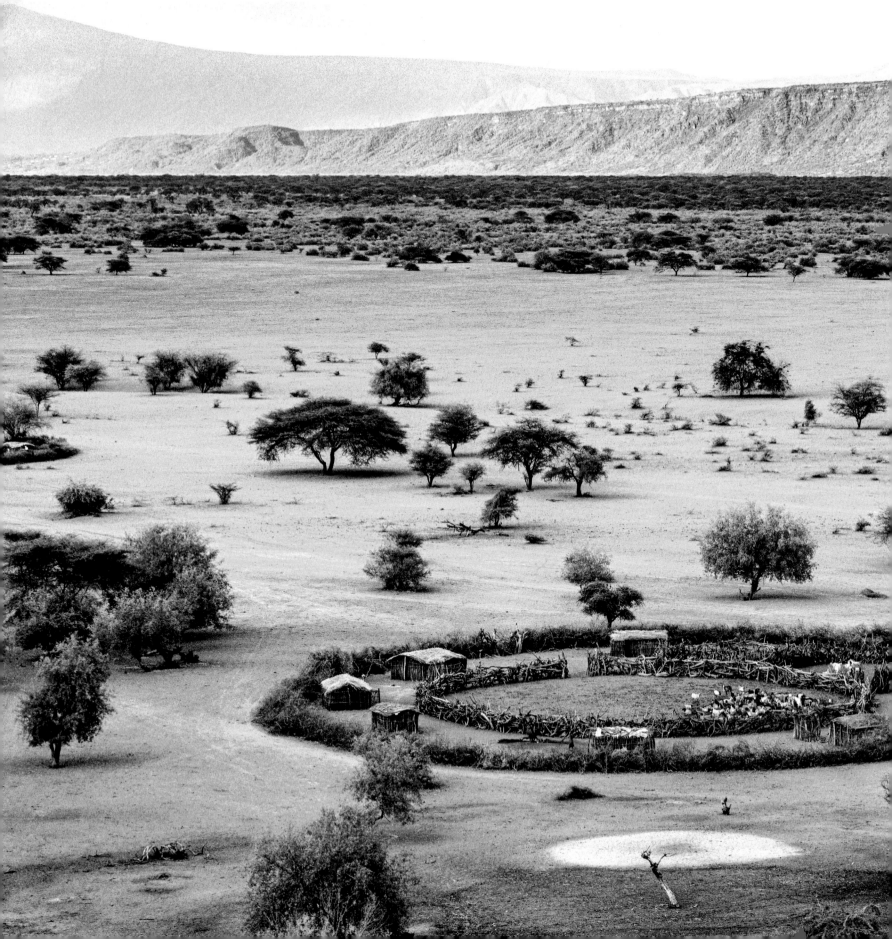

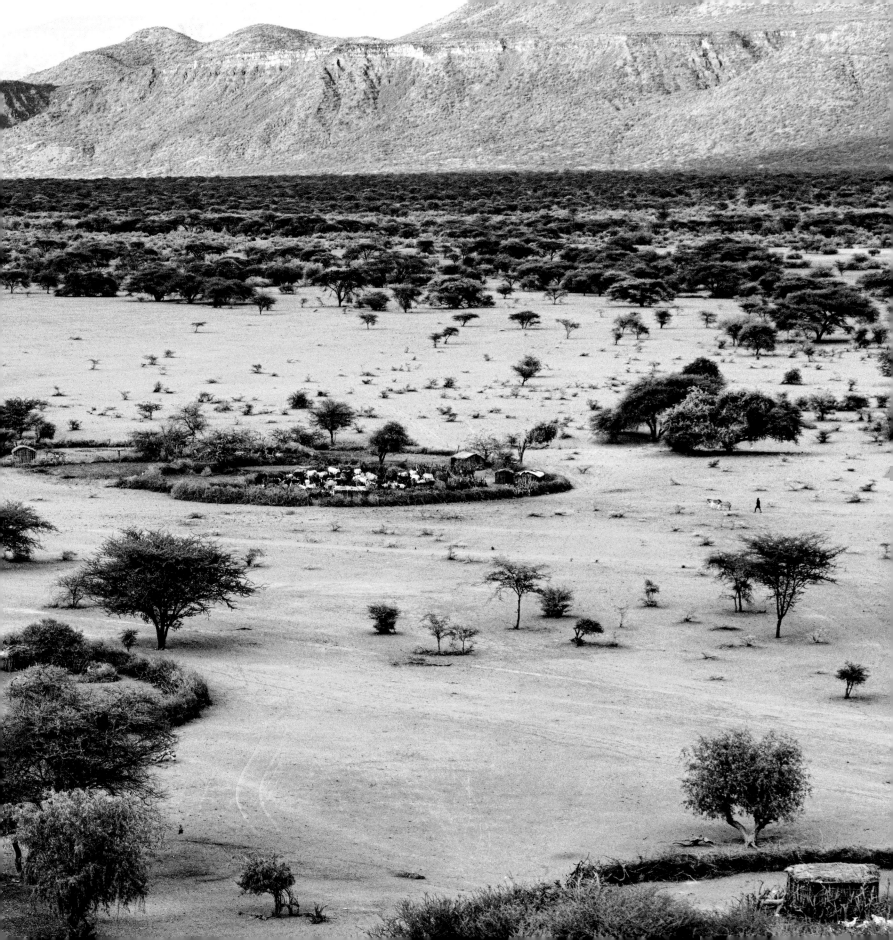

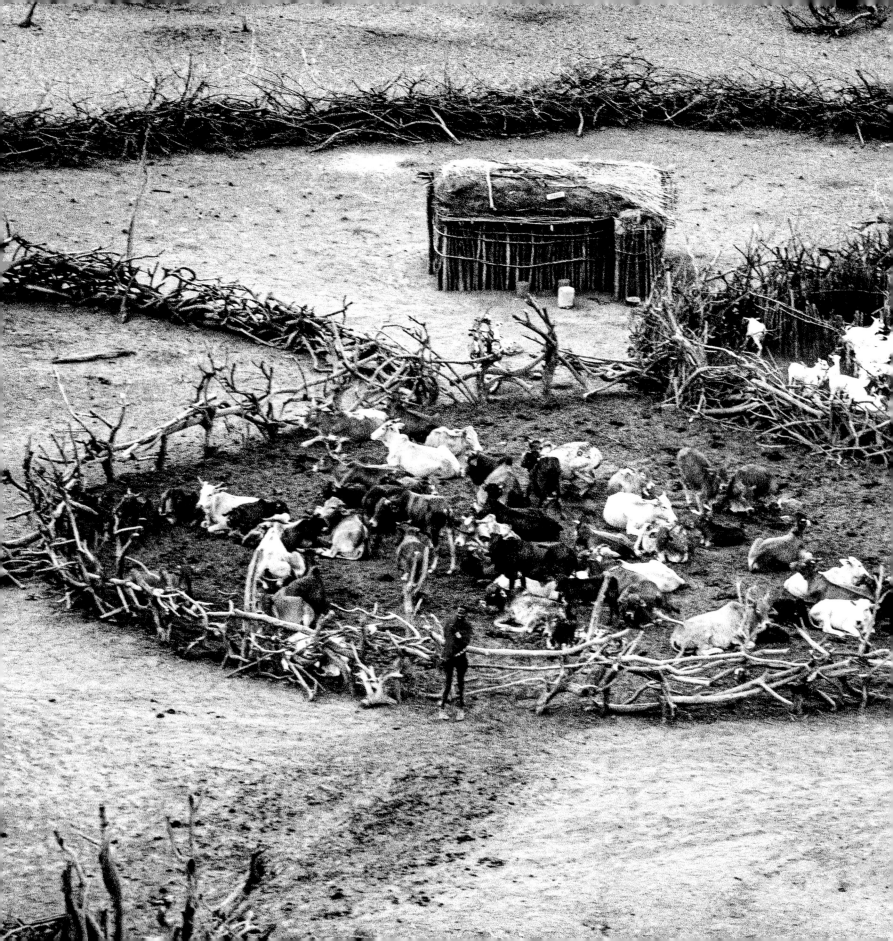

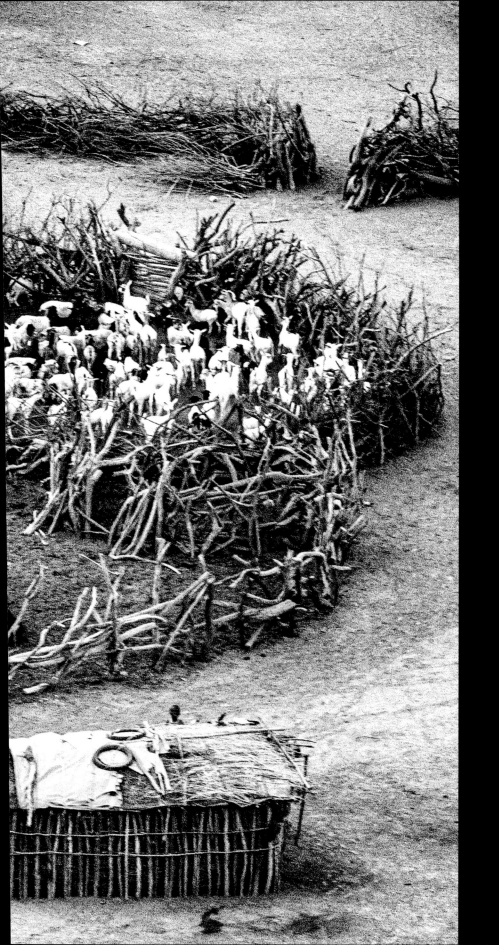

184-185

在人與自然互相尊重、和平共處的草原上，成群家畜
有條不紊地列隊回到村莊，呈現一派安寧靜謐的氣氛。

Human are living peacefully in nature here on the
savanna. A herd of cattle is returning to the village
in a queue, creating a harmonious and soothing
atmosphere.

186-187

草原上的土著馬賽人依舊保持著最傳統的生活模式，
他們把帶刺的金合歡樹木圍成圈，作為村落抵禦野獸
入侵的防護籬笆。

The indigenous Maasai on the savanna are still
living in a traditional way. The villages are protected
from wild animals by a circle of thorny fence made
of branches of acacia trees.

188-189

柵欄以內居住著 4 至 8 個家庭，同樣圍成圓形，村莊
的最中間則是他們賴以生存的家畜。

There are 4 to 8 houses in one village, arranged also
in a circular shape. In the very middle of the fence,
Maasai have placed their livestock, which are the
most fundamental and important wealth to them.

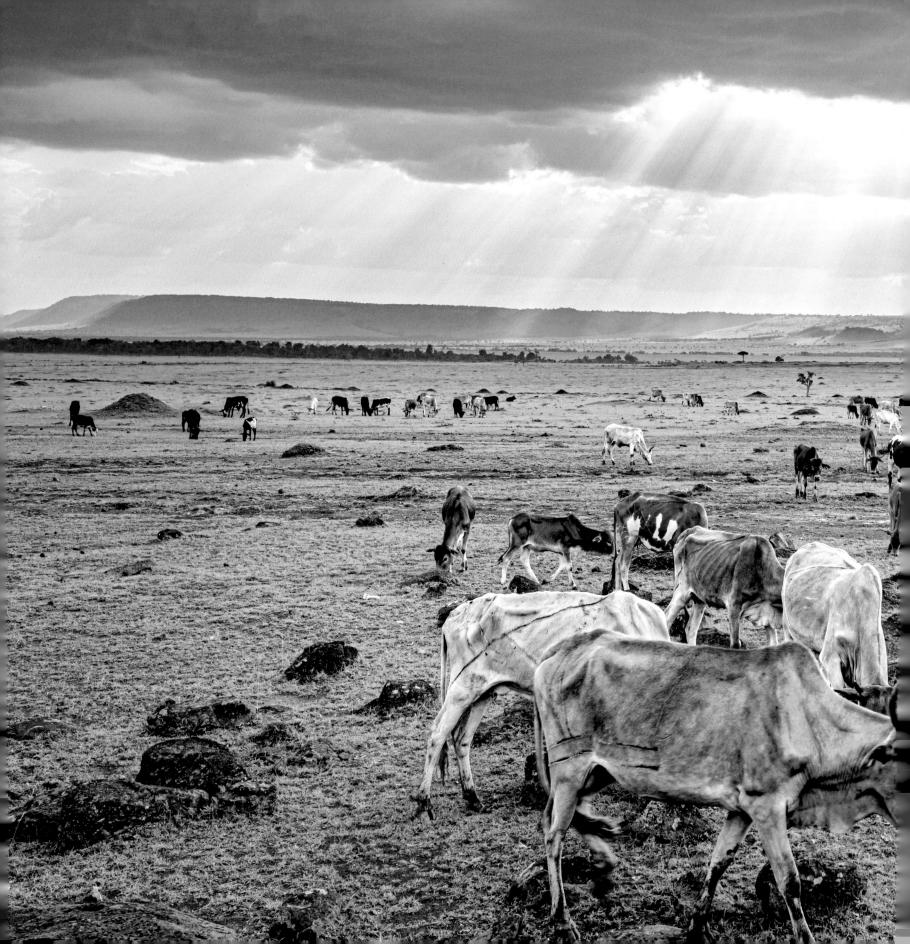

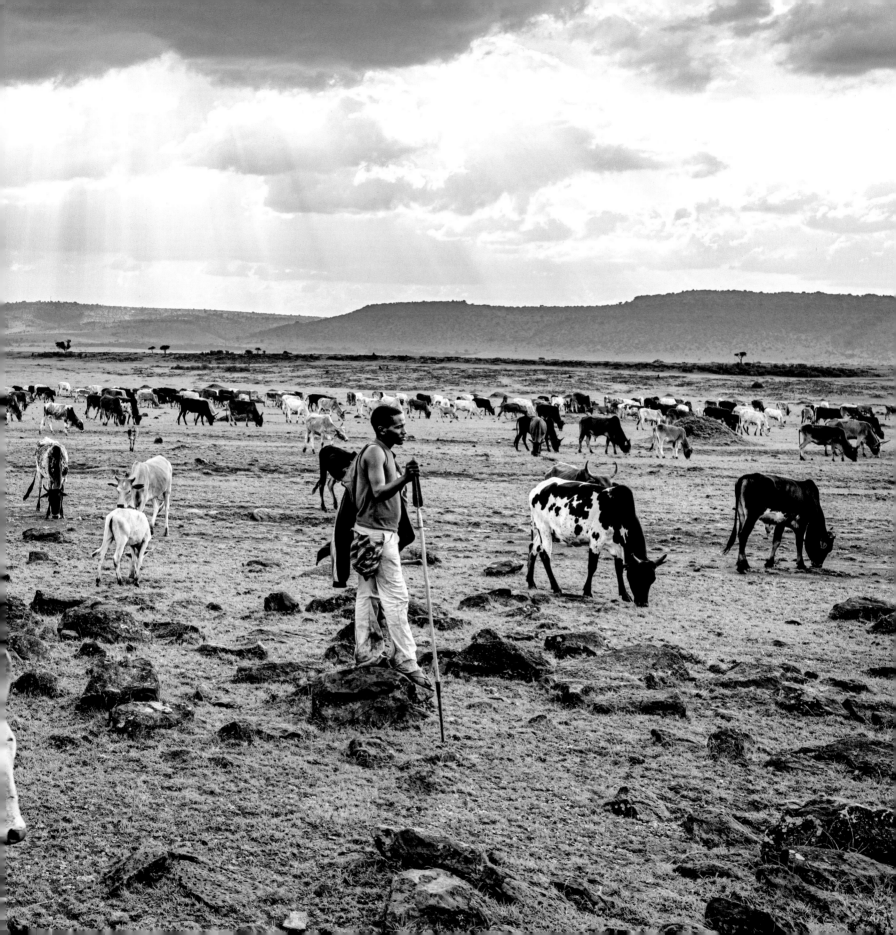

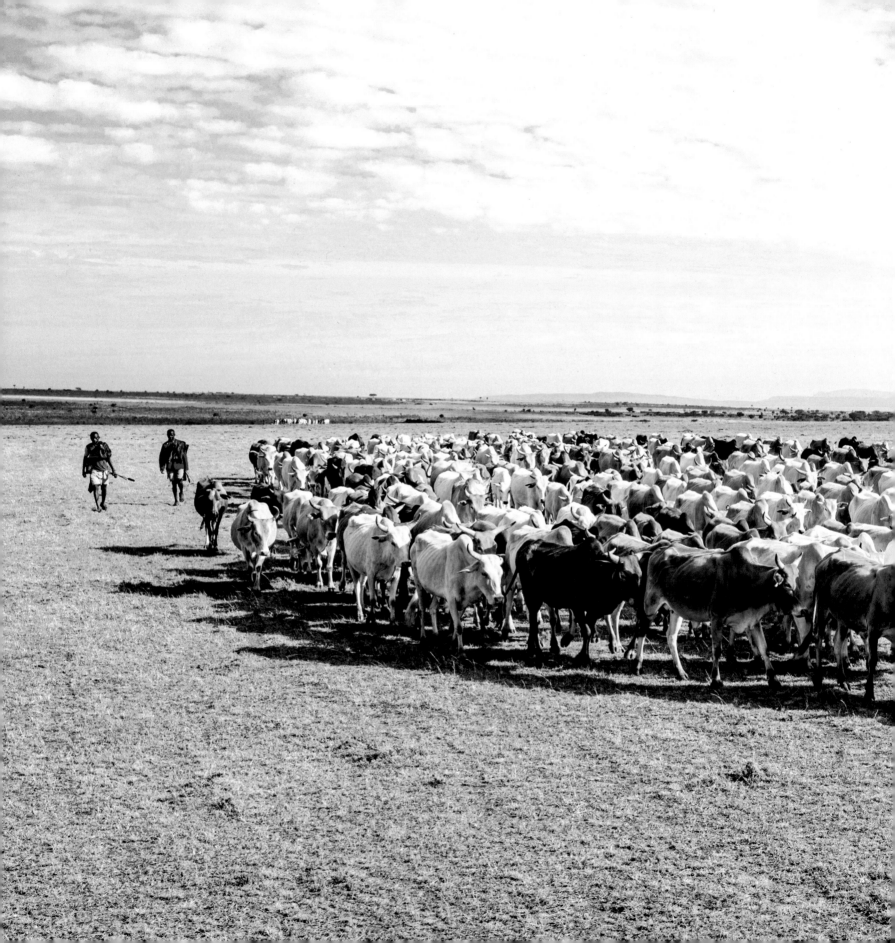

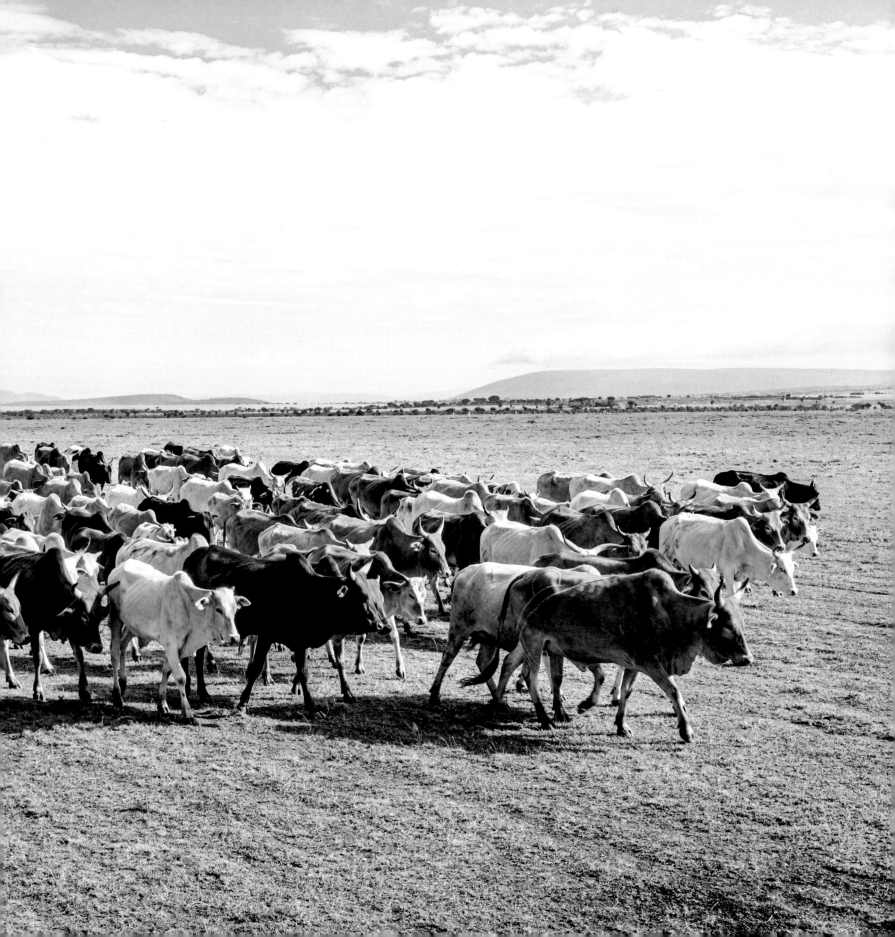

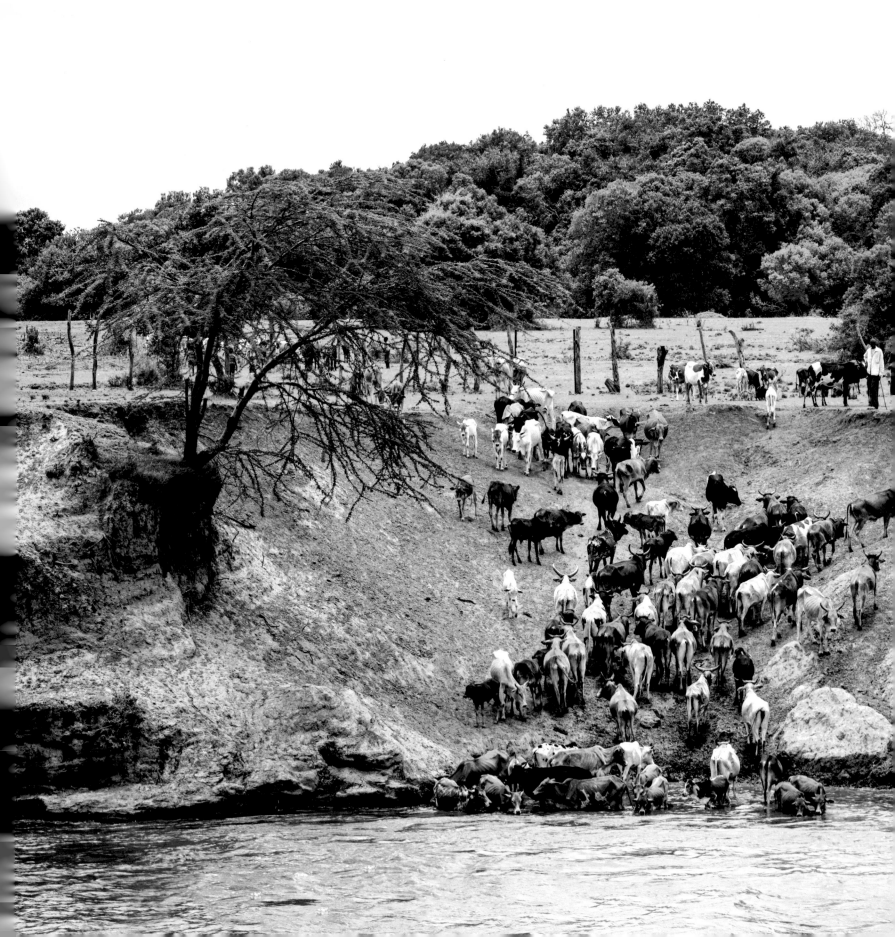

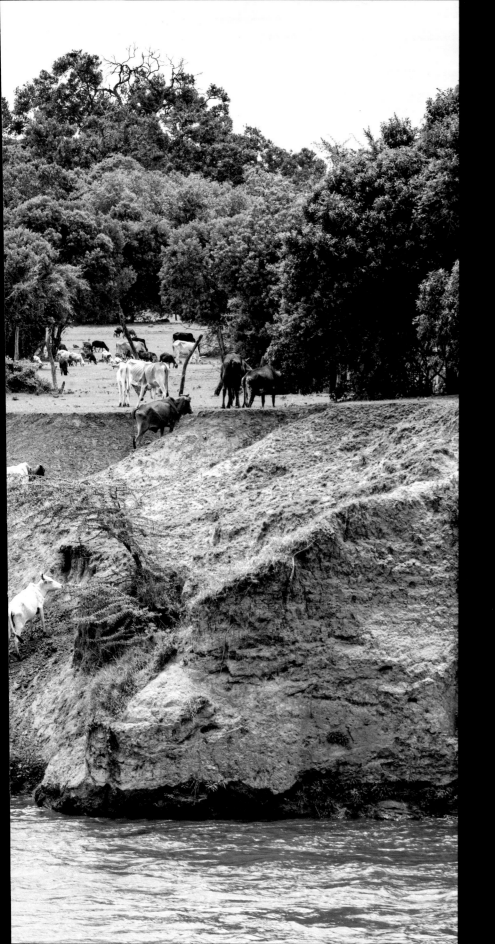

190-191

馬賽男人自幼學習以棍棒武器抵禦進攻的技巧，無論到哪裡都棍不離身。放牧的時候，當牛群都在悠閒進食，手持長矛的馬賽男子靜靜佇立一旁。

Males of Maasai are often seen with a long-stick weapon in hand wherever they go, for they have been learning how to use it for defense or attack since childhood. Even when pasturing, this Maasai man is holding his spear and waiting quietly for the herds to finish eating.

192-193

在牧民的驅趕下，黑白黃三色的家牛混雜成群，整齊地朝著同一方向前進。一望無垠的草原遠處，隱隱約約能看見另一個牧群。

Shepherds are herding a group of cattle in three different colors – black, white, and yellow, all heading at the same direction unanimously. Take a look at the boundless savanna, you are able to vaguely see another herd of cattle far away.

194-195

牛群順著斜坡下到河邊飲水，而牧民則在岸上守候著。

The cattle are drinking water at the river down the slope while the shepherds are waiting on the bank.

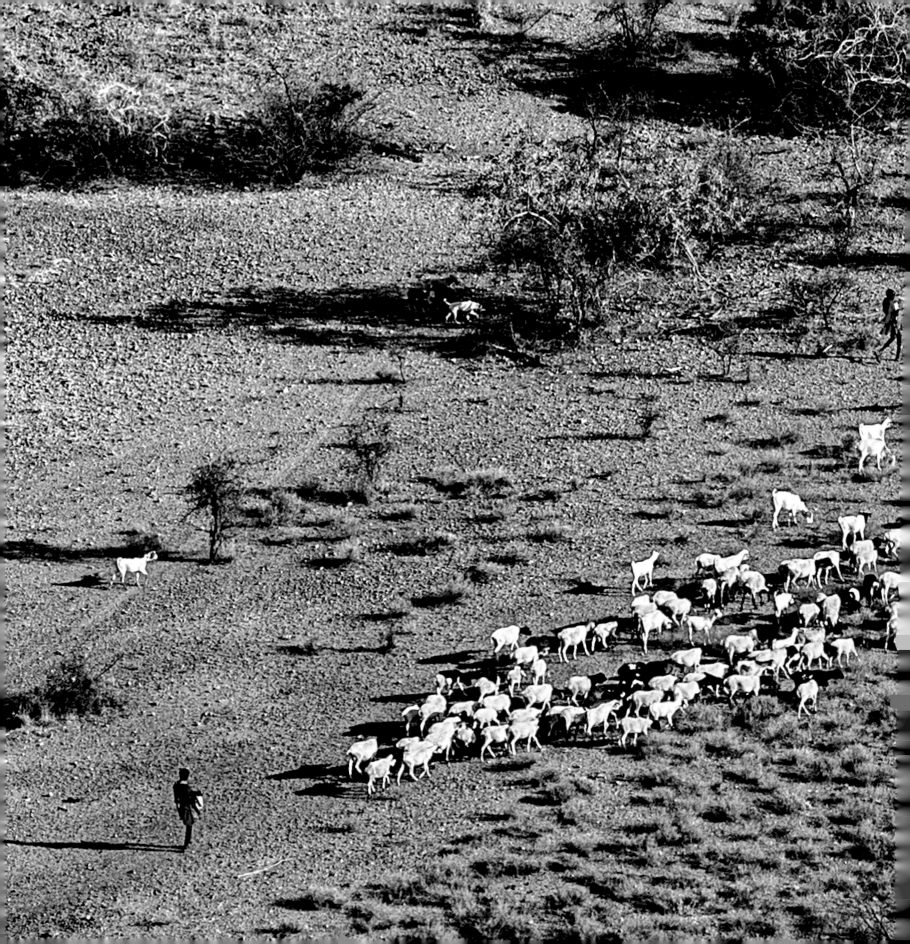

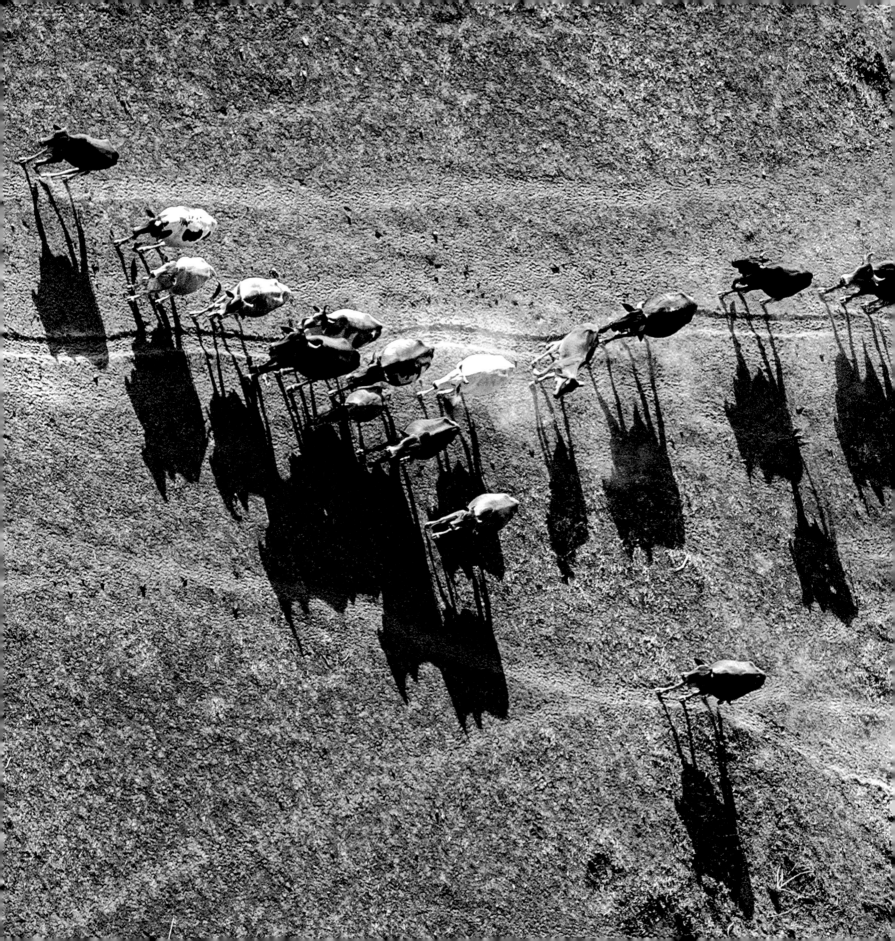

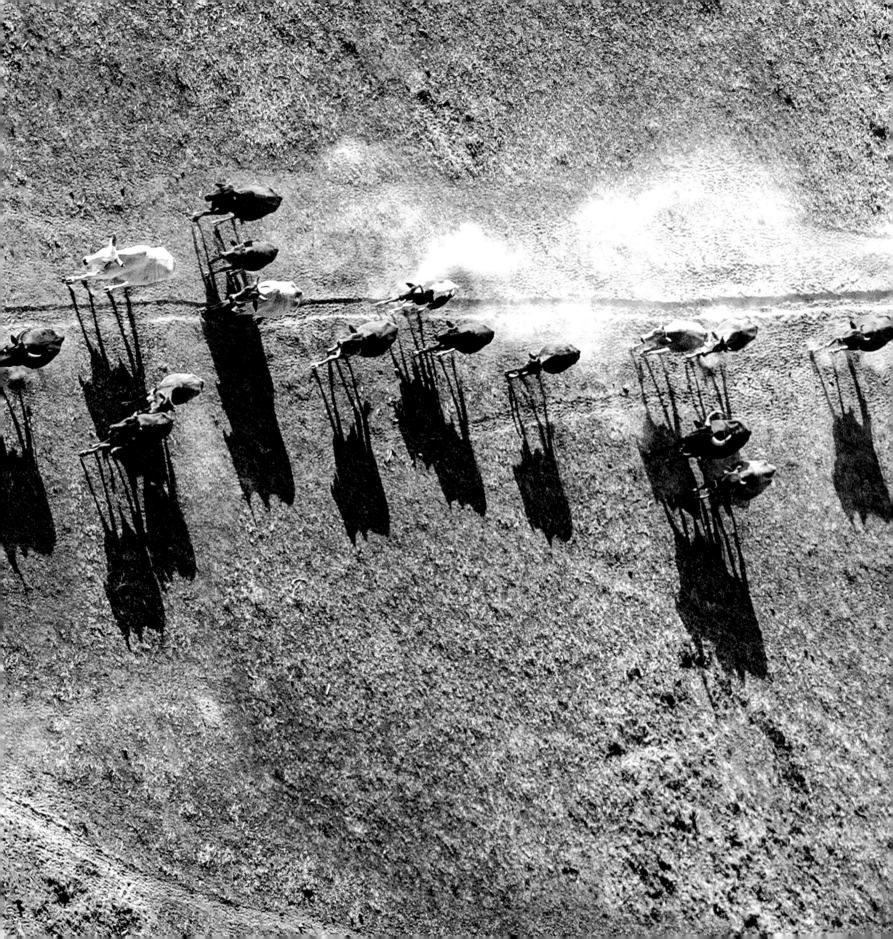

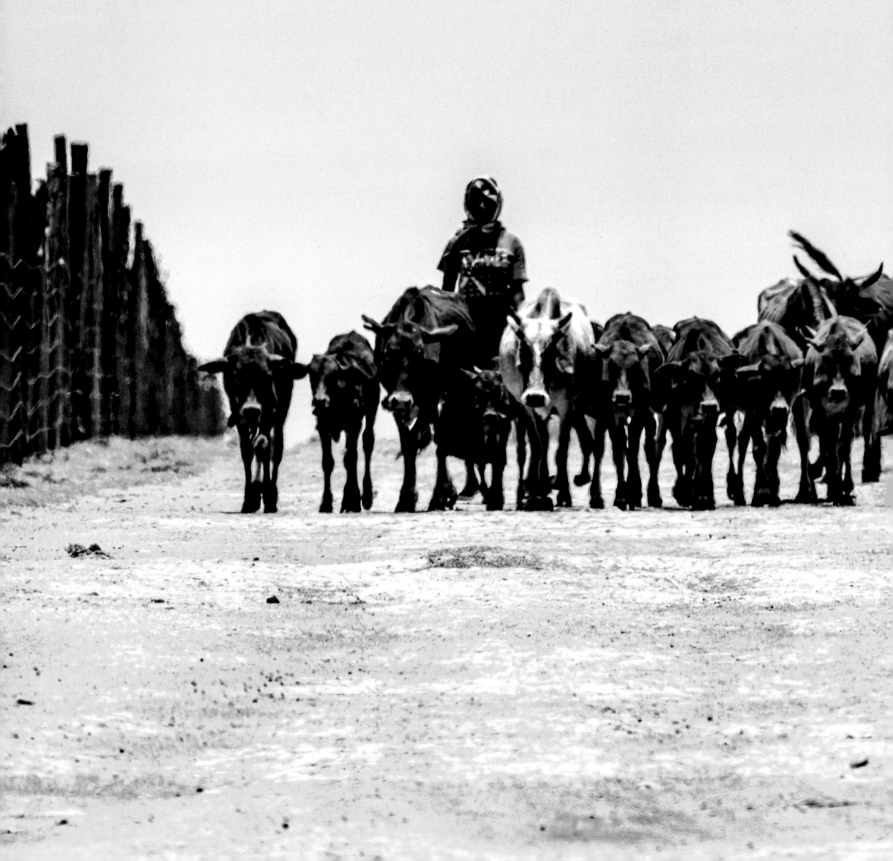

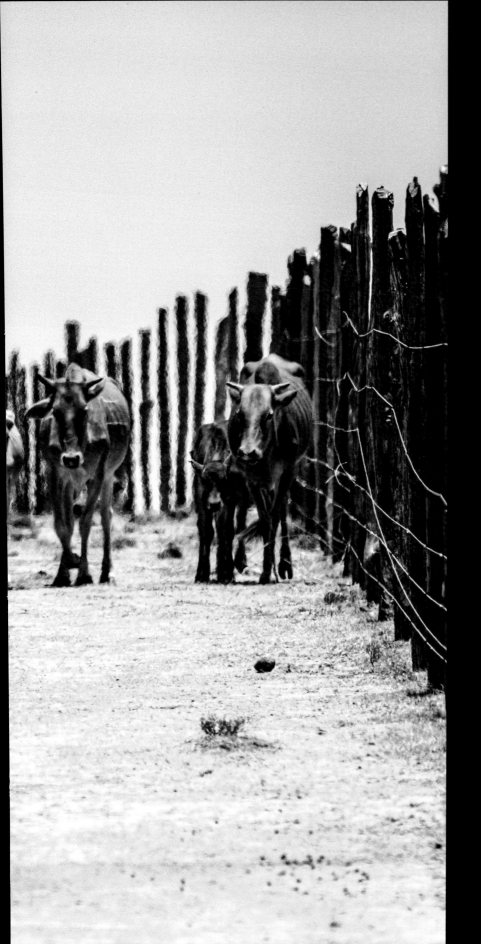

196-197

馬賽人過著逐水草而居的遊牧生活，當季節更替導致水草資源變化，他們也會跟著動物大遷徙的步伐移居。

Maasai are nomads who move their homes along with the great migration of animals when the condition of grassland changes by season.

198-199

牛群順著地上的一條直線前進，偶有幾隻稍微偏離了主隊伍。

The herds are following a straight line on the ground, with several of them slightly deviating from the main queue.

200-201

馬賽人開闢了一條以木柵欄圍著的放牧之路。

The Maasai have opened up a path of grazing by erecting wooden fences on both sides.

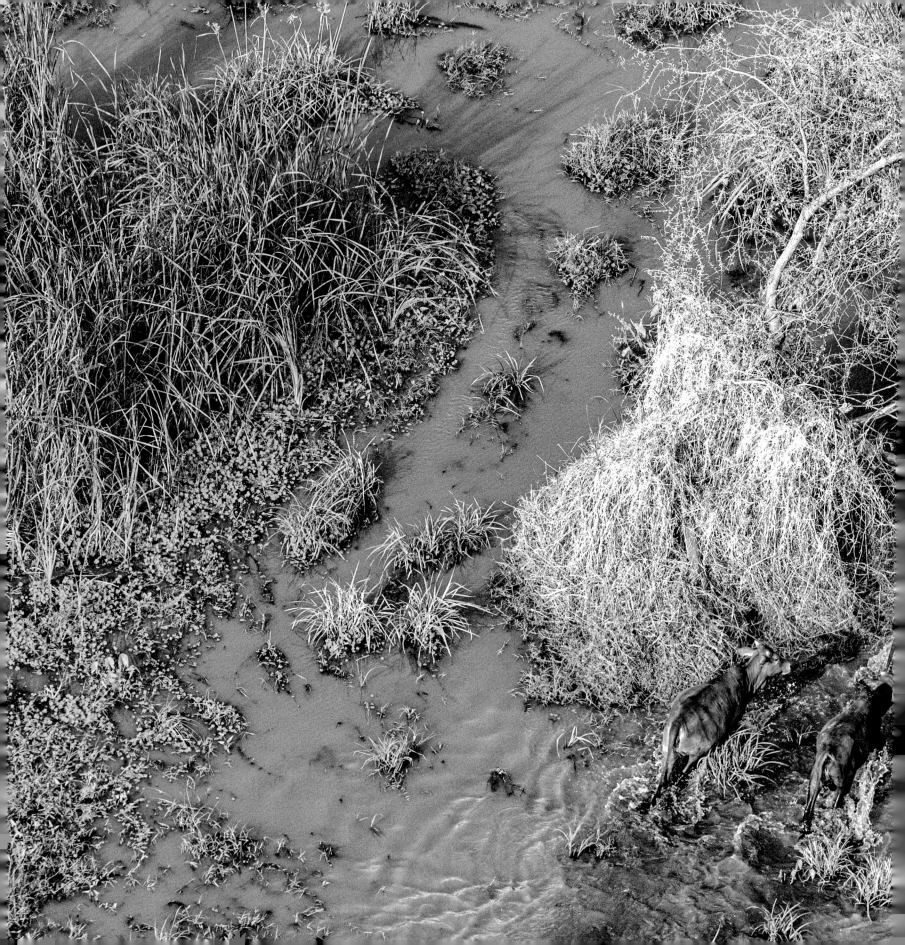

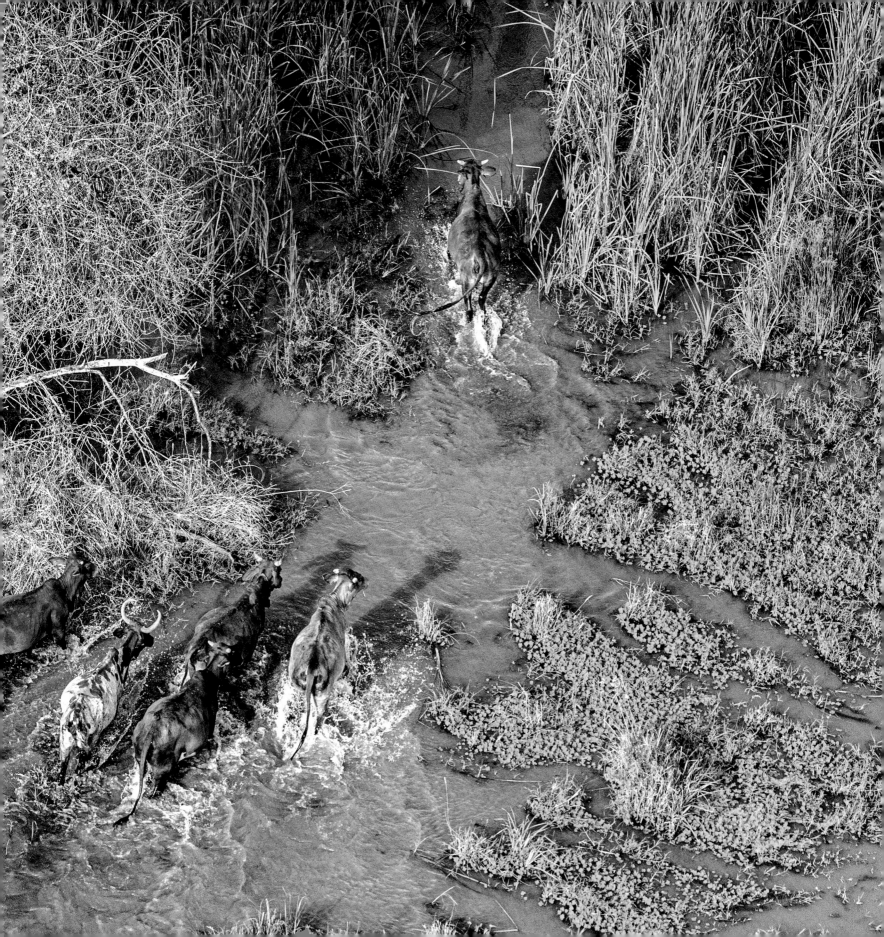

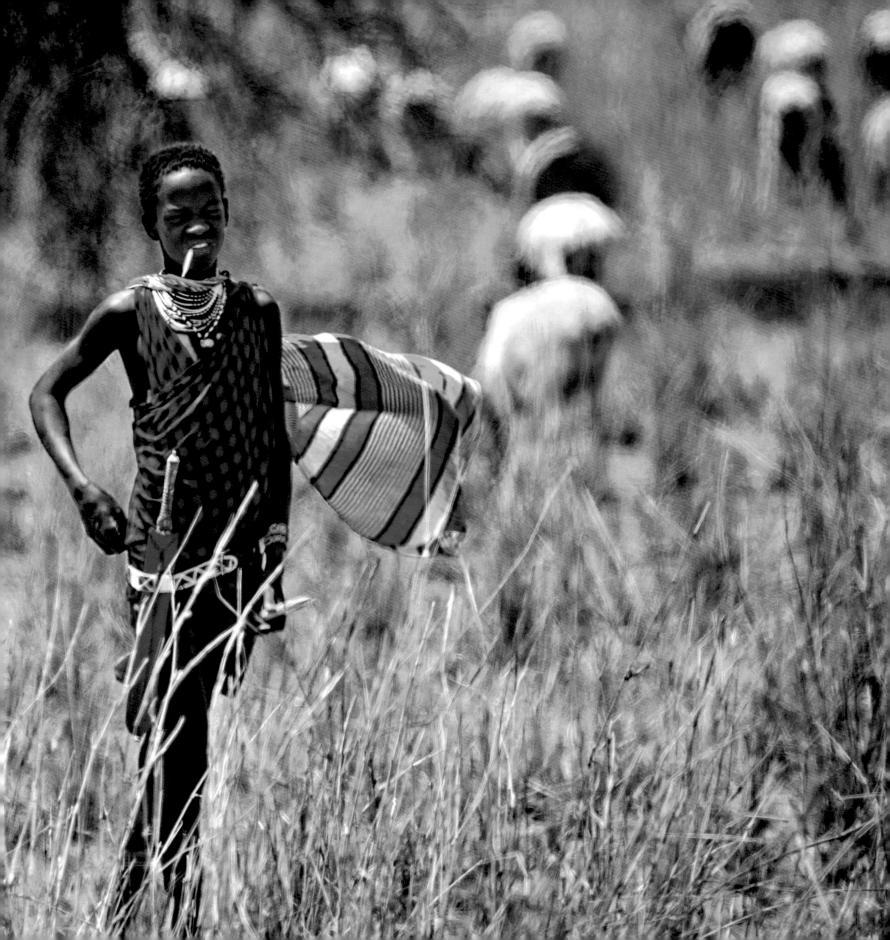

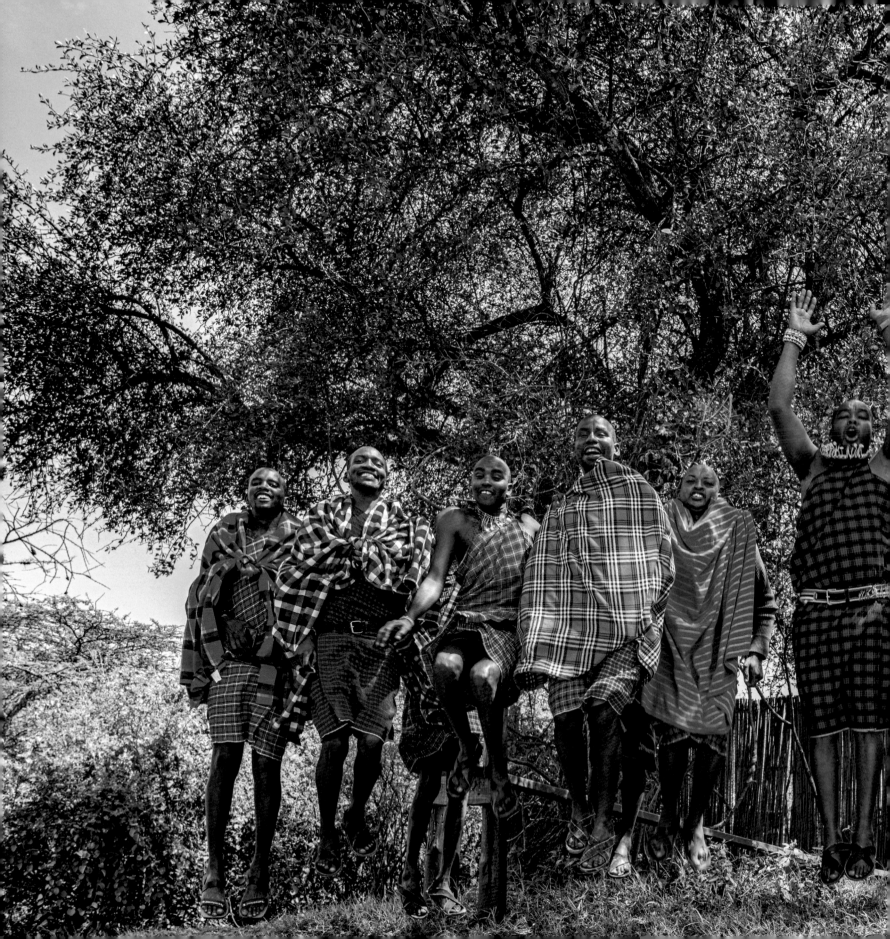

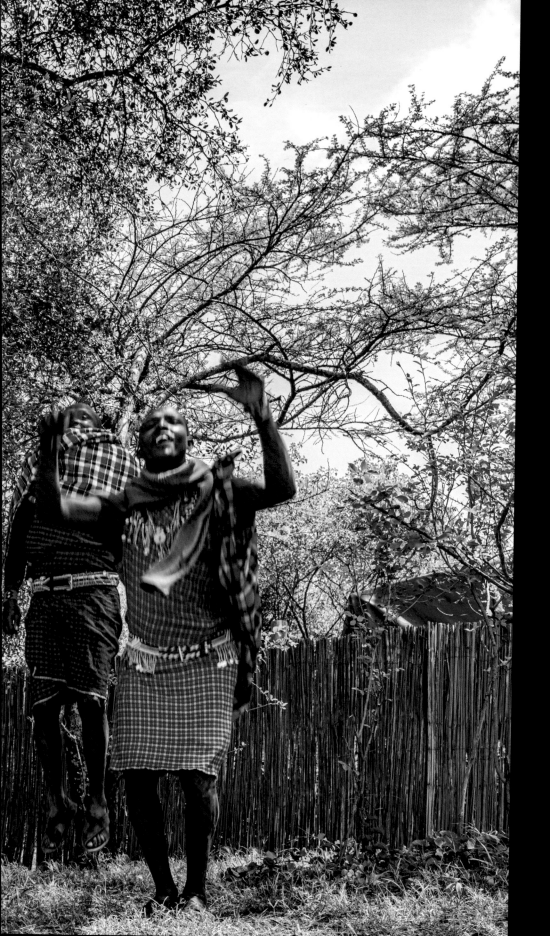

202-203

幾隻家牛在河中飲水之餘，玩起了互相追逐的遊戲。

After finish drinking in the river, several cattles are playing a game of chase.

204-205

一位牧童身上穿著馬賽服飾中最常見的元素——格紋布料，腰間掛著一把短刀。

Checkered cloths are commonly used among Maasai clothing – a shepherd boy is wearing one with a dagger hanging around his waist.

206-207

馬賽人傳統的跳高舞，讓人聯想到田園交響曲第三樂章——「鄉民的快樂集會」，結束一天的工作的村民隨著歡快的節奏起舞。

The traditional jumping dance of Maasai resembles that of the third movement of Pastoral Symphony – "Merry gathering of country folk", depicting off-work Maasai dancing with cheerful beats.

田園交響曲的最終樂章——「天晴後牧
羊人的感恩之歌」，像是對馬賽人的真實
寫照。他們對自然的恩賜總是心存感恩，
即使面對困難也能保持微笑，這裡的孩
童即使不如都市長大的同輩一般有眾多
娛樂方式，亦能怡然自得、樂觀向上。

The final movement of Pastoral is the
"Shepherd's song", expressing the
cheerful and thankful feelings after a
storm. The spirit of Maasai is somehow
the perfect embodiment of it. They
are always thankful to nature and
maintaining a smile even when facing
up to difficulties. Children here, even
without the assorted games enjoyed
by their peers in the cities, stay self-
entertaining and optimistic all the time.

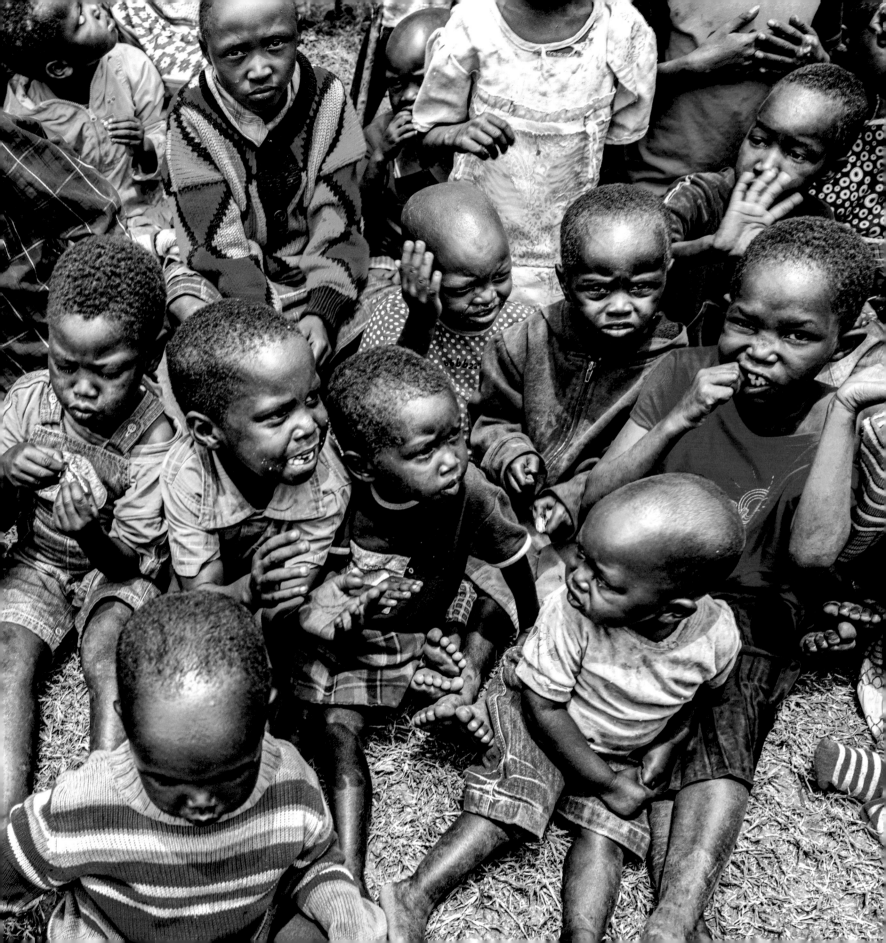

豔麗的顏色是馬賽人標誌性穿著特徵，他們相信紅色能夠驅逐野獸，因此紅衣最為常見。（左）馬賽女性通常為光頭或只留極短的頭髮，身上掛滿五彩繽紛的飾物，再吊上反光金屬片，讓人眼花撩亂。據說飾物隨著年齡遞增。（右）

Bright colors are the signature of Maasai clothing. They love red clothes for they believe this color can drive away beasts. (Left) Maasai women keep their heads bald or with extremely short hair. They wear colorful and dazzling accessories made up of colorful beads, hung with reflective metal plates. The older a Maasai woman becomes, the more accessories she wears. (Right)

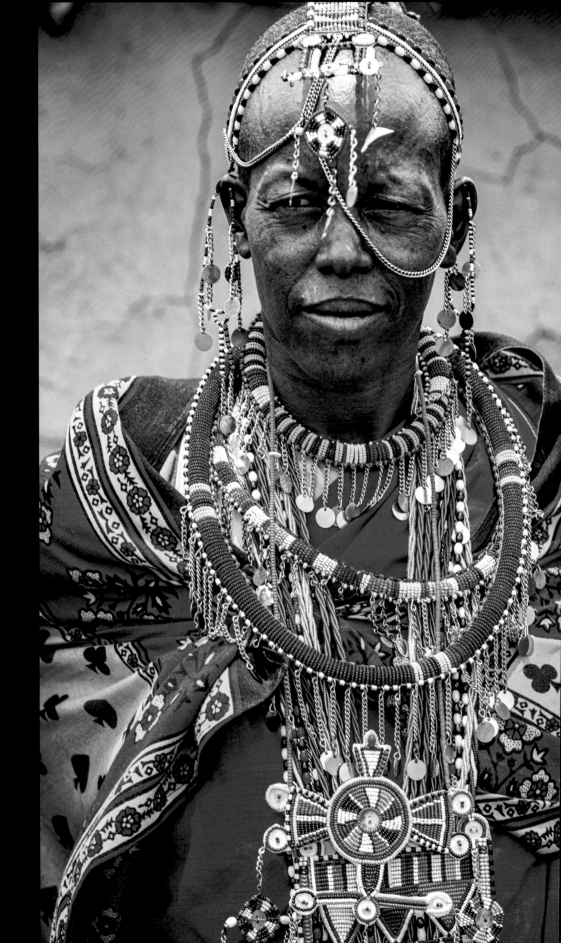

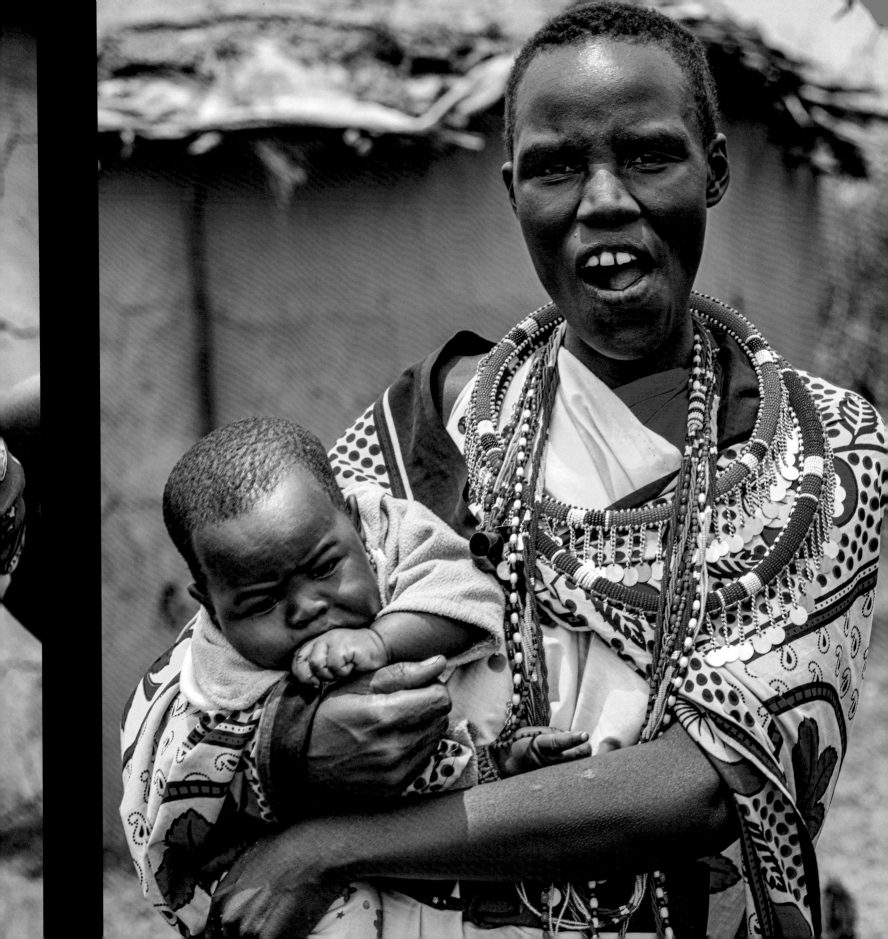

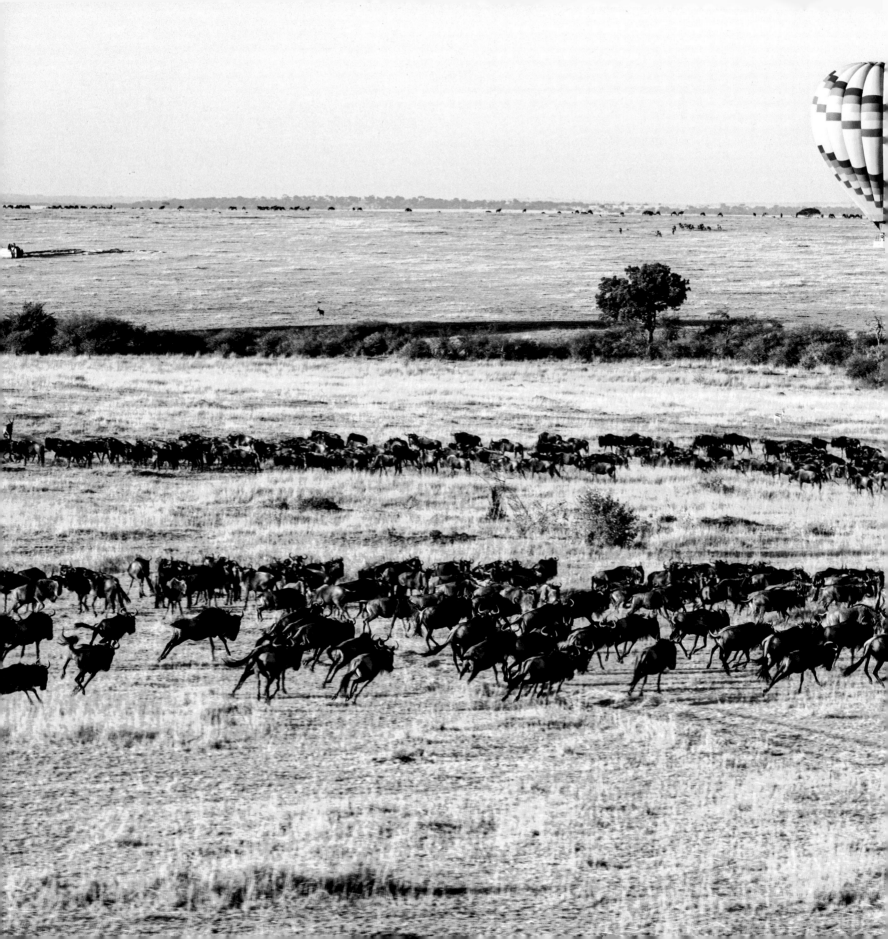

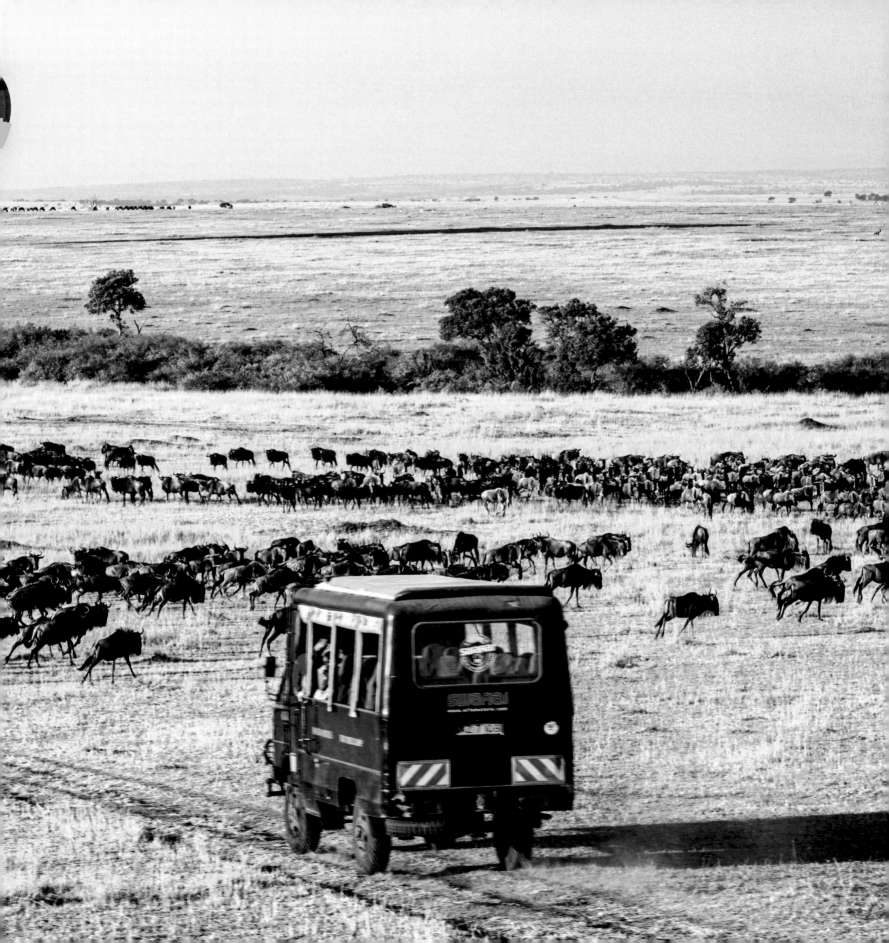

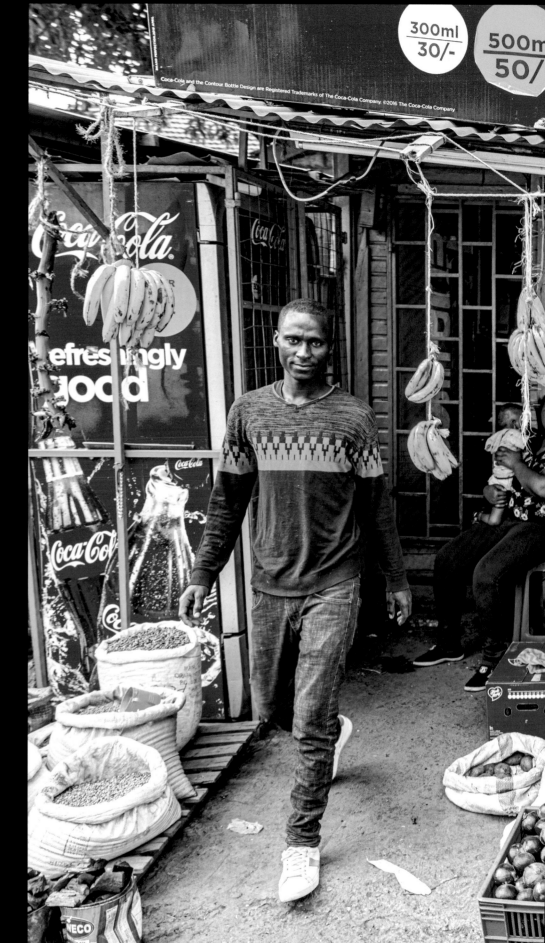

212-213

非洲的野生動物之旅始於 19 世紀，當時實質上是一場大型狩獵活動。隨著動物保護受到日益增長的關注，旅途的主要活動逐漸轉變為觀賞。

Safari trips originated in the 19th century, and at that time, it was substantially a big-game hunt. With growing attention towards animal protection, however, the journey now is more about observation and sightseeing.

214-215

肥沃的土壤和適宜的氣候賦予東非豐盛的水果產量，香蕉、芒果、熱情果等熱帶水果在此能以頗為低廉的價格買到。

East Africa, endowed with rich lands and suitable weather, abounds with fruit. Here one is able to buy tropical fruits such as bananas, mangoes and passion fruit at a low price.

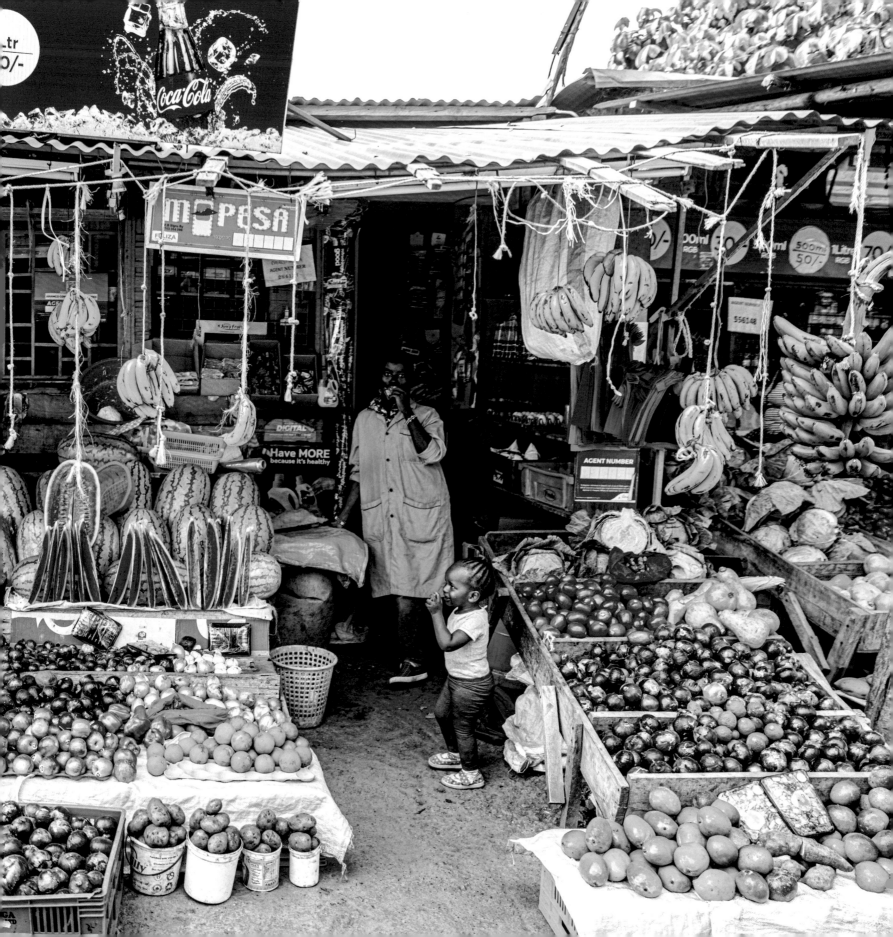

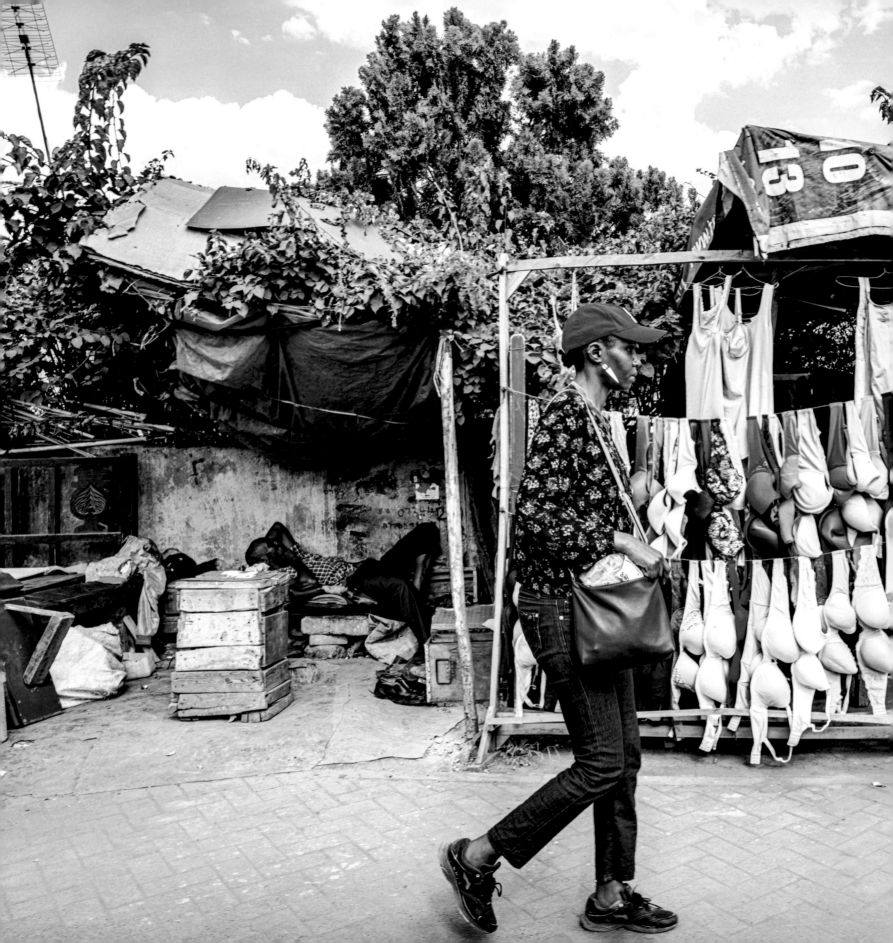

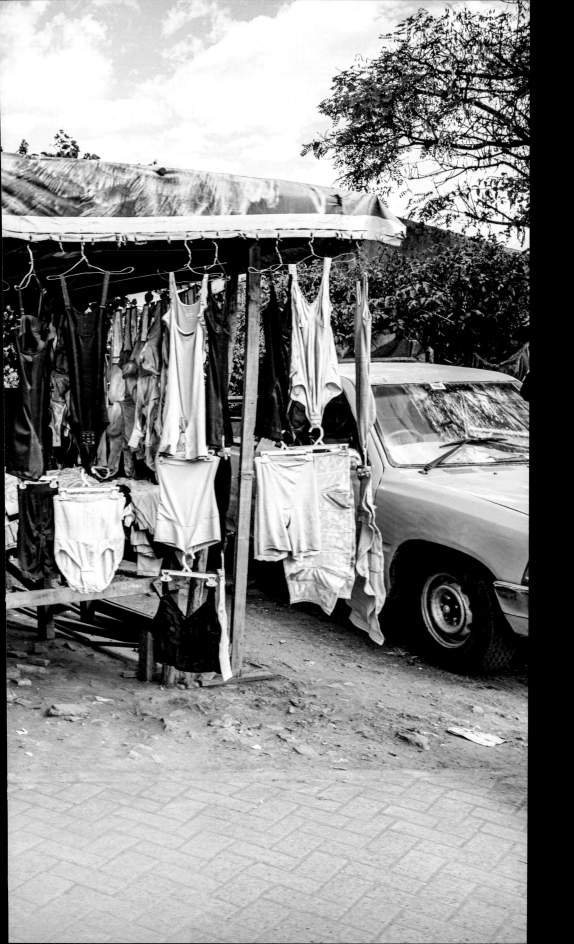

216-217

許多鄰近自然保護區的商舖僅以簡易的木架支撐而起。

The stores at the periphery of nature reserves are primitively built by several wooden sticks.

218-219

人類與動物在大自然中互惠共存，共享田園風光及資源。隨著經濟發展，周邊城市亦建設有不少高樓大廈，例如肯亞的首都及最大城市奈洛比。

Human and animals are living harmoniously in nature. Economic growth has brought modern buildings into cities, such as Nairobi, the capital and largest city in Kenya.

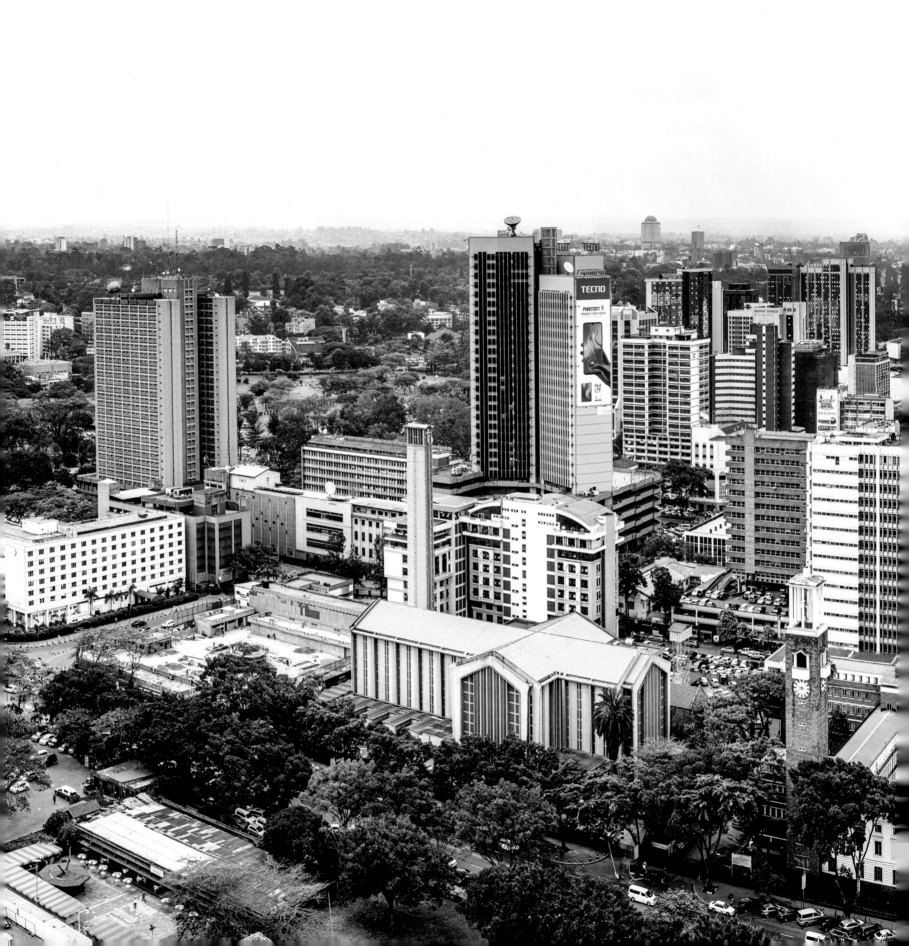

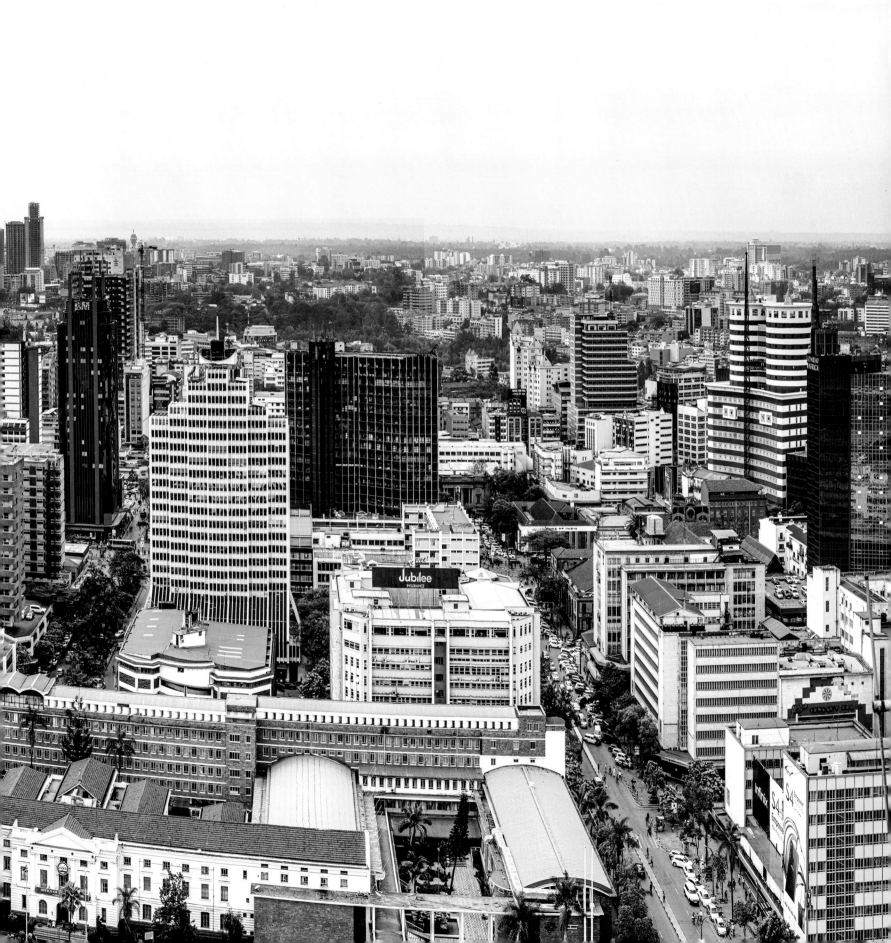

# 歡樂
# ODE TO JOY

近鏡之下變化豐富的色彩與形狀

Close-up shots of the ever-changing colors and shapes

# 歡樂
# ODE TO JOY

1785 年，德國詩人席勒為歌頌友誼而創作了《歡樂頌》，繼而在 1803 年進行改寫，把主題昇華為對自由、博愛的歌頌。貝多芬作為席勒的崇拜者，很早就有將這首詩篇改編為音樂作品的想法。

在 1822 至 1824 年間，貝多芬終於在其生平所完成的最後一部交響曲——D 小調第九交響曲的第四樂章中，融入了《歡樂頌》，經過莊嚴、活潑、沉穩的前三樂章的鋪墊之後，情緒的累積在最後一個樂章中得到釋放，譜寫出人類對自由、平等、和平的嚮往。這首帶有傳奇色彩的作品，是貝多芬在完全失聰之後所創作的宏大傑作，是他最真實、最純粹從心而發的靈感，更突破性地在交響樂中加入了人聲合唱，因此亦被稱為《合唱交響曲》。

這首作品不但對眾多後世的作曲家影響深遠，其第四樂章更被歐盟採用為盟歌。2001 年，聯合國教科文組織將德國柏林國立圖書館收藏的《第九交響曲》手稿列入了「世界記憶名錄」當中。

若是在自然界中找尋最適合表現這首交響曲主題的物種，相信非雀鳥莫屬。牠們展翅高飛的形象是自由的最佳象徵，在聚居群體中恪守本分的牠們亦深諳和平共處的重要性。也許正因此，在人們的眼中，牠們總是處於一種理想的歡樂狀態之中。

本章以東非的雀鳥為主體，捕捉牠們或飛行或休憩的種種瞬間，配以色彩或型態上獨特的背景，構成的是一幅幅彷如畫作般的相片。

In 1785, German poet Friedrich Schiller composed an ode in praise of friendship, and later in 1803, slight changes were made to transcend the essence to commend freedom and philanthropy, becoming the "Ode to Joy" we are familiar with today. As a fan of Schiller, Beethoven had been trying to create a derivative music piece out of this poem.

Eventually between 1822 and 1824, in his last completed symphony the Symphony No. 9 in D minor, Beethoven had based the fourth movement on "Ode to Joy" after building up solemnity, liveliness and profoundness in the first three movements. The combined emotions have climaxed in the final movement, to emphasize the desire for freedom, equality and peace. This legendary masterpiece was composed after he had completely lost his hearing, expressing the realest and innermost sentiment in his mind. The addition of the final chorus was truly a breakthrough in symphony composing; therefore, it is also called "Choral Symphony".

Having far-fetching influence on so many composers of later generations is simply the first effect of Choral Symphony. Its fourth movement is also the organizational anthem of the European Union. In 2001, the original manuscript kept in the Berlin State Library, Germany, was registered in the United Nations' Memory of the World Program.

If one is to choose an endorsing animal for this symphony, birds, will definitely stand out. Their flying figures with wings expanded widely are the perfect representation for the pursuit of freedom; they respect the importance of harmony by abiding by certain rules in the social group they belong to. In the eyes of humans, birds always stay high-spirited as if they have already achieved the idealistic happiness.

This chapter is mainly about birds in East Africa. They are flying over or resting at colorful or uniquely shaped backgrounds. The photos capturing these sceneries are surreal enough to imitate actual paintings.

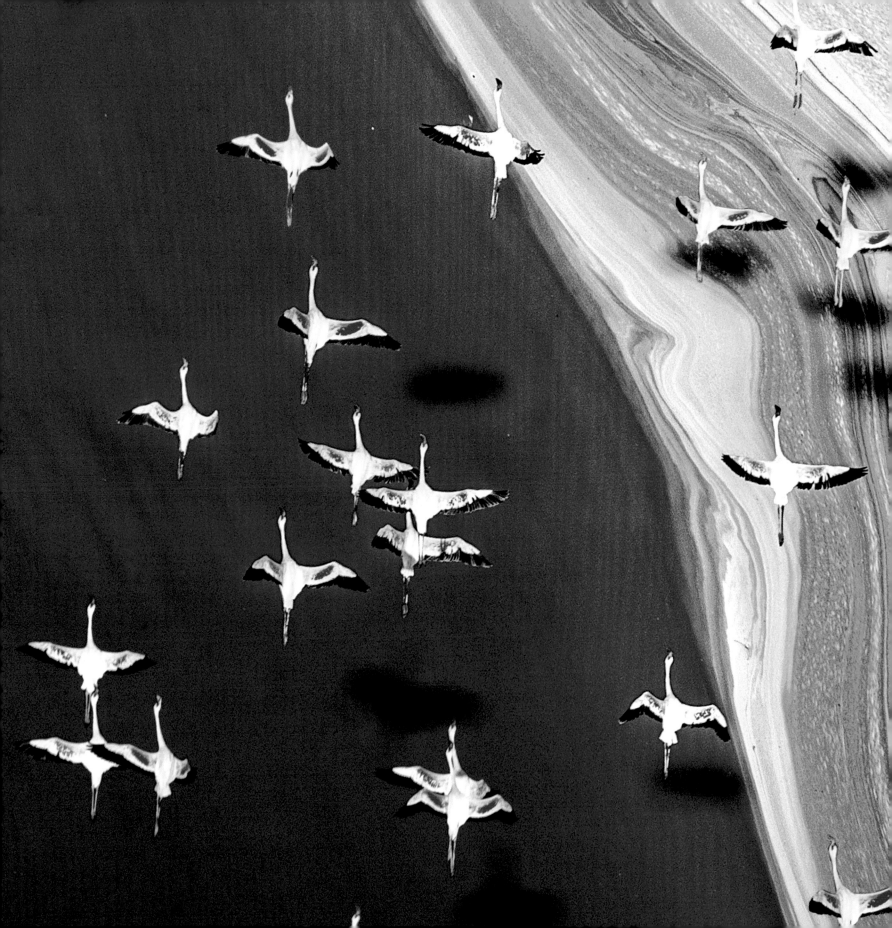

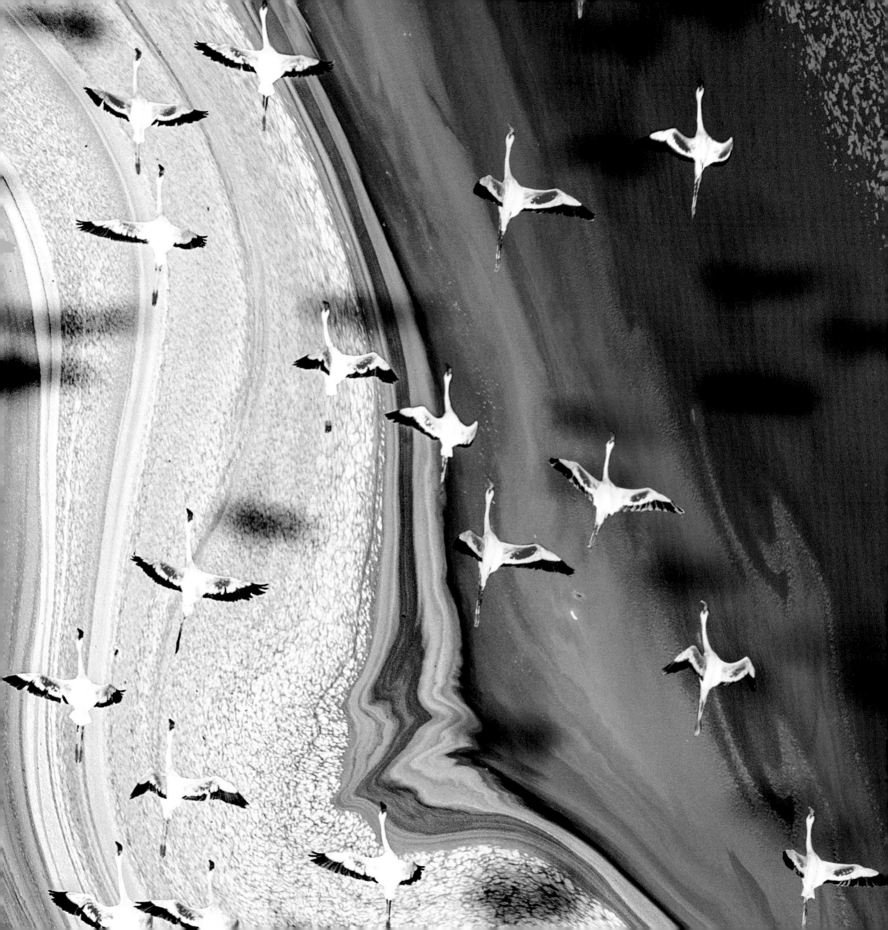

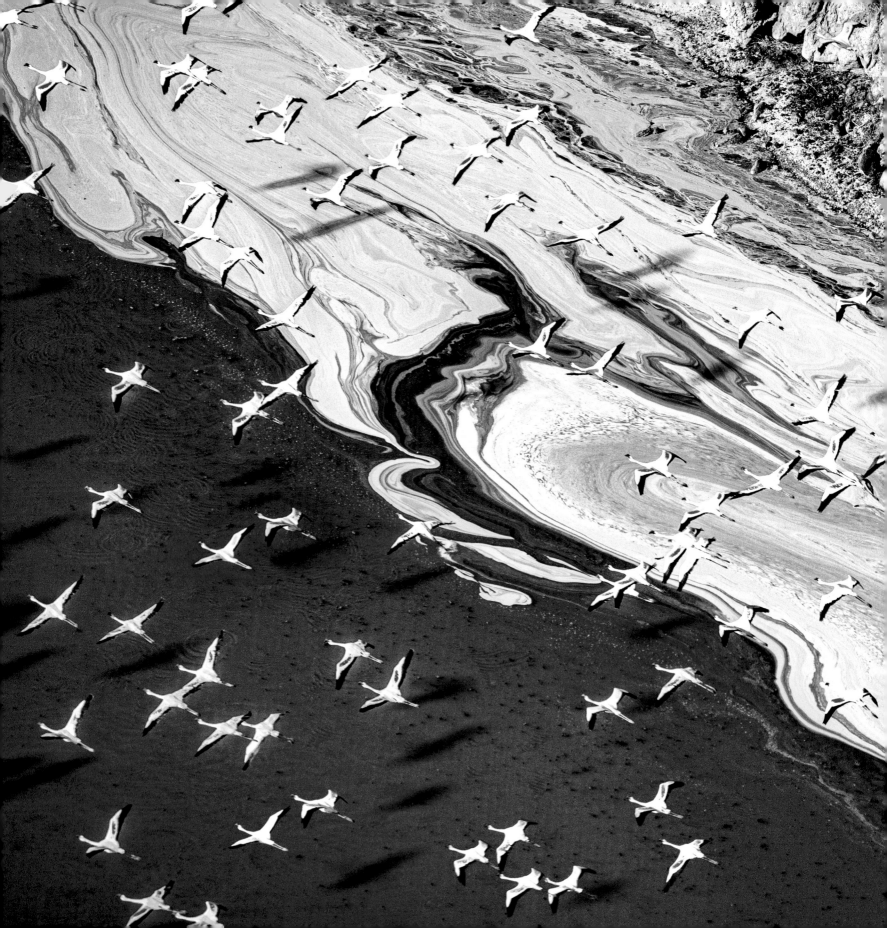

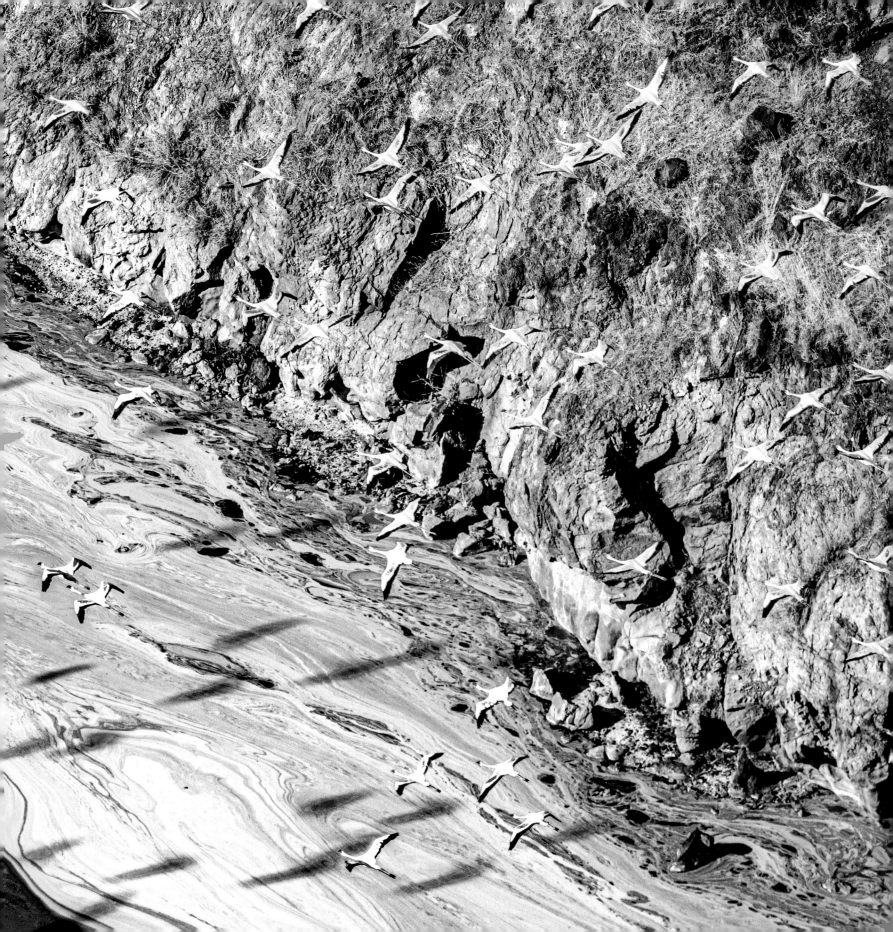

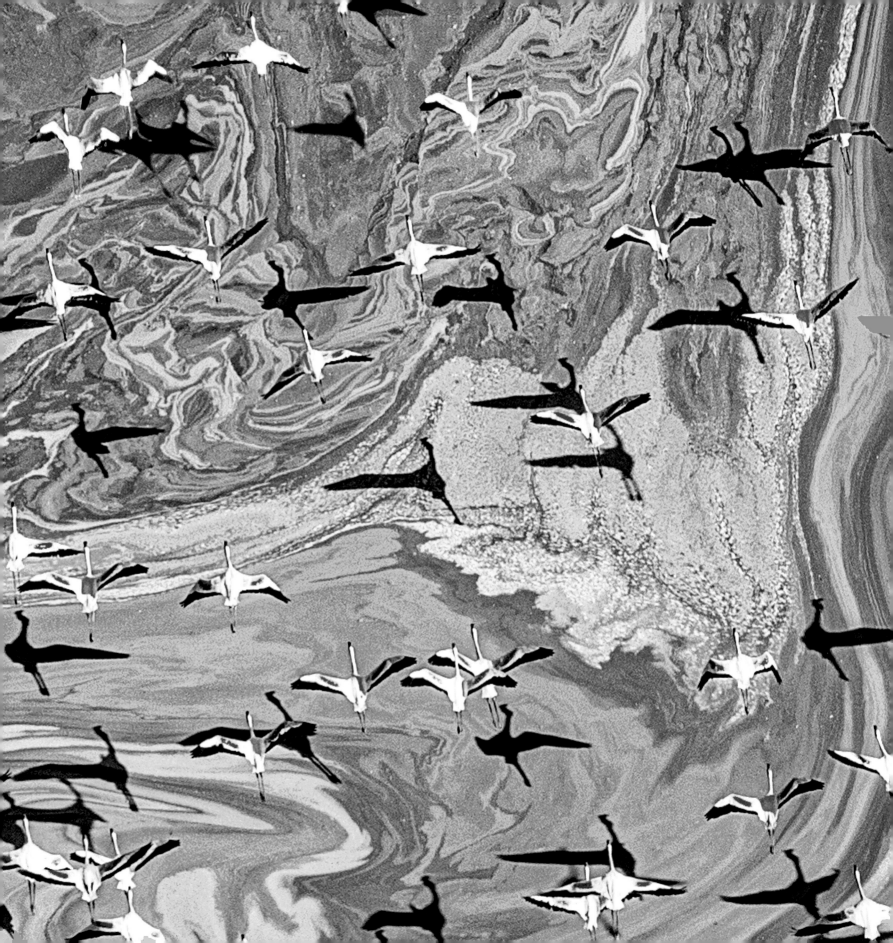

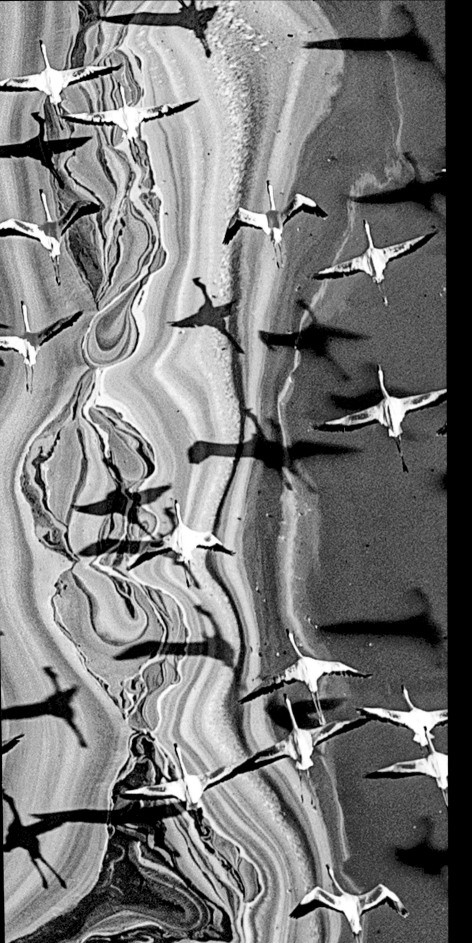

224-225

如流沙般的沉積鹽以優美的線條把馬加迪湖分成碧綠與幽藍兩個部分，綴以數十隻翩翩而過的小紅鶴，彷彿一幅油畫般讓人賞心悅目。

The sand-like deposits have divided Lake Magadi into two parts – one in aquamarine and the other in aegean blue. The nature has decorated the scene with dozens of flying lesser flamingos, creating a stunning painting in front of us.

226-227

岩壁邊漂浮了一層奶白色的沉積物，乍看之下彷彿小紅鶴來到了一個度假海灘。

A layer of milky-white deposit is floating at the edge of the rocks, which, at a glance, looks like a beach resort for flamingos.

228-229

碳酸鈉結晶的不規則線條排列，猶如經過精心設計的咖啡拉花藝術一般。

The irregular and curvy arrangement of soda ash look like the work of elaborately designed latte art.

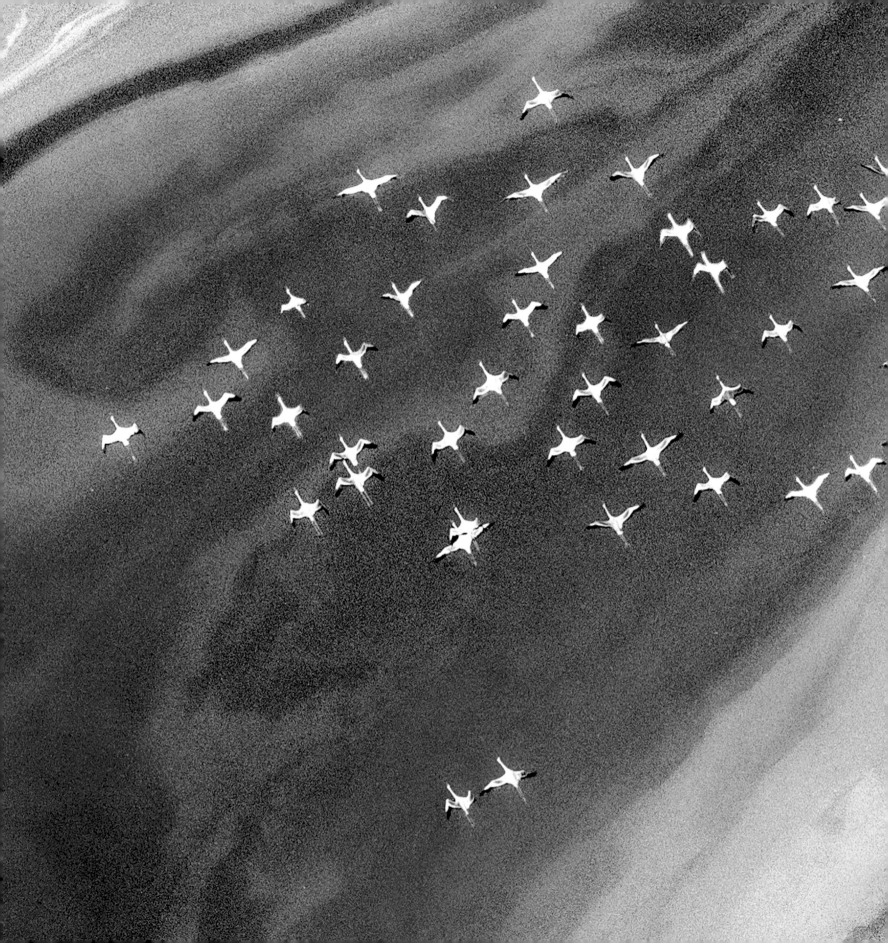

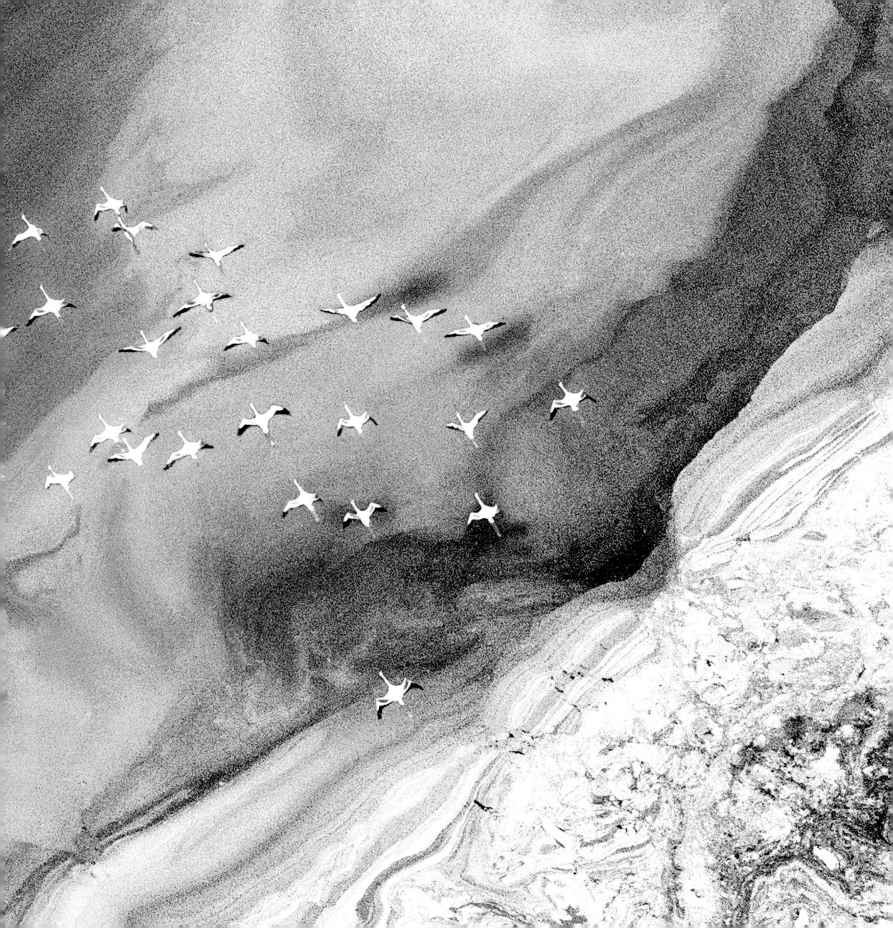

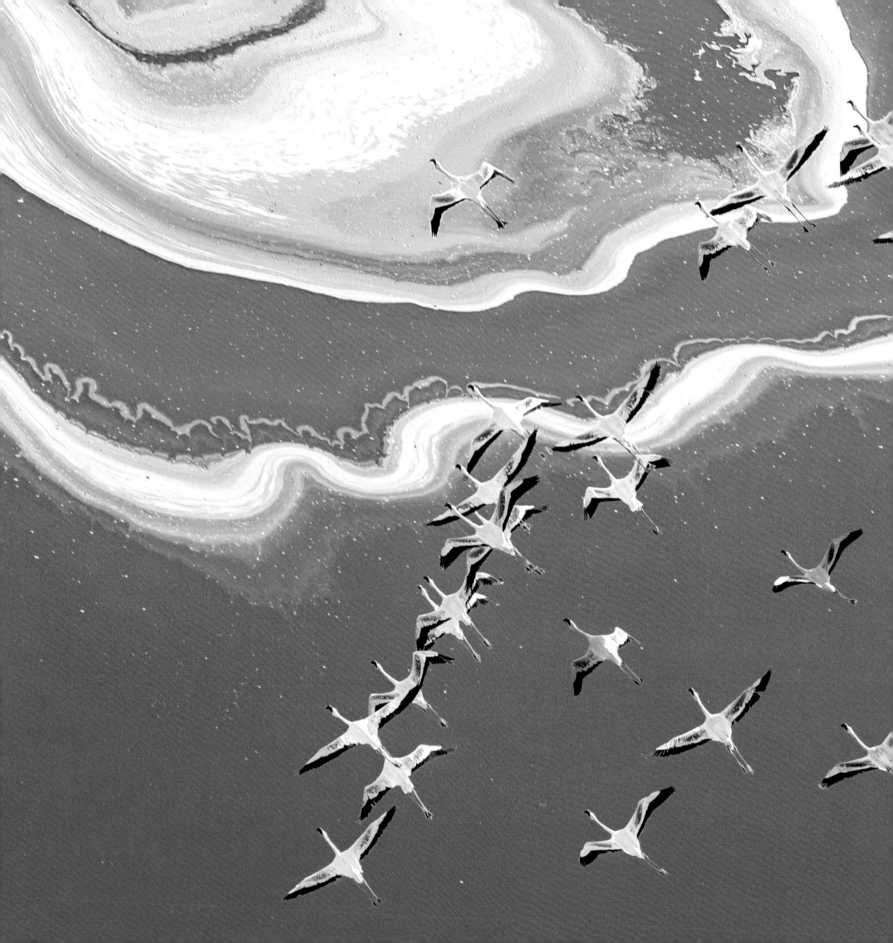

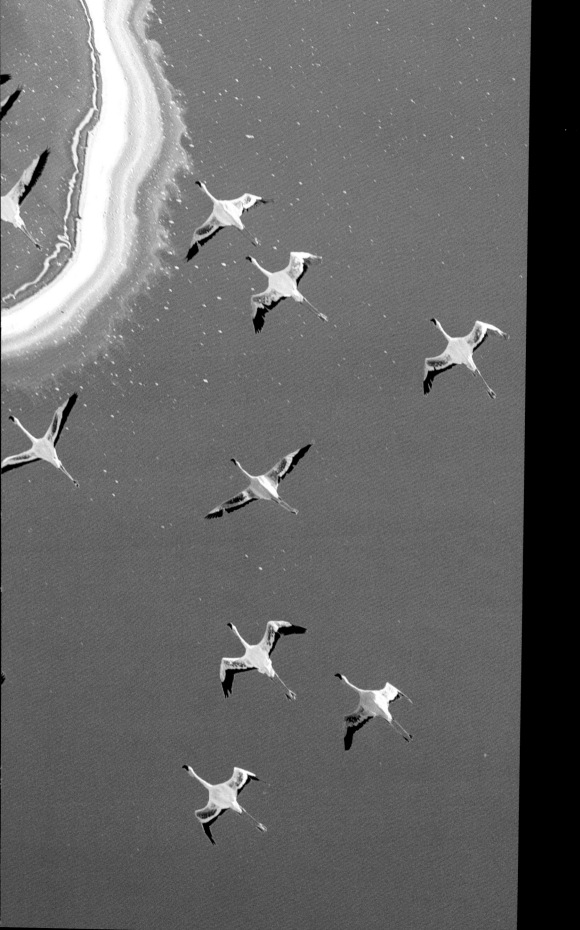

230-231

碳酸鈉的晶體透著銀白色，在光線反射
之下像是璀璨的鑽石。

The silver and white crystals of sodium
carbonate are shining like diamonds.

232-233

豆綠色湖水上泛著白沫，猶如一碗剛剛
泡好的綠茶。

The view of white foams floating on
the sage green lake looks like a cup of
freshly brewed green tea.

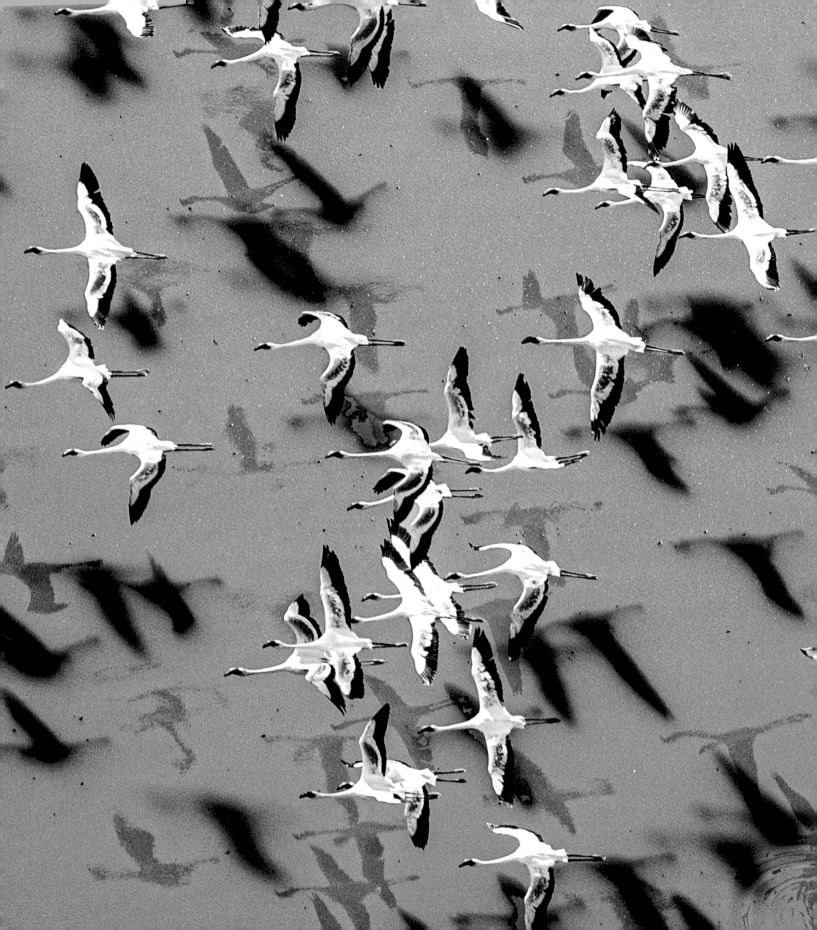

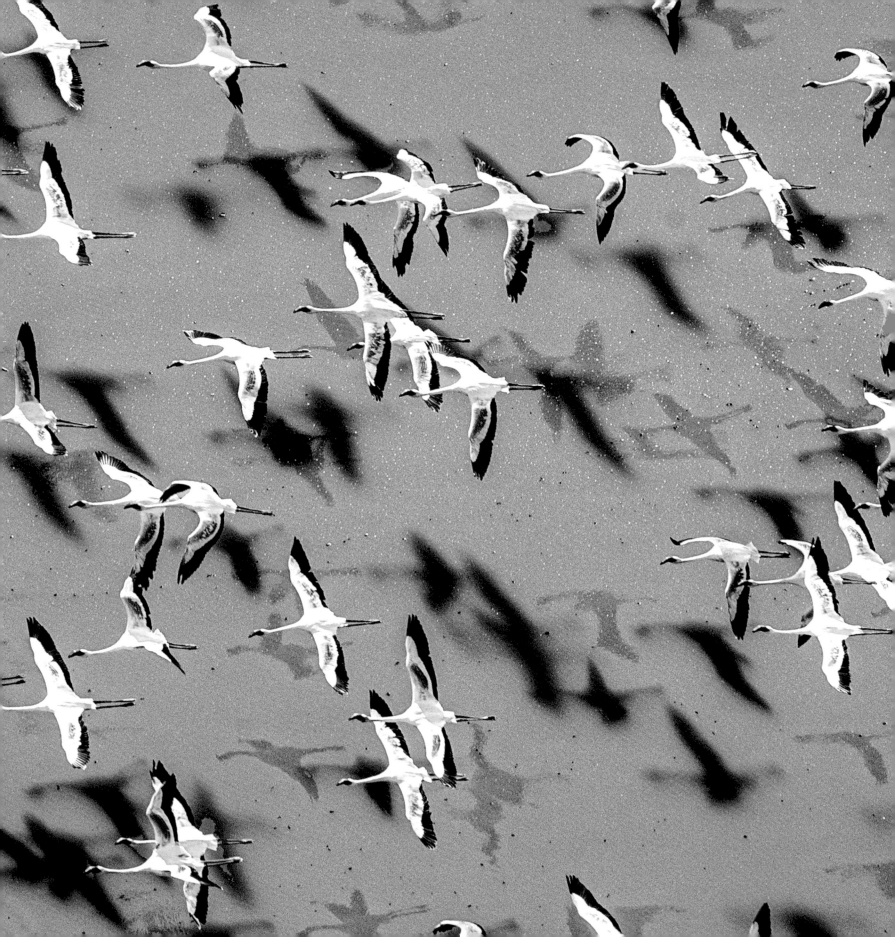

234-235

低空掠過的小紅鶴同時看見水中的倒映及水面的陰影，一定感到十分有趣。

It must be interesting for the lesser flamingos to see both their reflections and shadows at the same time while skimming over the lake.

236-237

非洲大裂谷附近的幾個鹼性湖在旱季面積顯著減少。在九至十月旱季接近尾聲之際，小紅鶴會聚集在這幾個高鹽度的鹼性湖產卵。陽光照射著站立在淺灘中的小紅鶴群，投下了一個個猶如四分音符般的倒影。

The sizes of the several soda lakes around the Great Rift Valley decrease substantially during dry season. Every September to October, when the dry season comes to an end, lesser flamingos gather at these lakes to lay their eggs. Under the sunlight, the shadows of the lesser flamingos in the shallow resemble the shapes of quarter notes.

238-239

陽光照射較少的湖水部分彷彿每隻小紅鶴有兩個倒影，而當陽光逐漸把湖水照亮，才發現原來其中一個「影子」為倒影。每一隻停降於此的小紅鶴，都在身後留下了數個波紋，波紋邊緣閃爍著點點金光，耀目之極。

There seem to be two shadows for each lesser flamingo in the areas with less sunlight. But it turns out one of them is actually the reflection, which can be seen clearly when the lake turns brighter under the sun. Every landing lesser flamingo has left several water ripples behind them, the fringe of which is decorated with dazzling golden glitters.

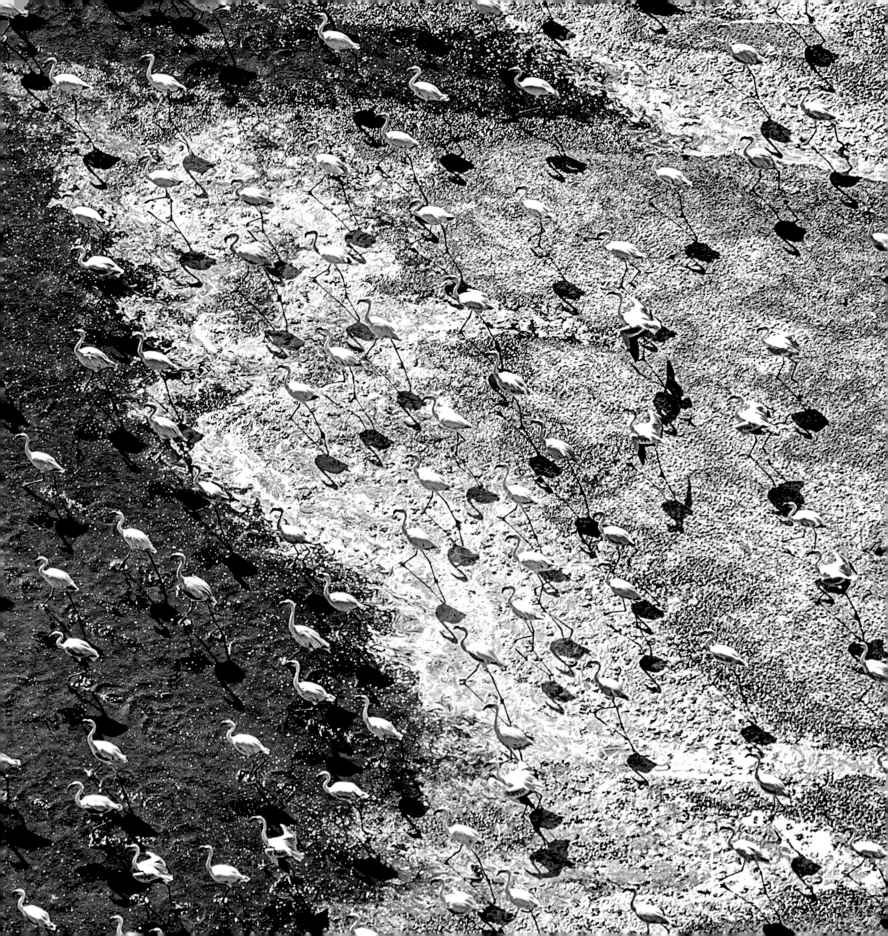

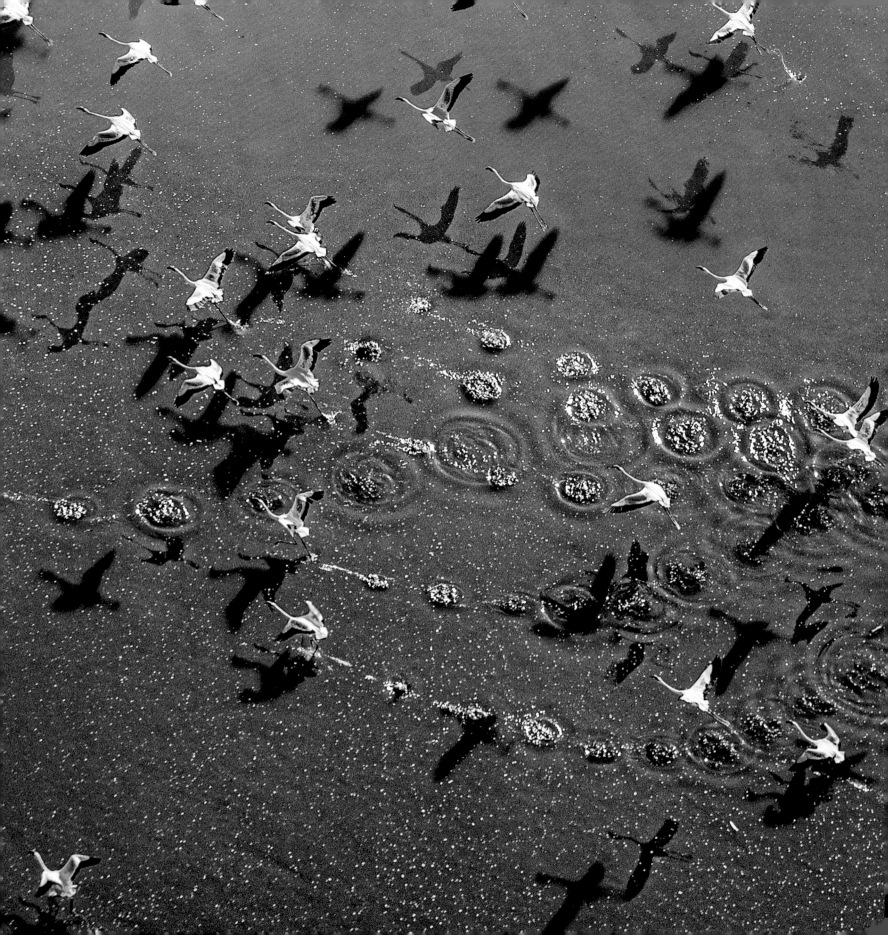

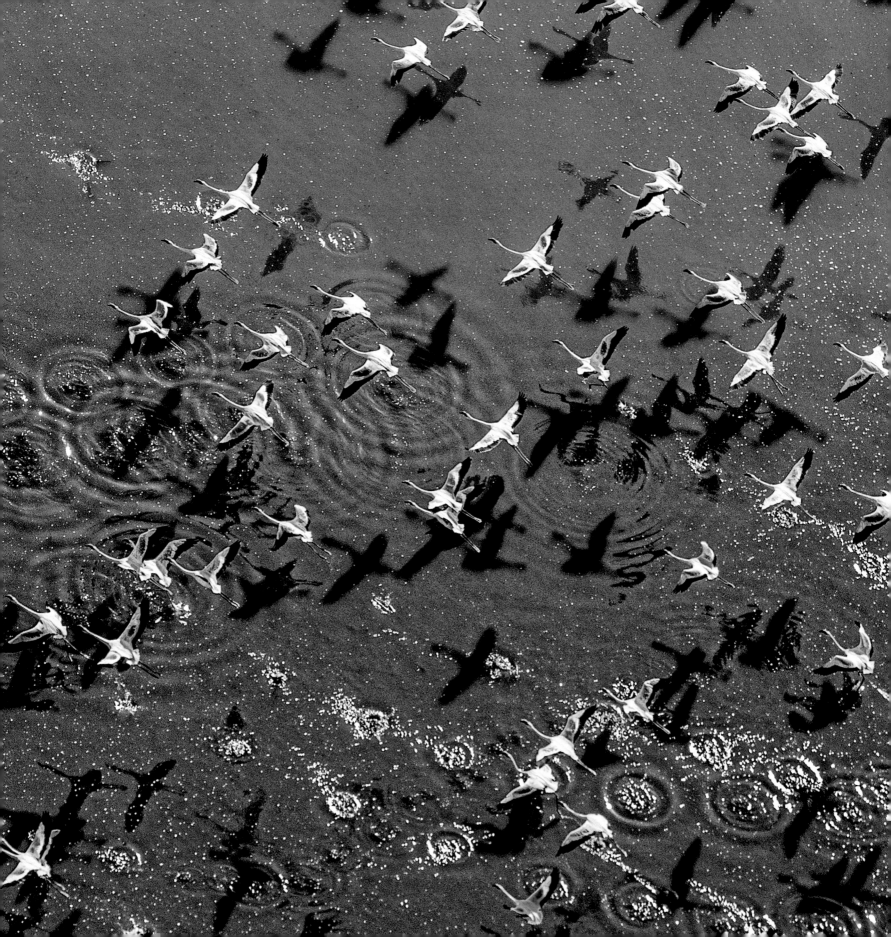

240-241

飛翔中的小紅鶴竟然形成了一個愛心的形狀，讓人驚嘆。

It's astonishing to see the lesser flamingos flying in the shape of a heart.

242-243

奮身俯衝向水中月影的身影，彷彿是喻示著對自由的嚮往。

The swooping action of the birds towards the reflection of the moon in the water is somehow representing the eager for freedom.

244-245

若非湖面的粼粼波光及鳥群的水影，澄澈如鏡的湖水幾乎完美呈現了天空的樣貌。

Were it not for the glittering ripples and reflections of birds, the glassy lake would have projected the mirror image of the sky.

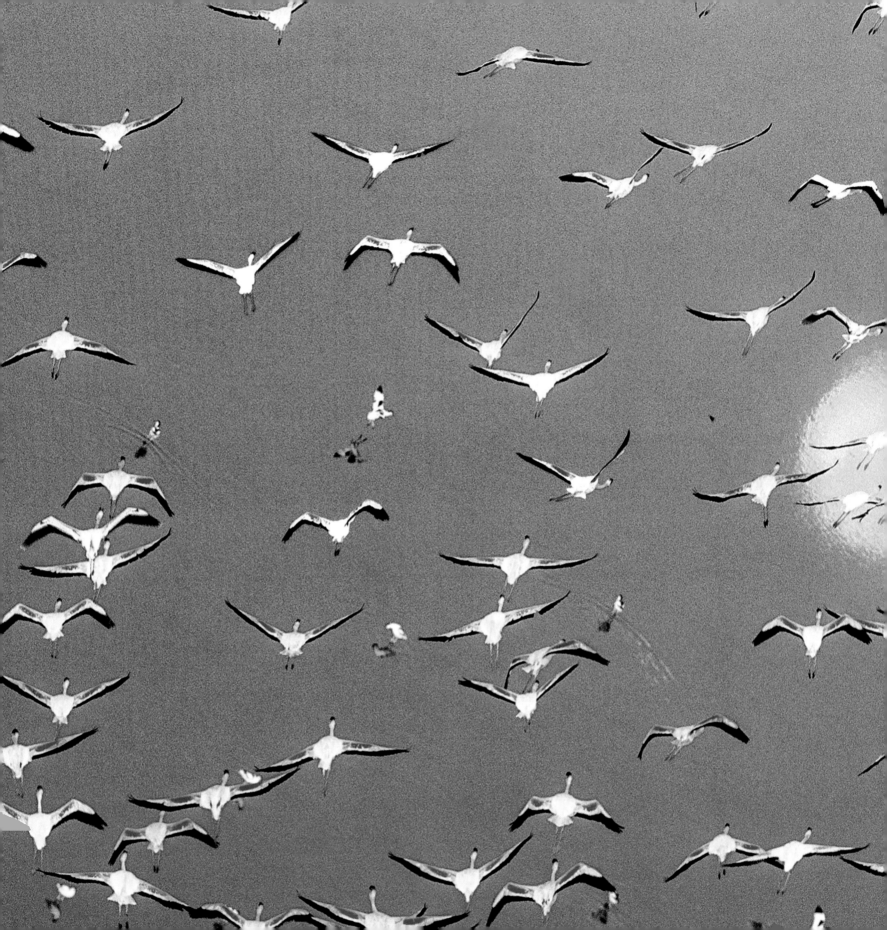

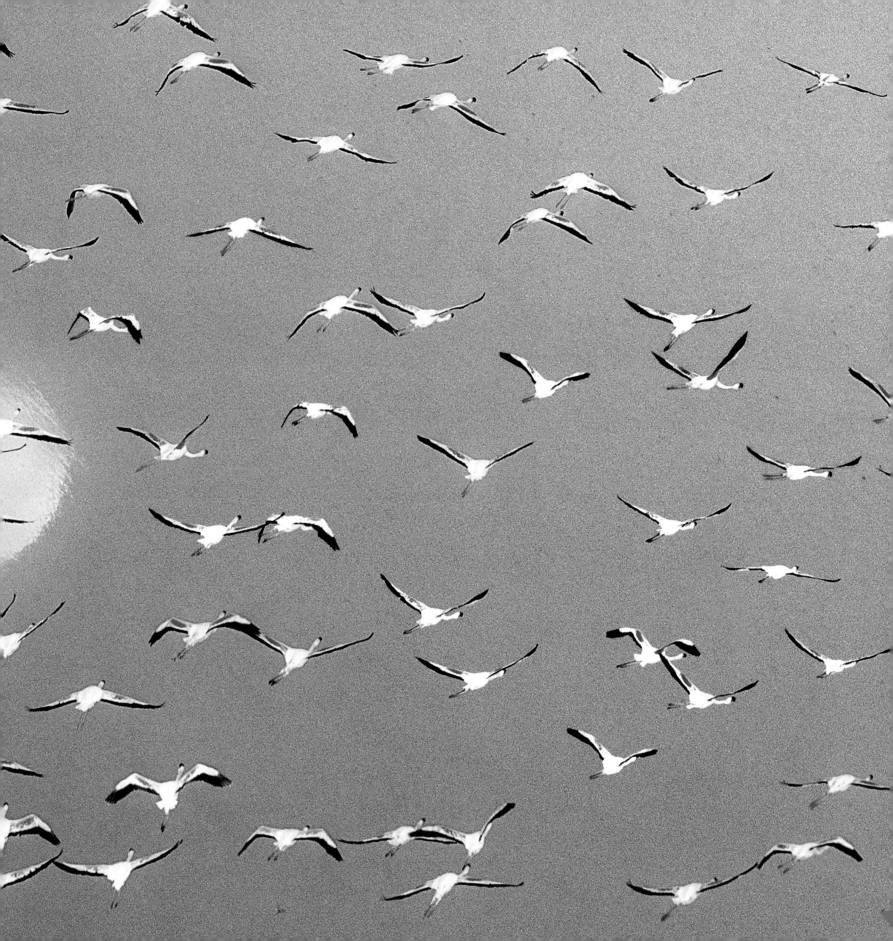

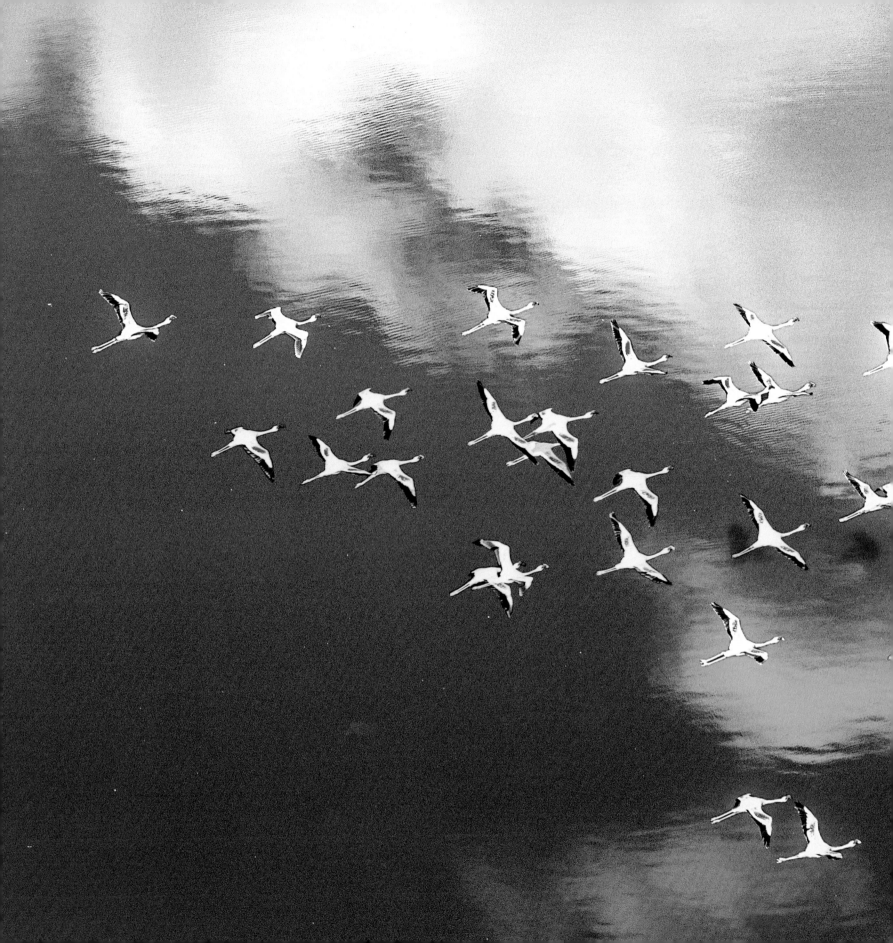

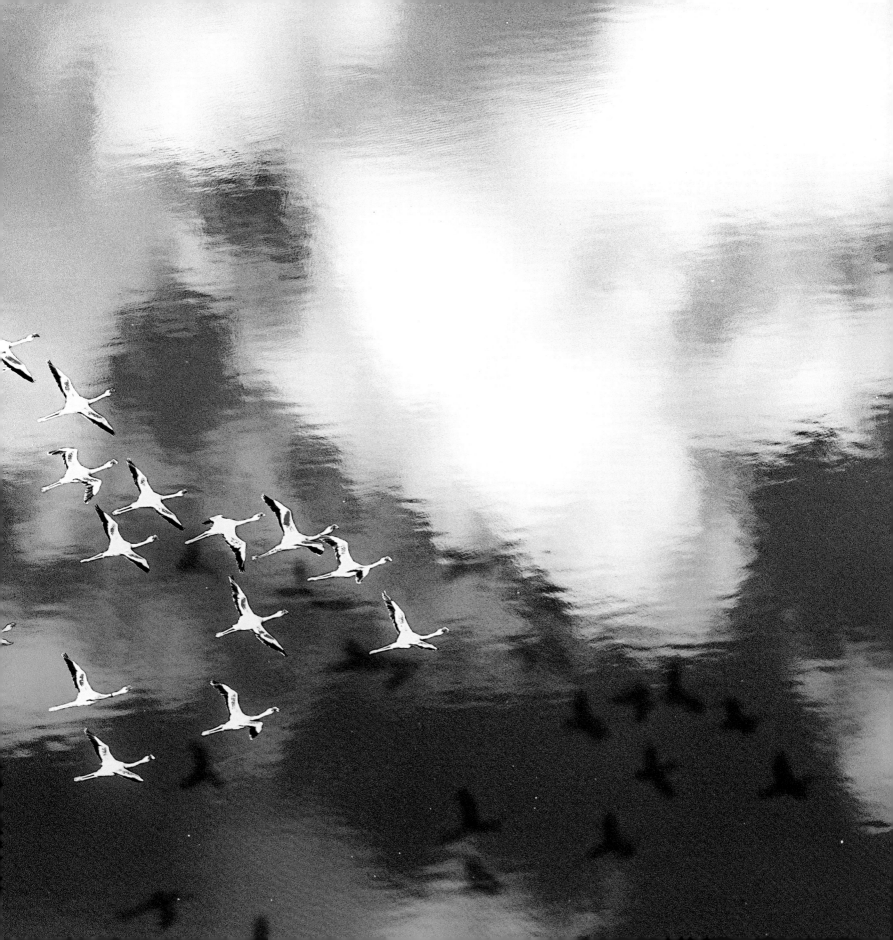

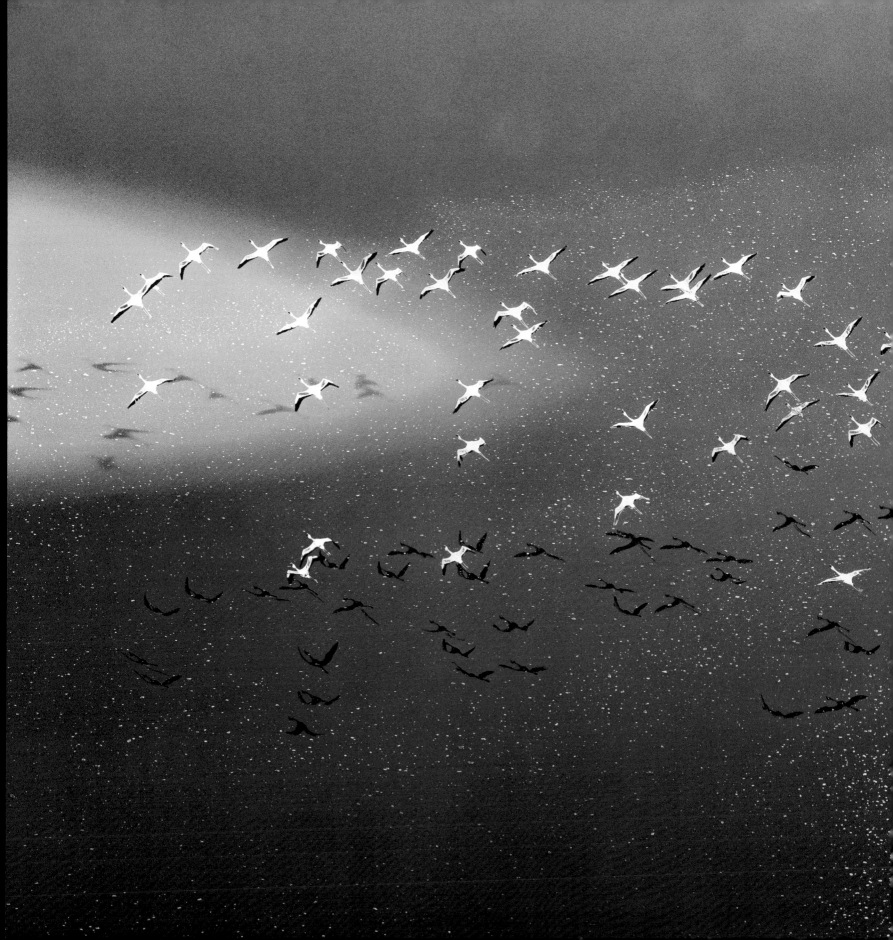

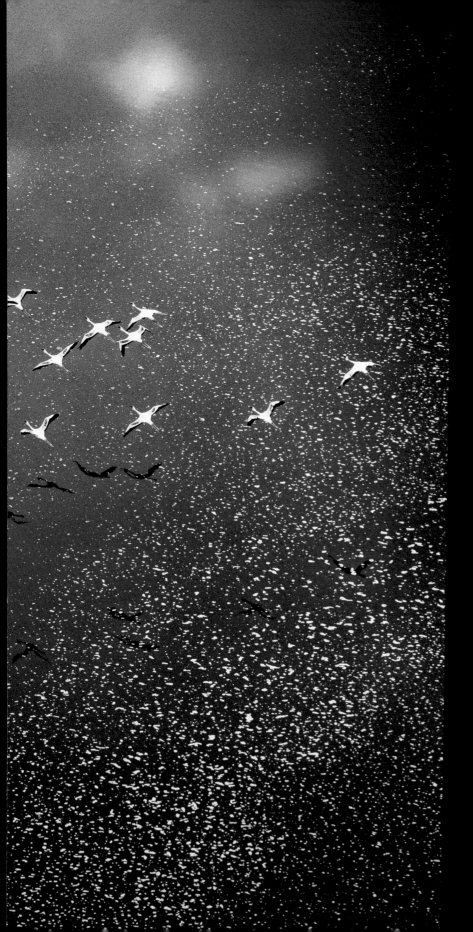

246-247

從橘黃色過度到靛藍色再演變成粉紫色的湖面上，灑落著星星點點的鹽鹼「雪花」，浪漫至極。

It is such a romantic scene where the "snowflakes" like soda ash are scattered around on the lake that changes from orange to indigo blue then to lilac.

248-249

舒展開長長脖頸的小紅鶴群似乎正在引吭齊高歌。

With their long necks stretching, the lesser flamingos look like a group of performers singing loudly together.

250-251

整齊排列成「人」字型飛翔的小紅鶴飛過陽光照射的區域，與身下流沙般的鹼性鹽結晶一同被鍍上了一層金光。

Aligning in a "V" shape, the lesser flamingos flying through sunlight have been plated with a golden lining, just as the sand-like soda crystals below them.

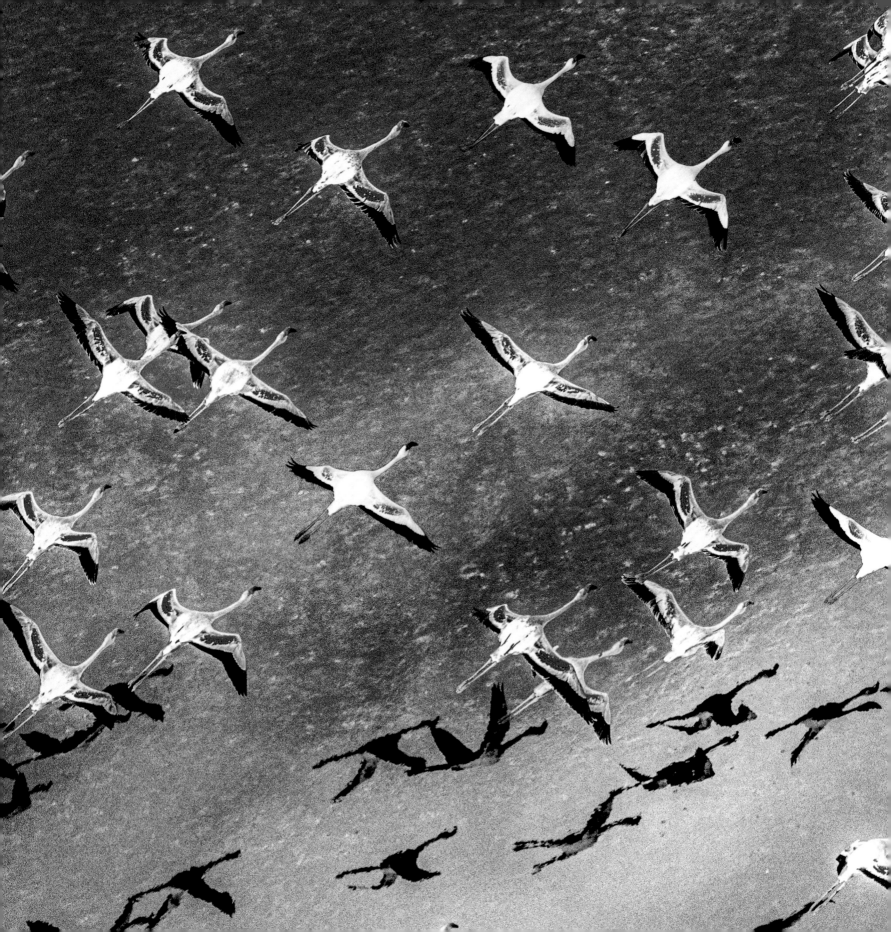

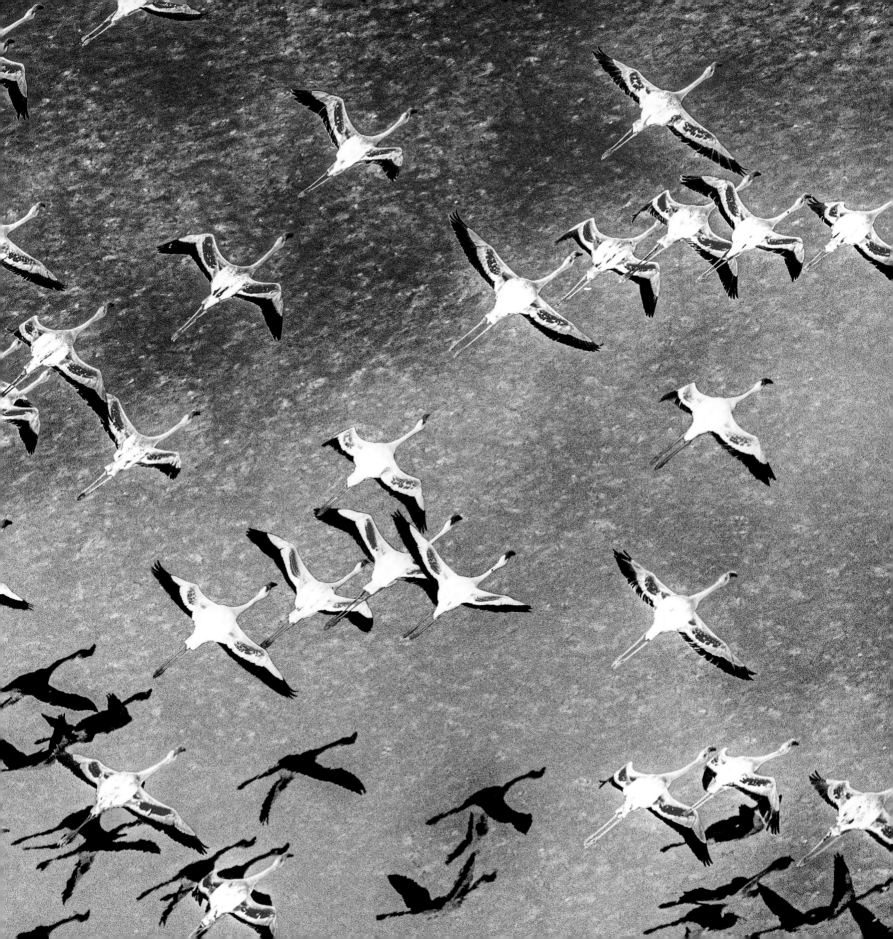

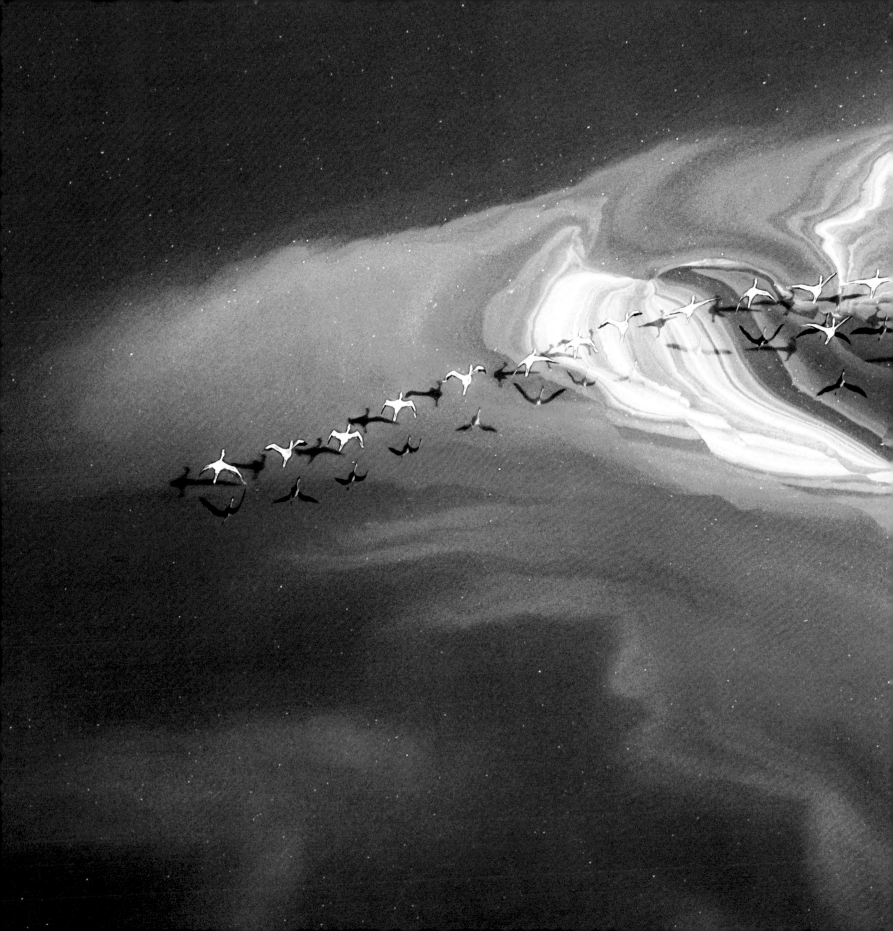

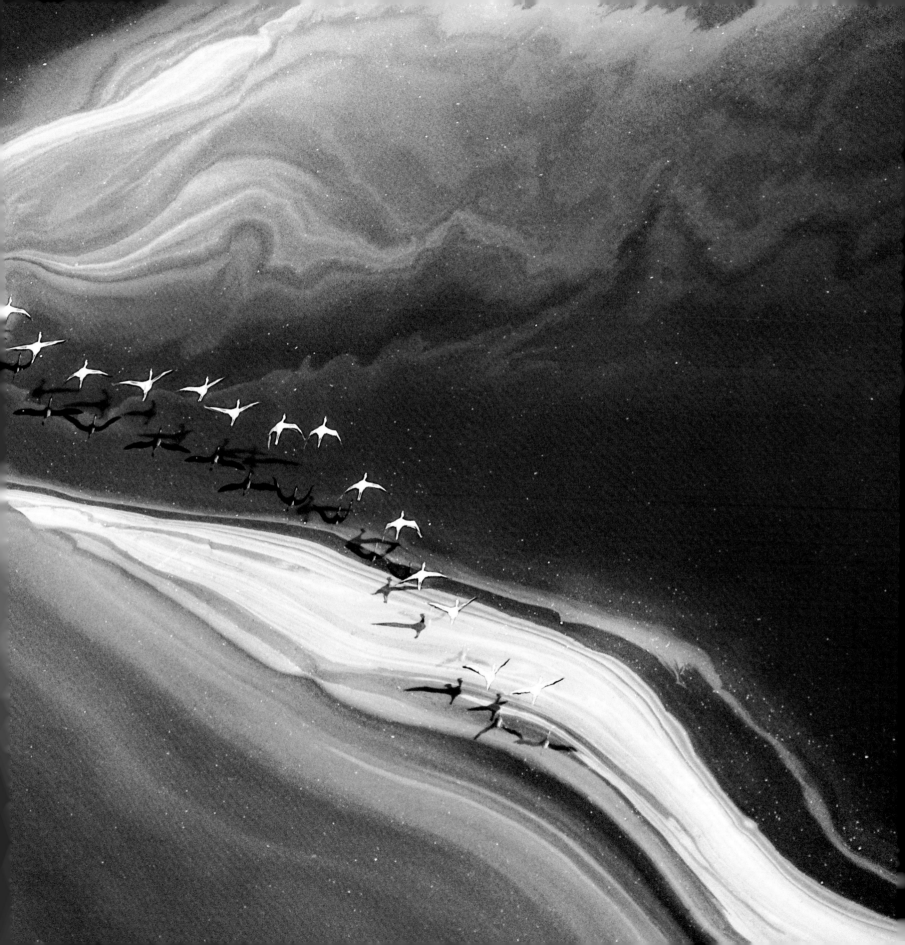

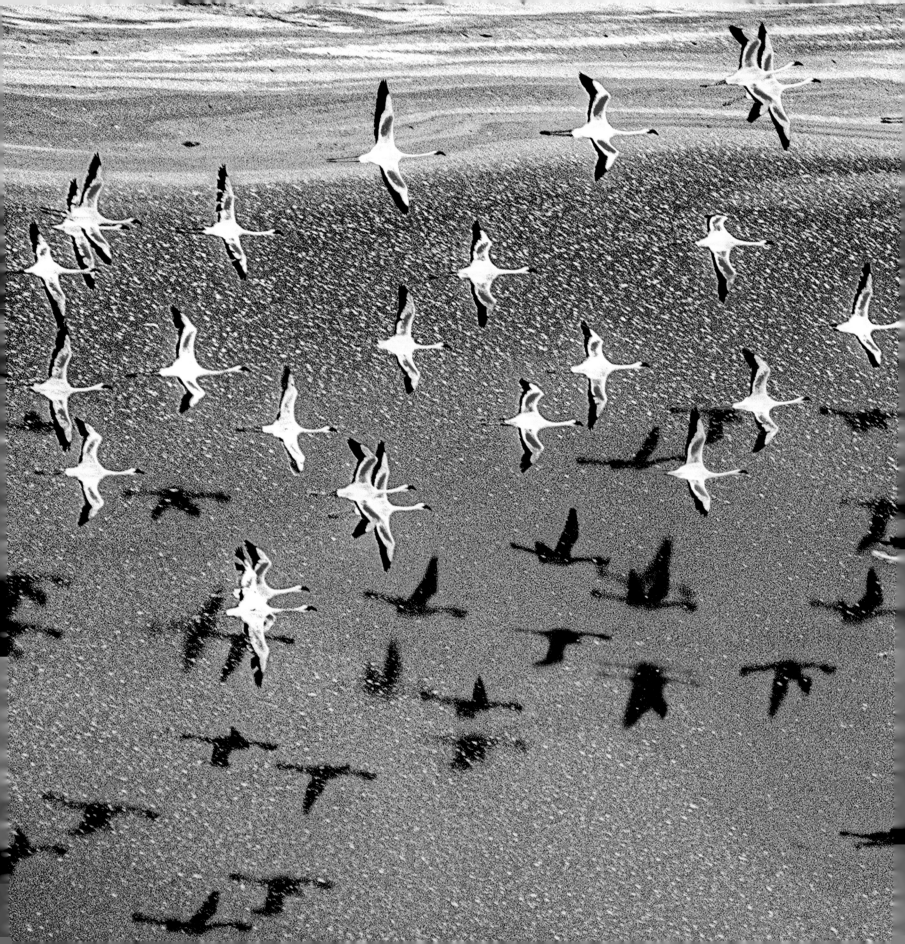

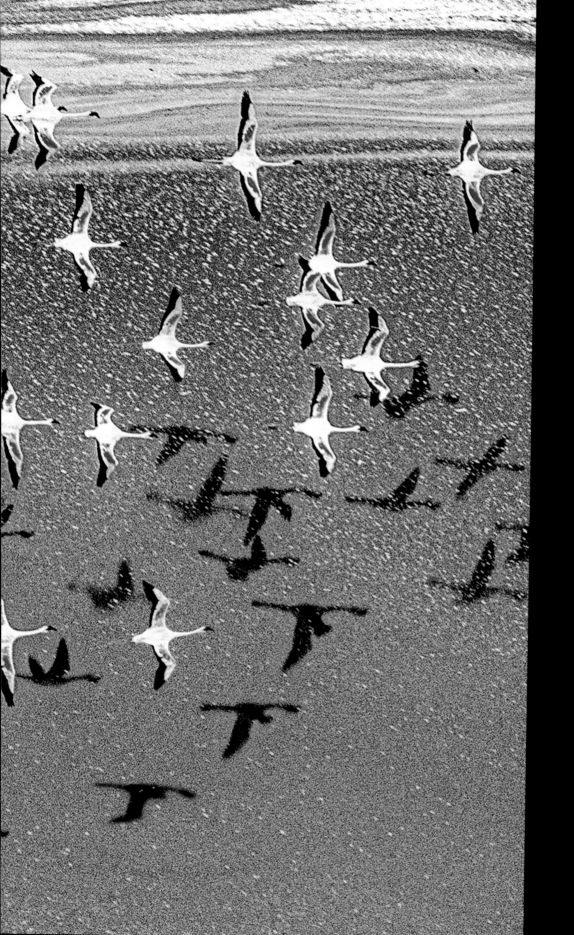

252-253

一群小紅鶴彷彿在不經意間闖入了璀璨
的銀河，又似是遊走於小行星之間。

A group of lesser flamingos seem
to accidentally fly into the sparkling
galaxy, or wander among the asteroid
belt.

254-255

碳酸鹽沉積物把湖水分成了涇渭分明的
兩種顏色，一邊是成熟神秘的深咖啡色，
另一邊則是浪漫溫柔的藍紫色。

The deposits of soda ashes have
divided the lake into two highly distinct
parts, one in a sophisticated and
mysterious brown, and the other in a
romantic and gentle violet blue.

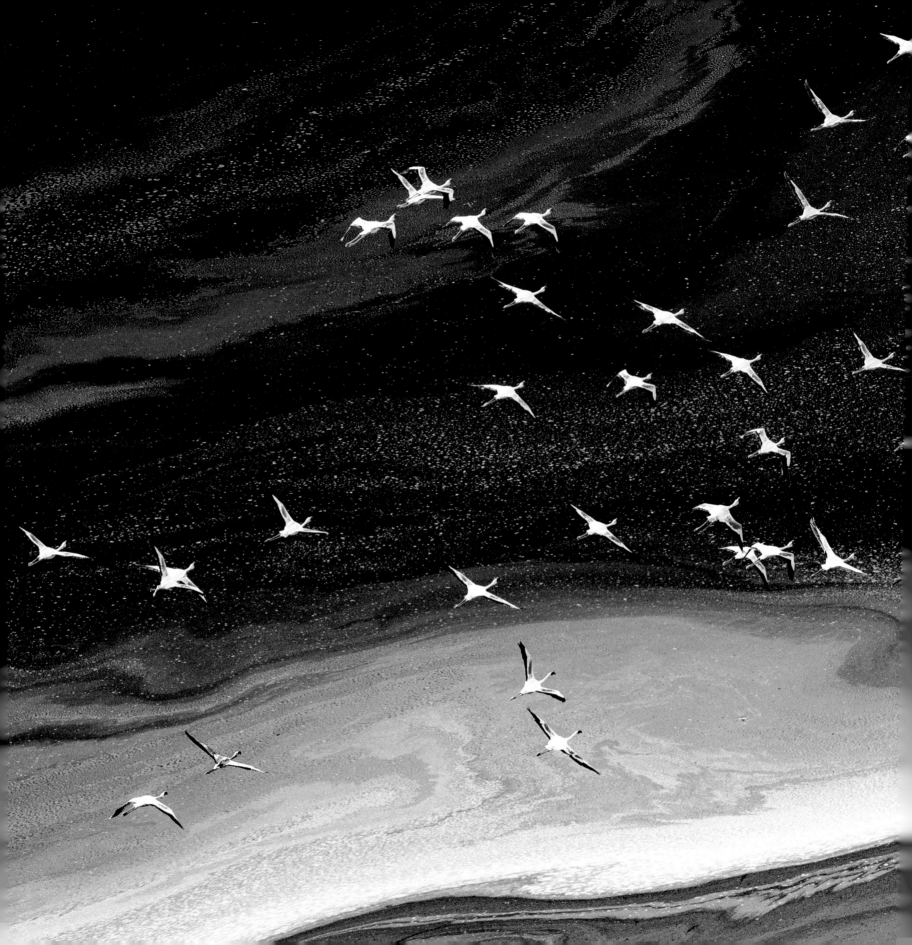

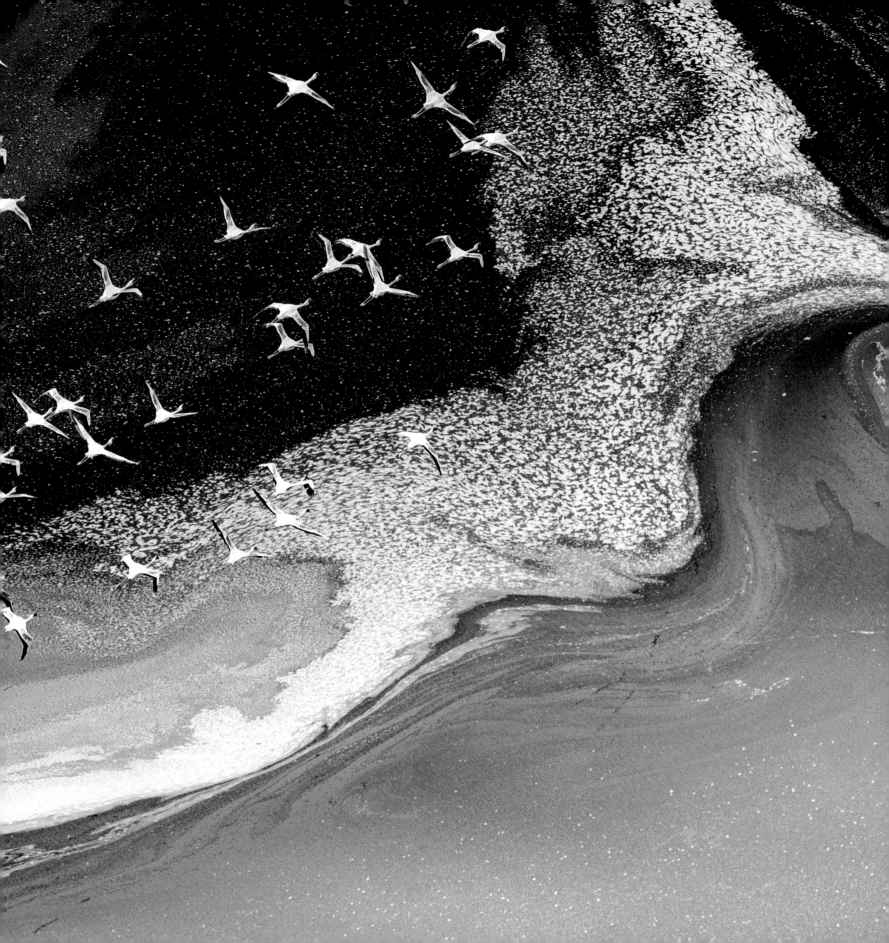

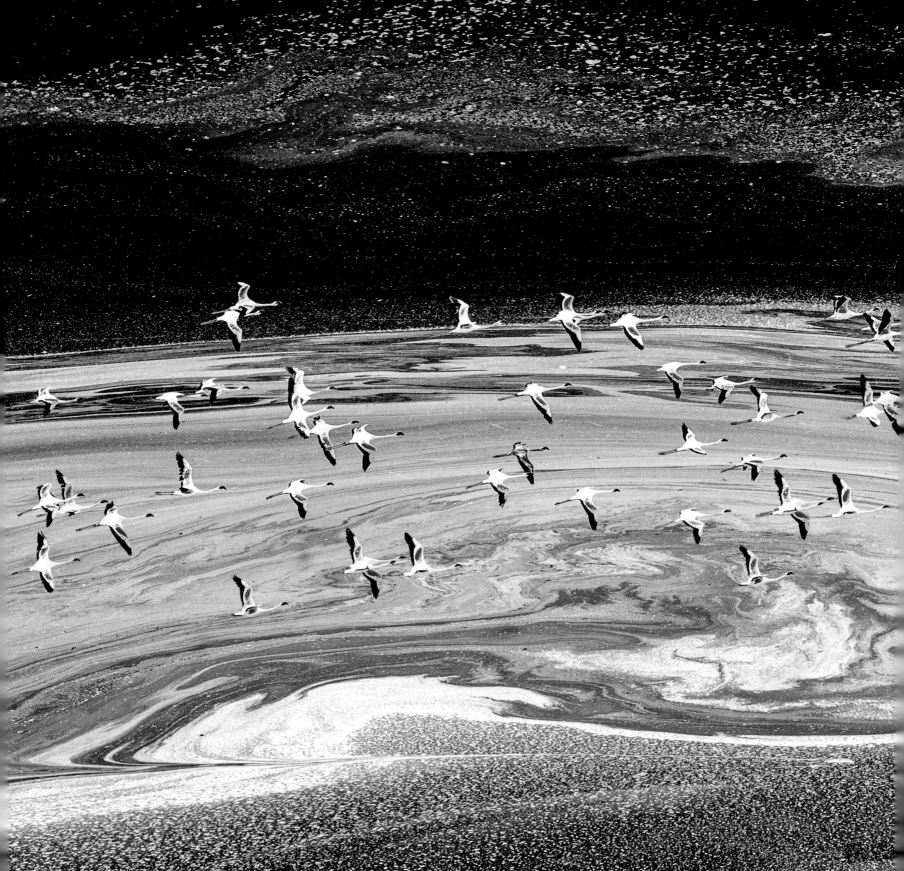

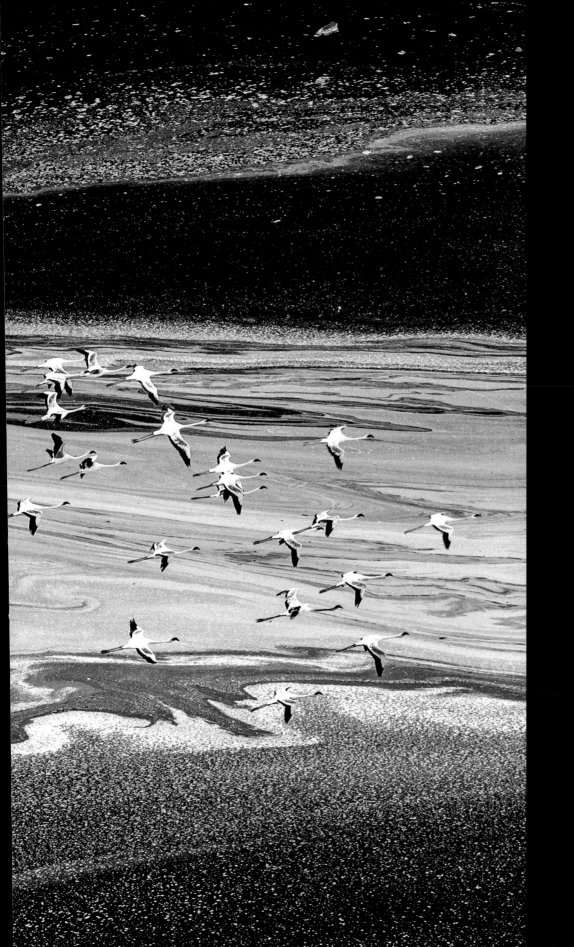

256-257

小紅鶴群彷彿正從土星環上空飛過，又似是穿越了閃耀的銀河，給人一種進入了科幻世界的不真實感。

The impression of a group of flamingos flying over "the rings of Saturn" through the glittering galaxy gives us the sense of surrealness in a sci-fi world.

258-259

湖上的晶體形成了猶如一個正在舞動中的蛇，而鳥群彷彿就是精通「弄蛇術」的表演者。

The soda ashes come into forming the shape of a dancing snake; the bird flock becomes the performer of "snake charming".

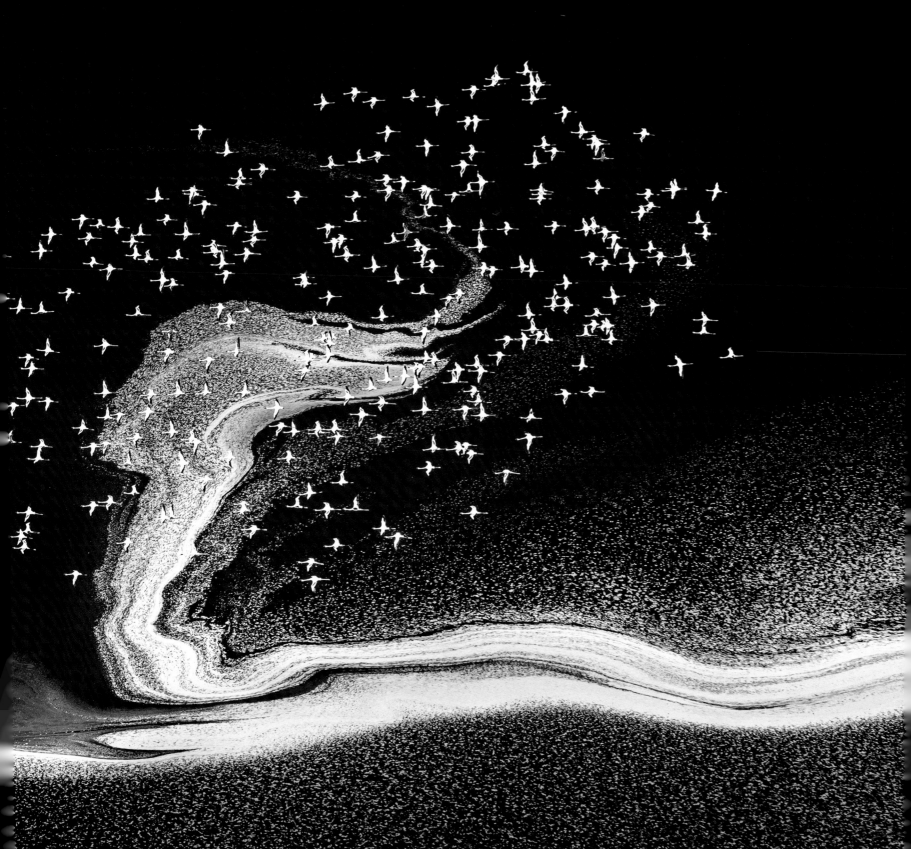

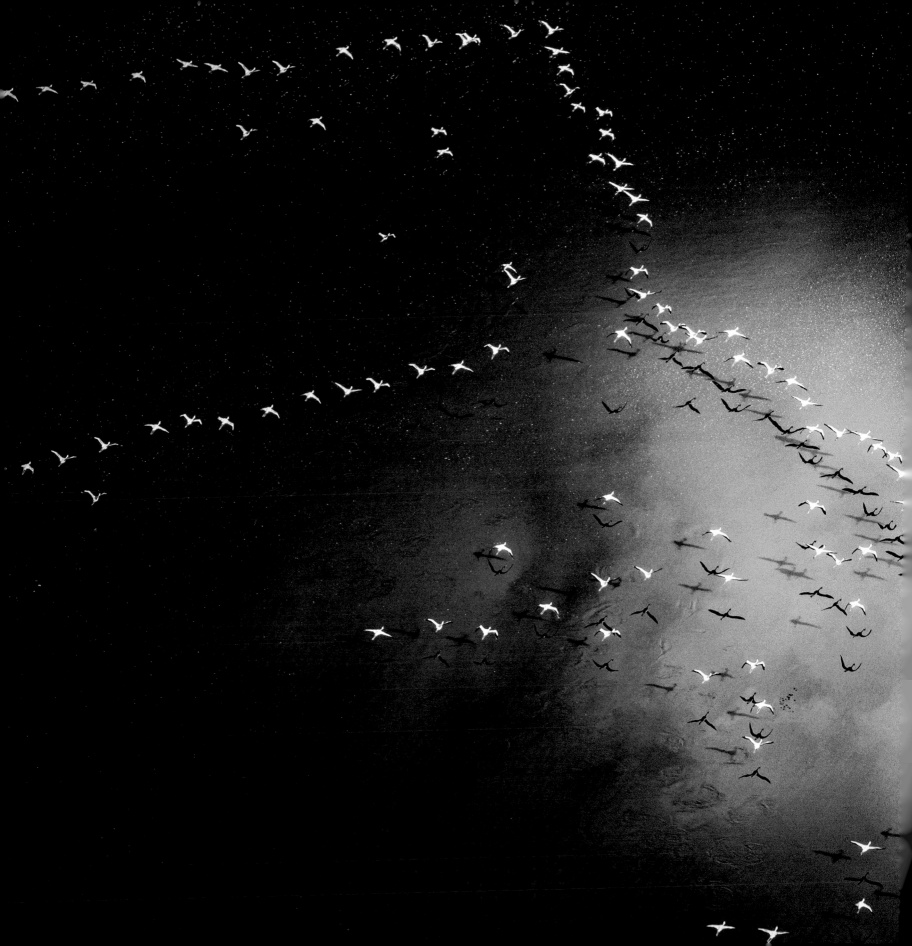

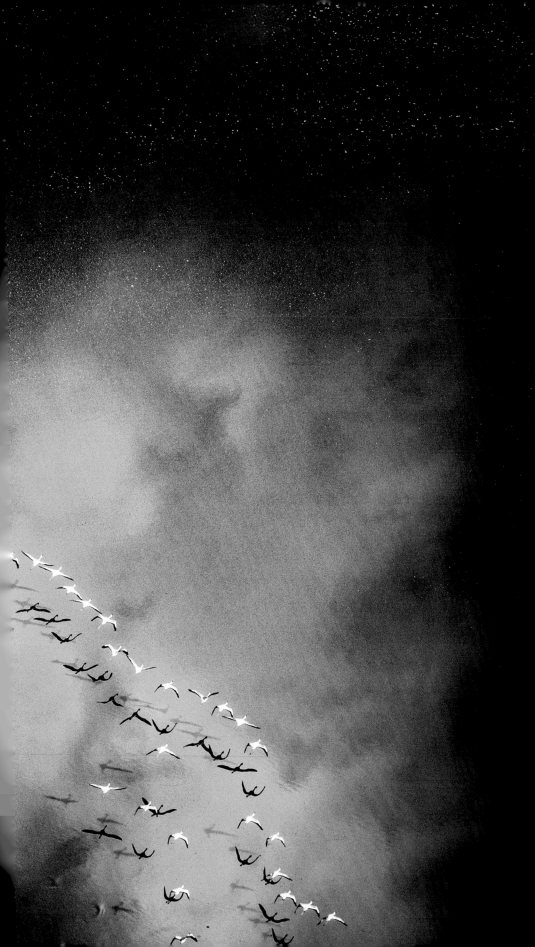

260-261

縱橫交錯的小紅鶴群似乎逐漸組成了一個五線譜的雛形。

The interlacing arrangement of lesser flamingos is shaping an embryonic form of a staff.

262-263

湖面鮮黃色的線條分佈，仿若熔漿隨著火山爆發噴射而出，把整片水域染成了橘紅色。

The shiny yellow curves are like lava erupted by a volcano that has dyed the lake orange.

264-265

湖面的沉積晶體佯裝成滾滾沙礫，小紅鶴群則扮演了沙塵暴中穿行而過的冒險家。

This crowd of lesser flamingos is pretending to be a group of adventurers passing through the "sandstorm" impersonated by crystal deposits.

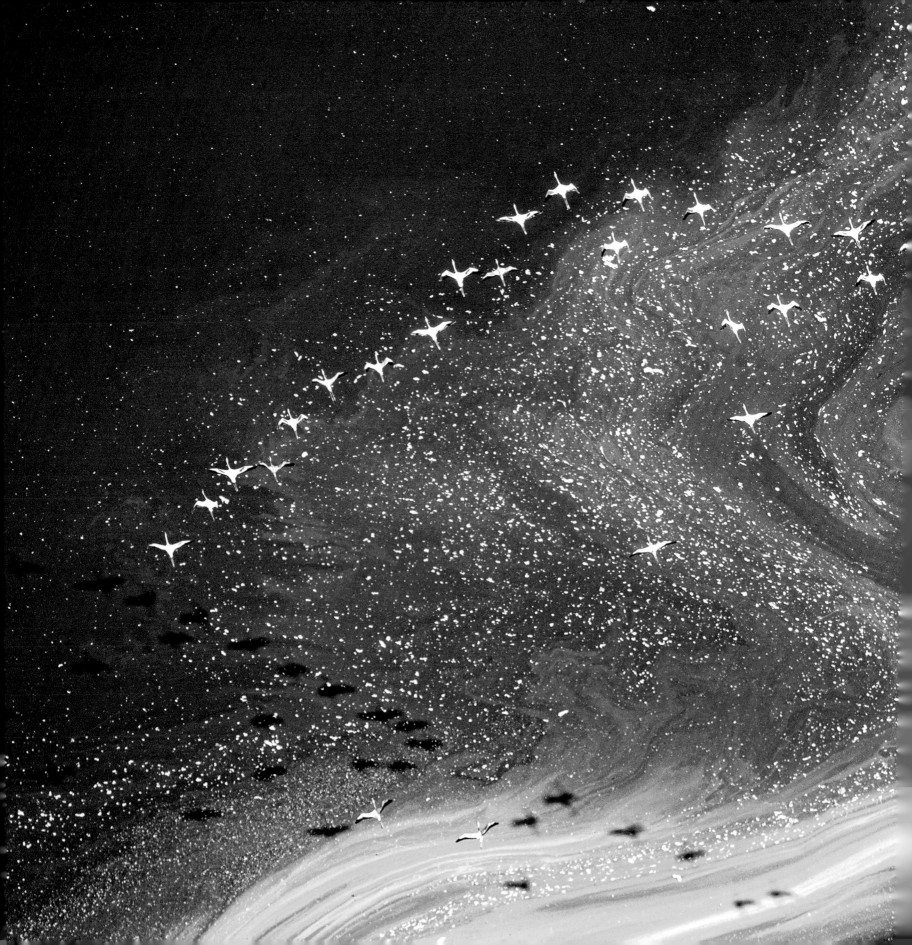

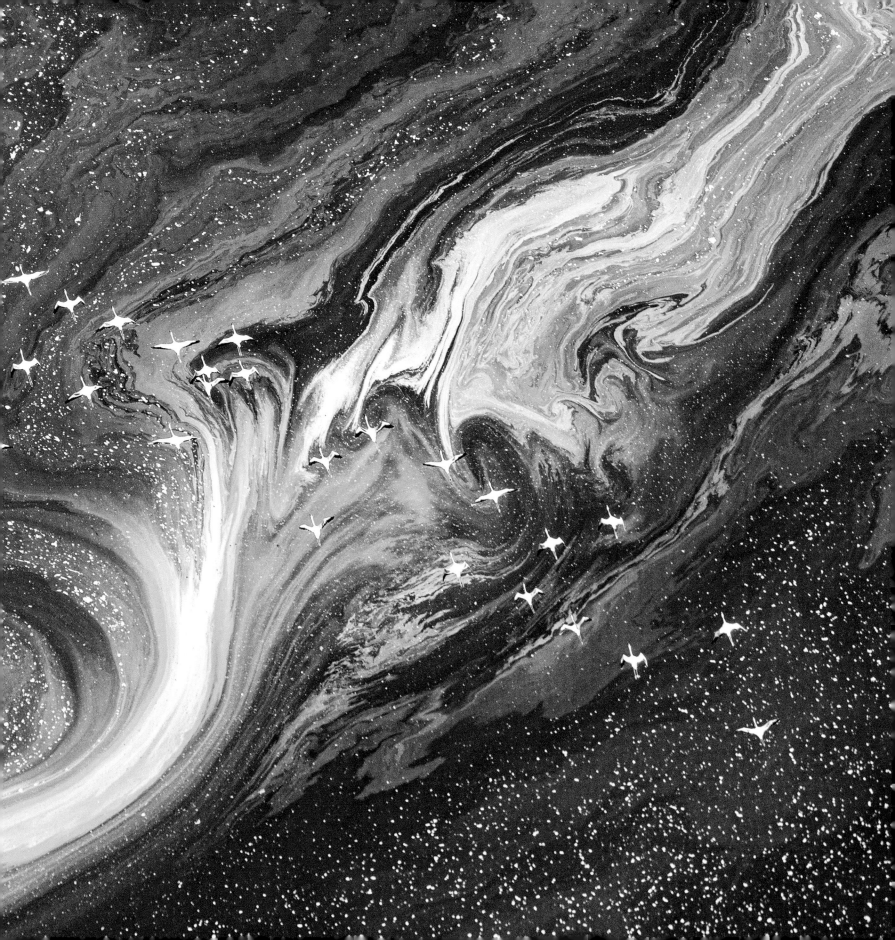

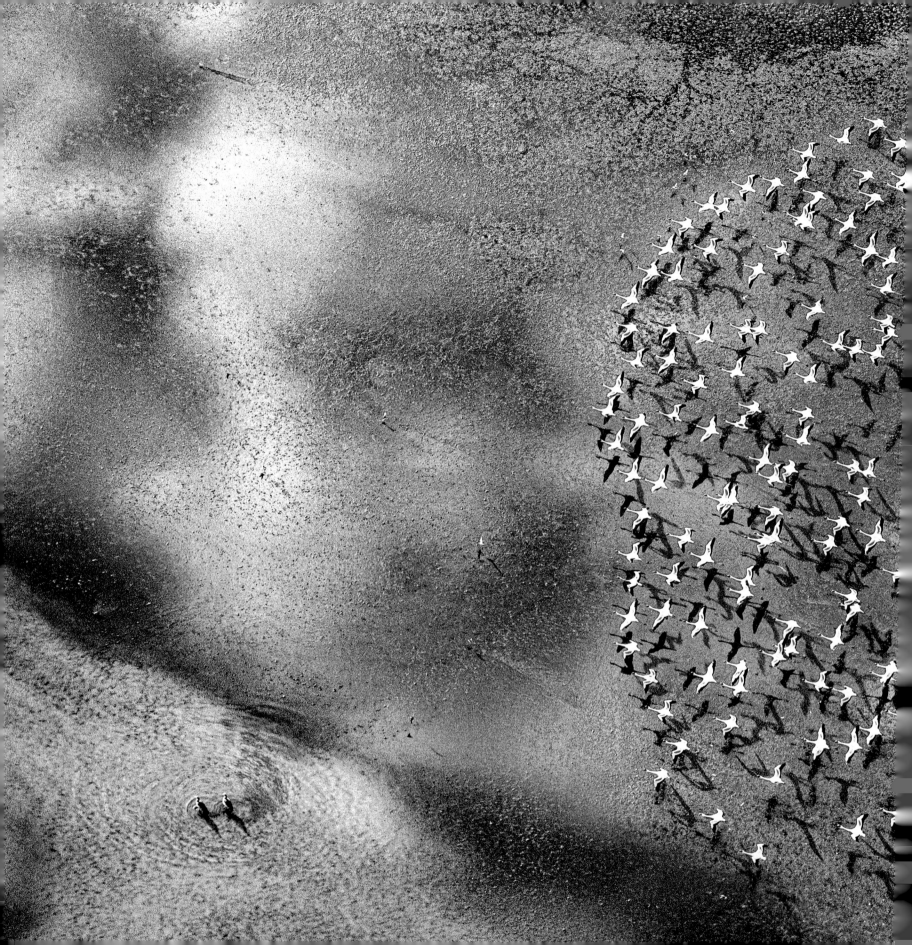

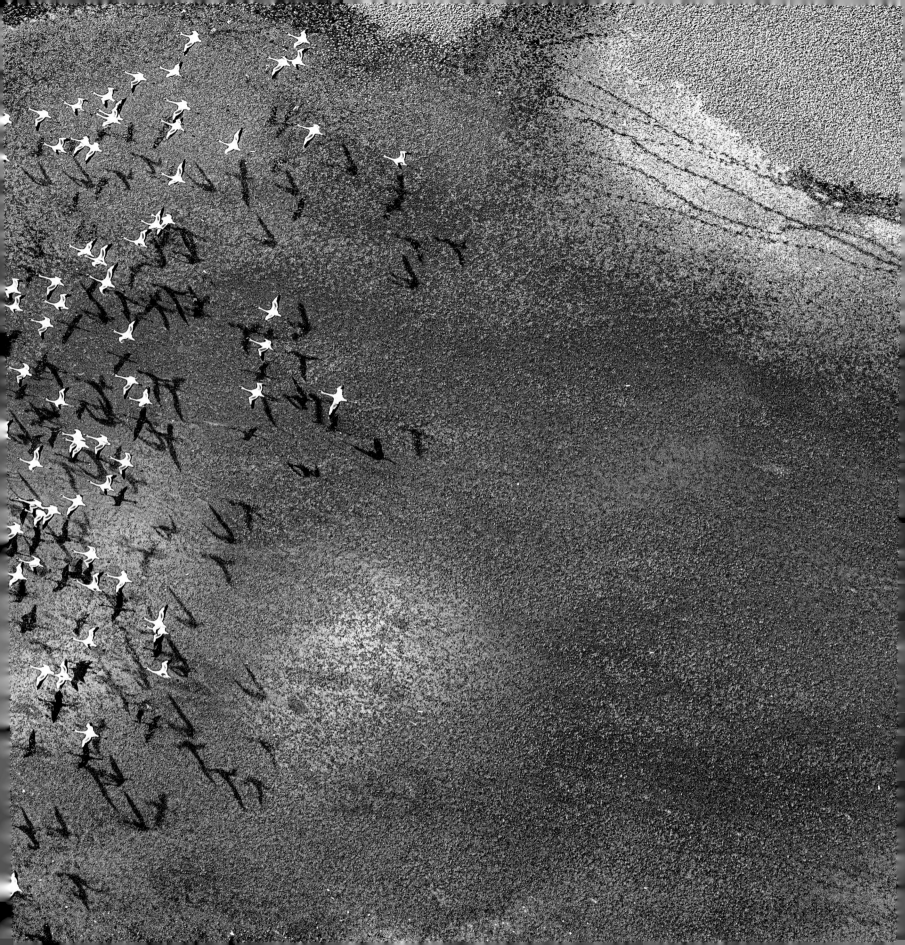

266-267

當漂浮的鹼性鹽結晶以顆粒狀聚集，尚未連成完整的一片時，就如同形成了一張巨大的輕紗，隱隱約約透露出底下的湖色。

Before the soda crystals joining into one entire piece, the particles converge and create a giant floating veil that vaguely shows the color of the lake underneath.

268-269

高溫火紅的馬加迪湖對於別的動物來說是致命的水域，但對小紅鶴來說，卻是最佳的美食天堂。

While the high temperature and alkalinity in Lake Magadi are deadly to other animals, here lies the paradise of food for lesser flamingos.

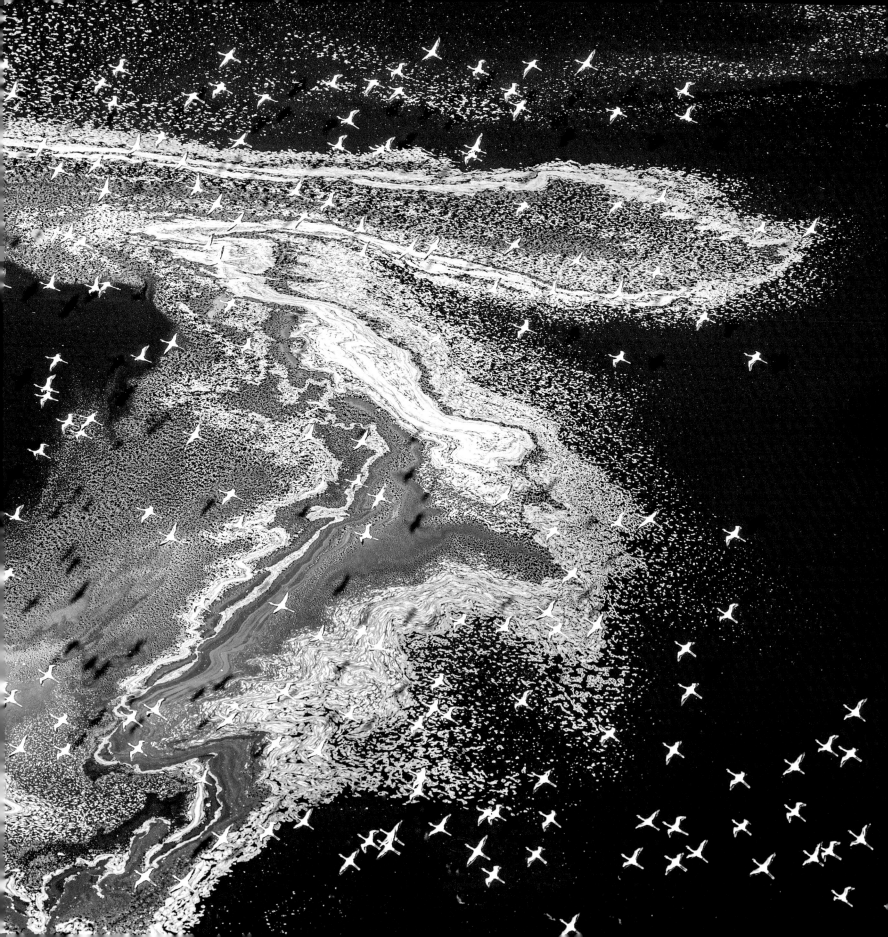

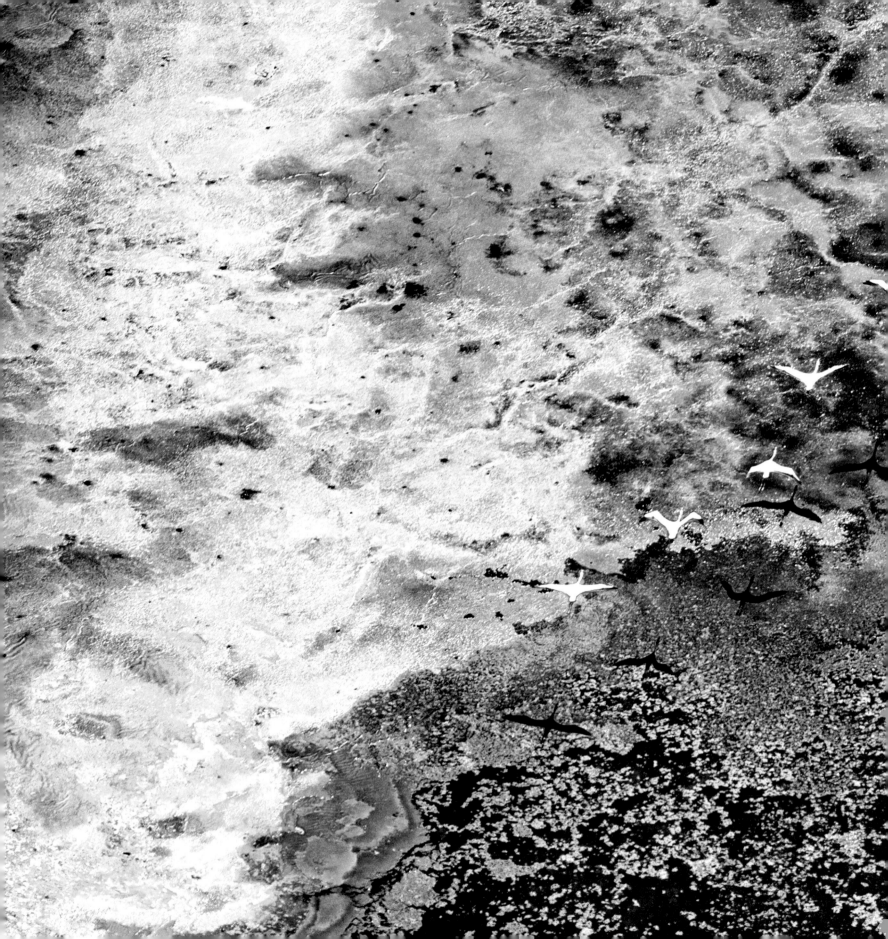

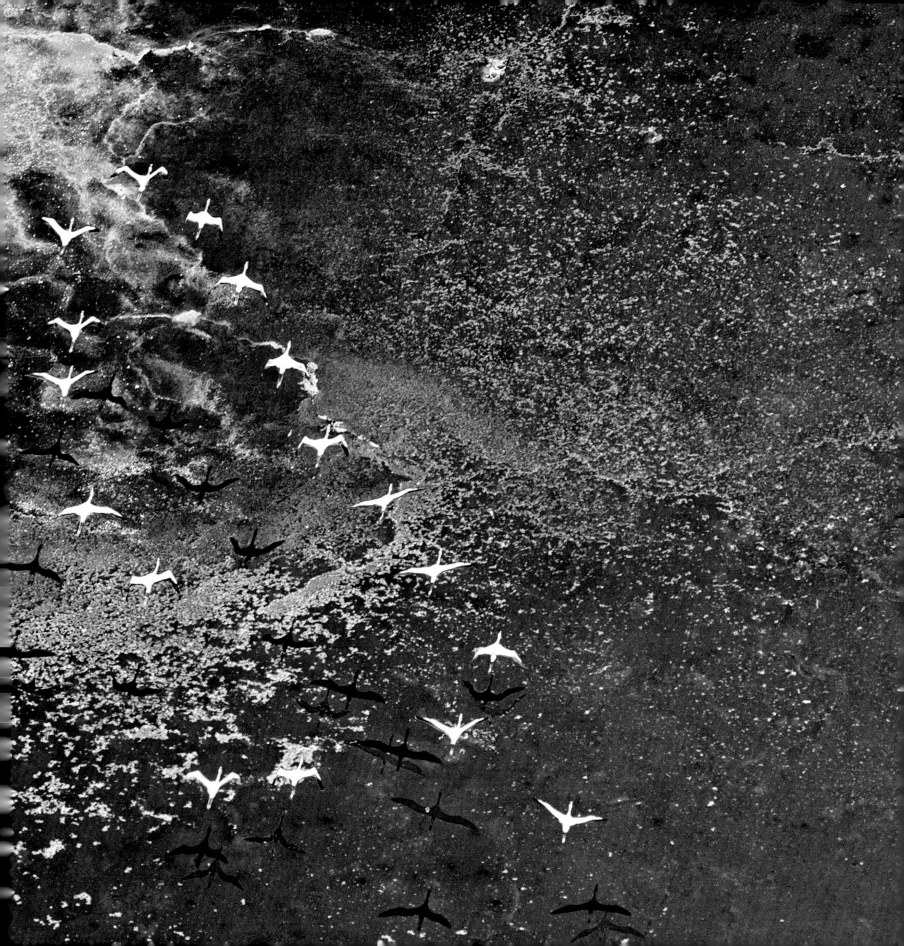

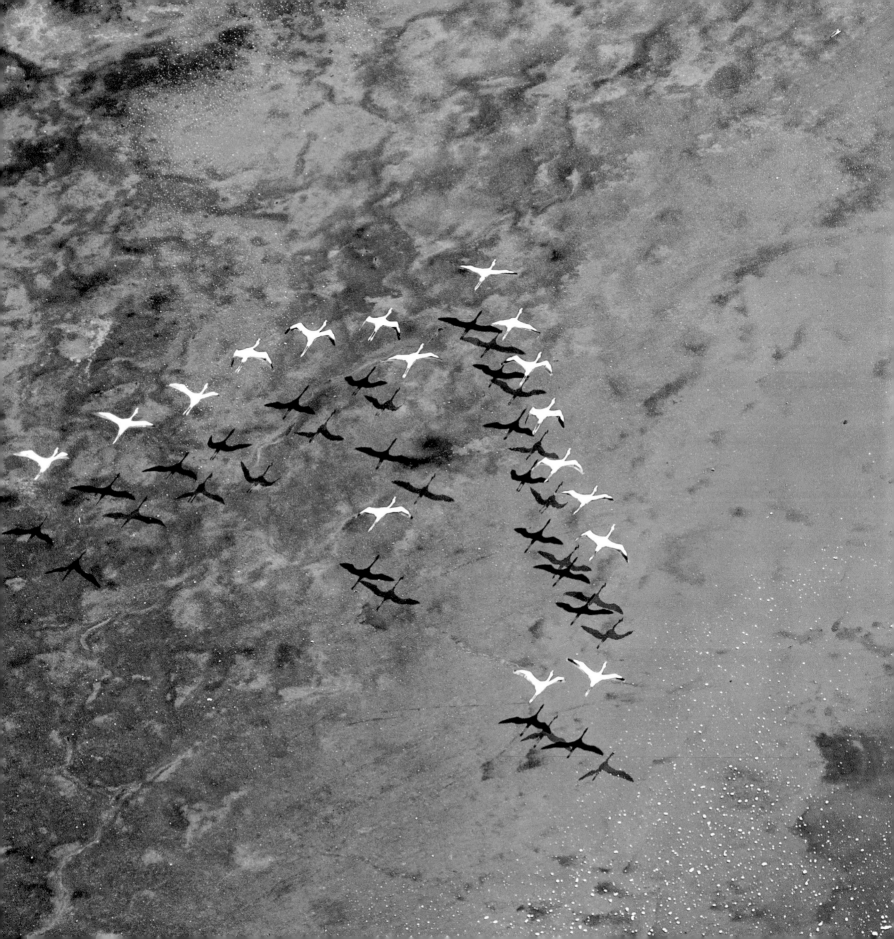

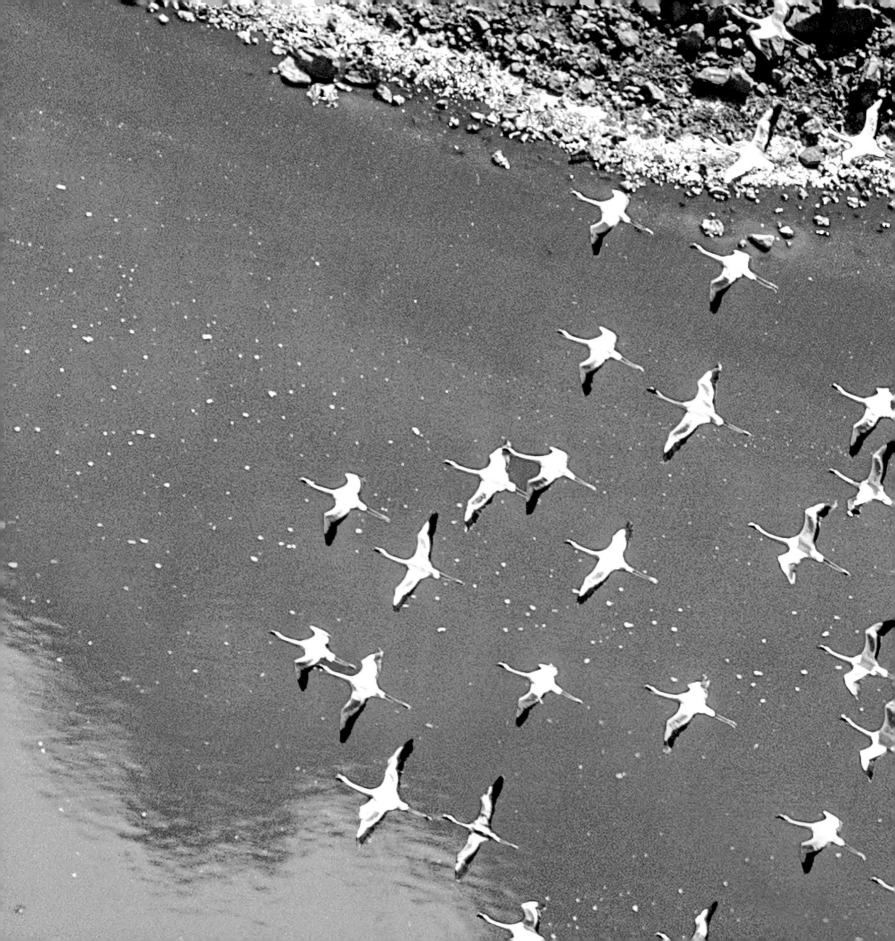

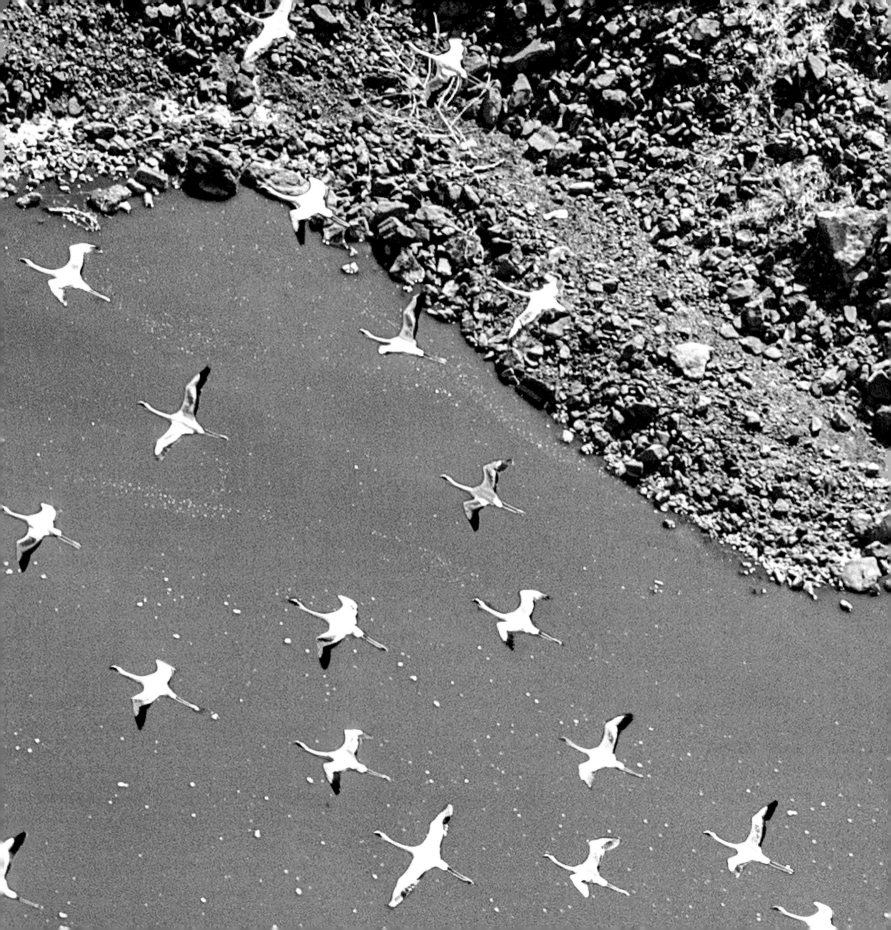

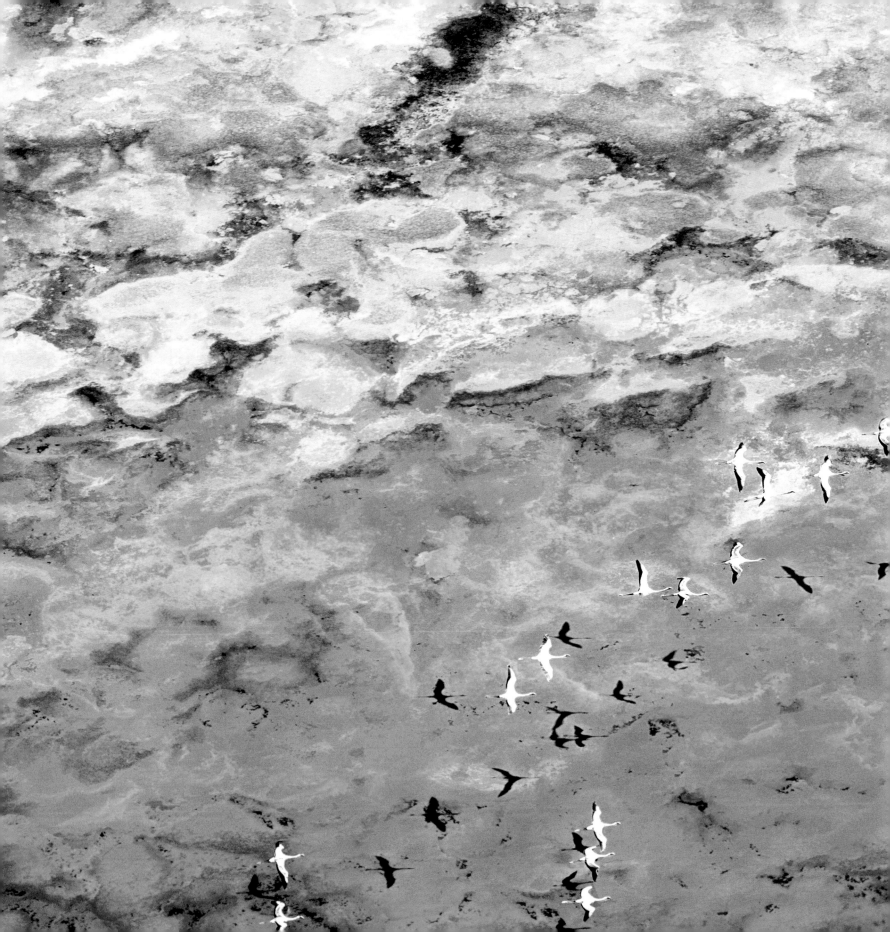

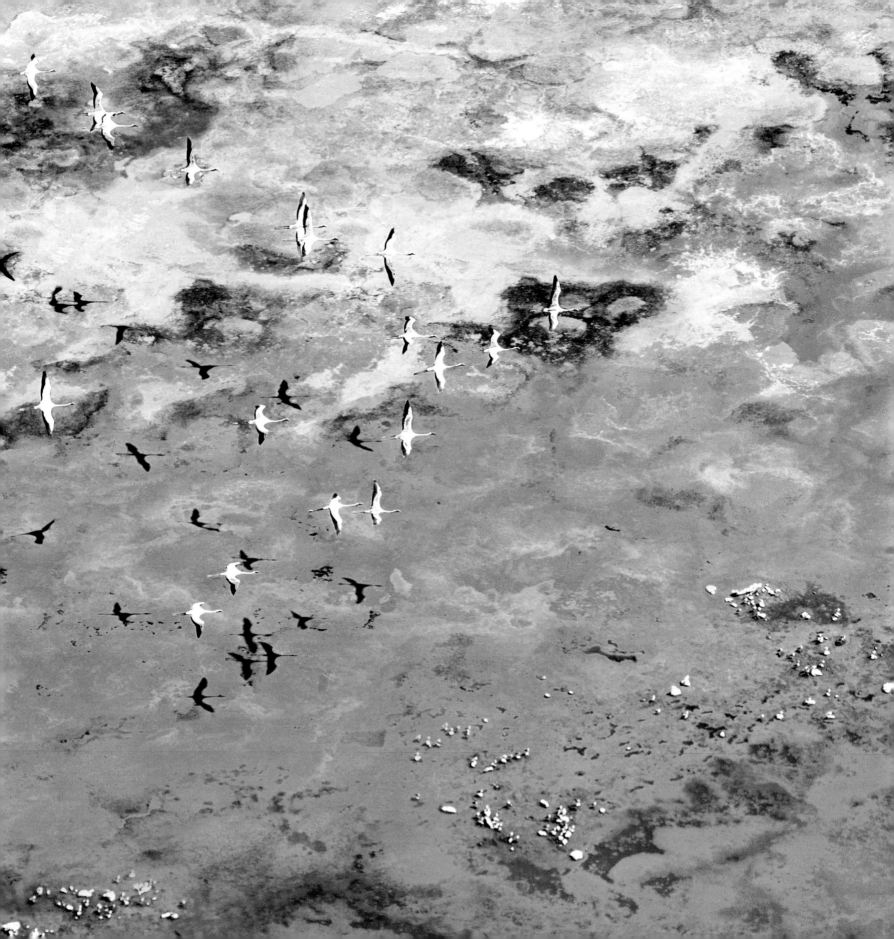

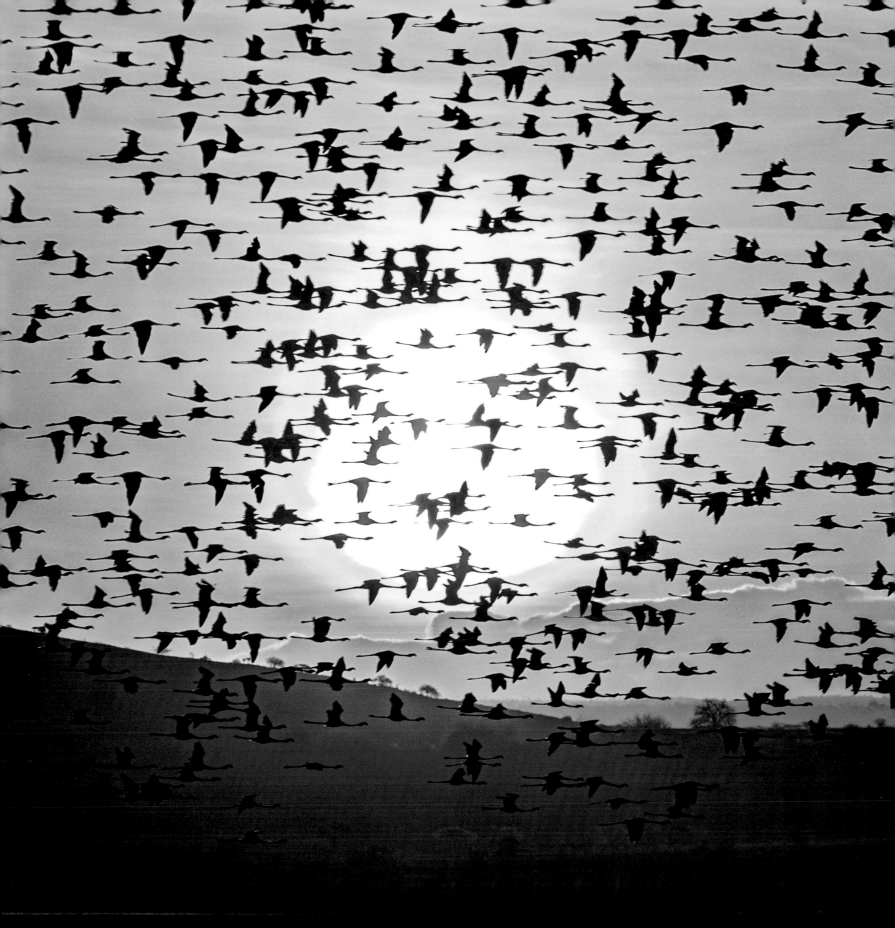

270-271

排列成三角形的紅鶴群猶如向未知世界進發、駛向神秘的遠航艦隊。

The flamingos in a triangular formation are like a naval fleet heading into a mysterious unknown world.

272-273

在旱季水量明顯減少的馬加迪湖，乾燥的岩石與鮮豔的橘黃色湖水形成了鮮明的對比。

During the dry seasons when water level is low, the dried rocks appear in high contrast to the bright orange lake at Magadi.

274-275

湖面除了碳酸鈉晶體，還有豐富的藍綠藻、古細菌和矽藻，形成了層層疊疊的各種色彩，馬加迪湖化身為一個大染缸。

Apart from soda ashes, there are also numerous cyanobacteria, archaeans and diatoms in the lake, creating layers and layers of different colors and turning Lake Magadi into a giant dyeing tank.

276-277

唐代著名詩人白居易的詩句「倦鳥暮歸林，浮雲晴歸山」是這幅場景的真實寫照。

"Beyond the far hills fades out drifting clouds; immersed in the sunset red, the song of homesick is sung by tired birds out aloud." - this verse written by the famous Chinese poet of Tang Dynasty, Bai Juyi, is the perfect description of this photo.

278-279

相片中斑駁的暖黃色彩過渡得頗為自然，竟然透著幾分印象畫派的味道。

The mottled shades of yellow, in the picture, are somehow blending naturally together in an impressionist way.

280-281

一片淡漠的色彩之上點綴著數十隻小紅鶴，彷彿是國畫所描繪的風景。

In front of us is a Chinese painting where a group of lesser flamingos acting as the adornment to the pale background.

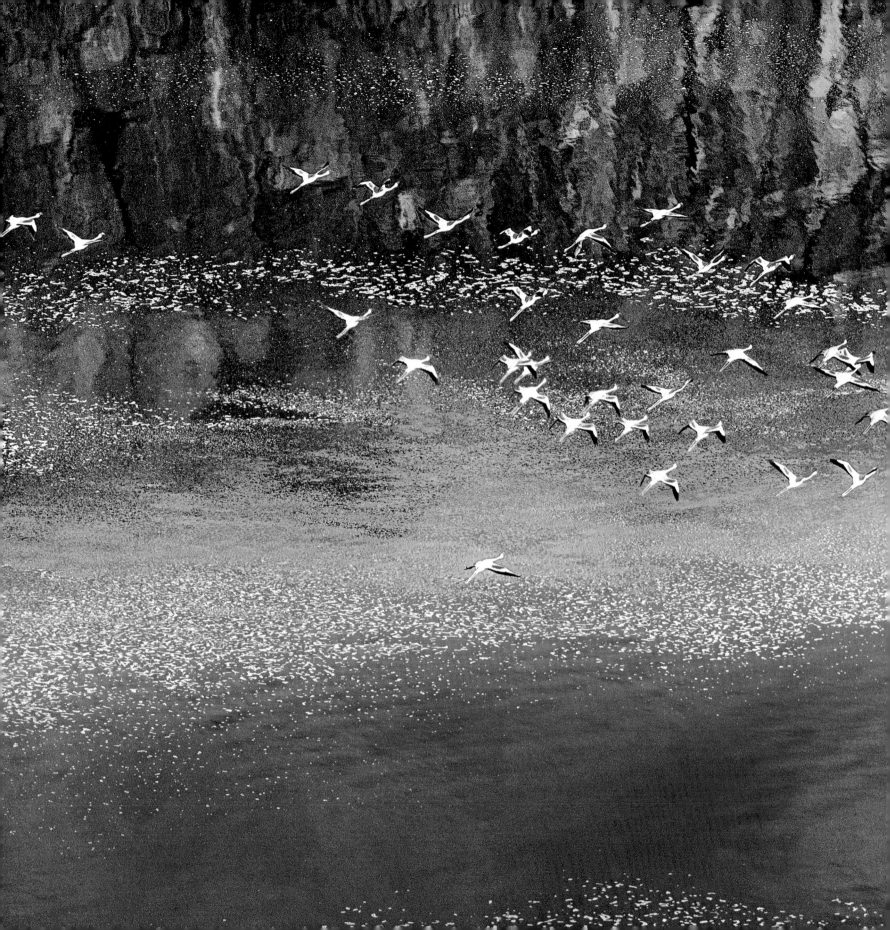

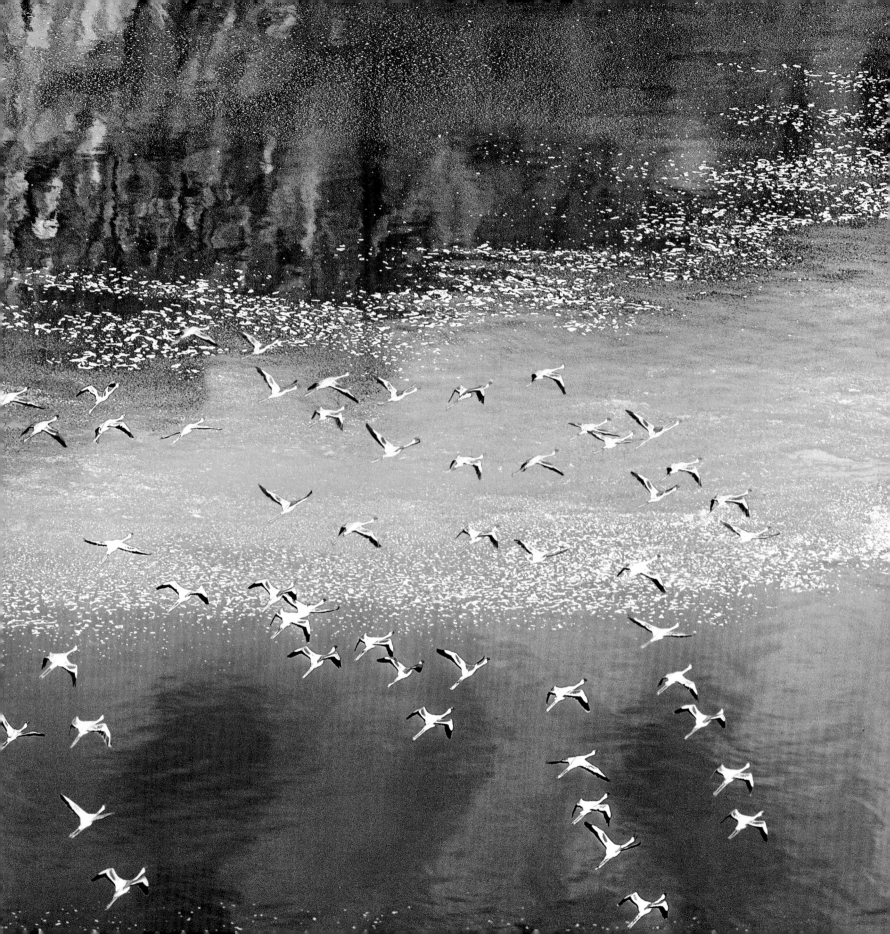

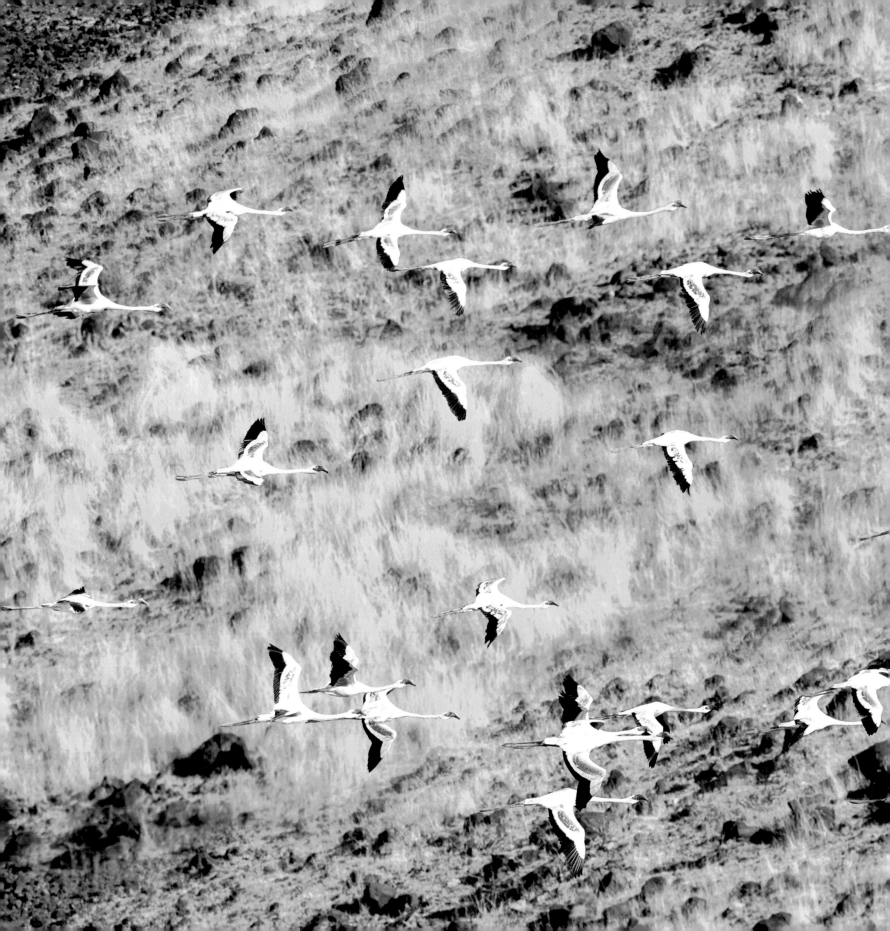

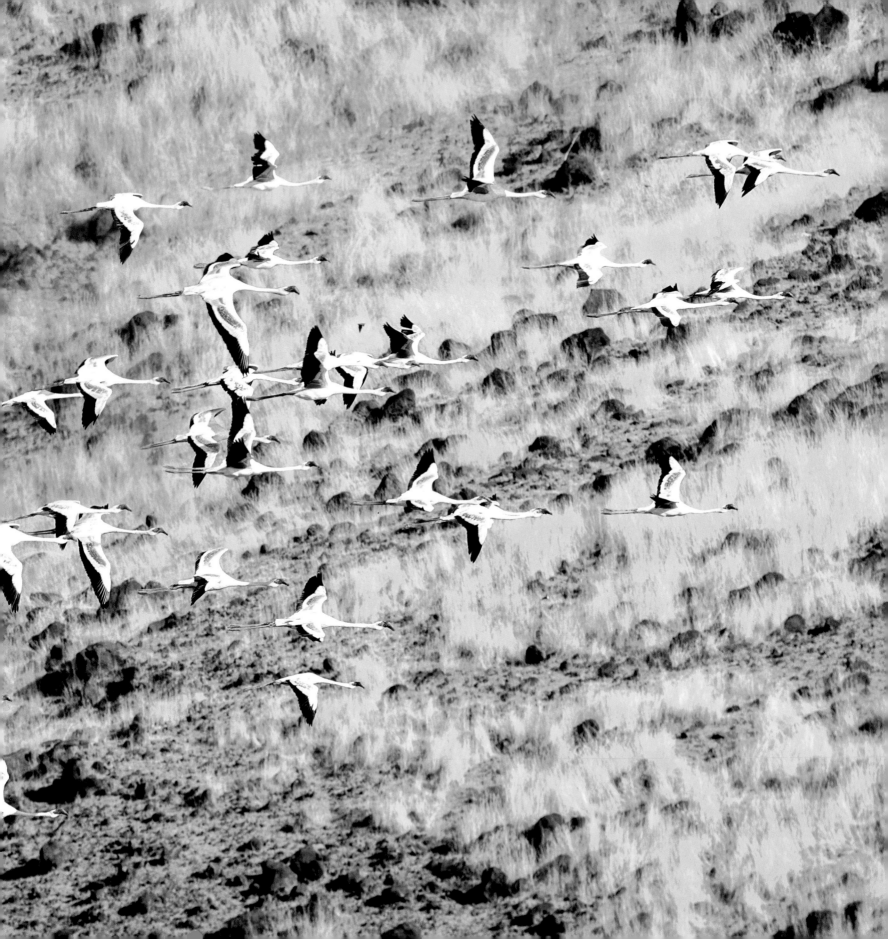

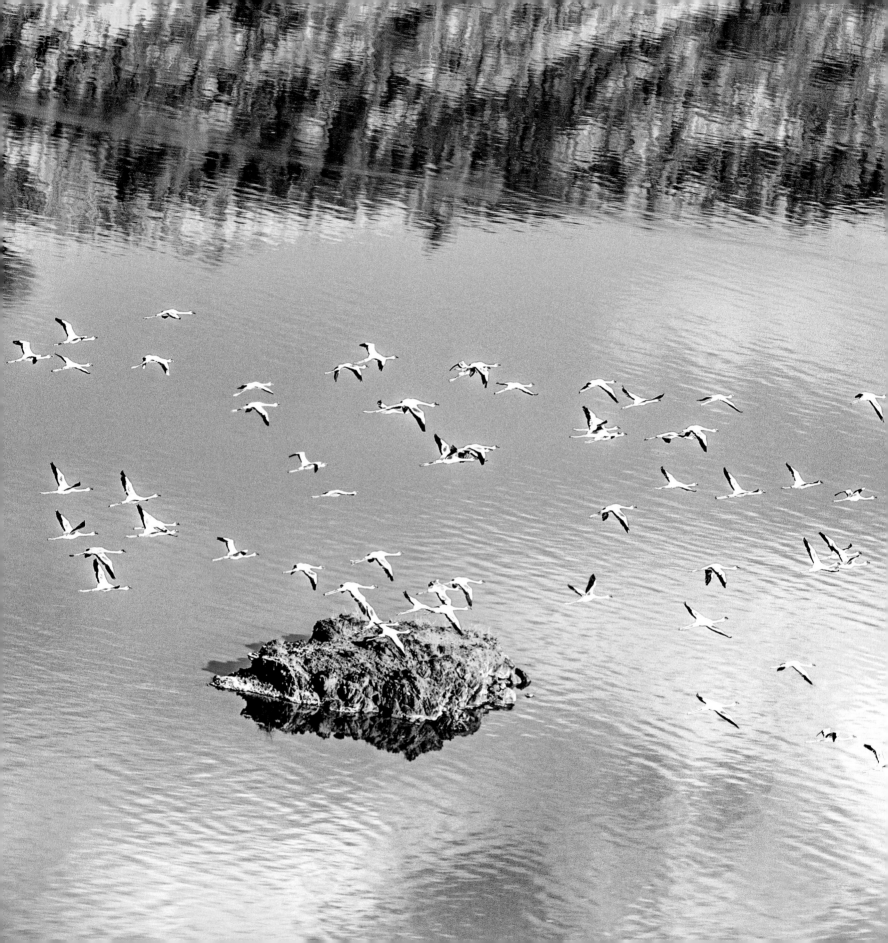

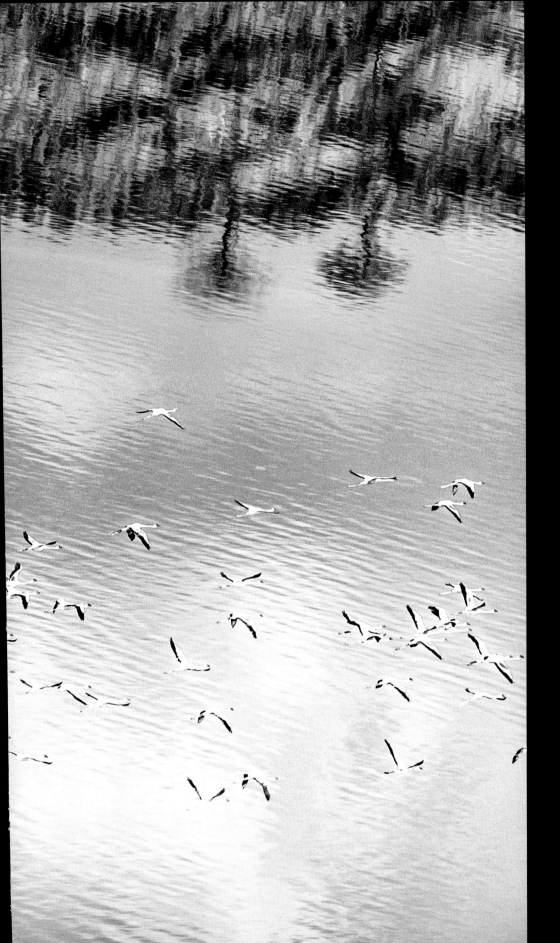

282-283

波光粼粼的湖心中央有一座形如海龜的小島，彷彿是紅鶴的度假勝地。

There is a tortoise-like island on the flickering lake, as if it's a tourist resort for lesser flamingos.

284-285

透過影像都彷彿能聽見低空掠過水面的水鳥群齊聲合唱的歡樂歌謠。

It seems that we are able to hear the happy songs by the choir of waders skimming over the water through this still image.

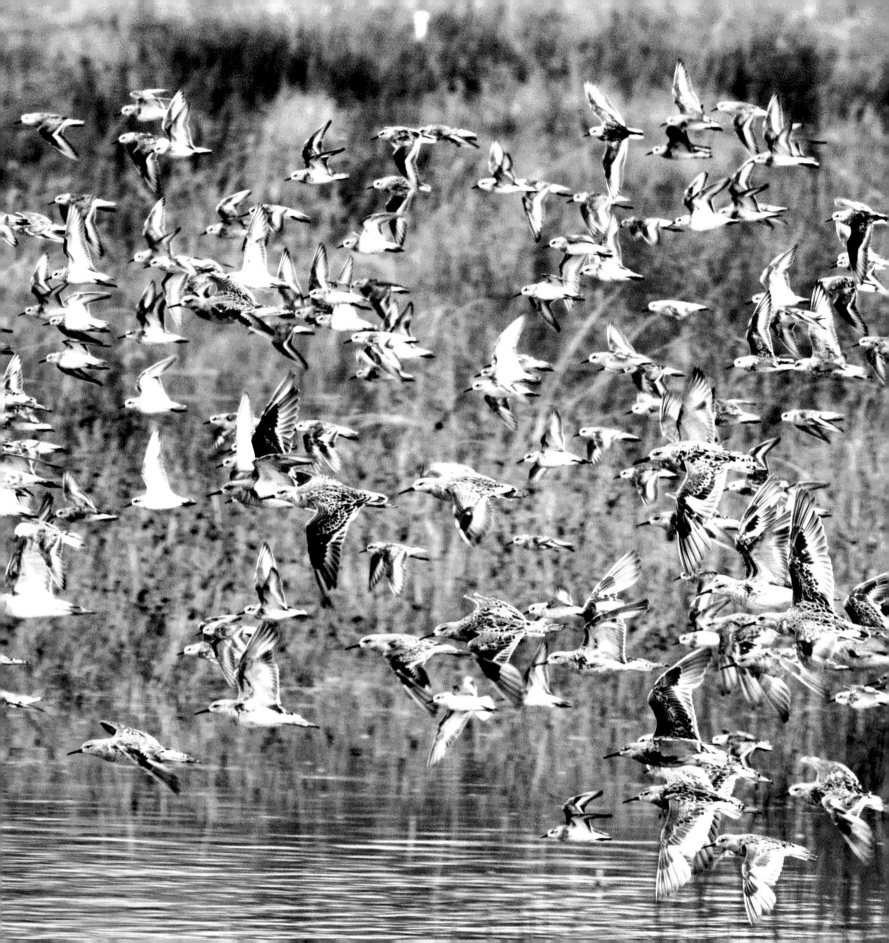

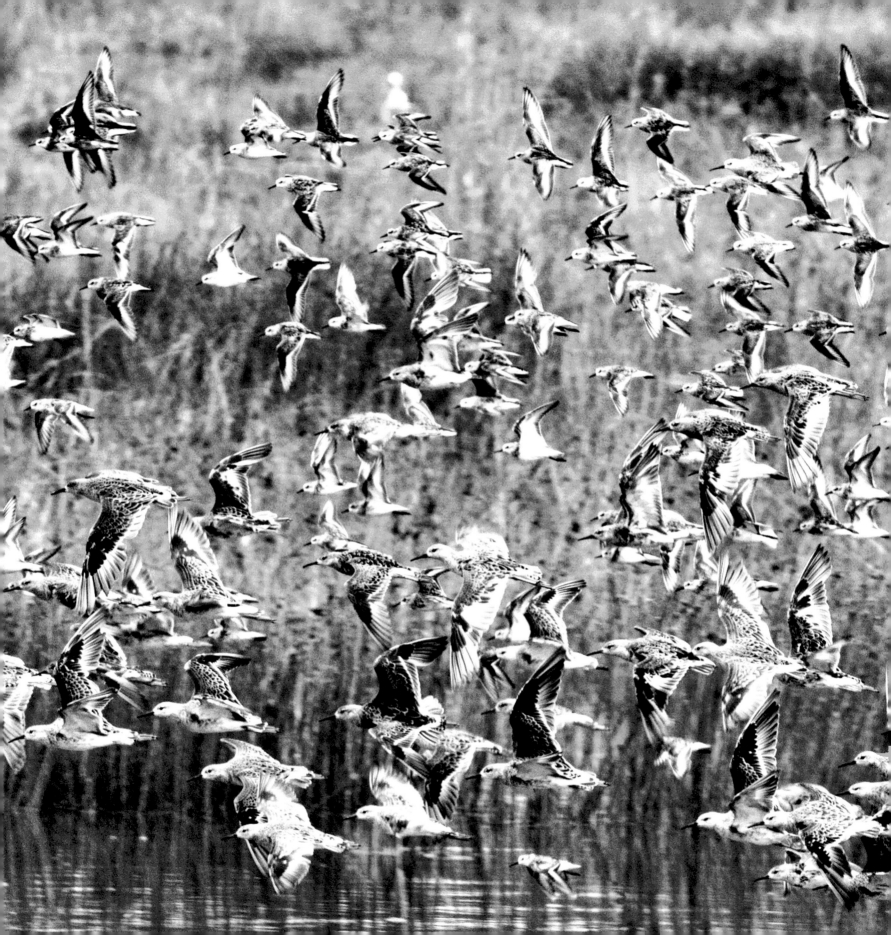

鳴謝 Acknowledgements

Zimman Shunji, Ryan Mok, Natalie Li, Kristie Leung, Chan Hiu, Sherrie Poon